WELCOME BOOKS PRESENTS

ONE PHOTOGRAPHER. 21 YEARS ON THE RED CARPET.

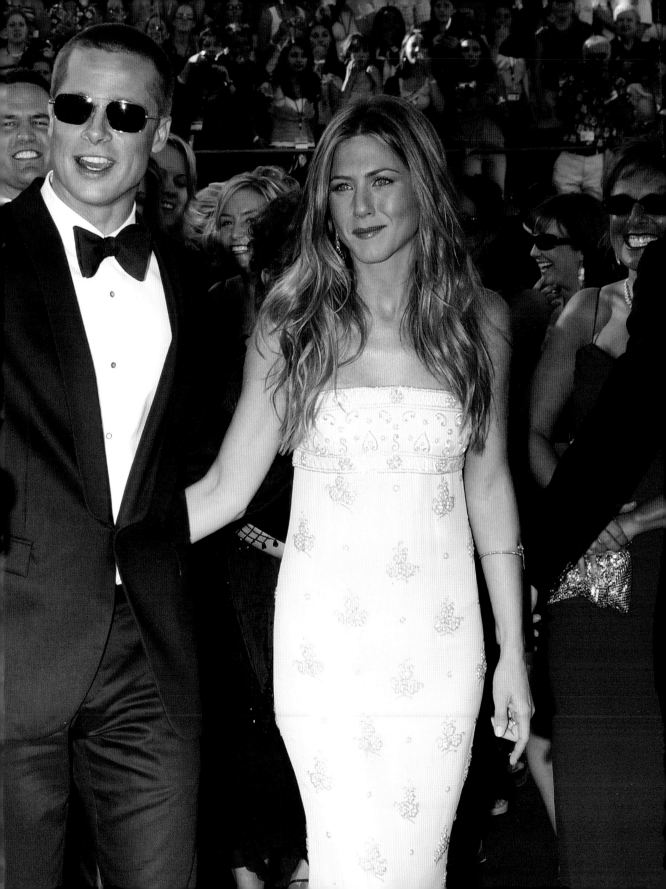

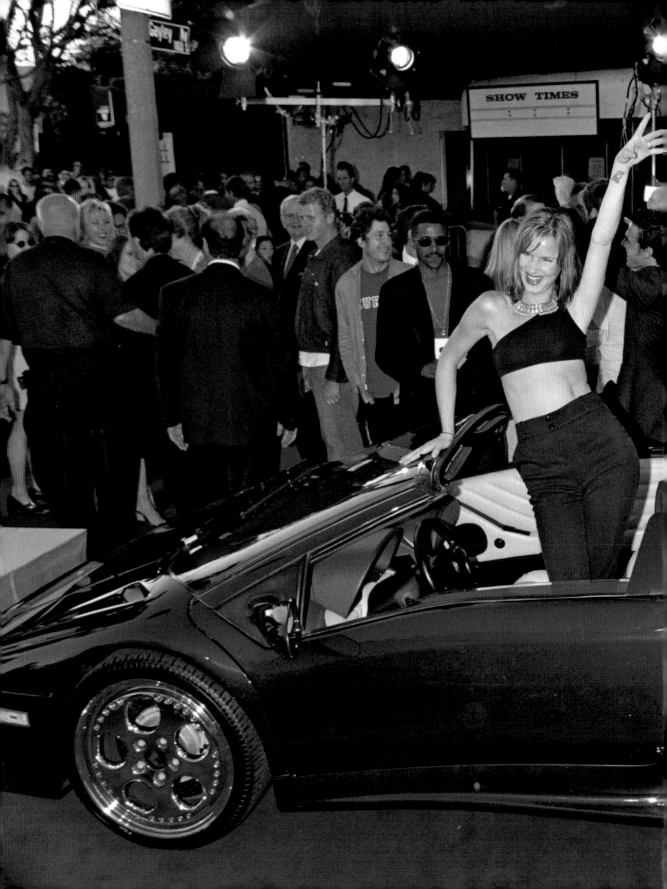

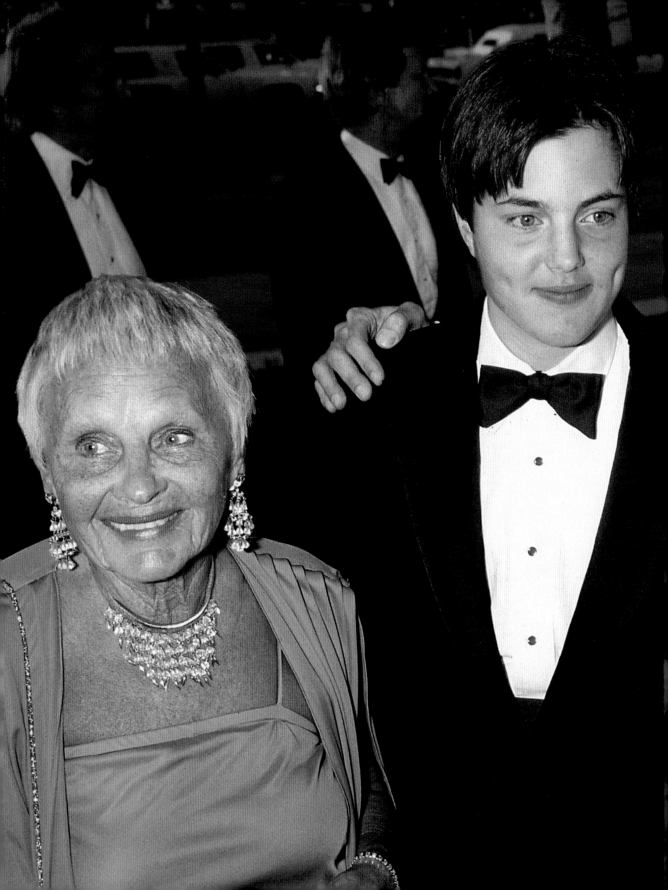

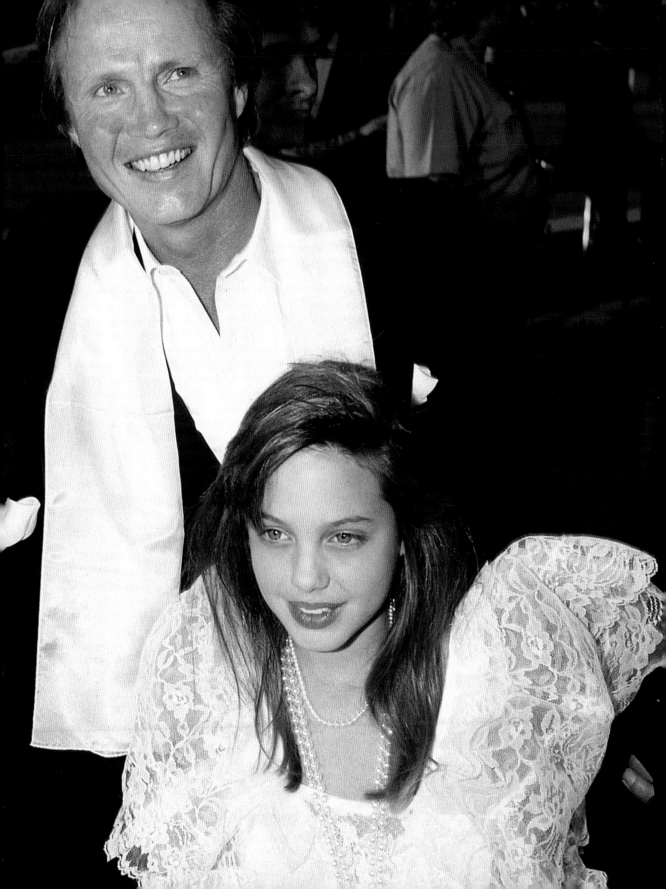

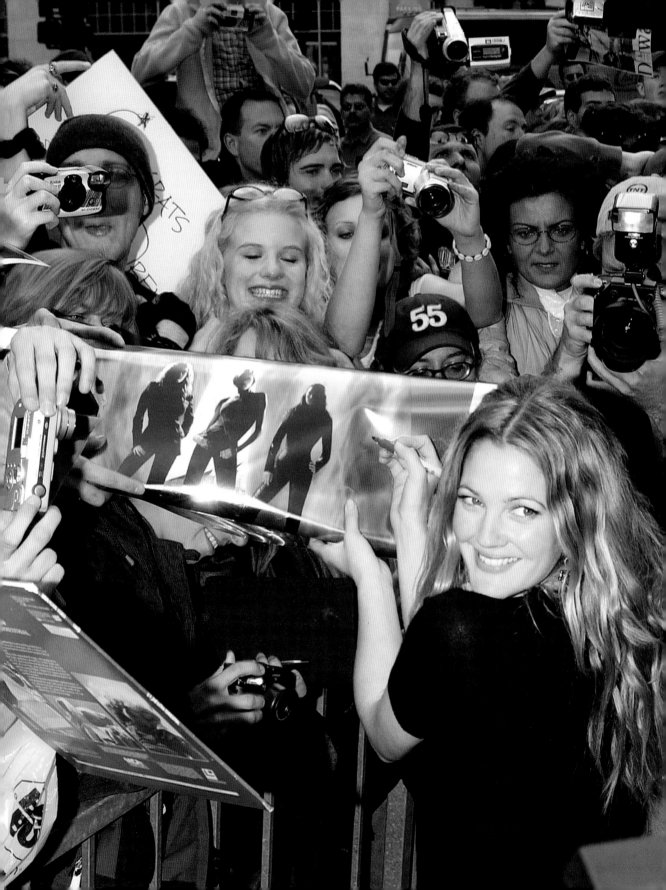

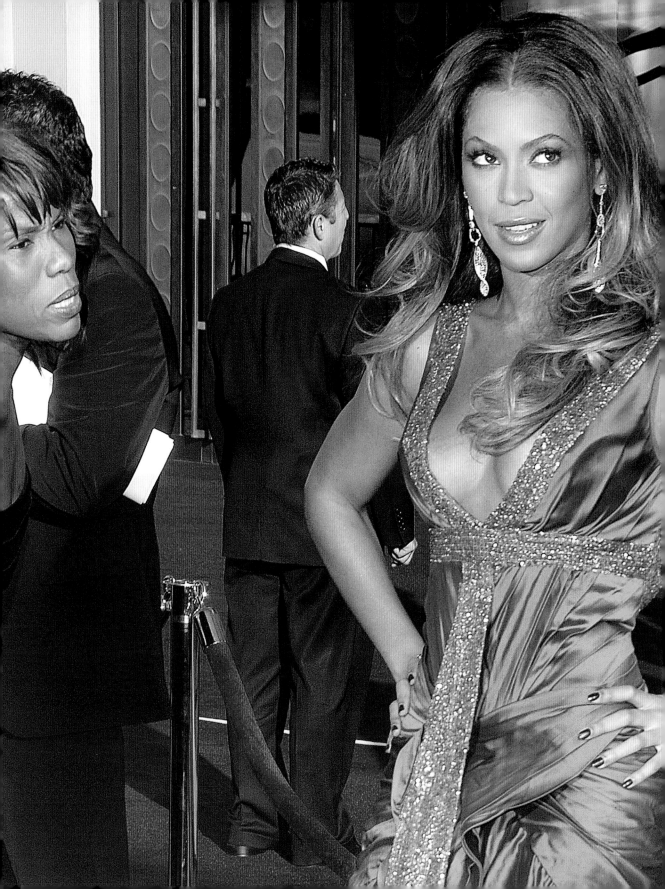

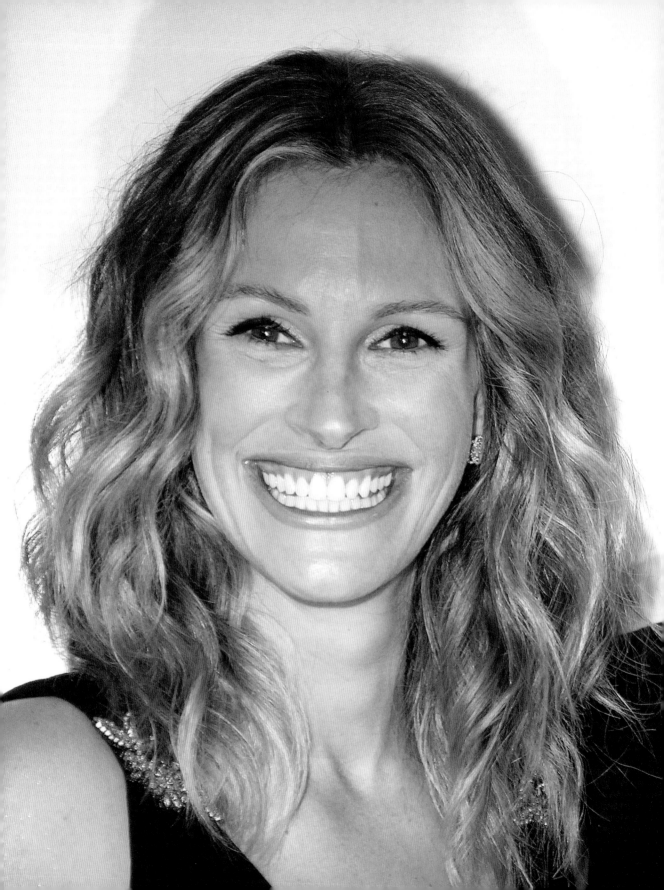

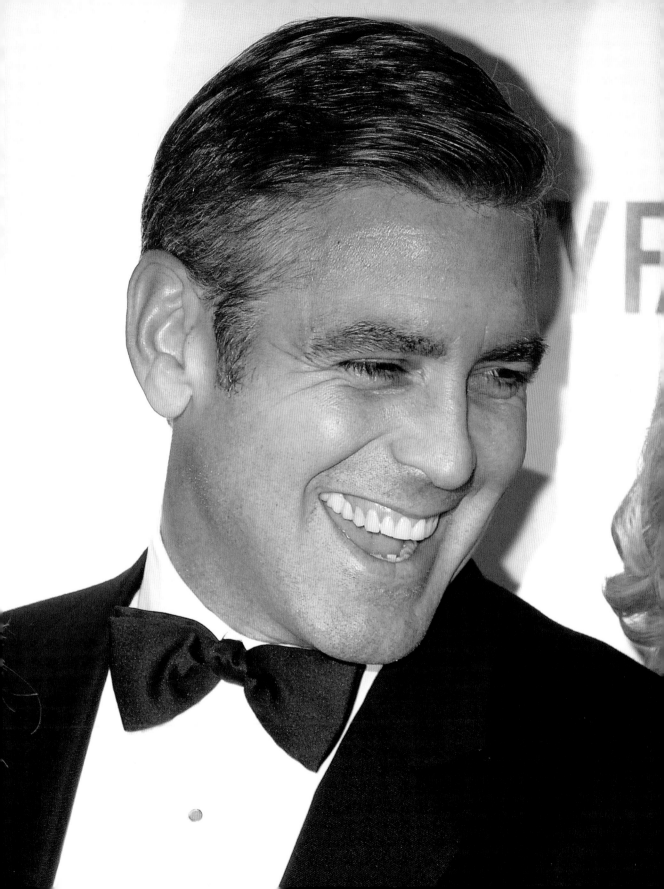

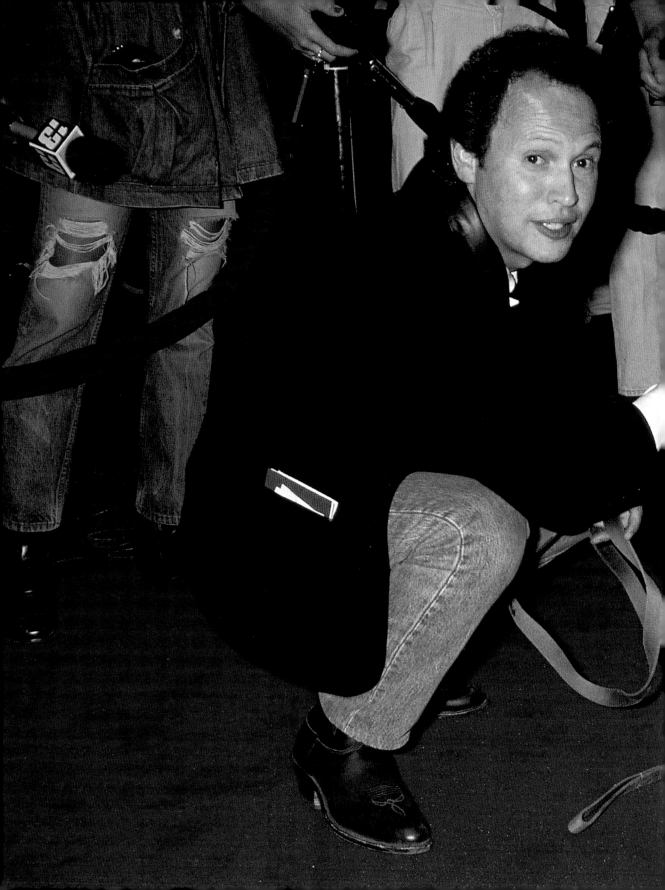

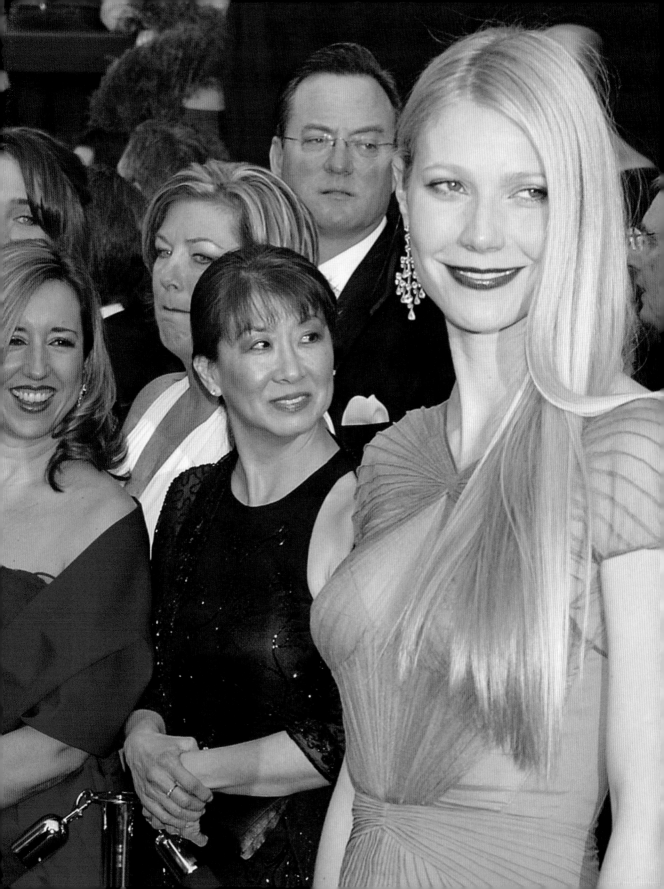

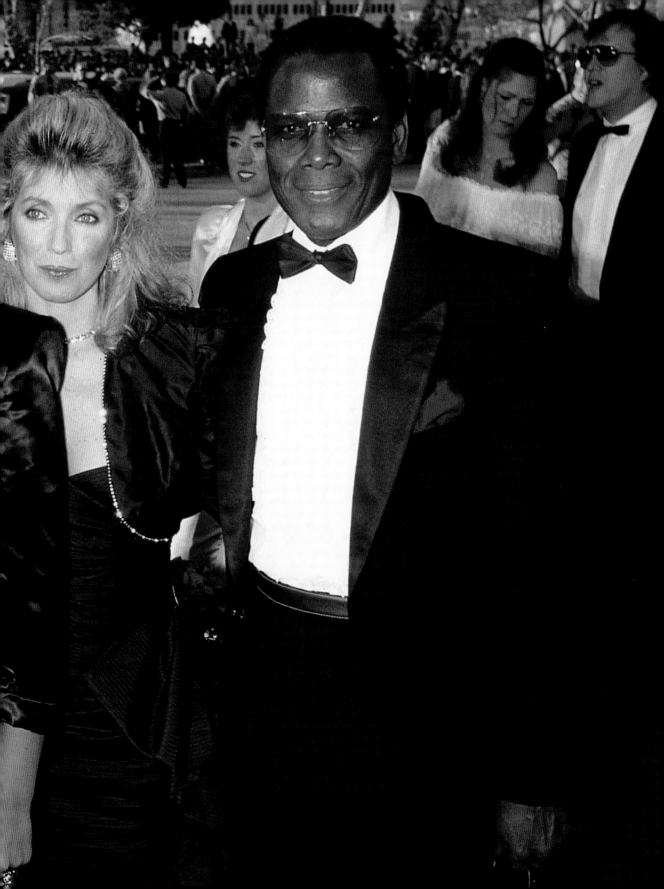

RED CARPET
21 YEARS OF FAME AND FASHION

PHOTOGRAPHS BY FRANK TRAPPER
EDITED BY KATRINA FRIED

welcome
BOOKS
NEW YORK & SAN FRANCISCO

Dedicated to the memory of Barry Sundermeier (1948–2008)

who made it happen

CONTENTS

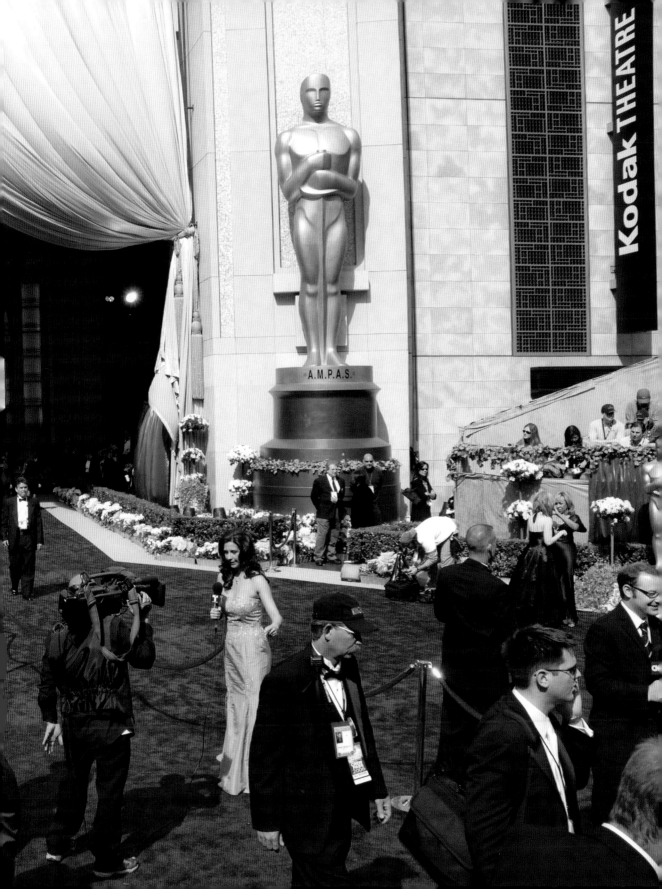

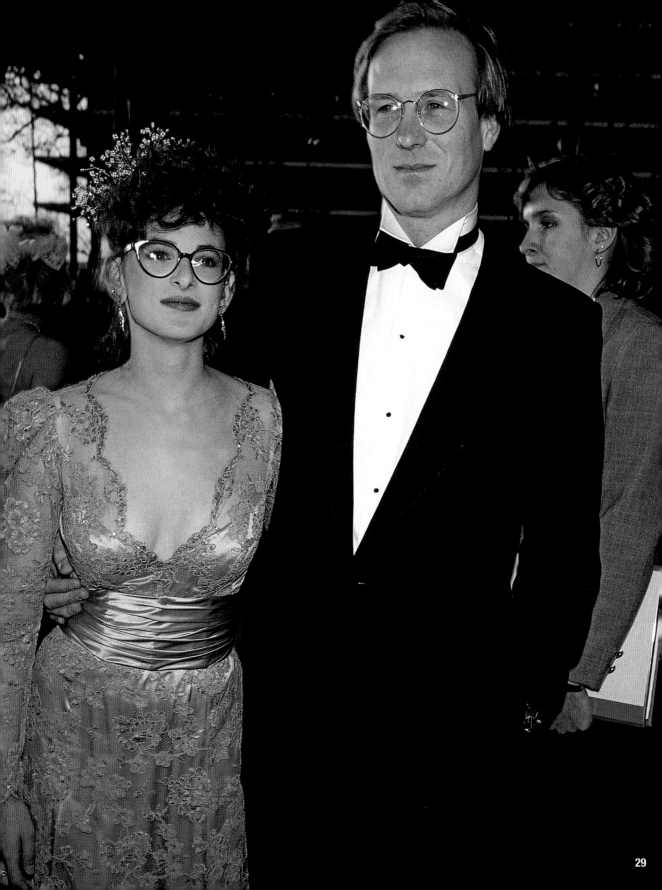

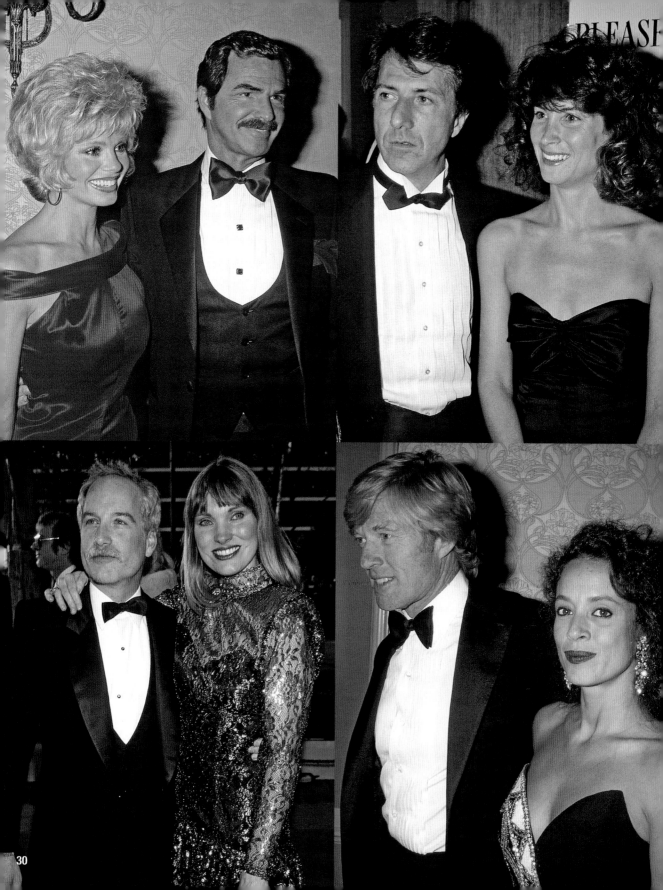

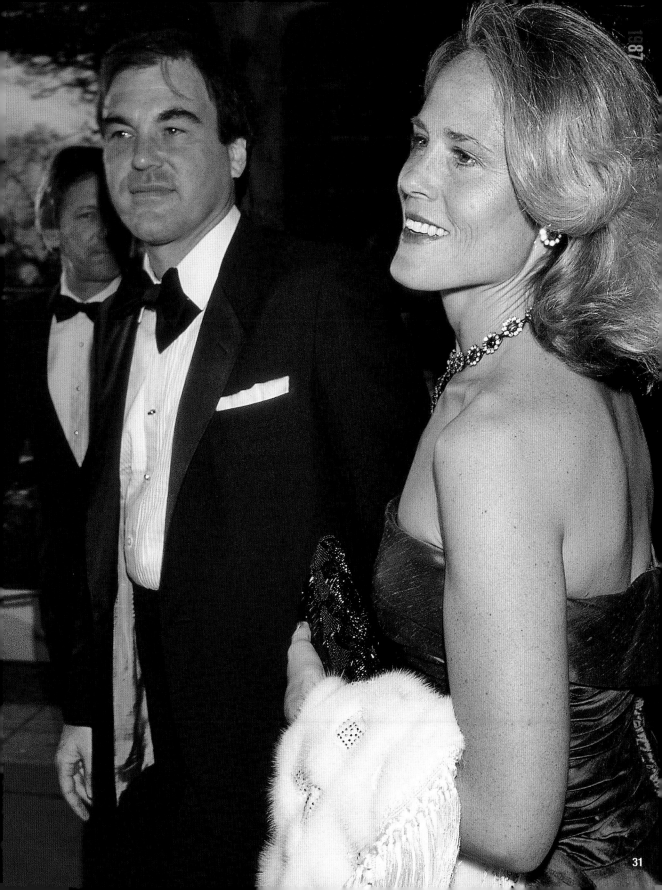

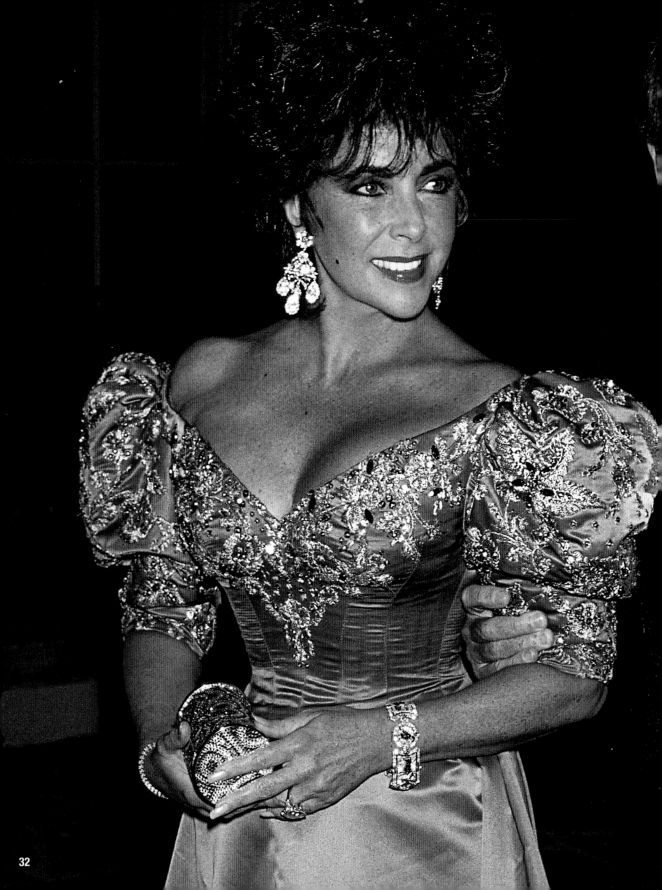

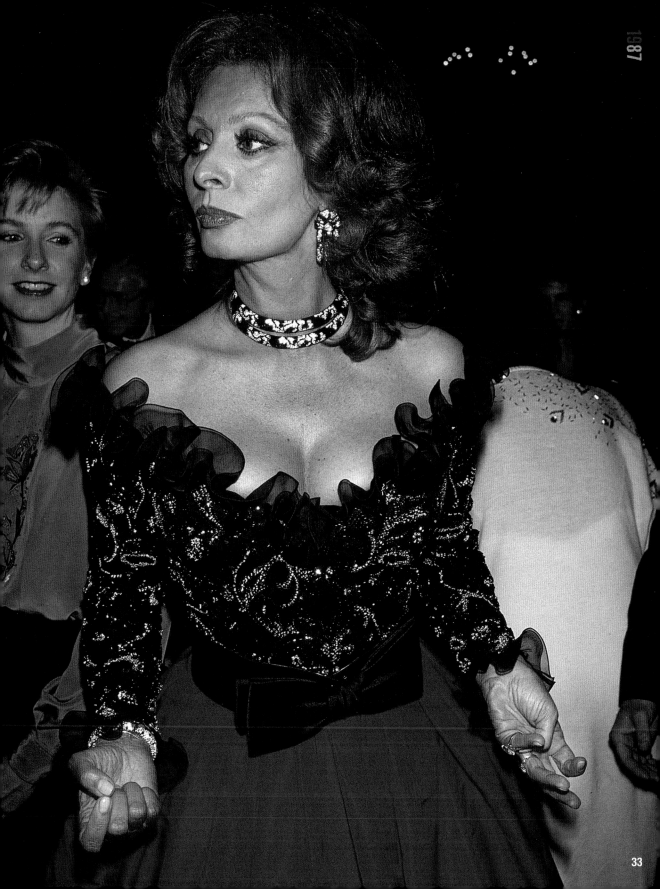

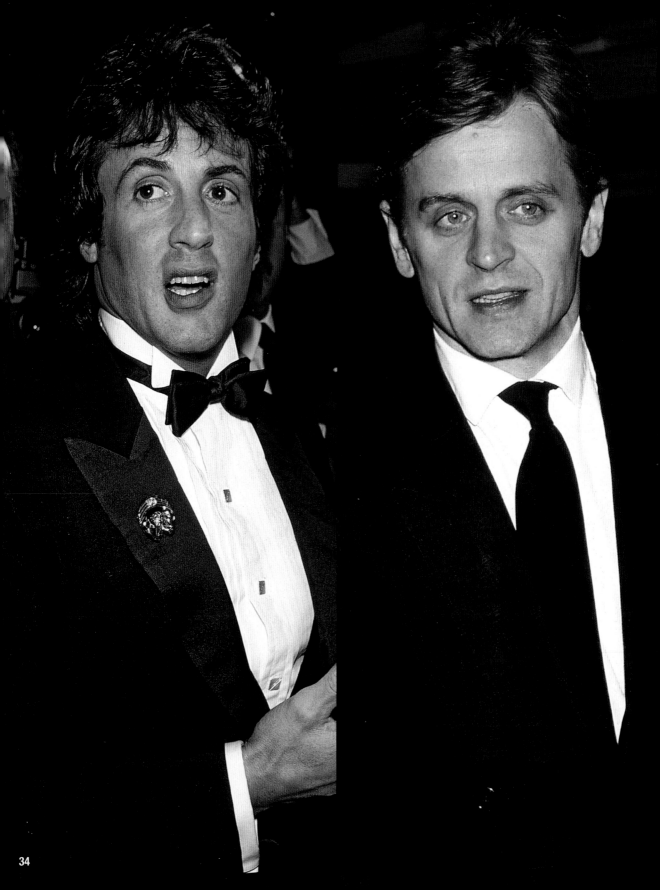

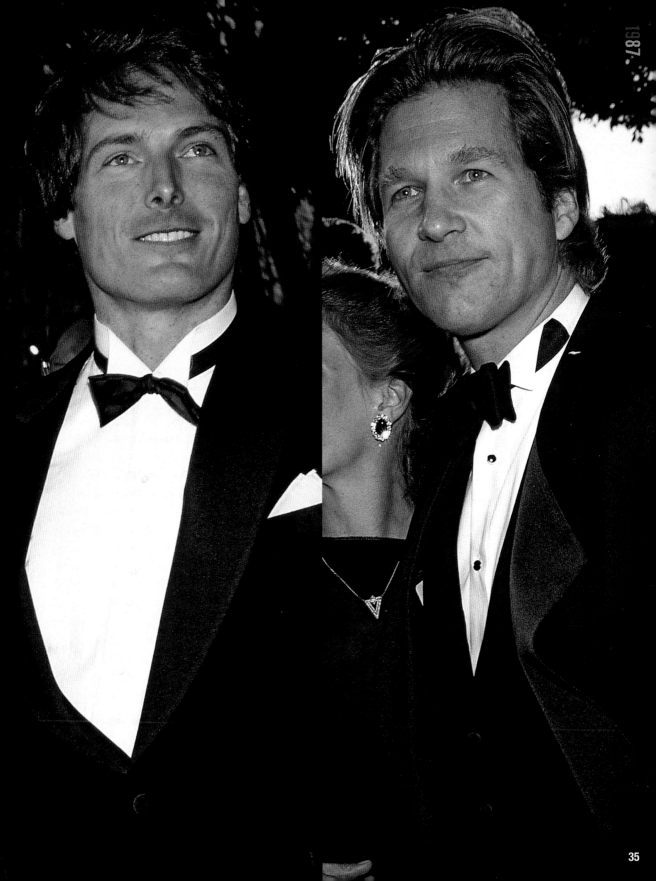

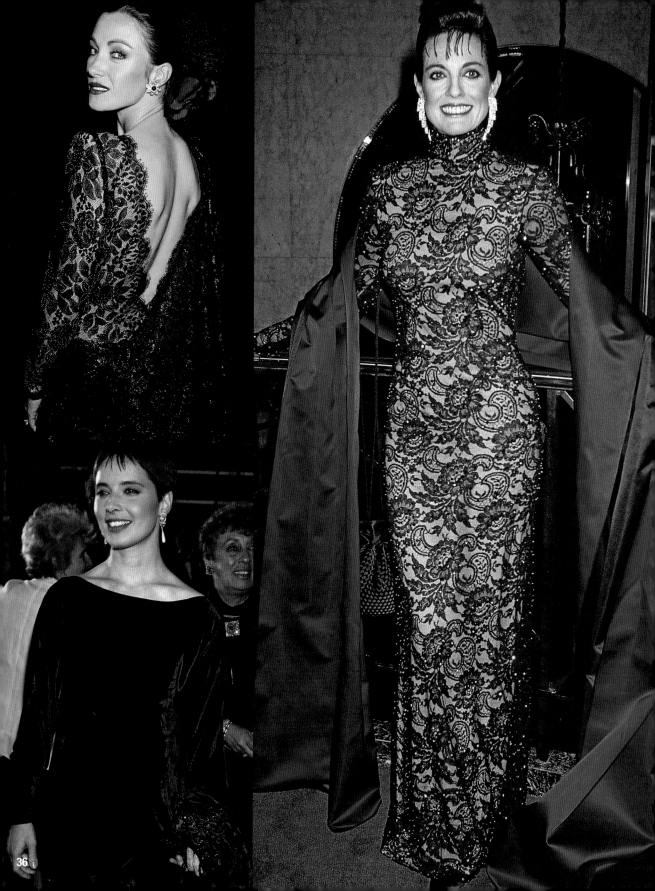

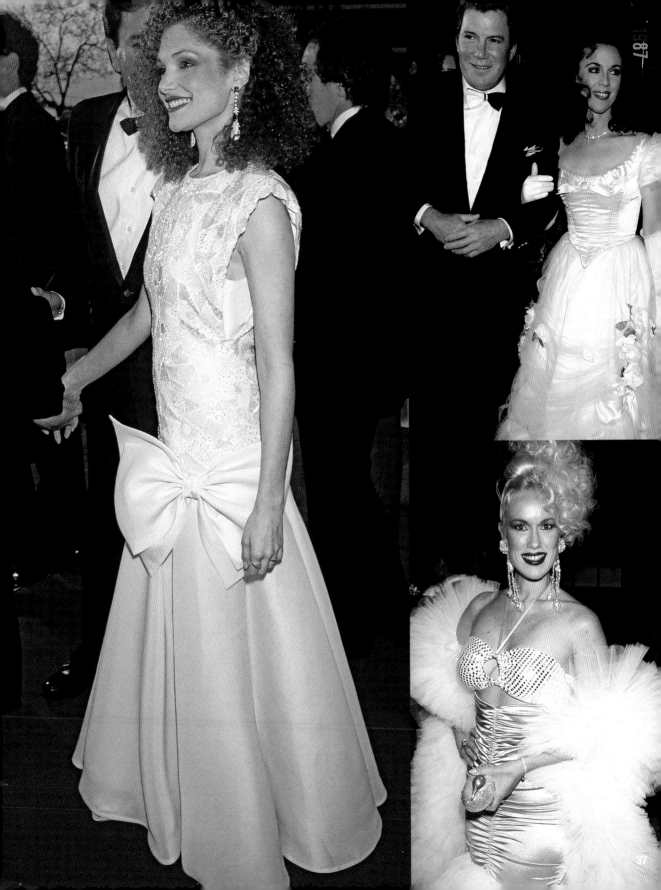

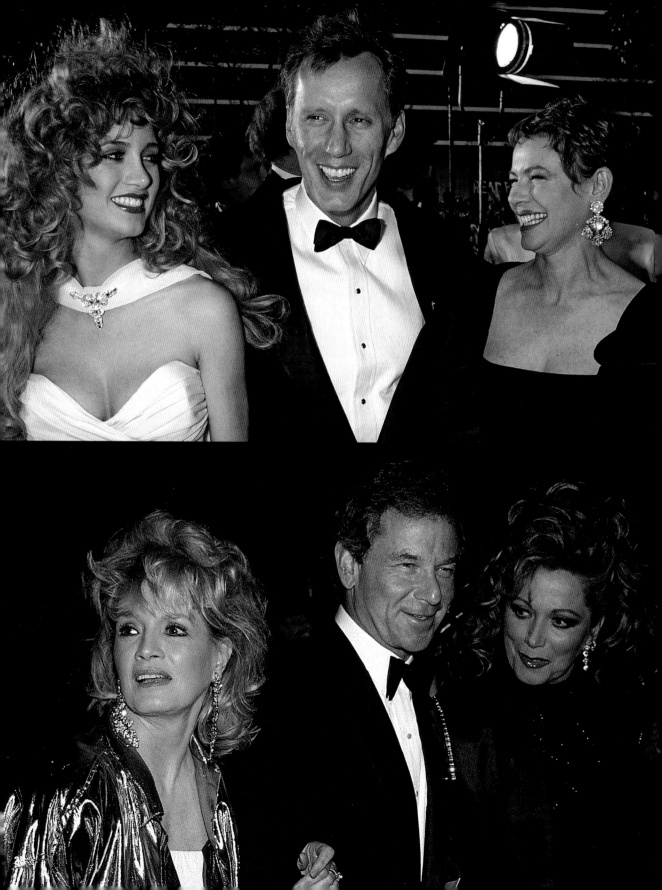

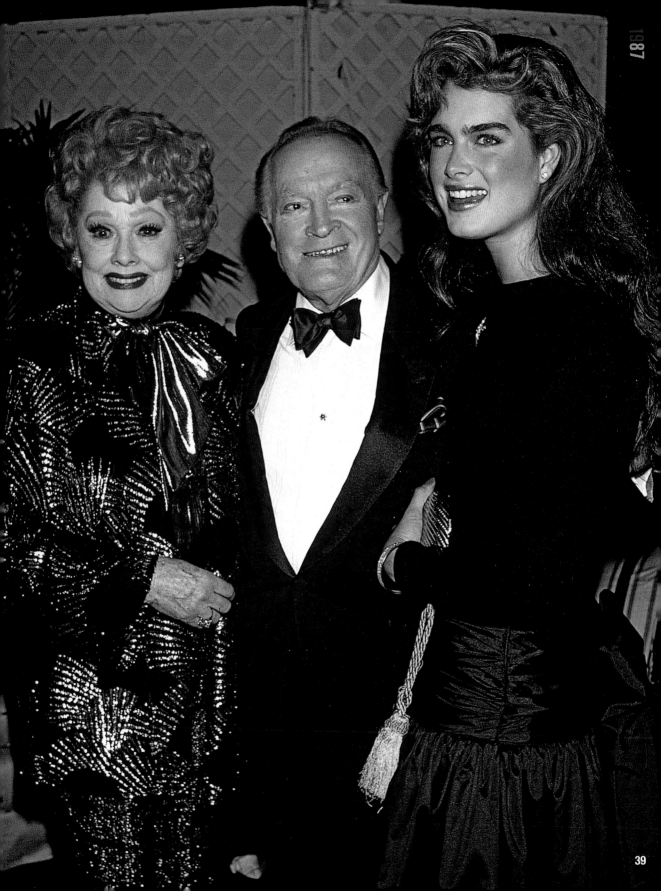

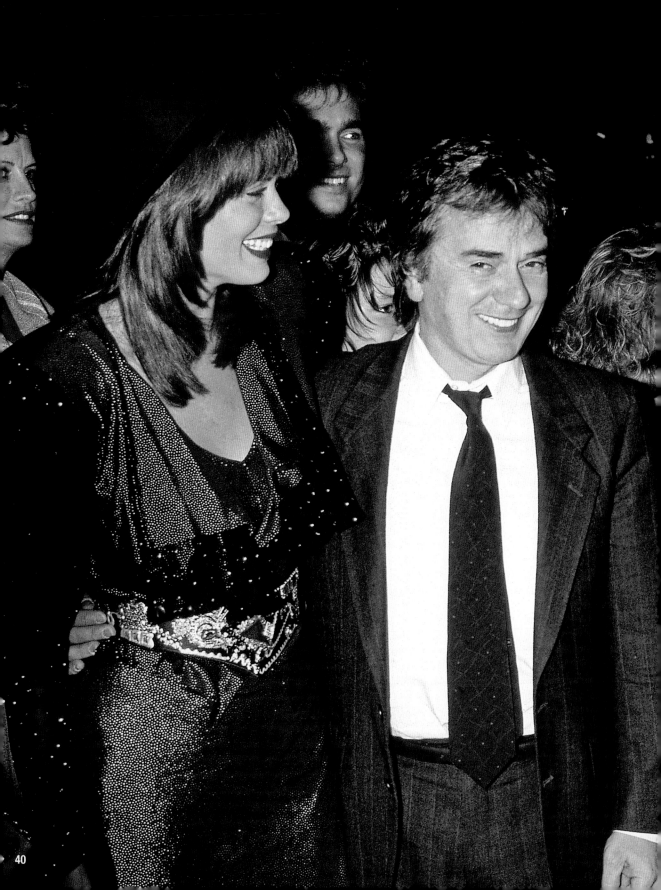

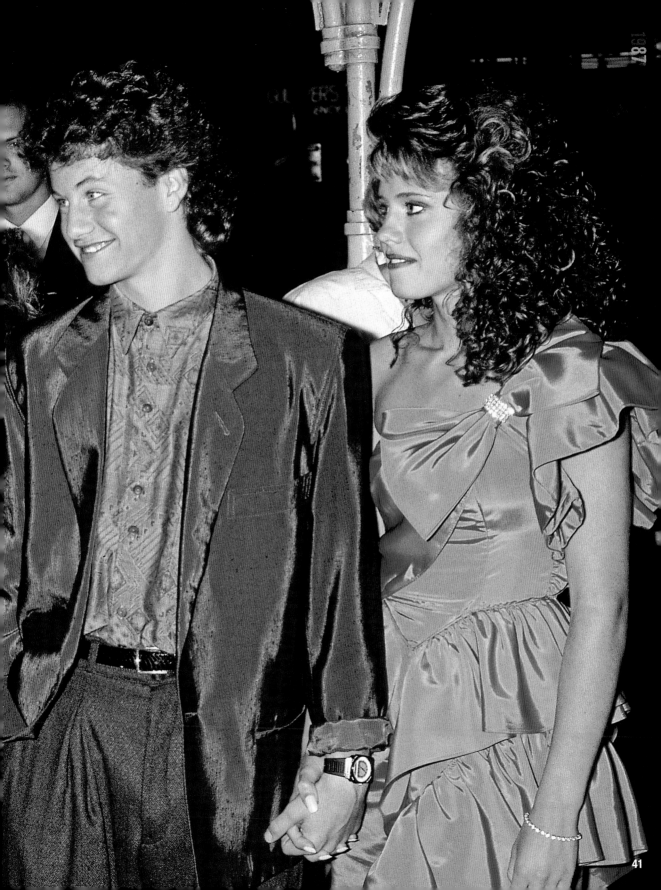

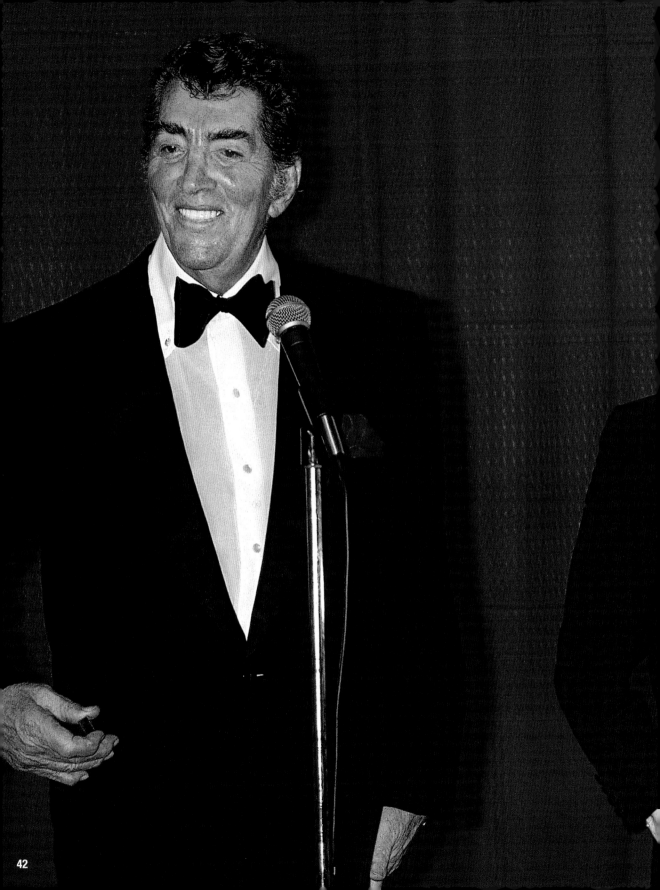

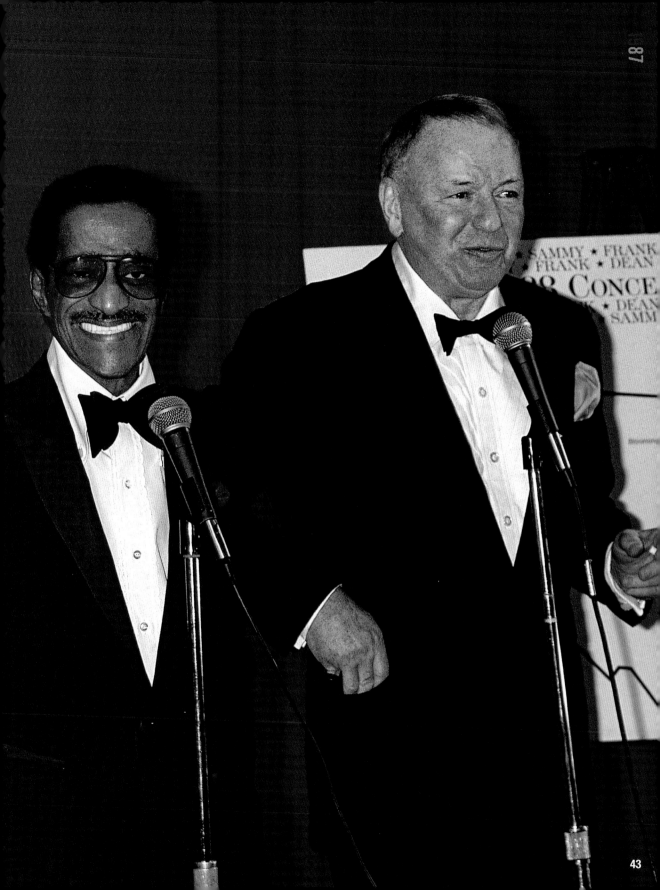

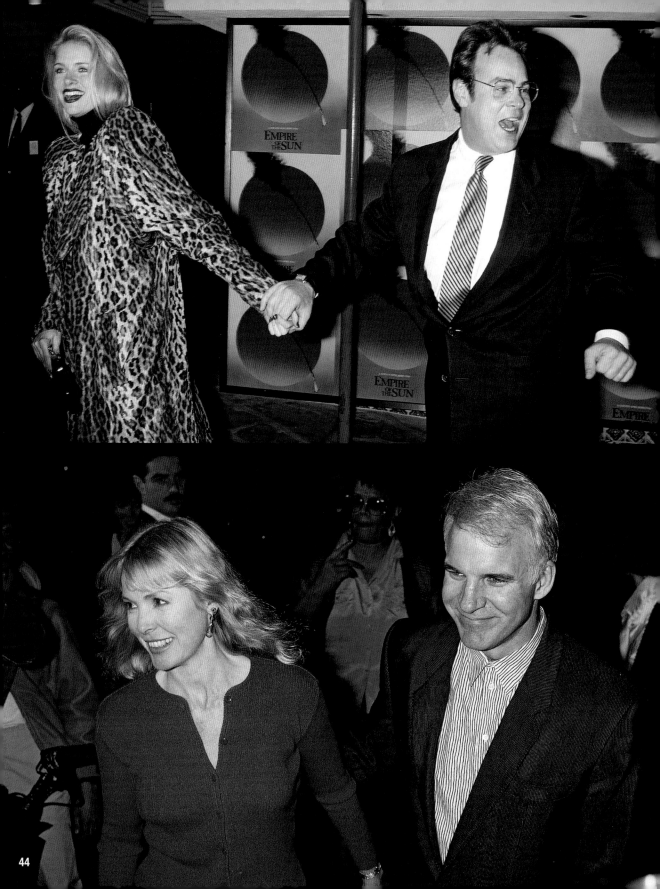

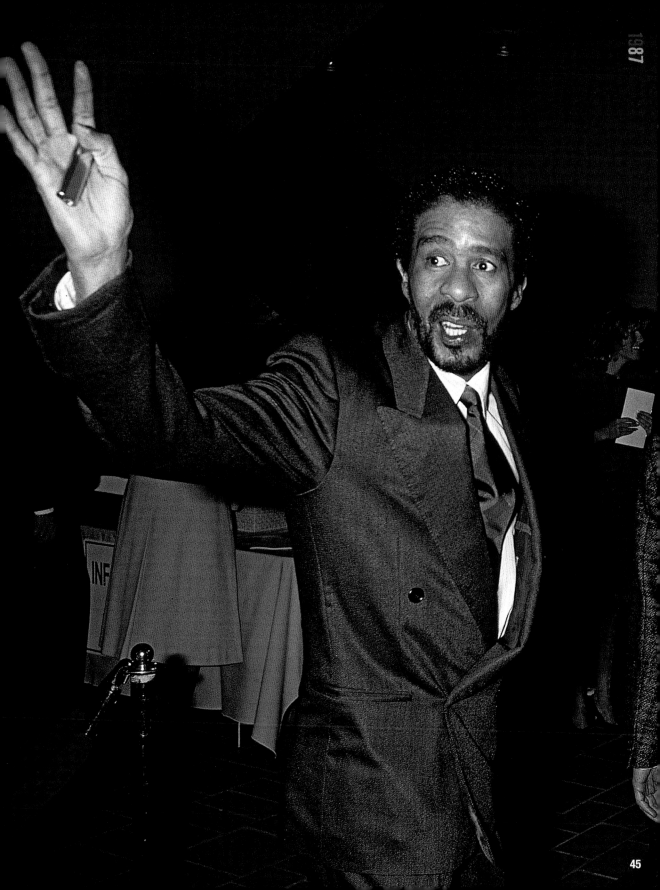

1987 1988 1989
1990 1991 1992
1993 1994 1995
1996 1997 1998
1999 2000 2001
2002 2003 2004
2005 2006 2007

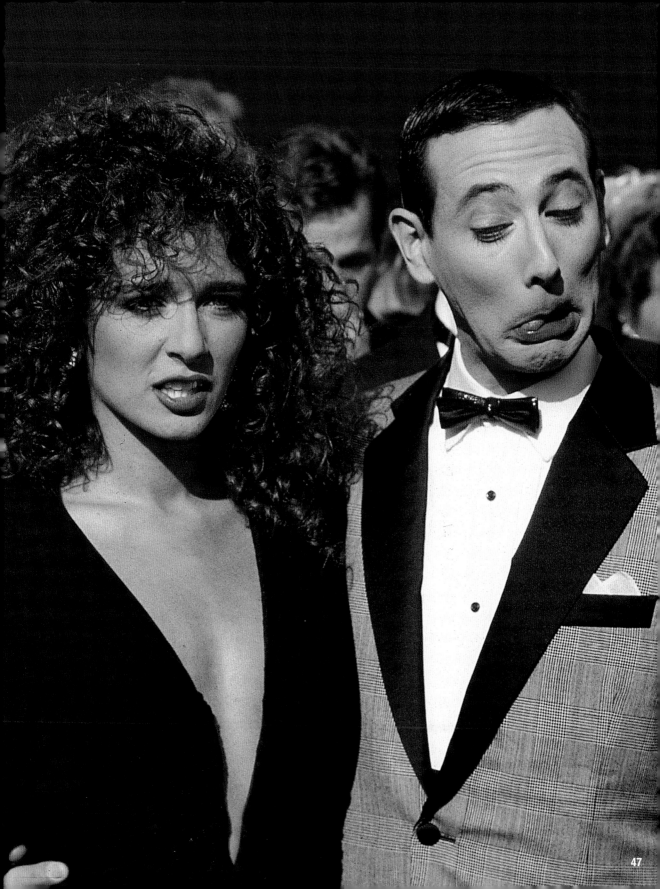

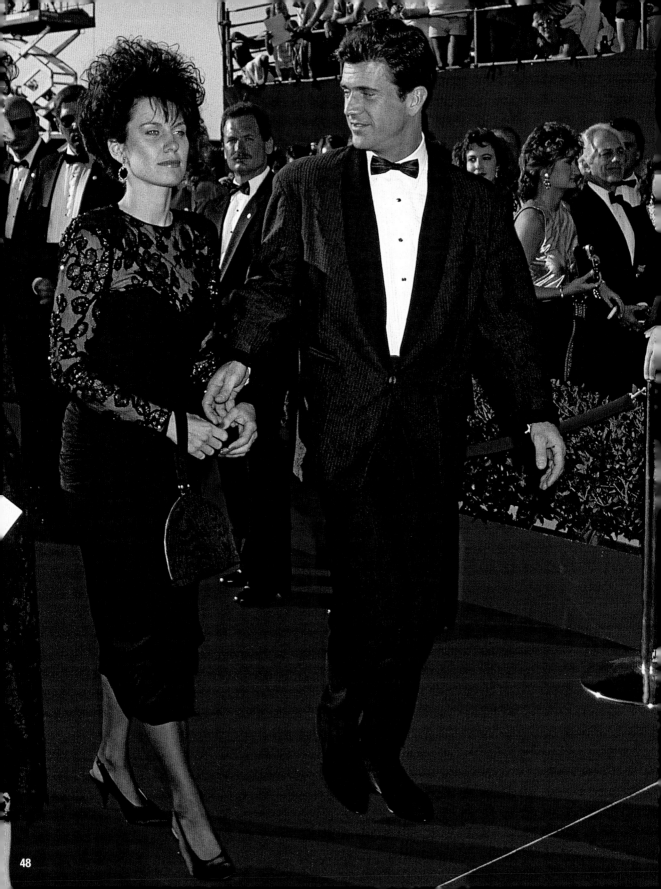

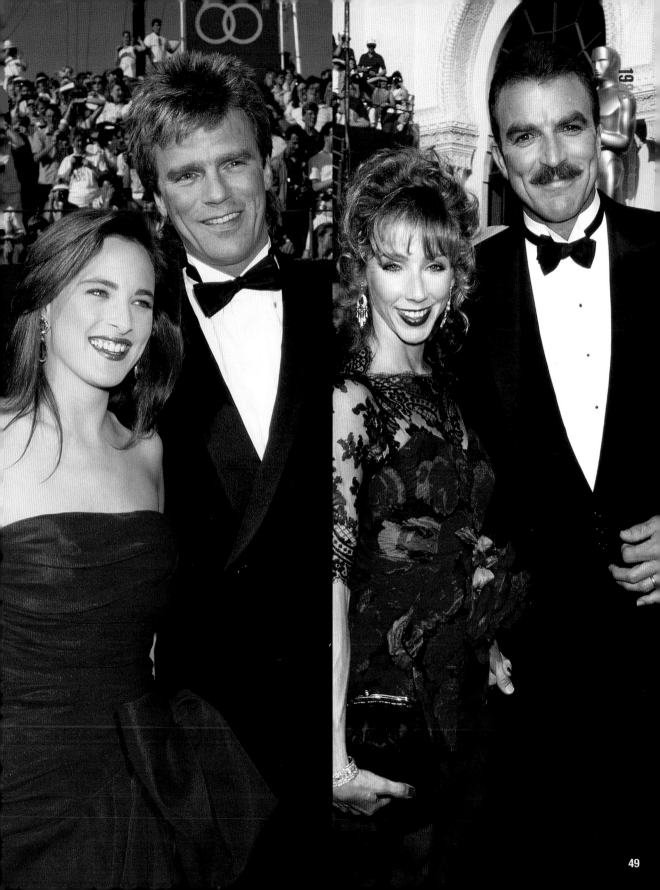

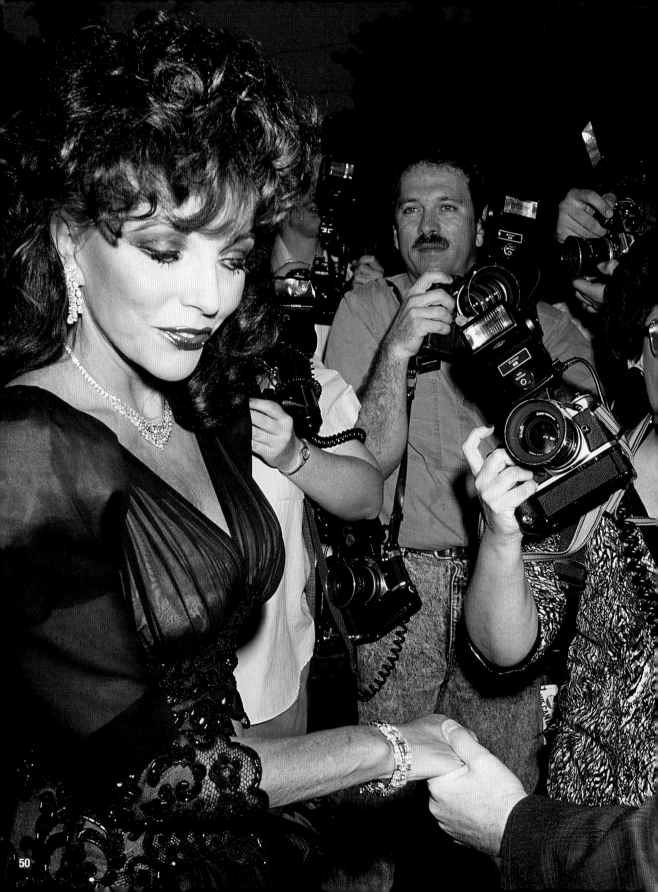

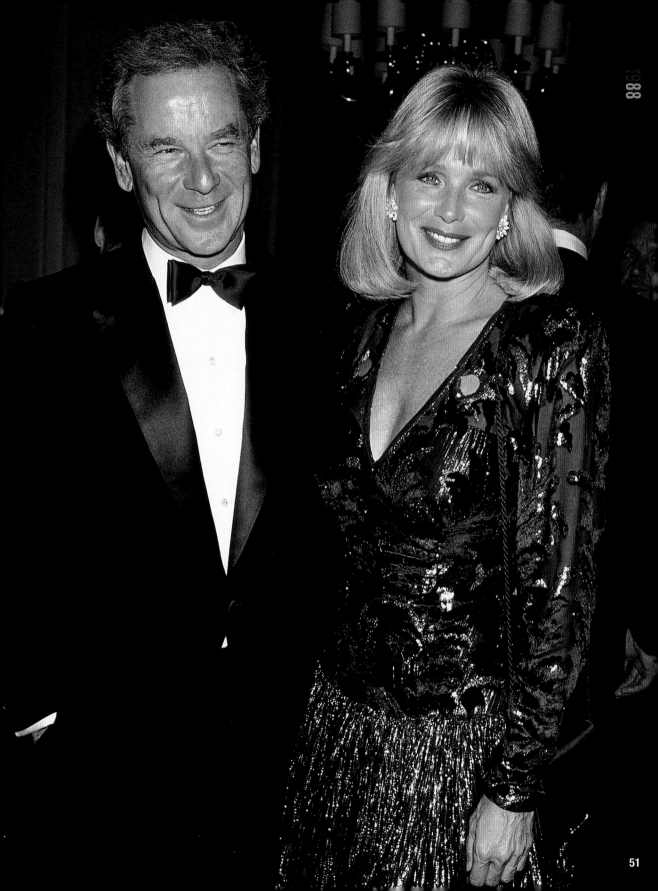

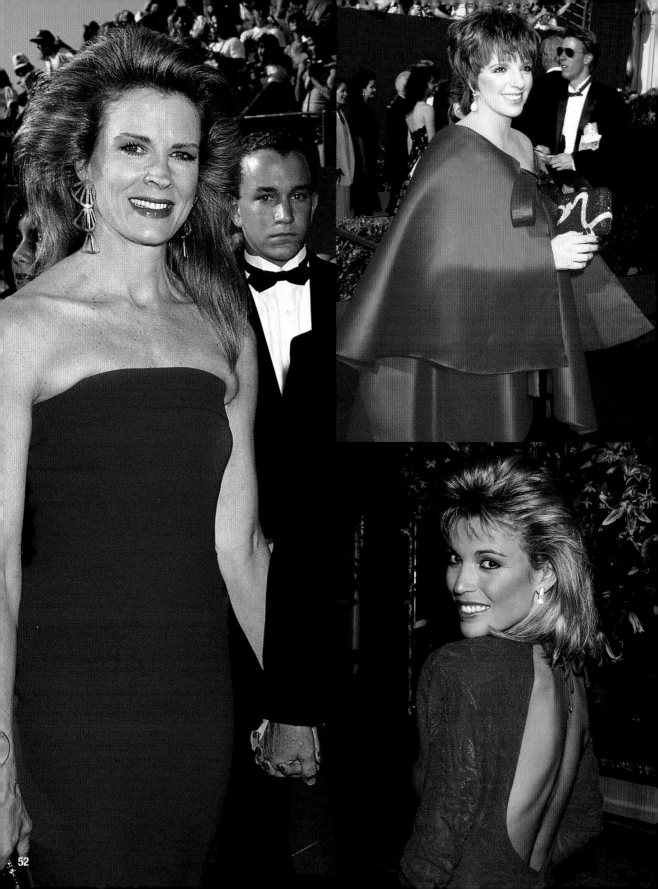

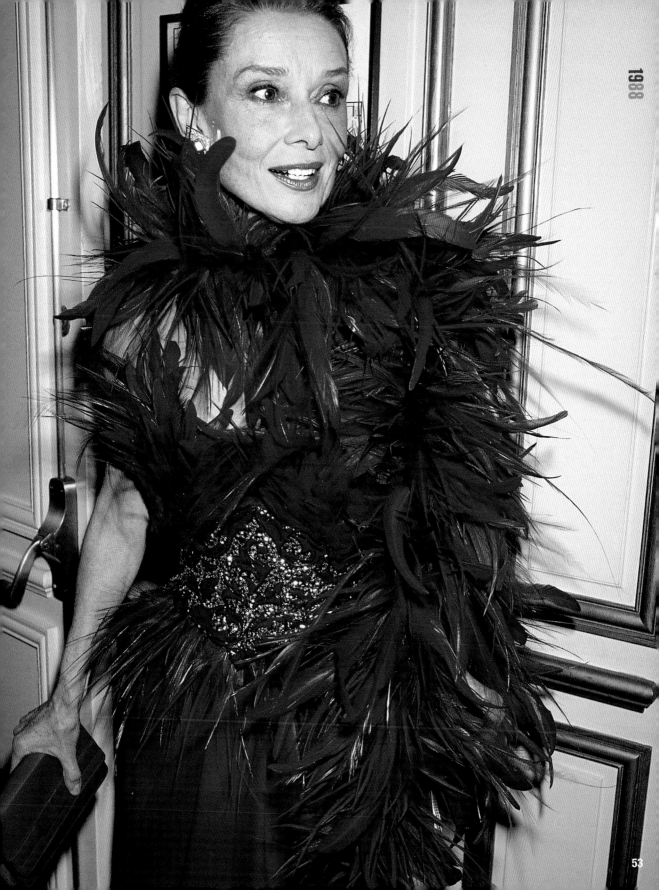

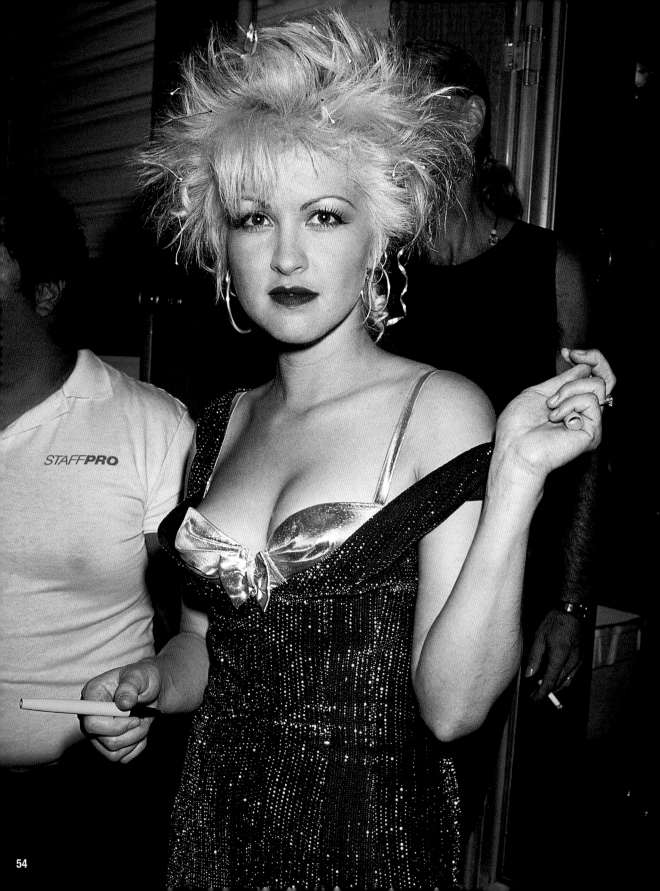

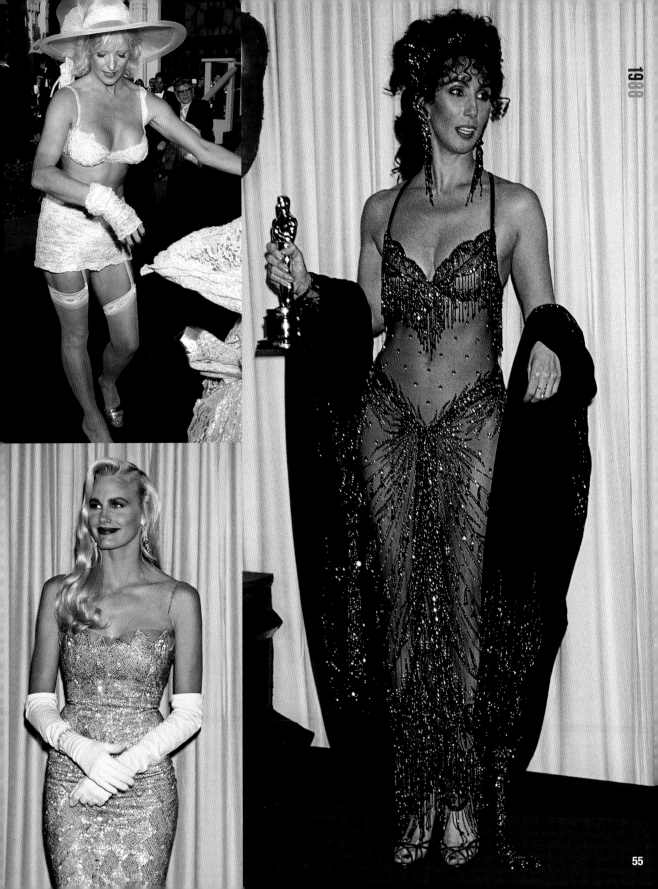

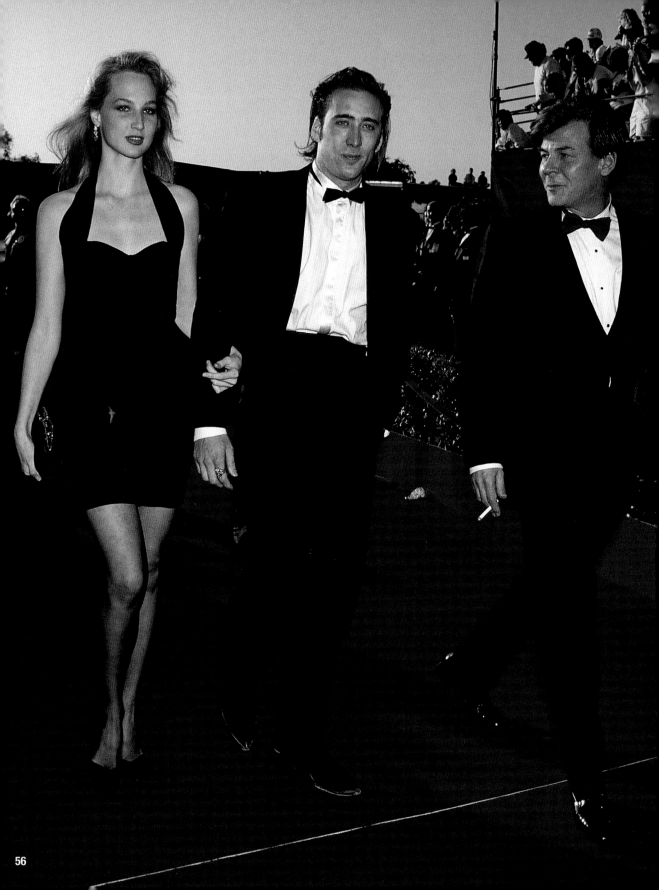

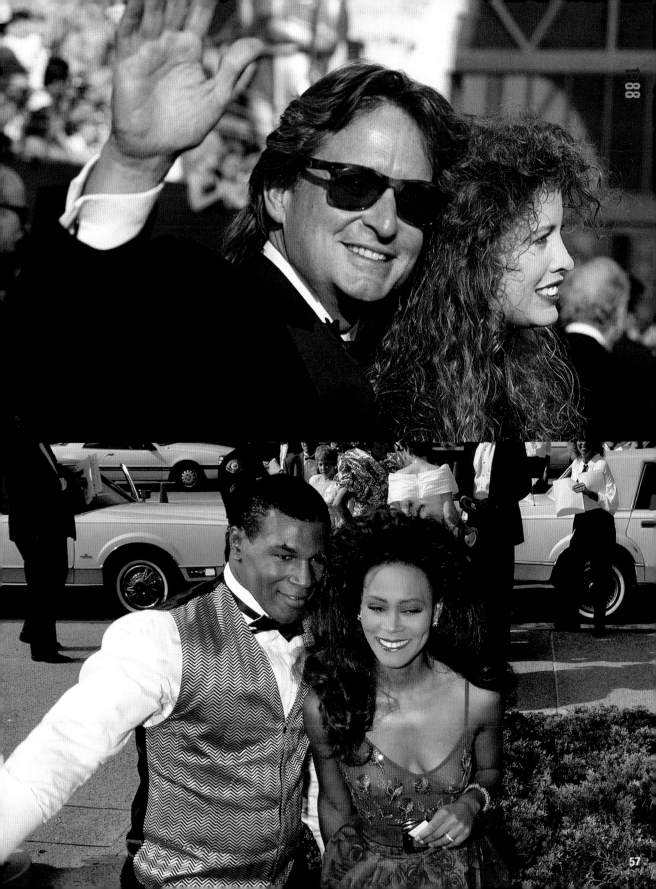

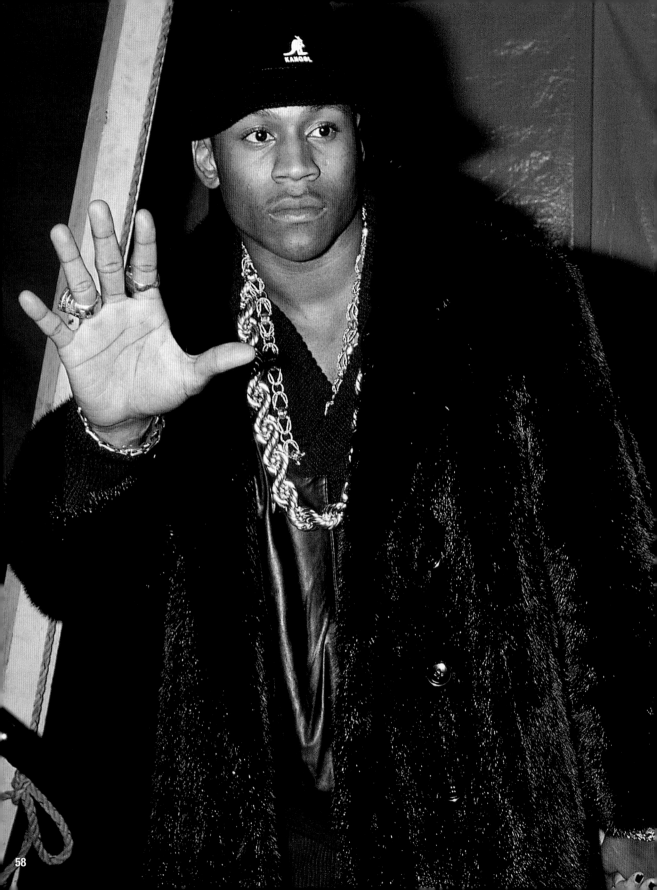

1987 1988 1989
1990 1991 1992
1993 1994 1995
1996 1997 1998
1999 2000 2001
2002 2003 2004
2005 2006 2007

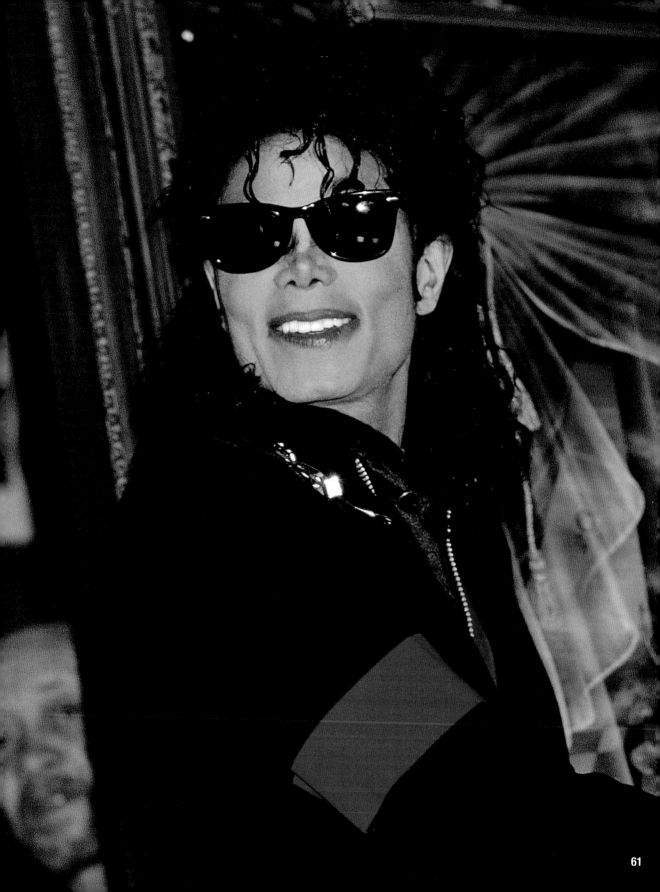

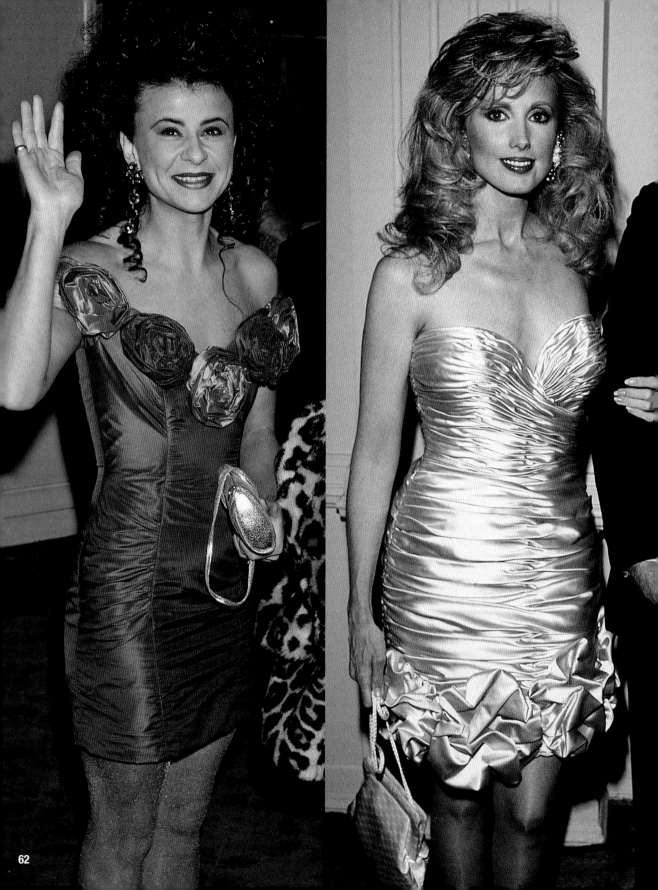

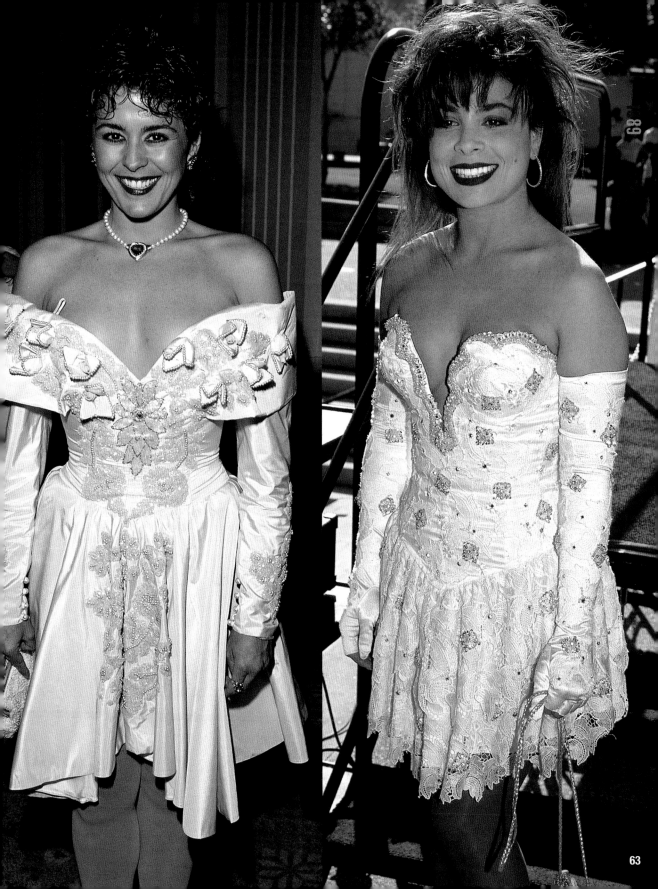

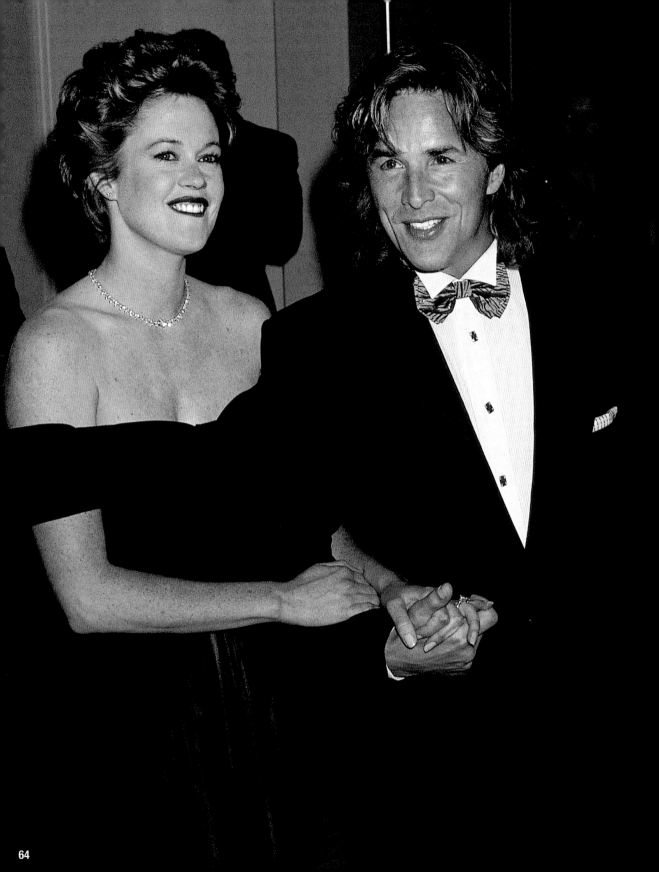

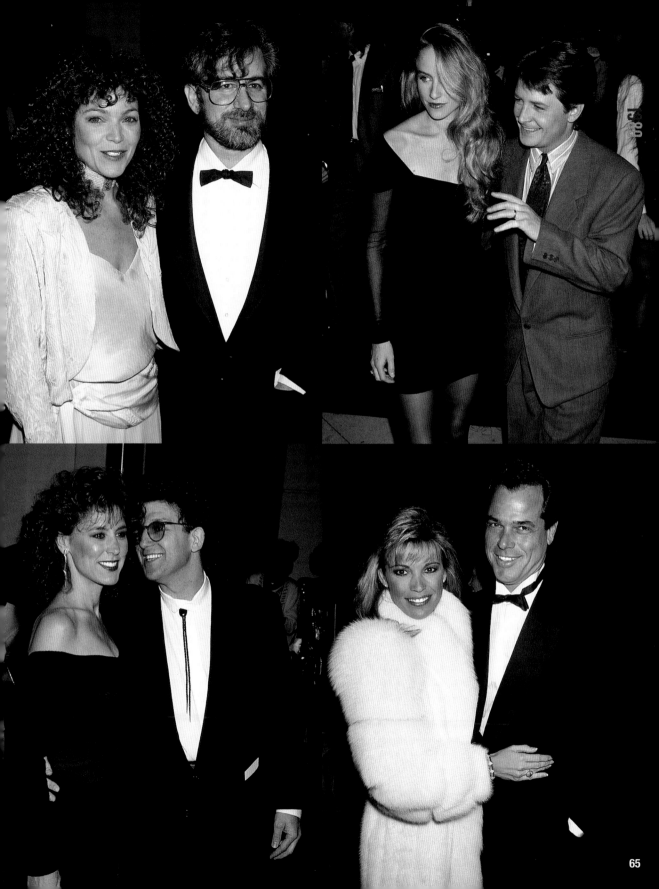

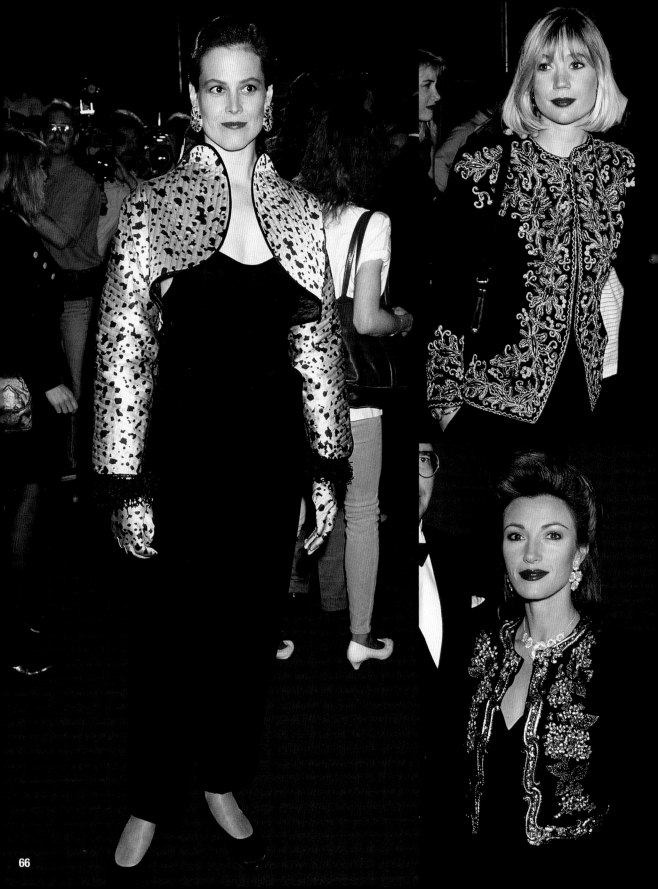

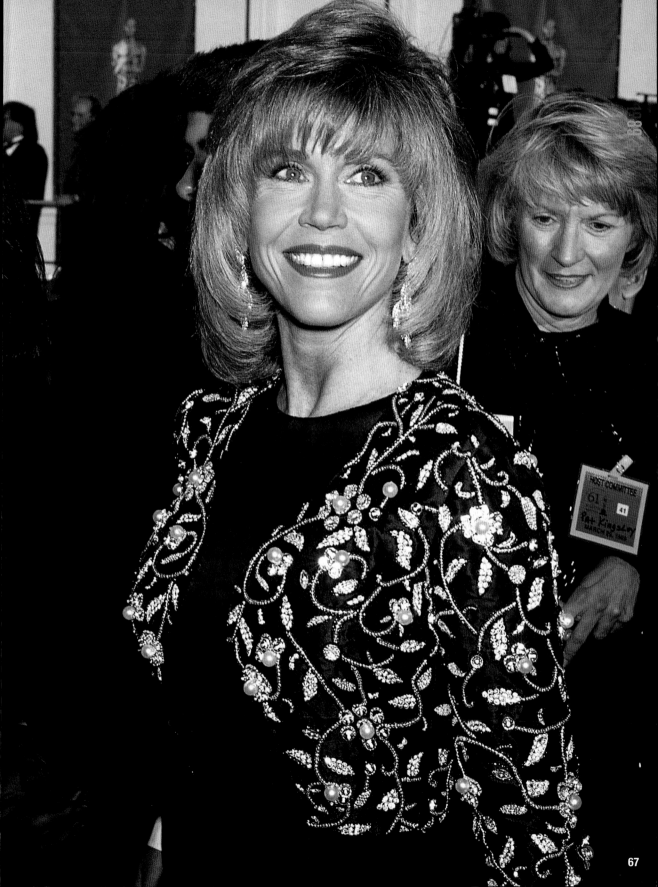

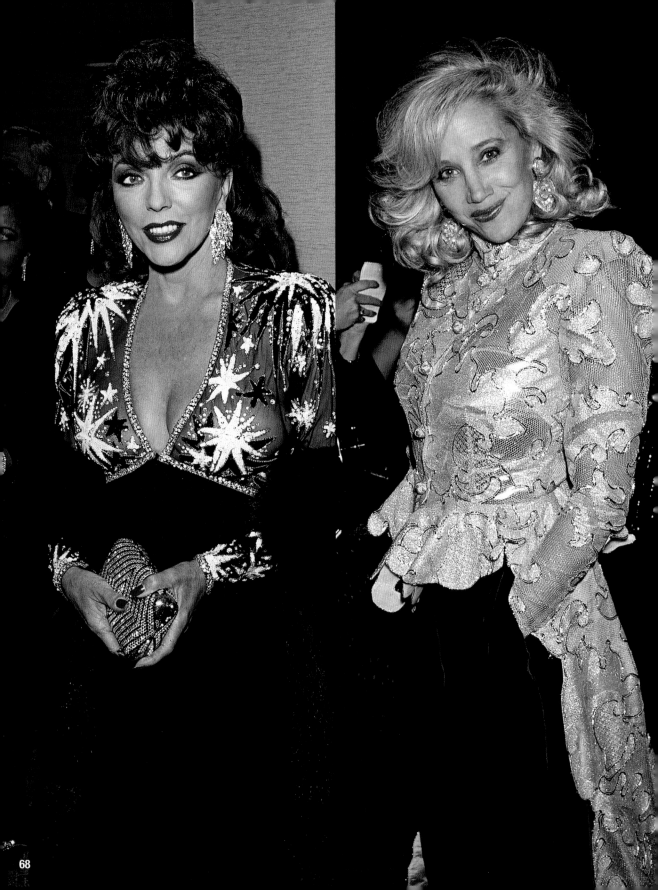

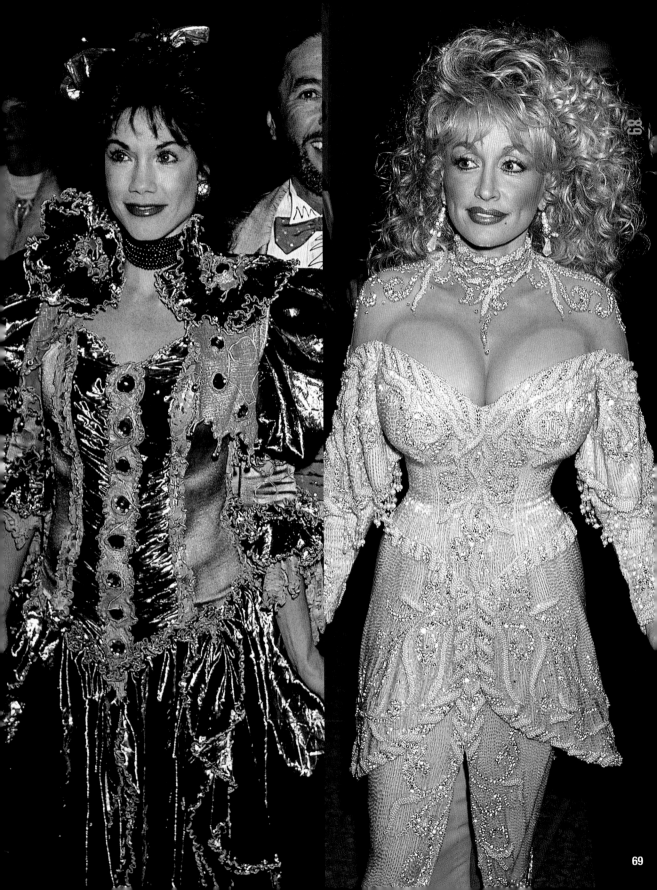

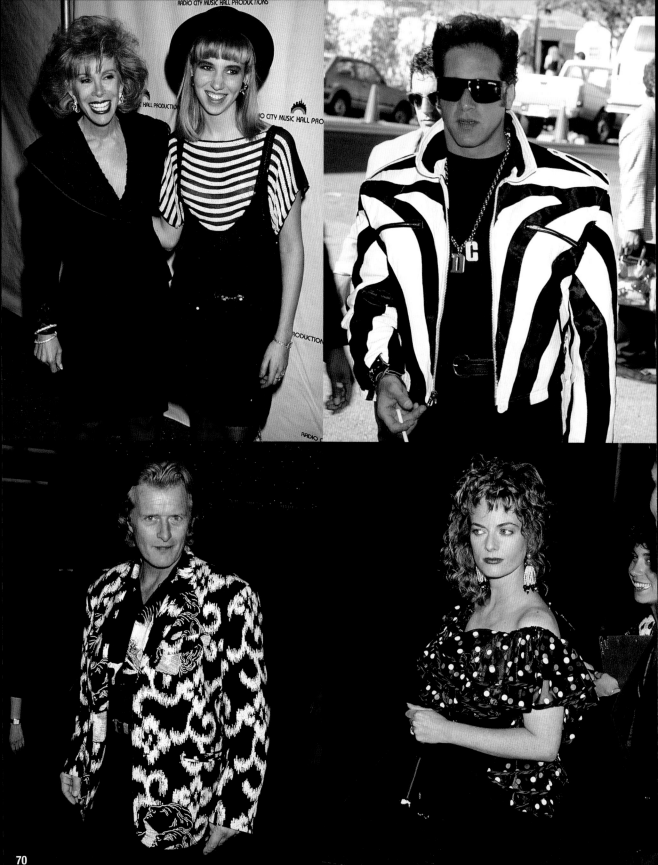

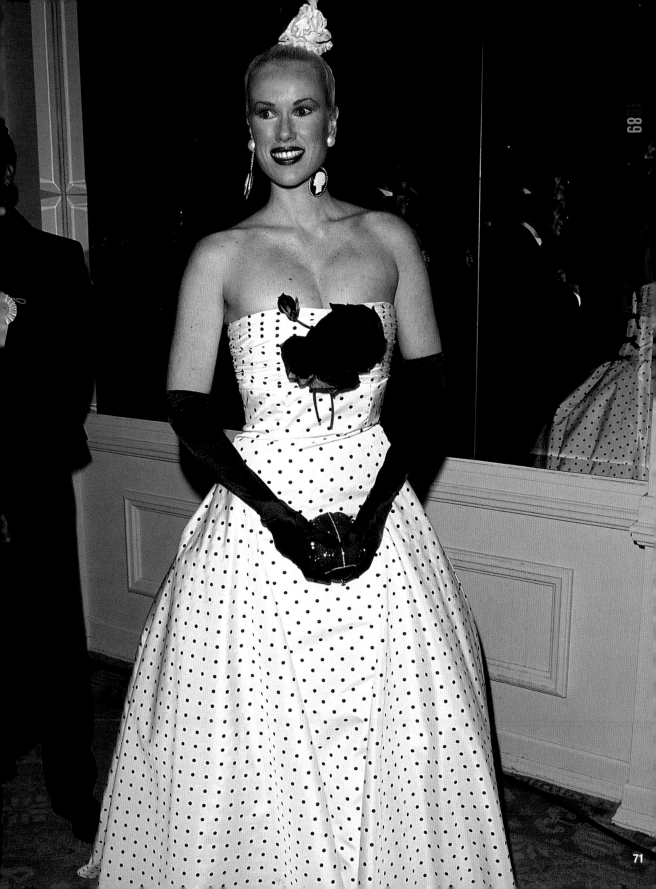

71

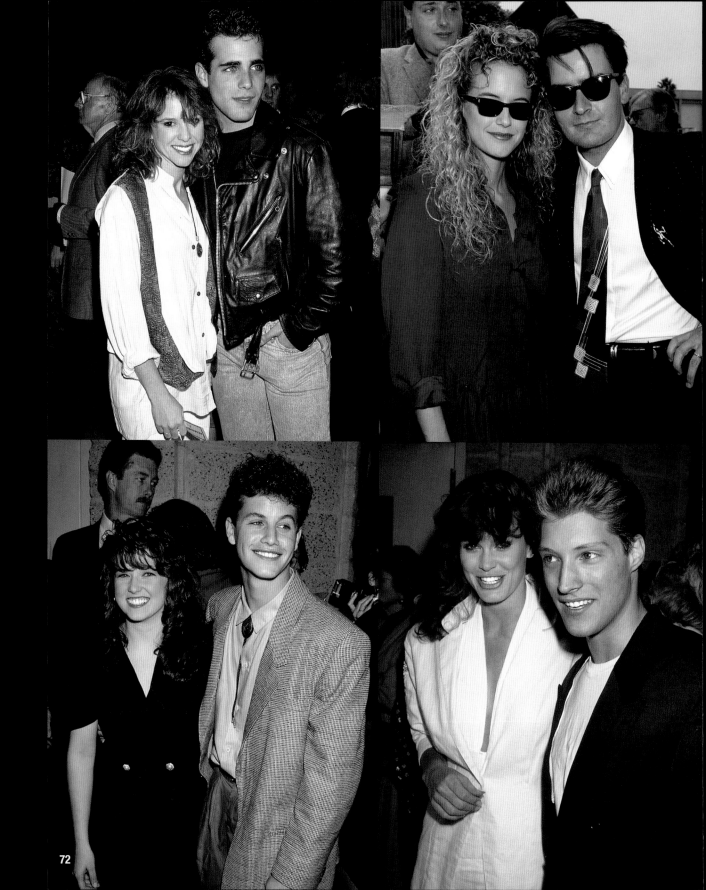

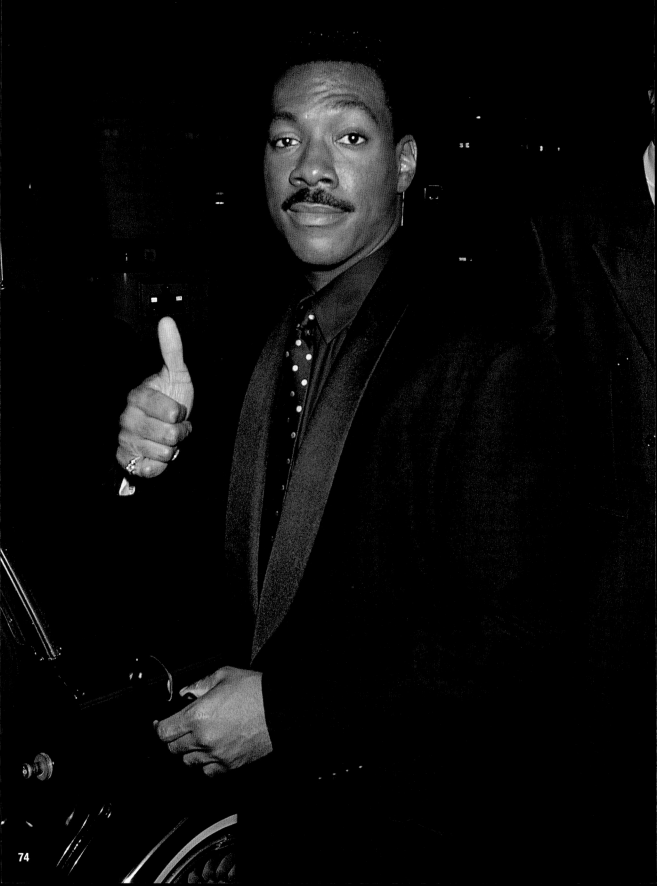

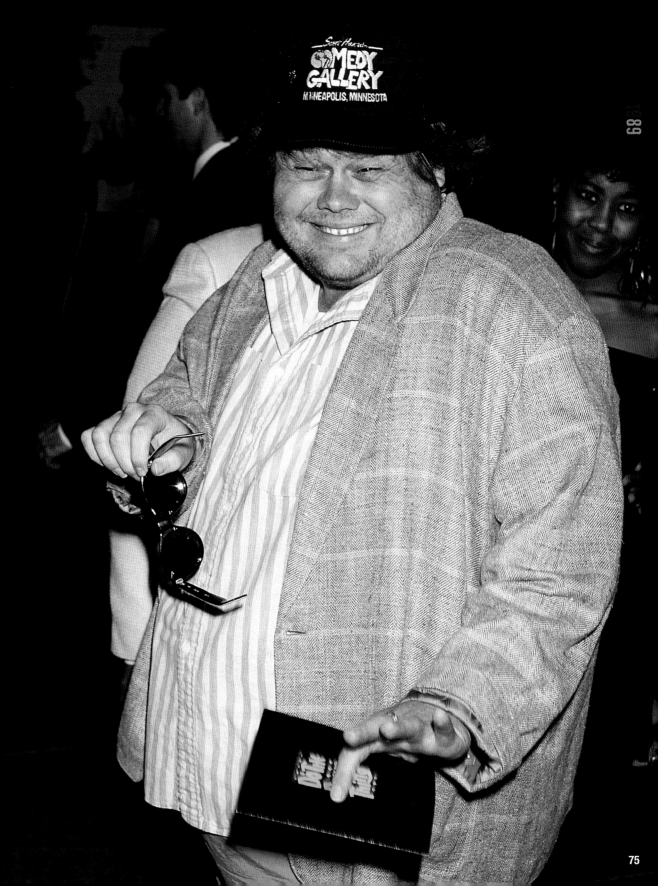

1987 1988 1989
1990 1991 1992
1993 1994 1995
1996 1997 1998
1999 2000 2001
2002 2003 2004
2005 2006 2007

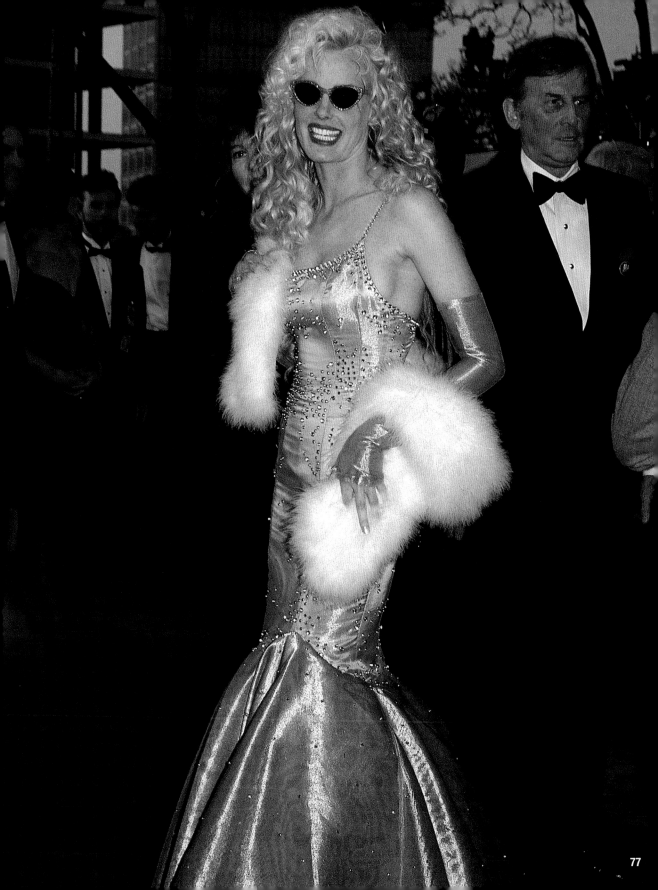

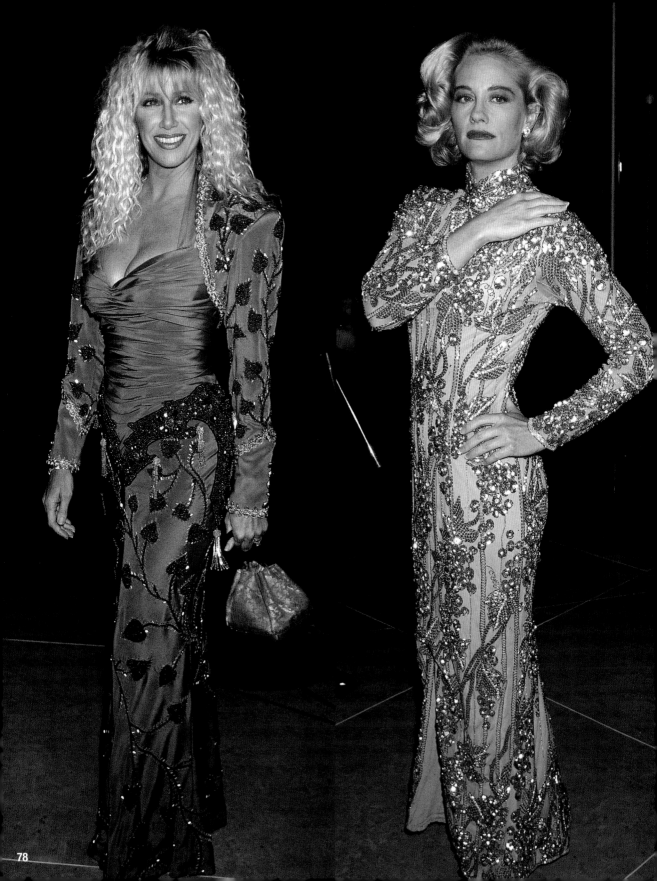

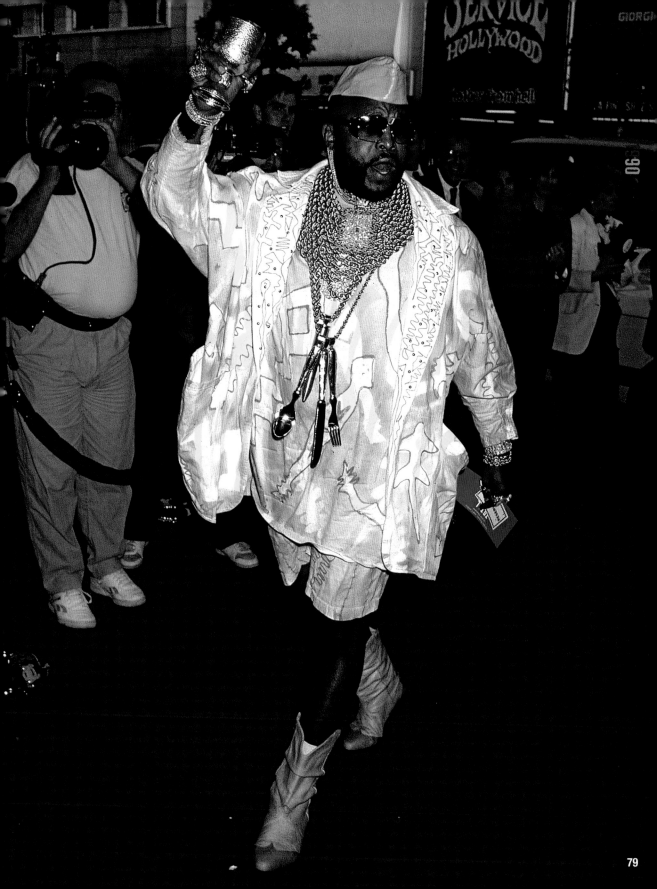

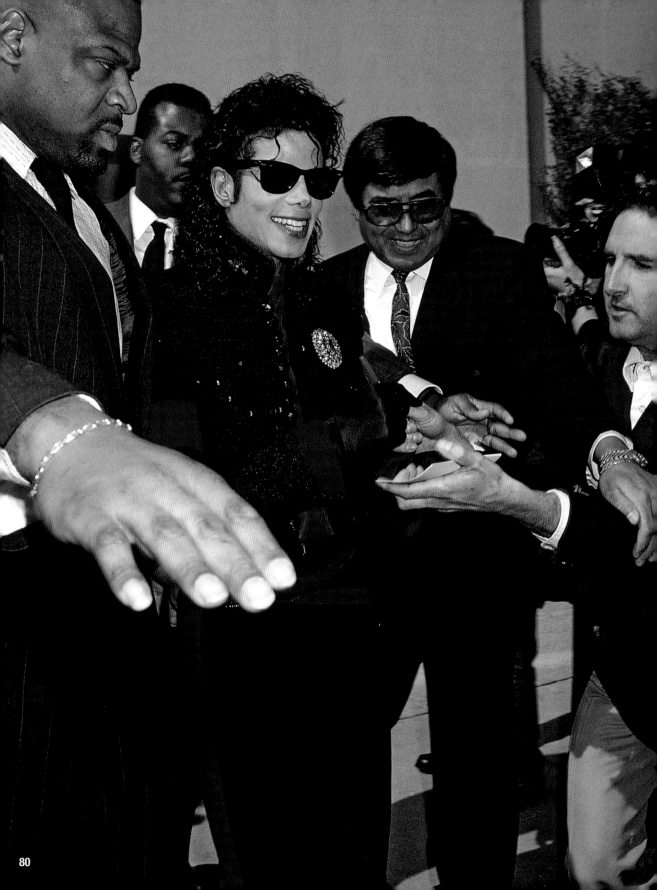

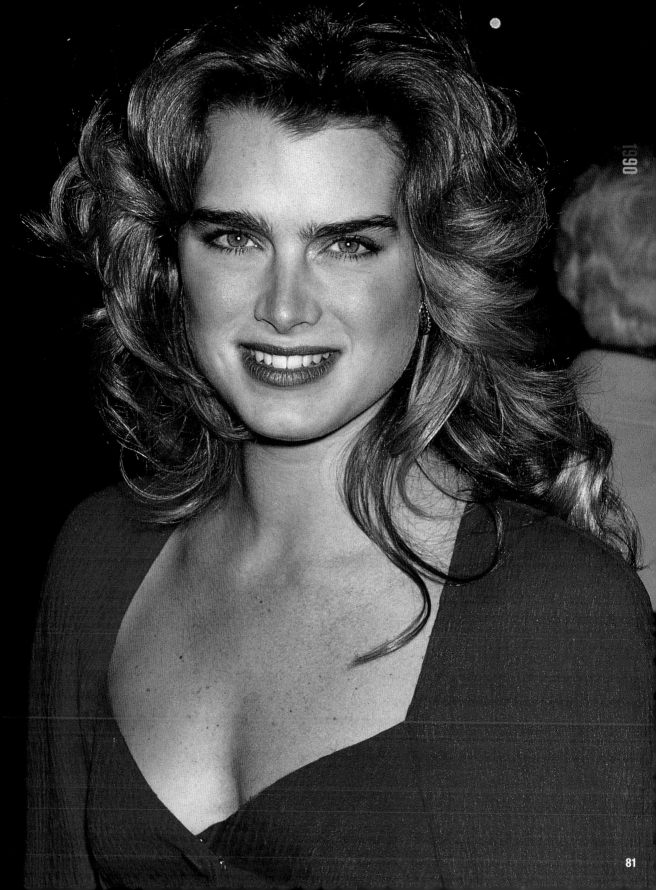

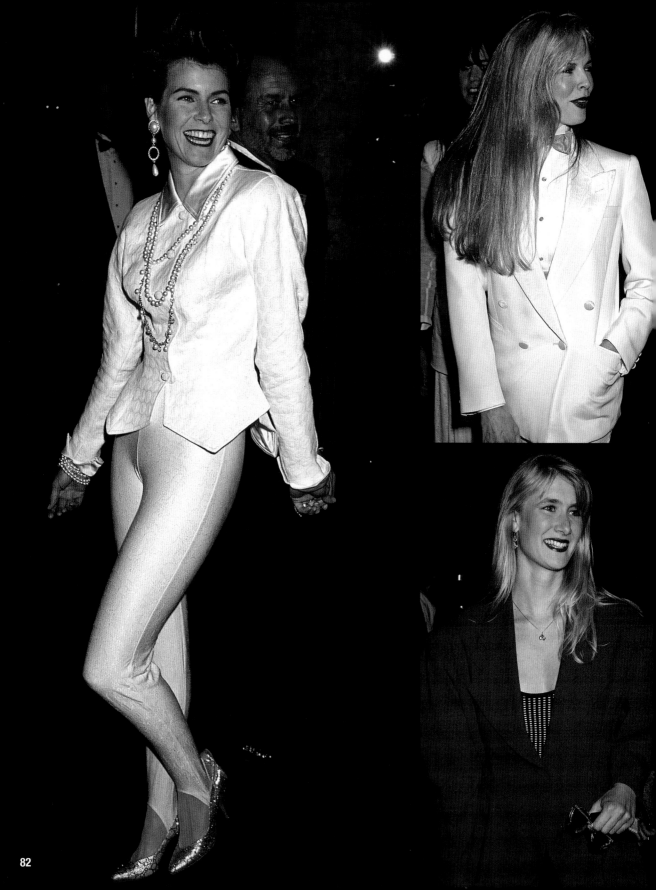

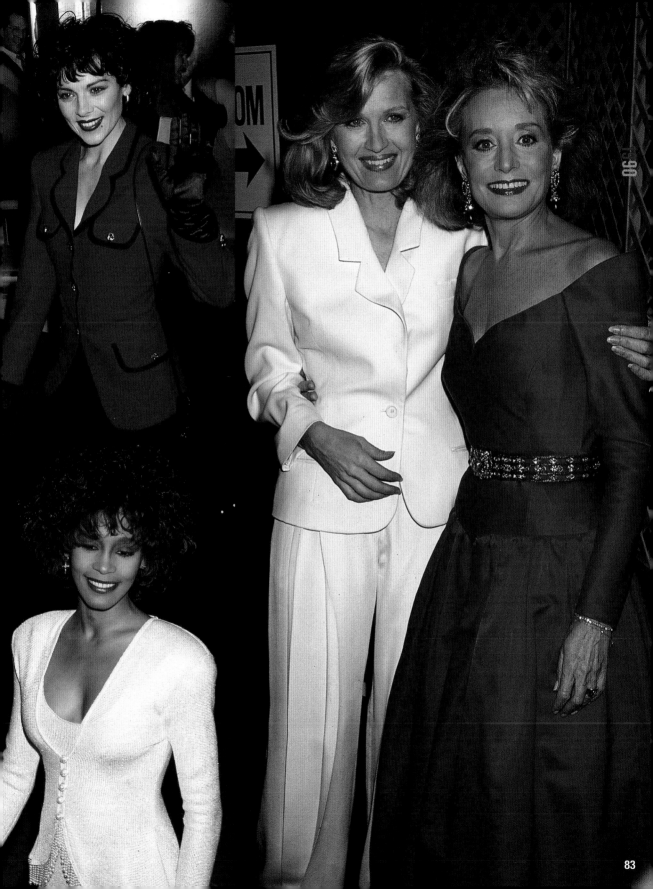

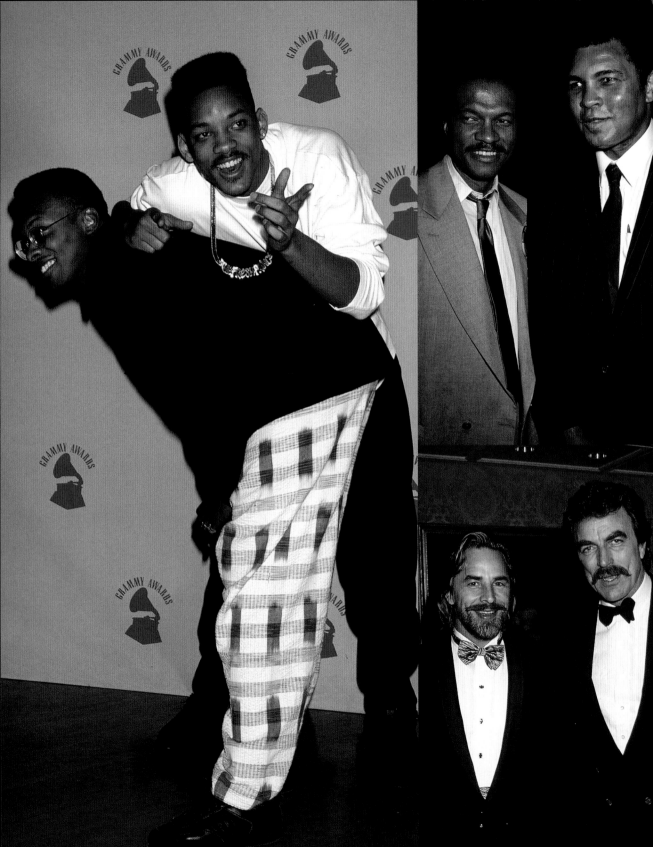

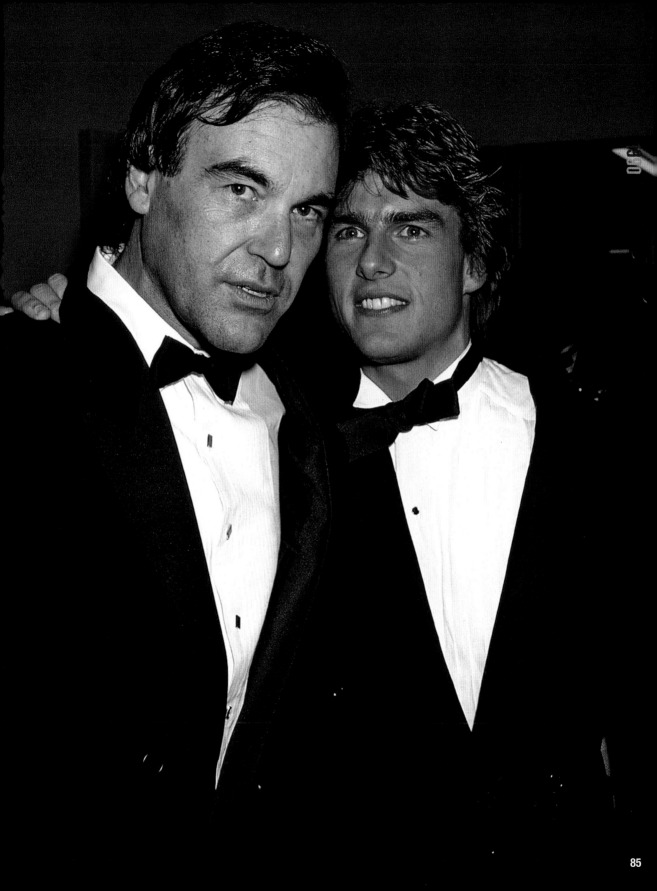

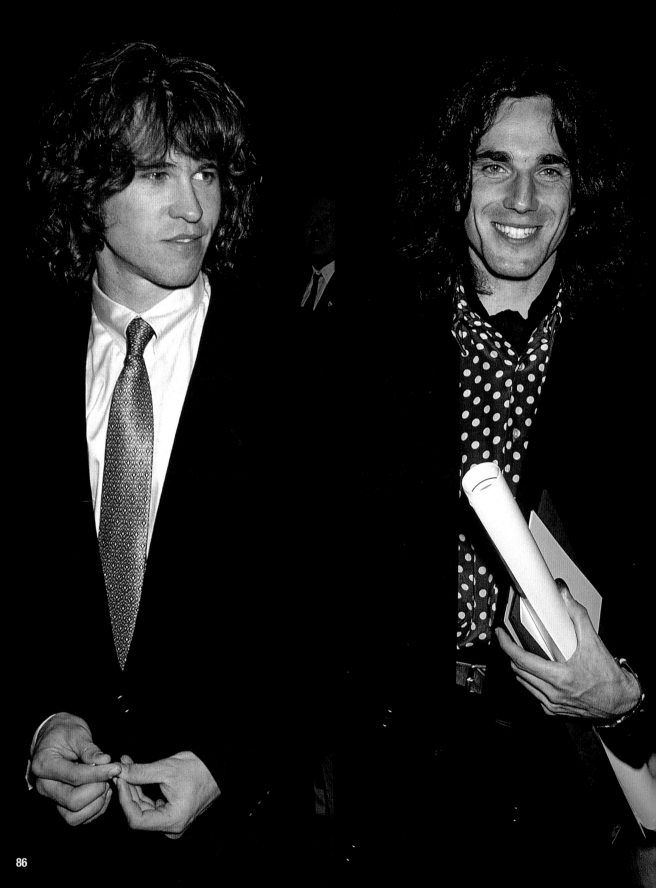

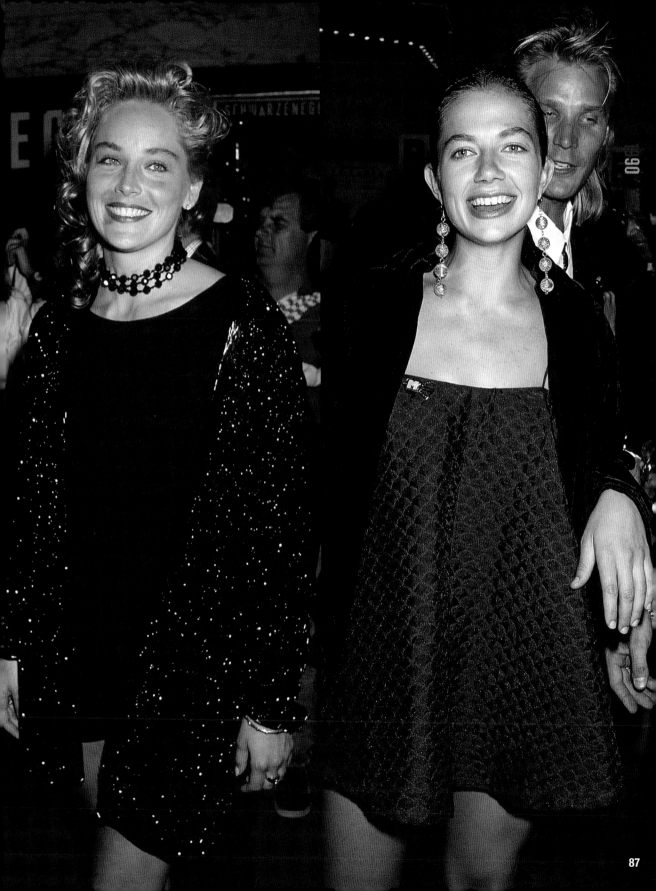

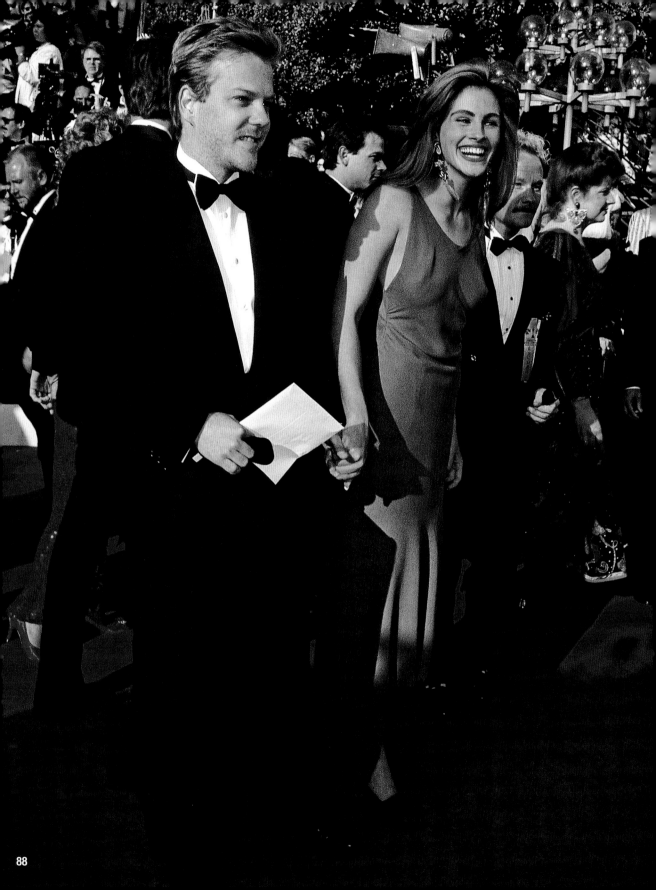

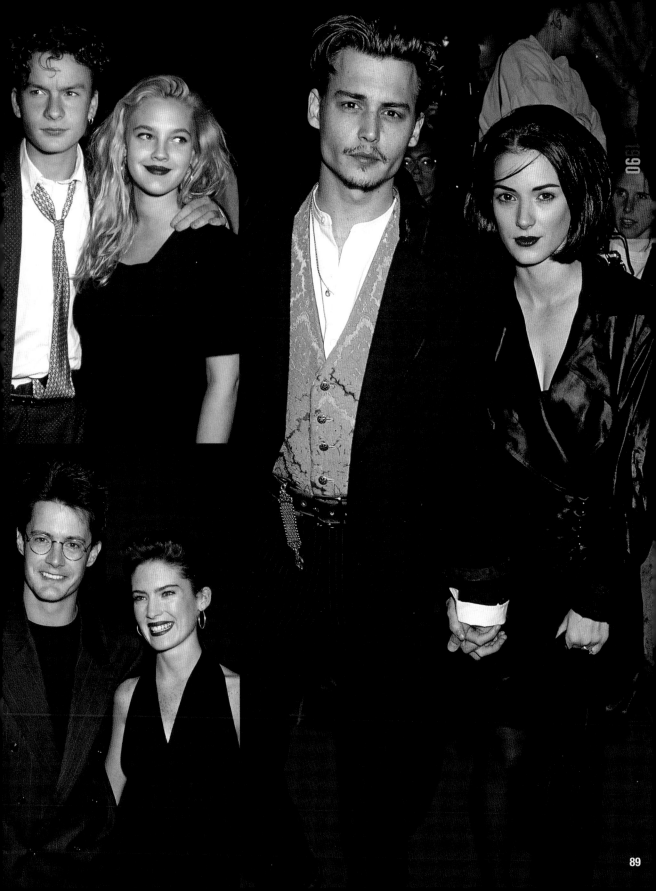

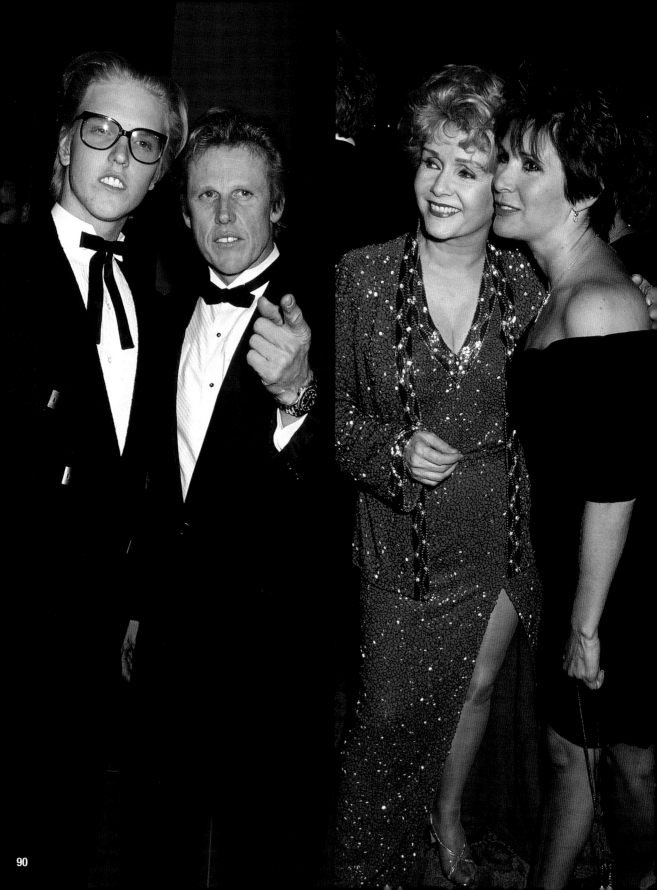

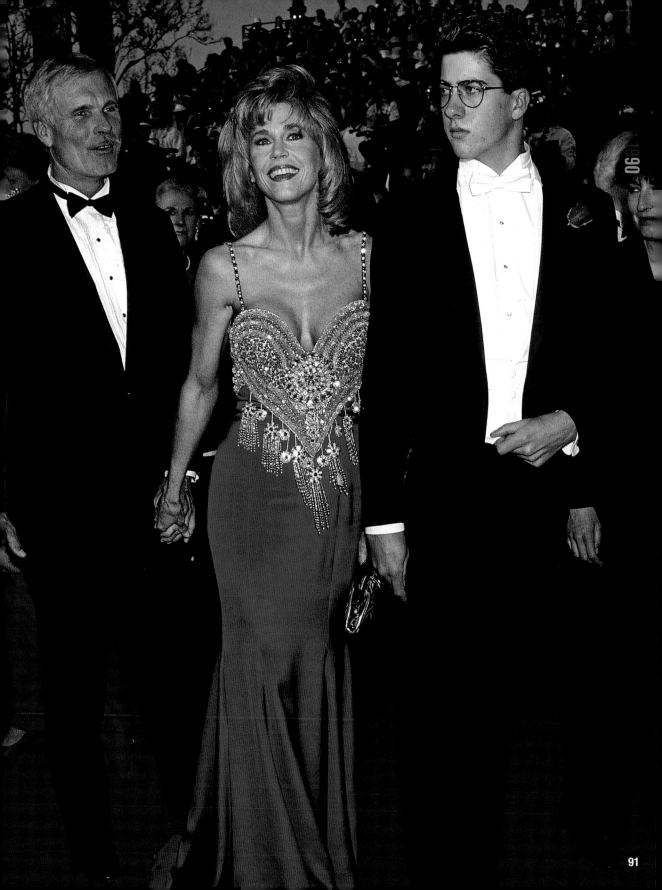

1987 1988 1989
1990 **1991** 1992
1993 1994 1995
1996 1997 1998
1999 2000 2001
2002 2003 2004
2005 2006 2007

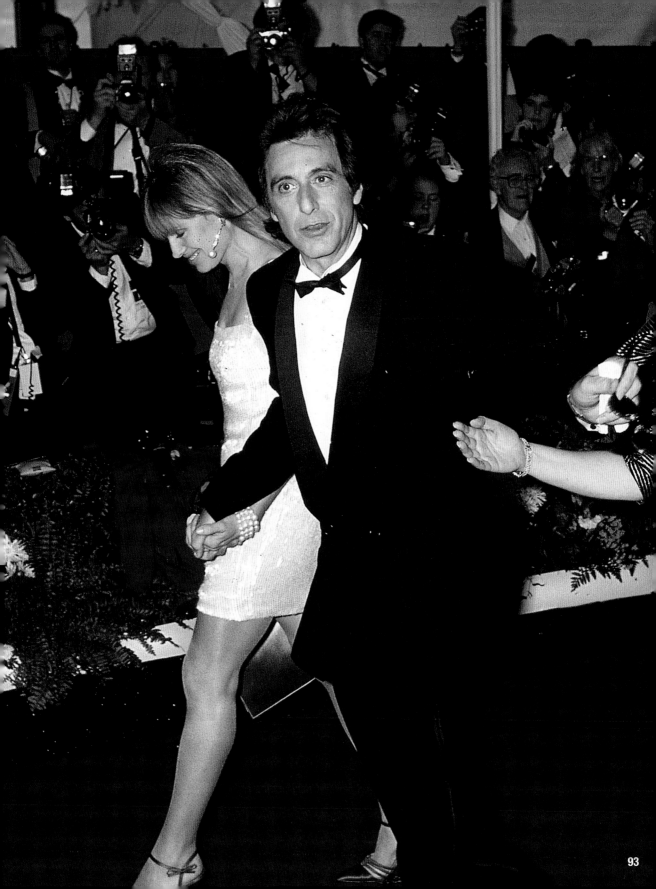

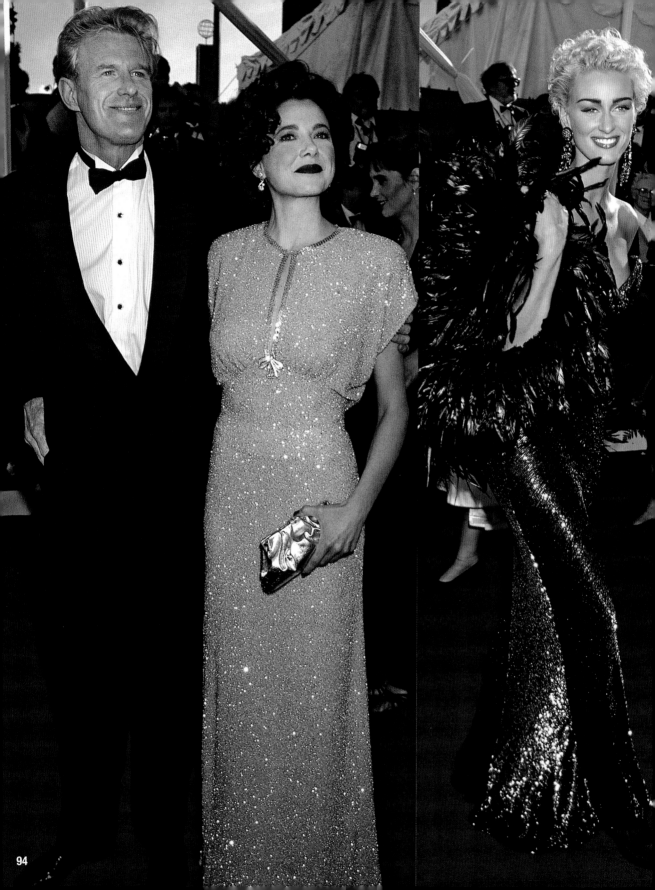

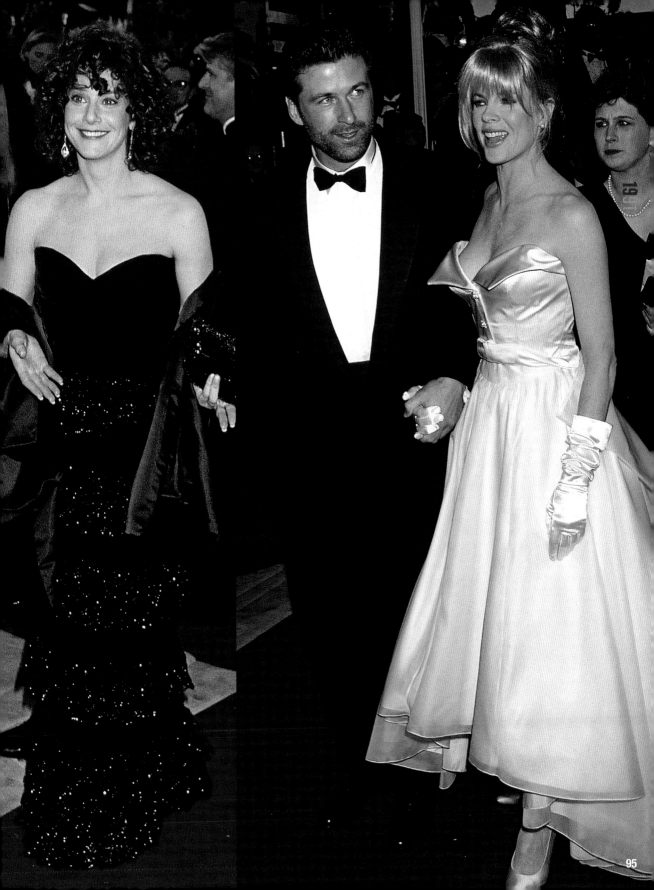

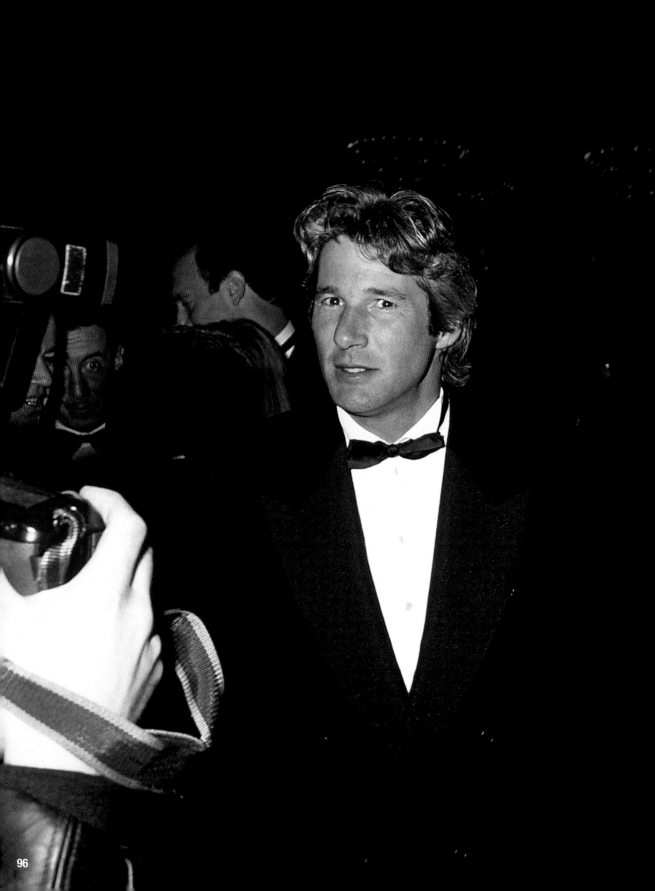

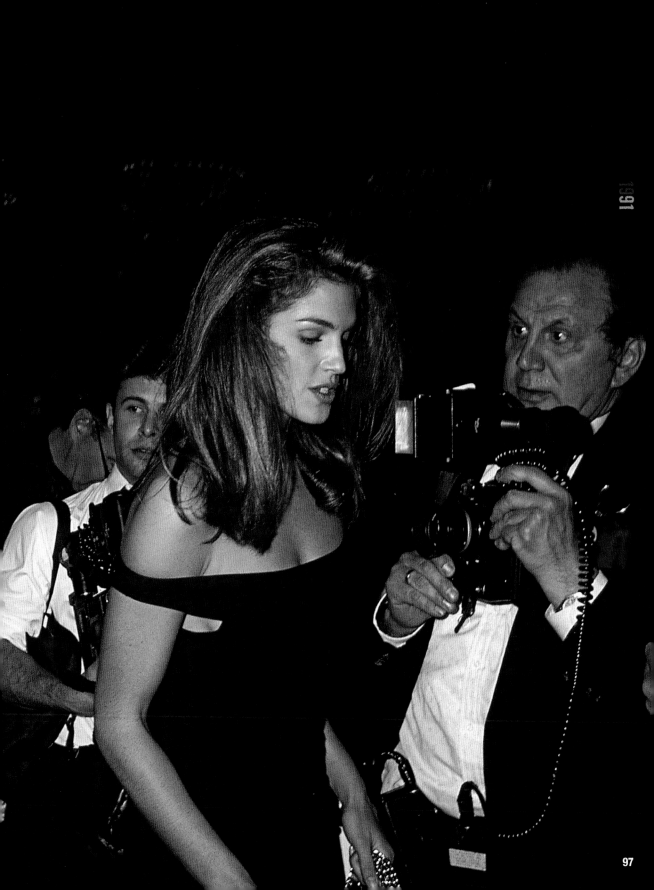

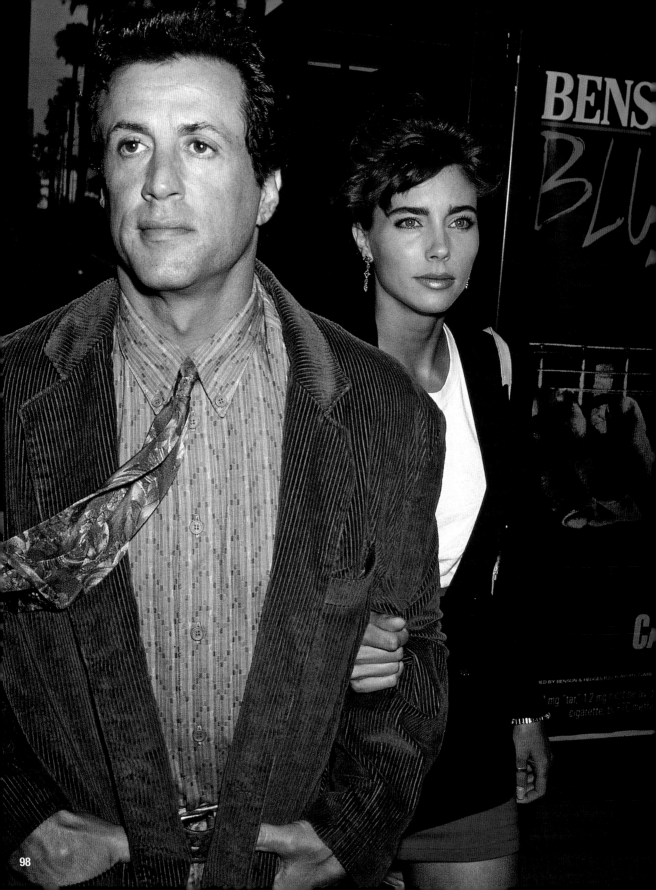

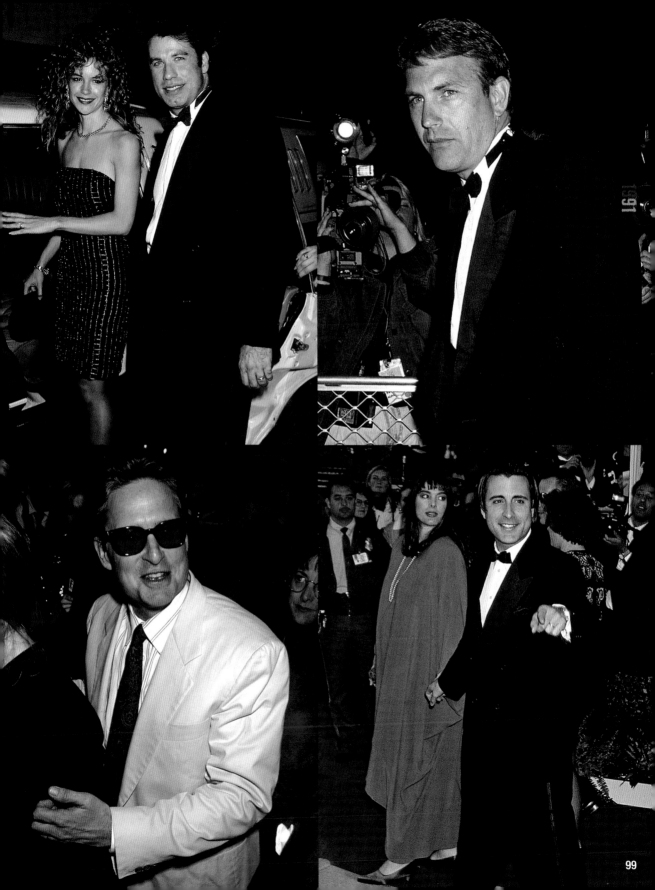

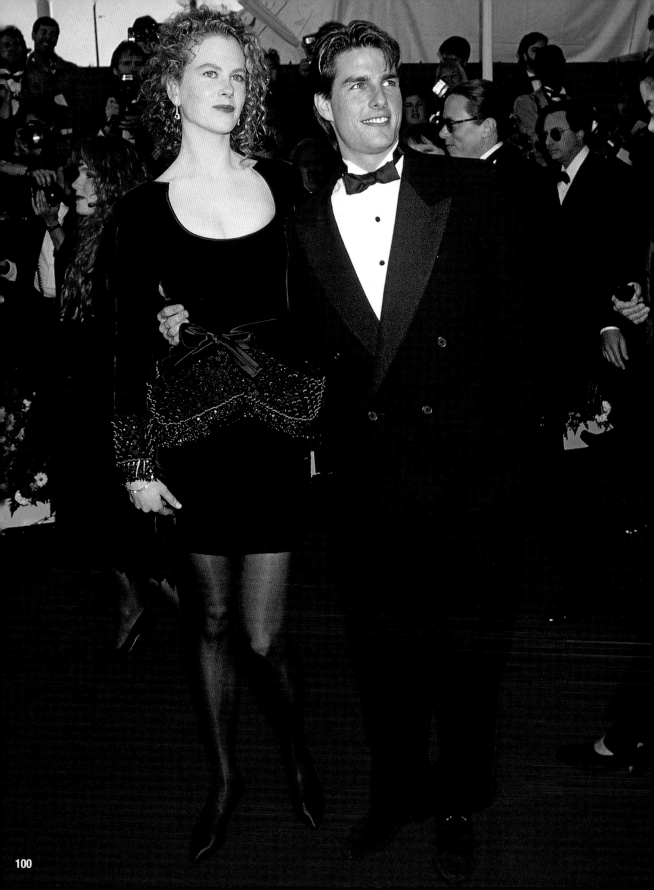

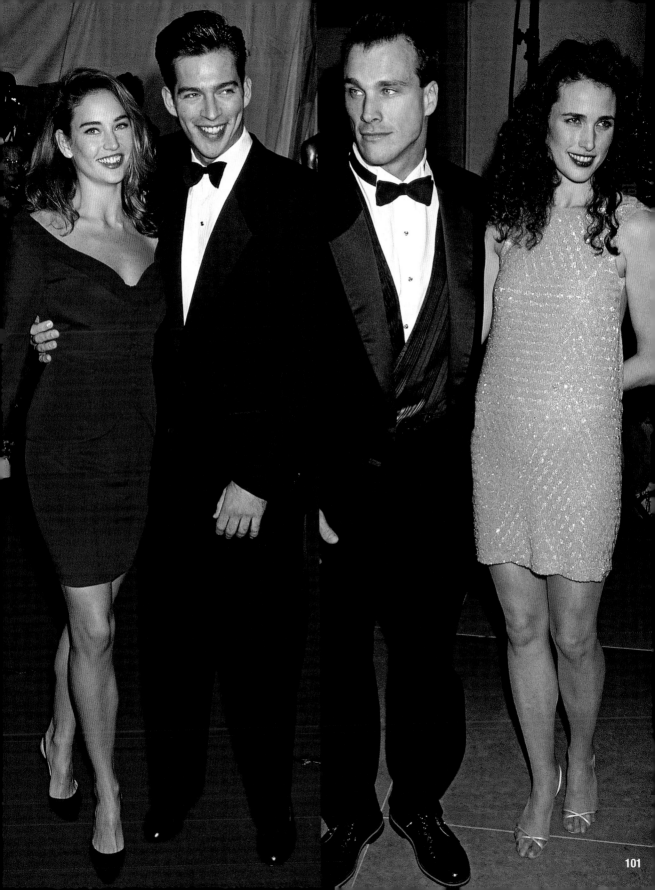

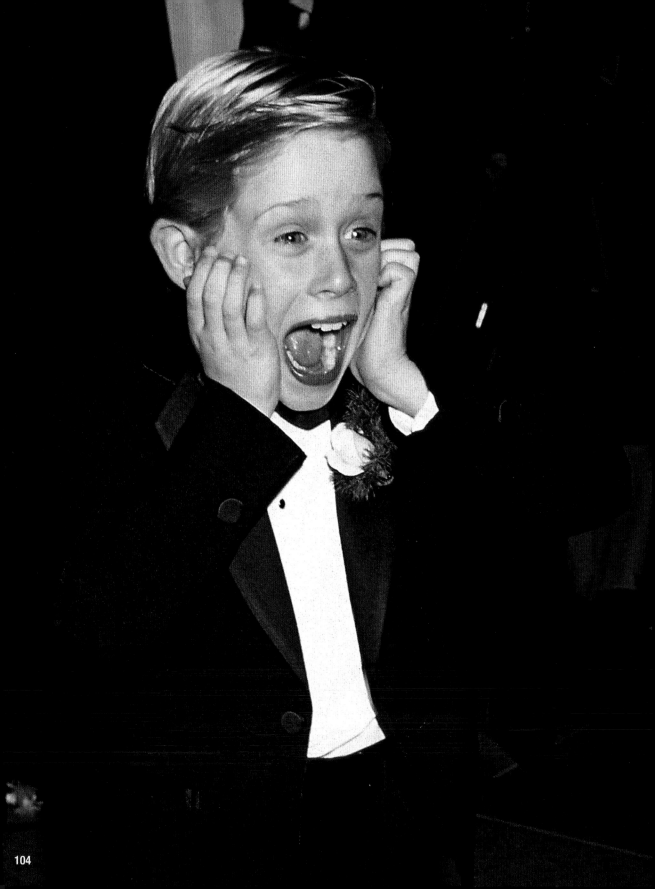

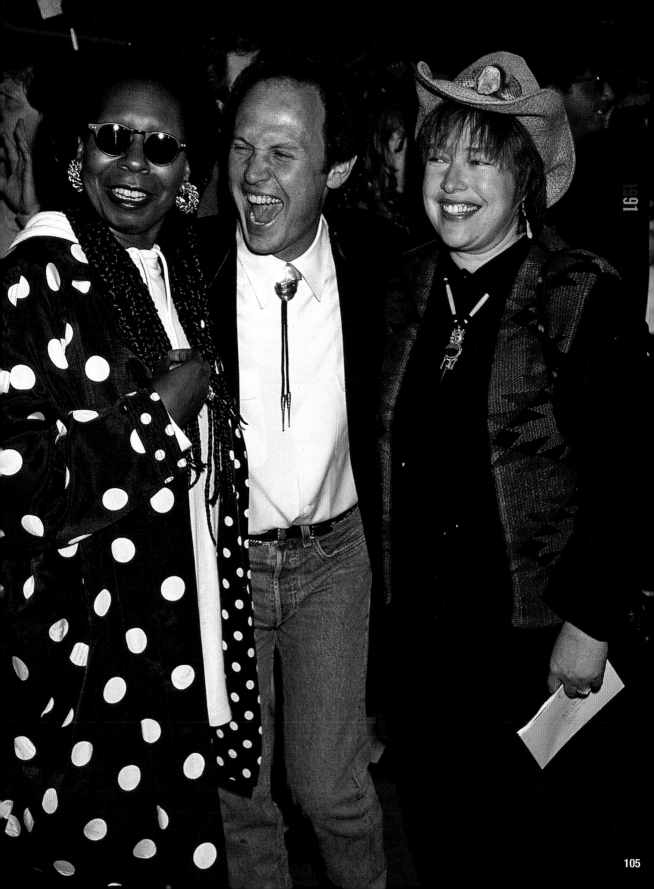

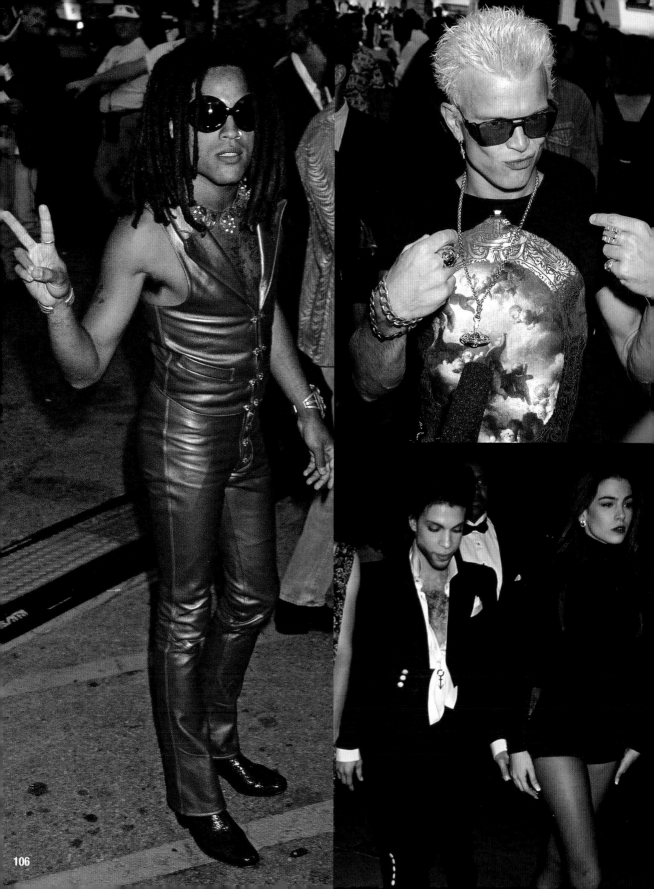

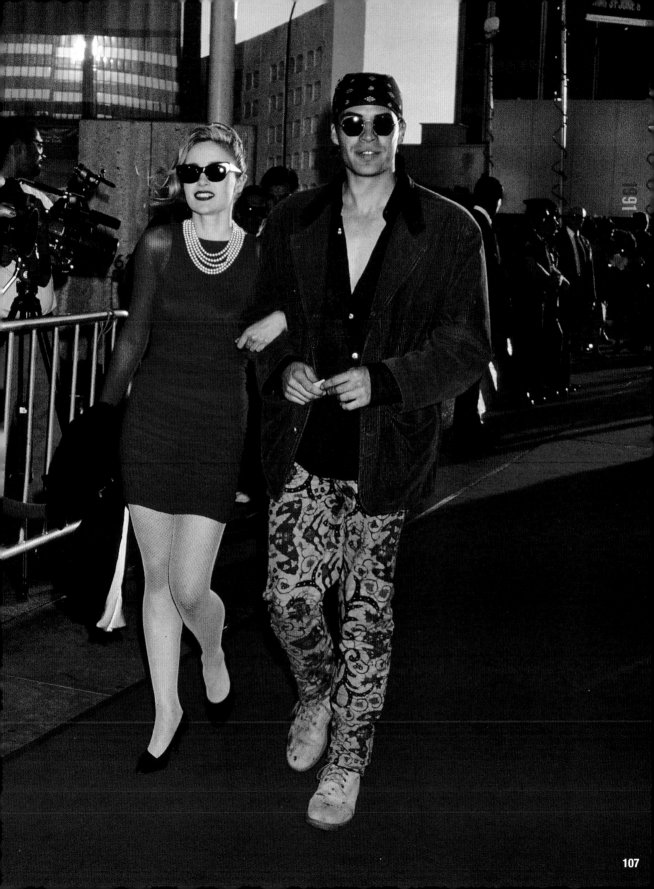

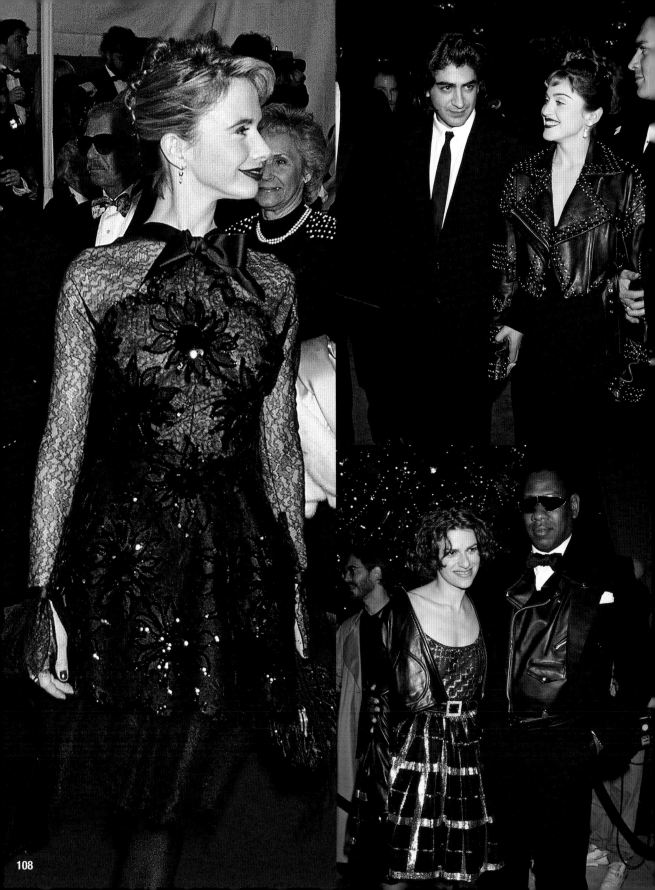

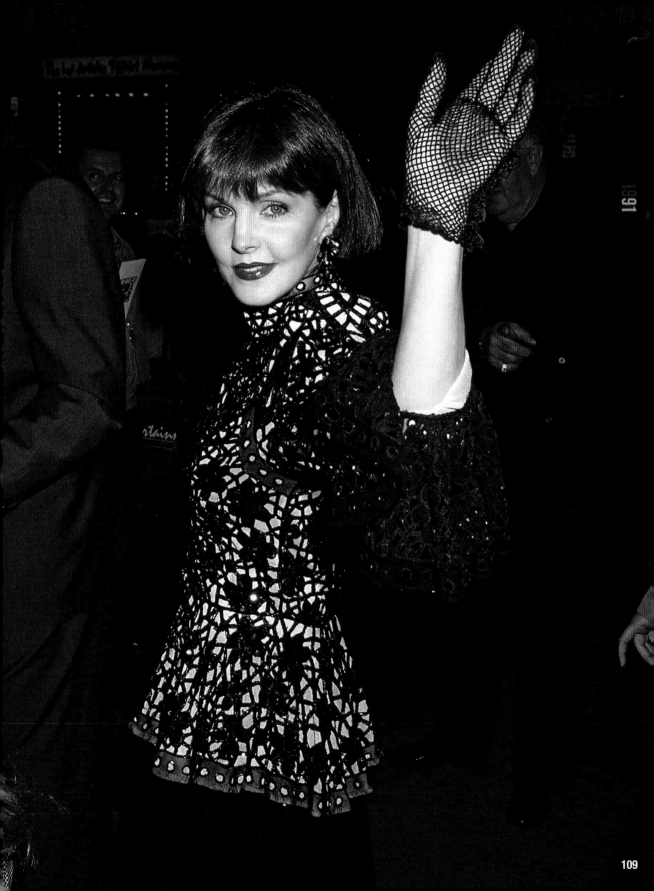

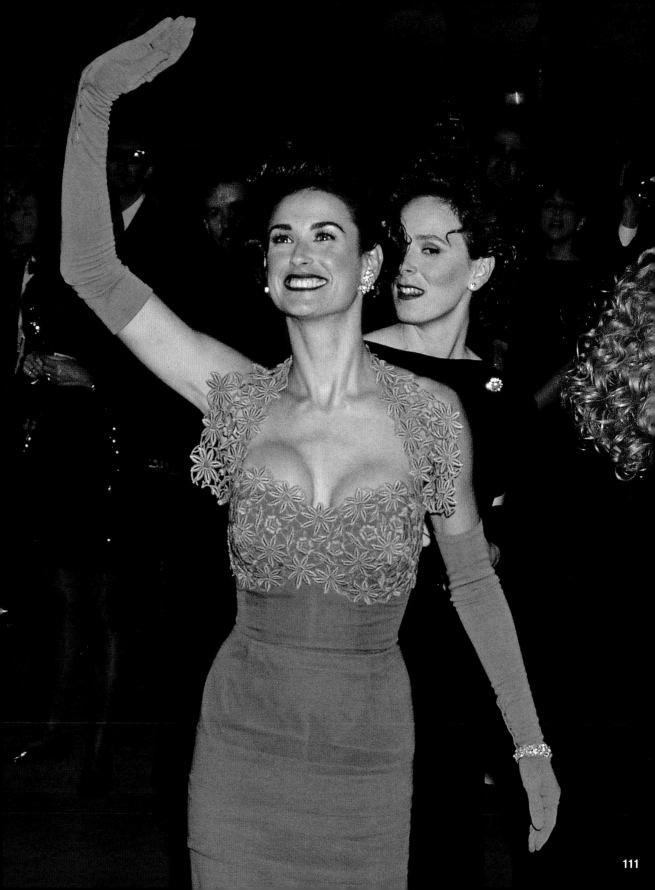

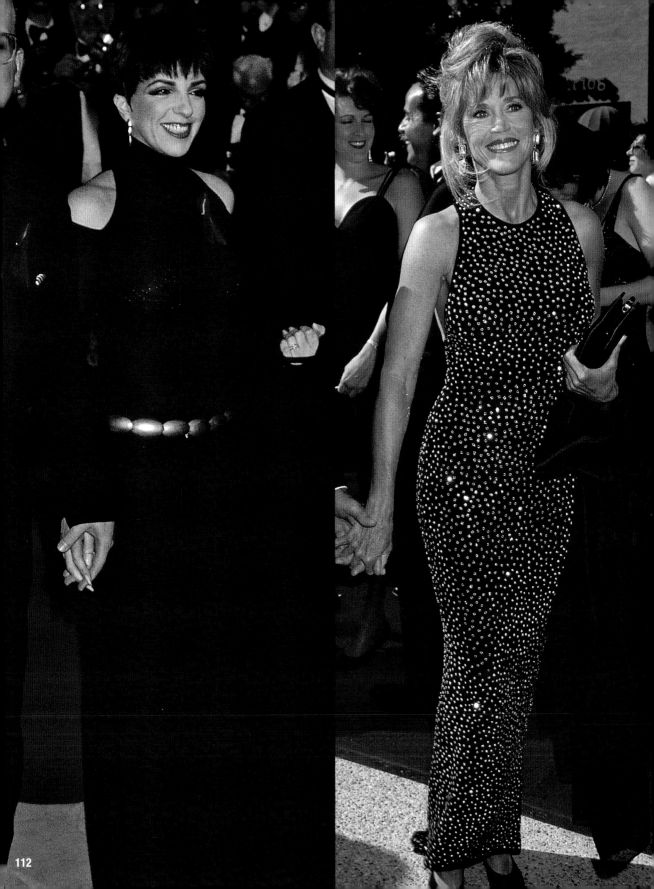

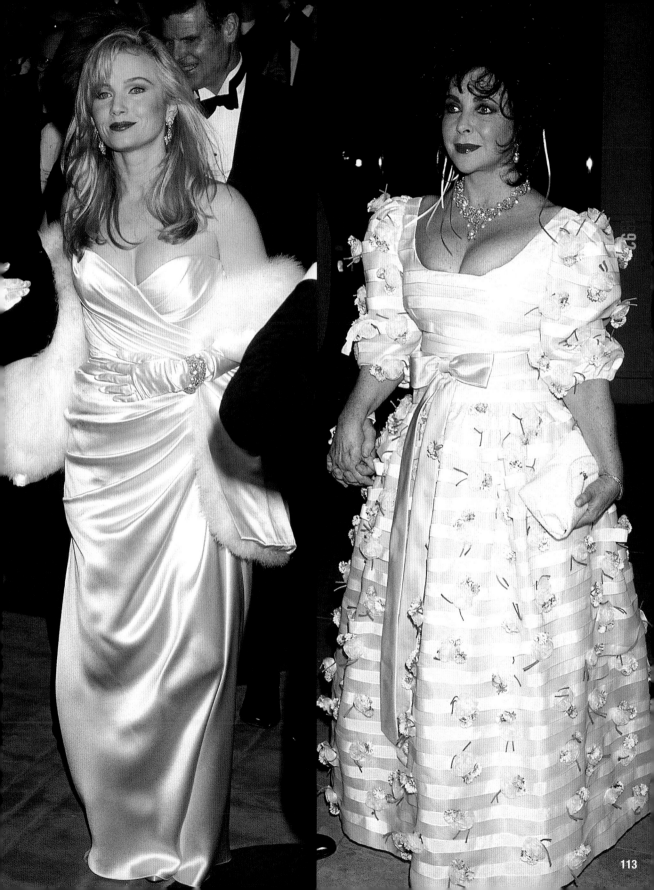

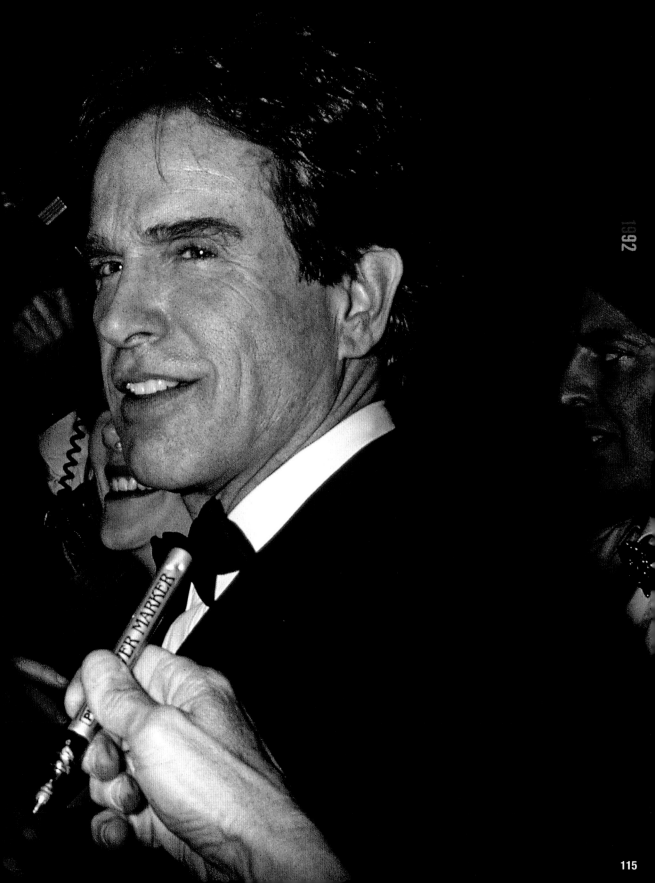

1992

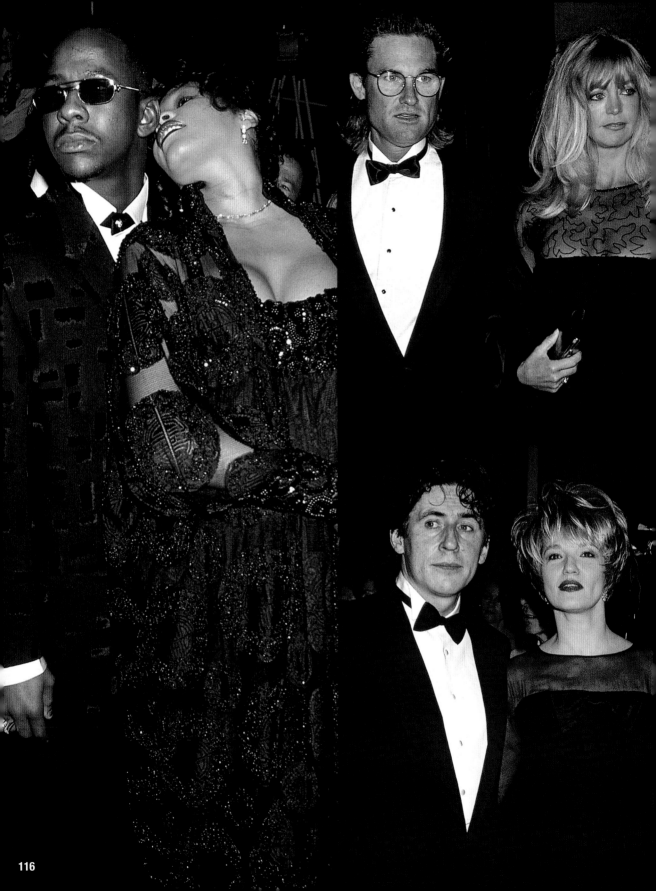

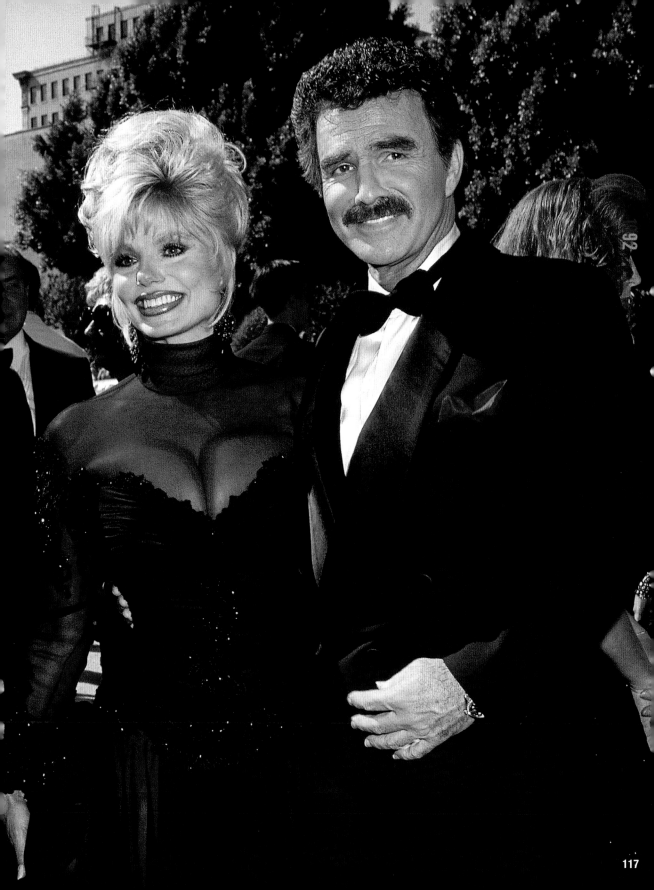

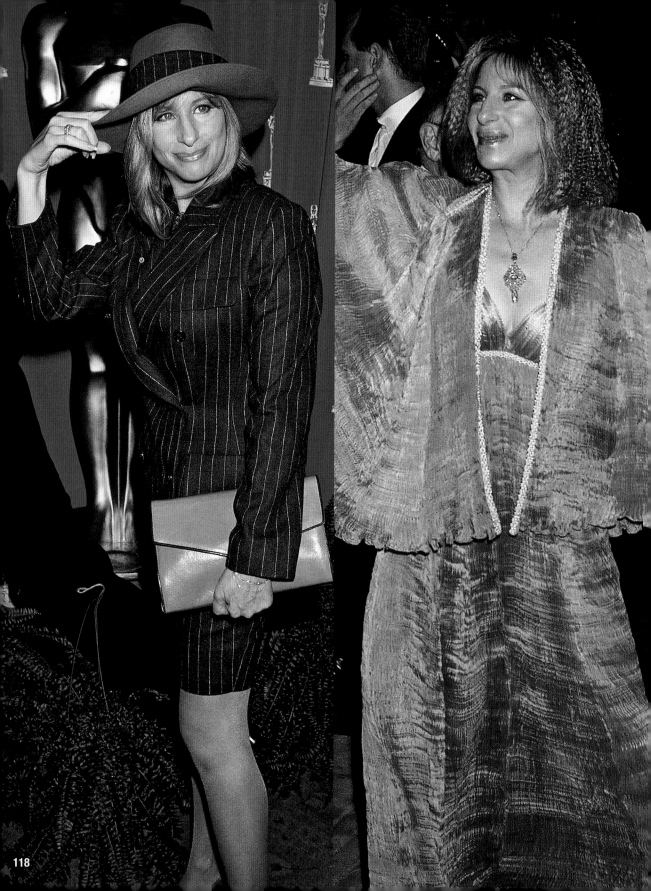

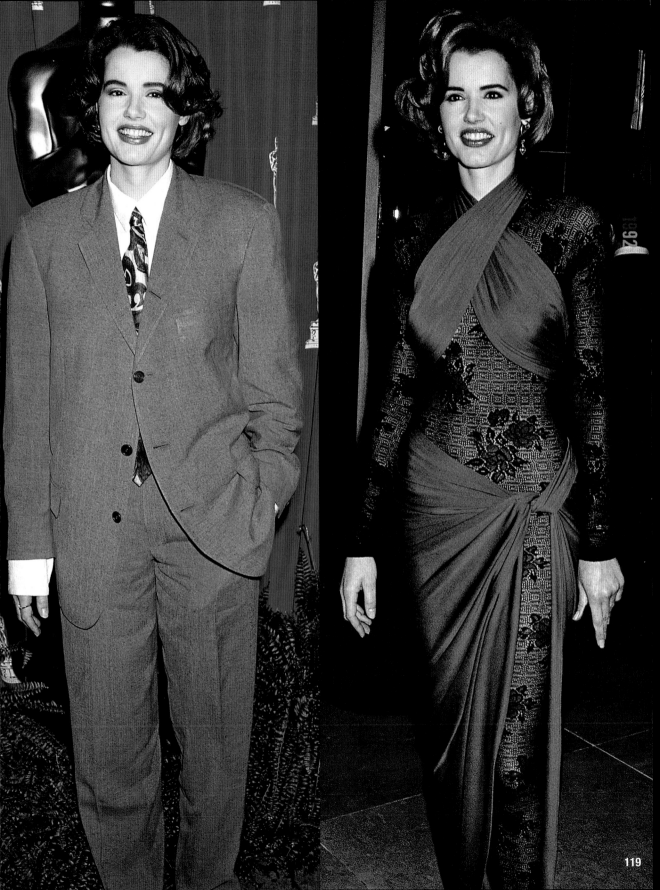

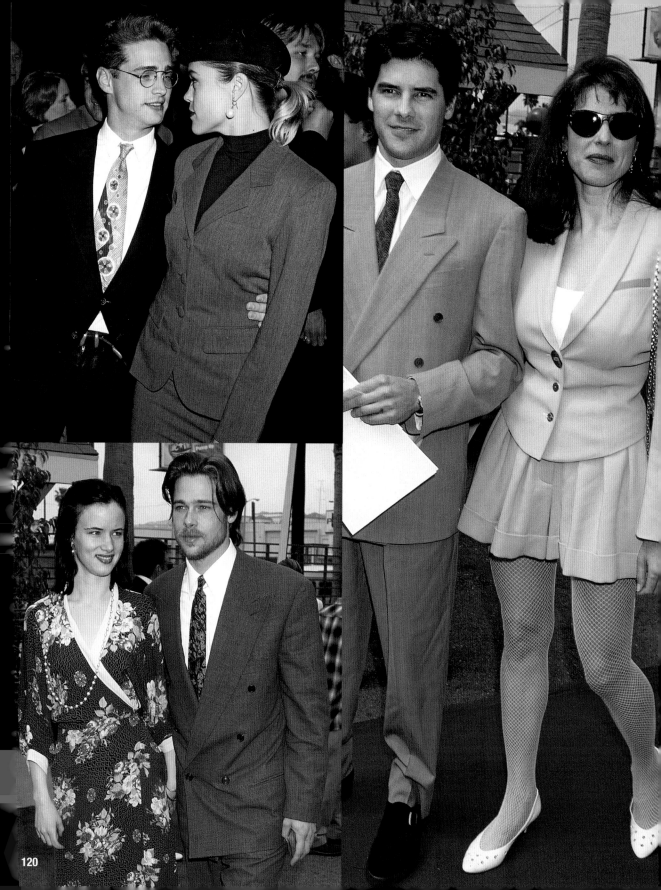

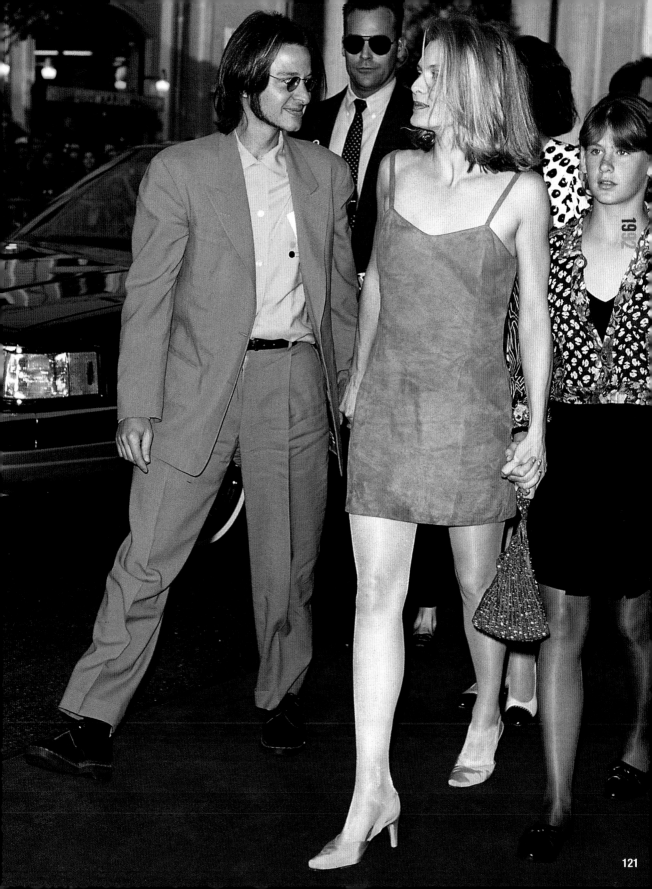

1992

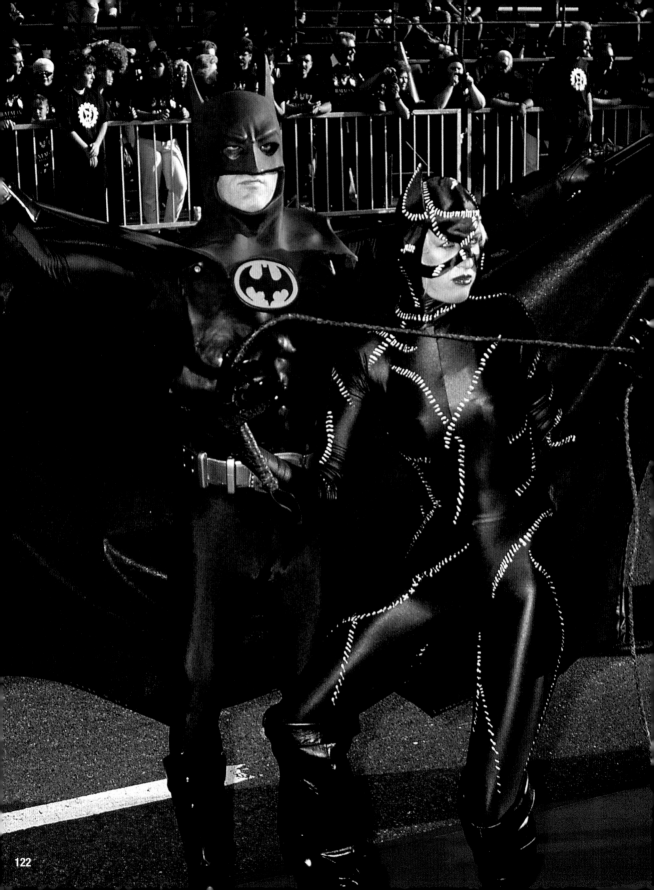

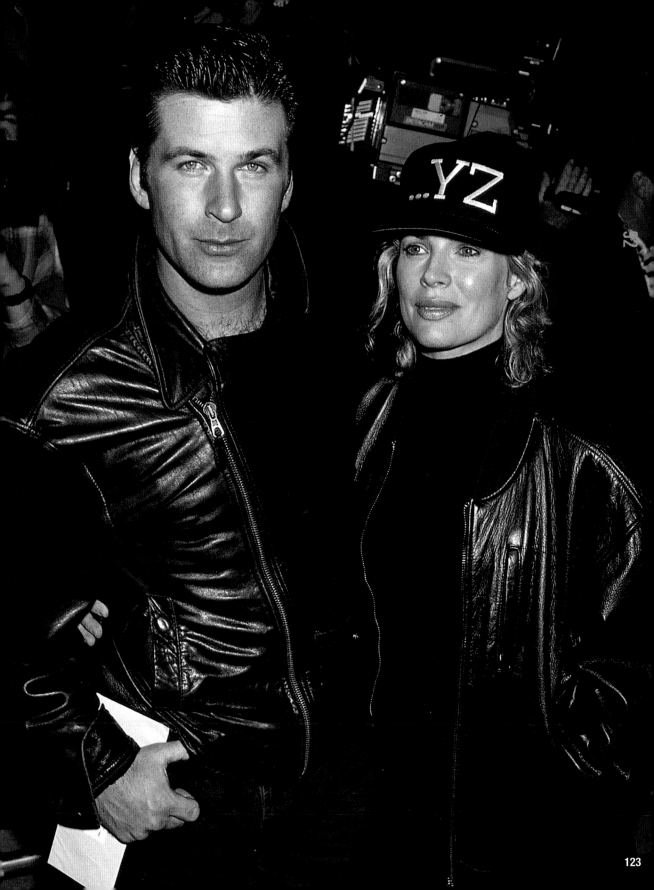

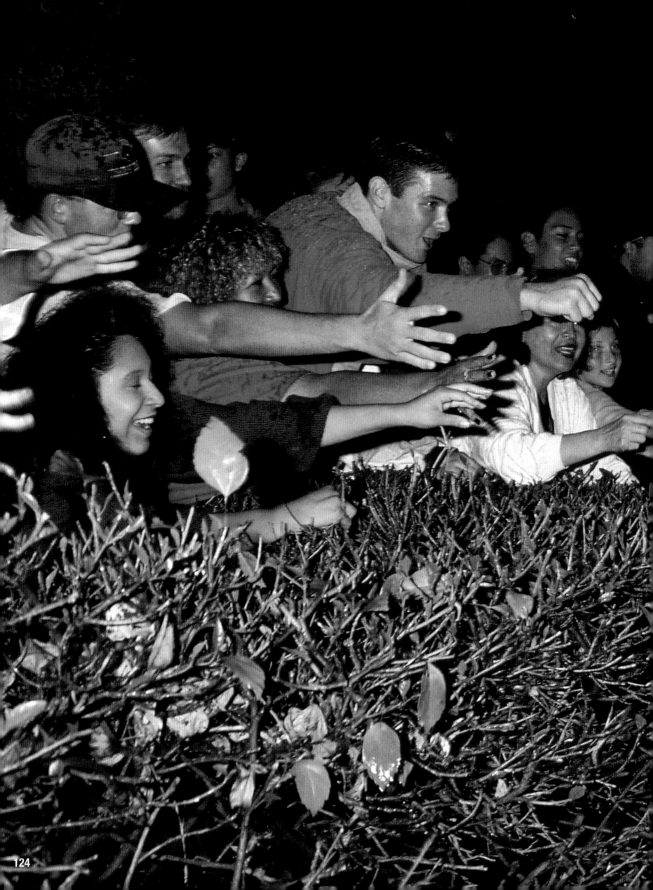

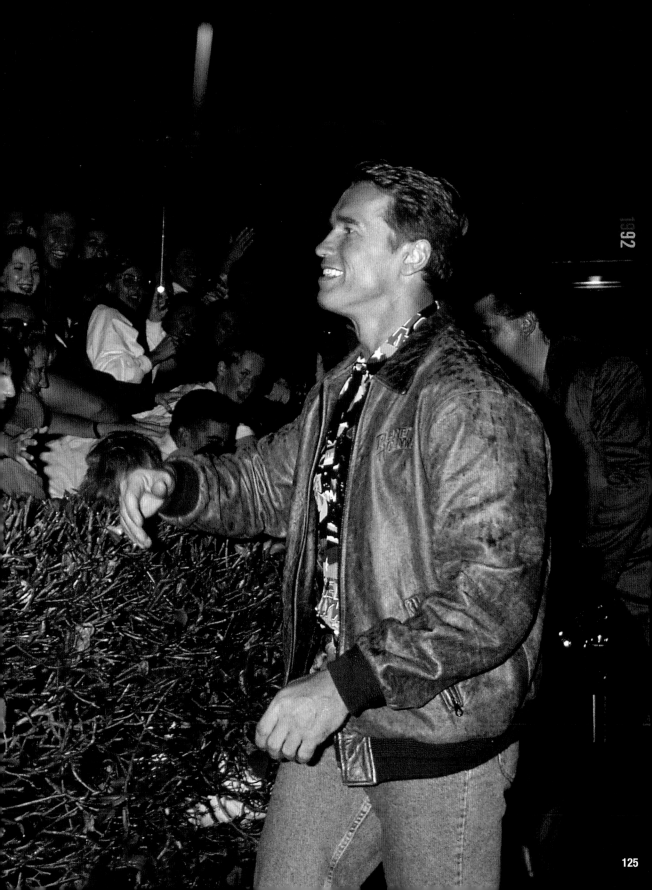

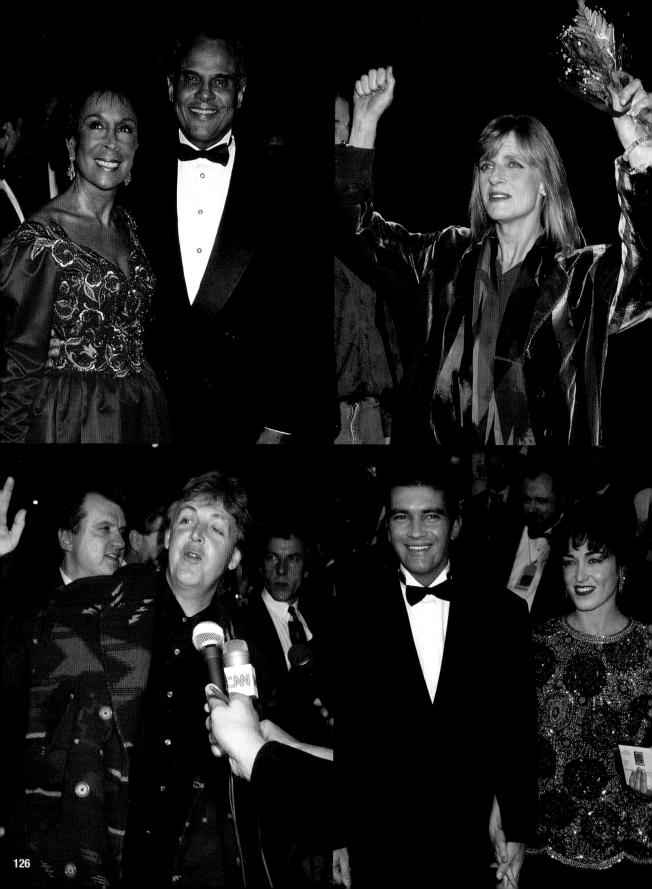

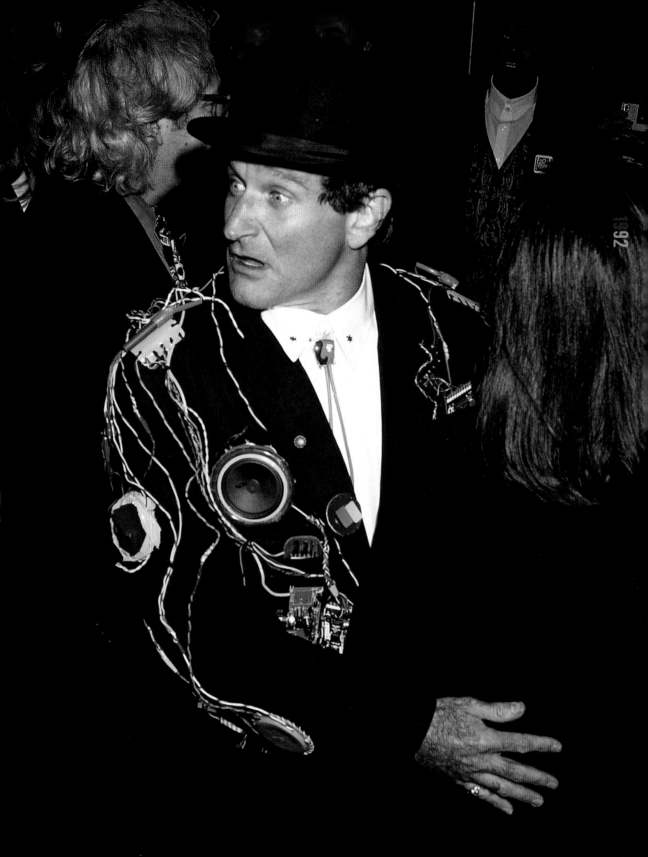

1987 1988 1989
1990 1991 1992
1993 1994 1995
1996 1997 1998
1999 2000 2001
2002 2003 2004
2005 2006 2007

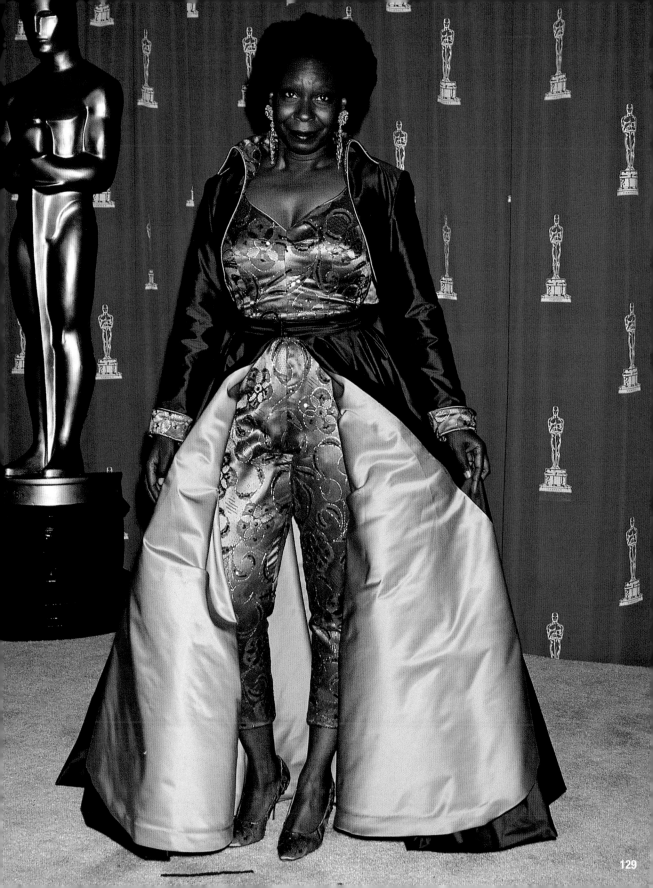

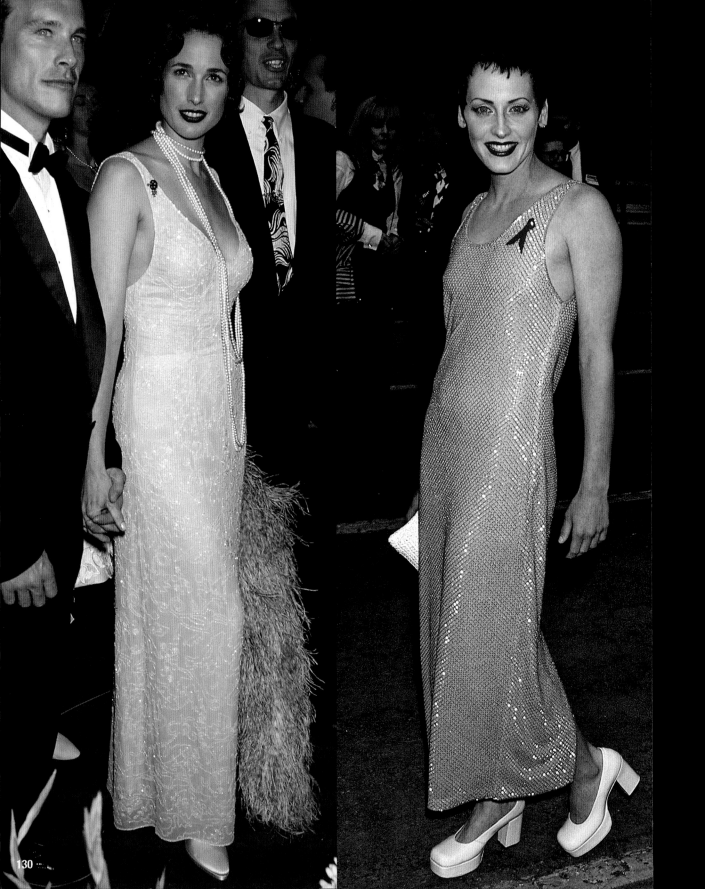

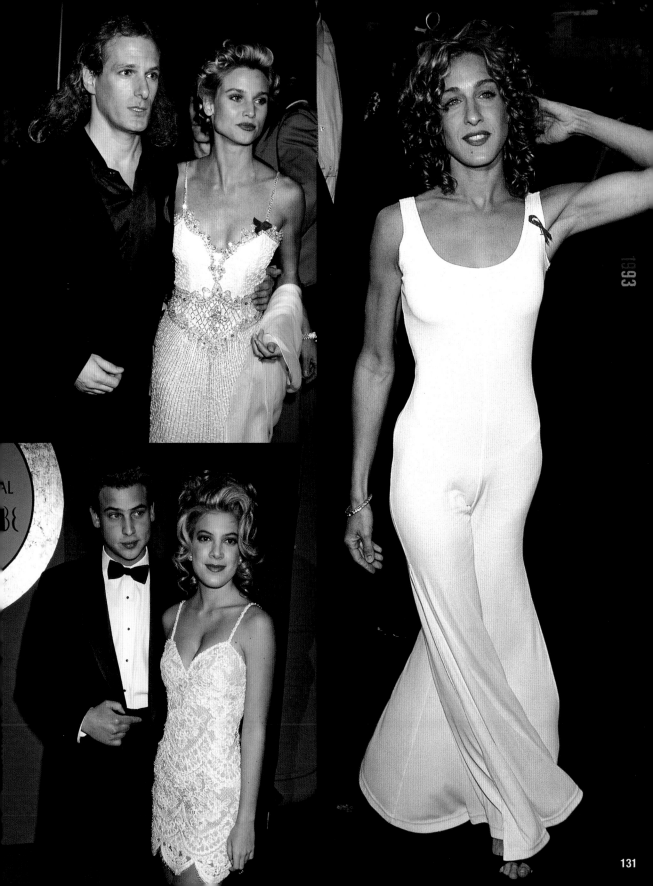

1993

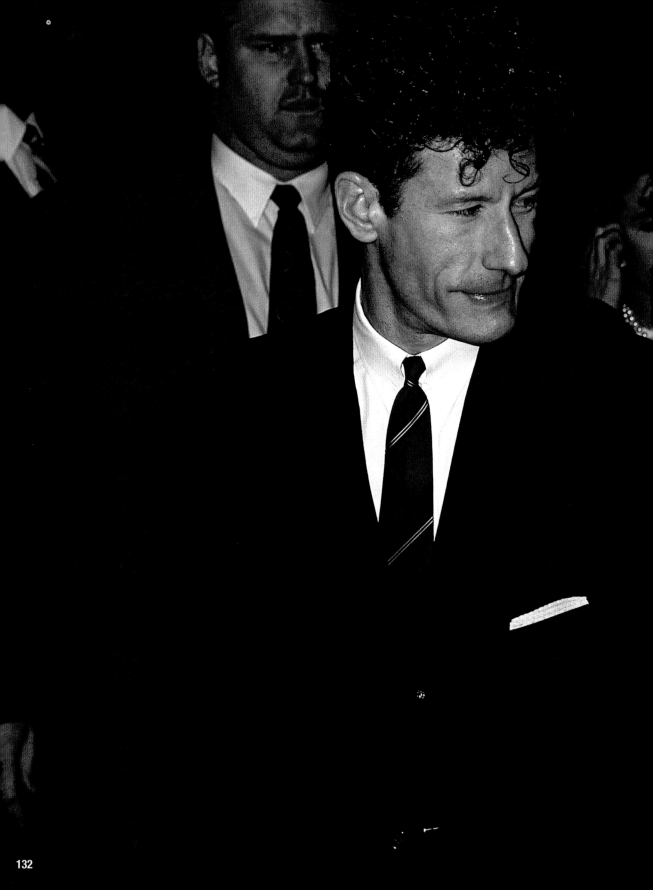

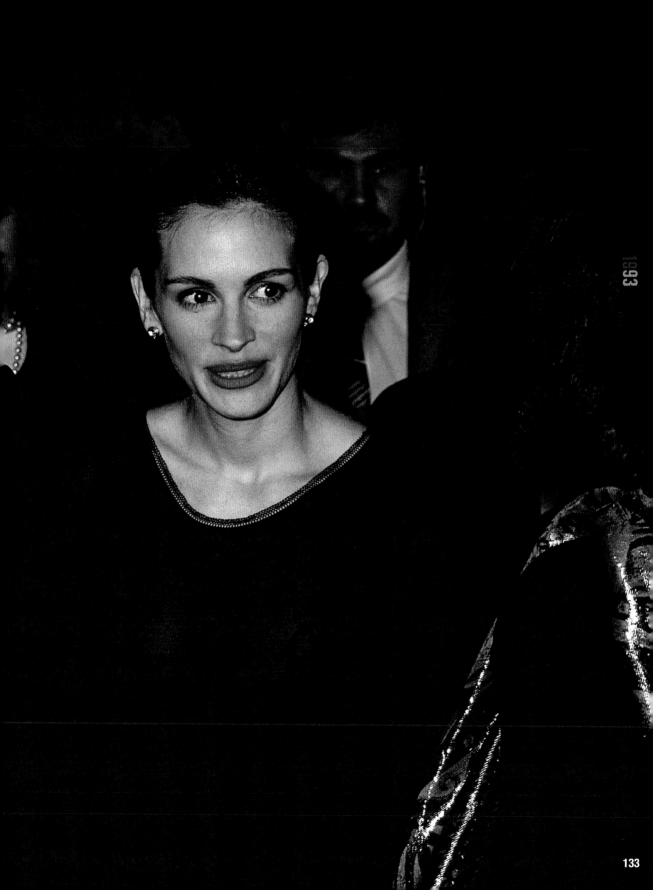

1893

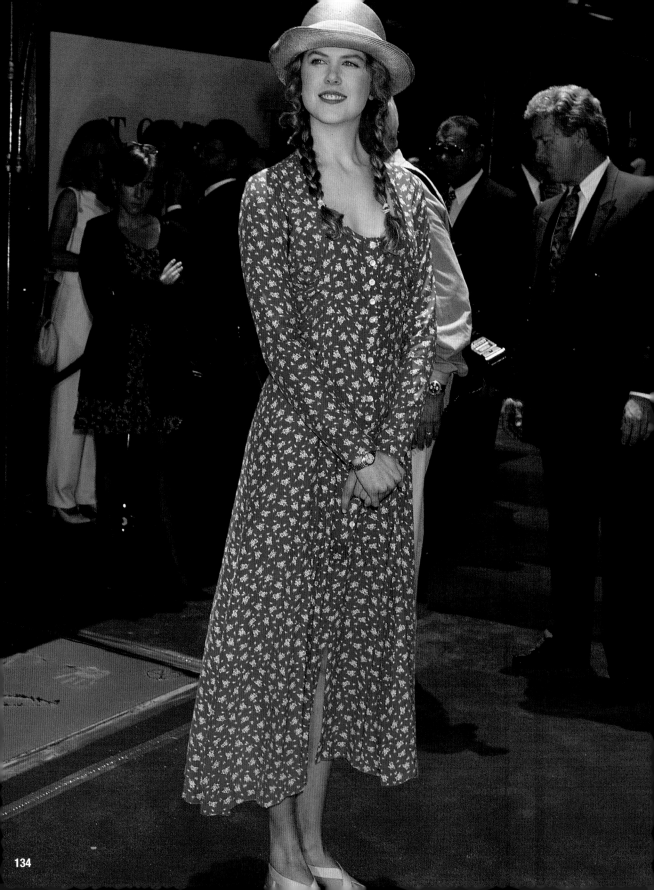

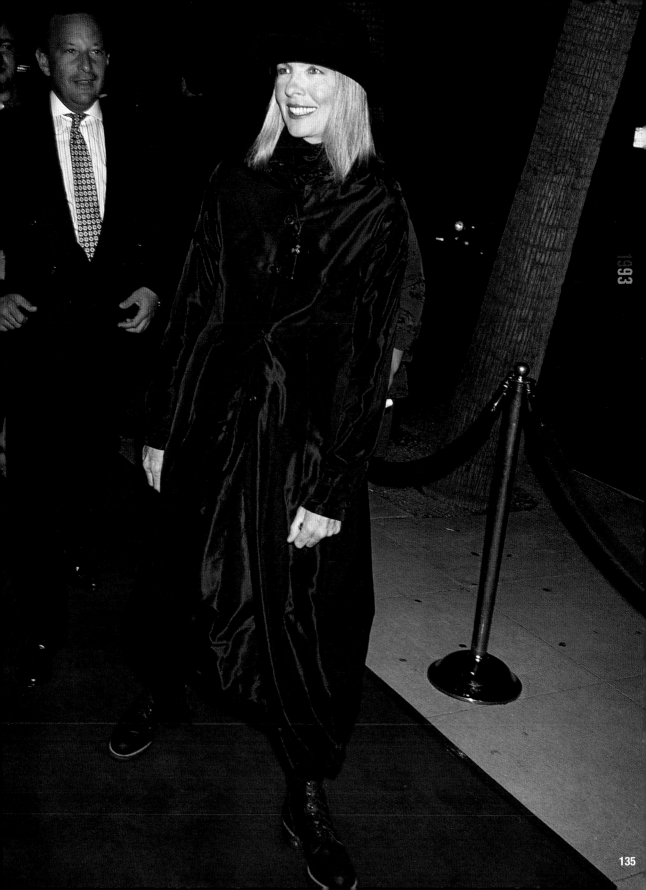

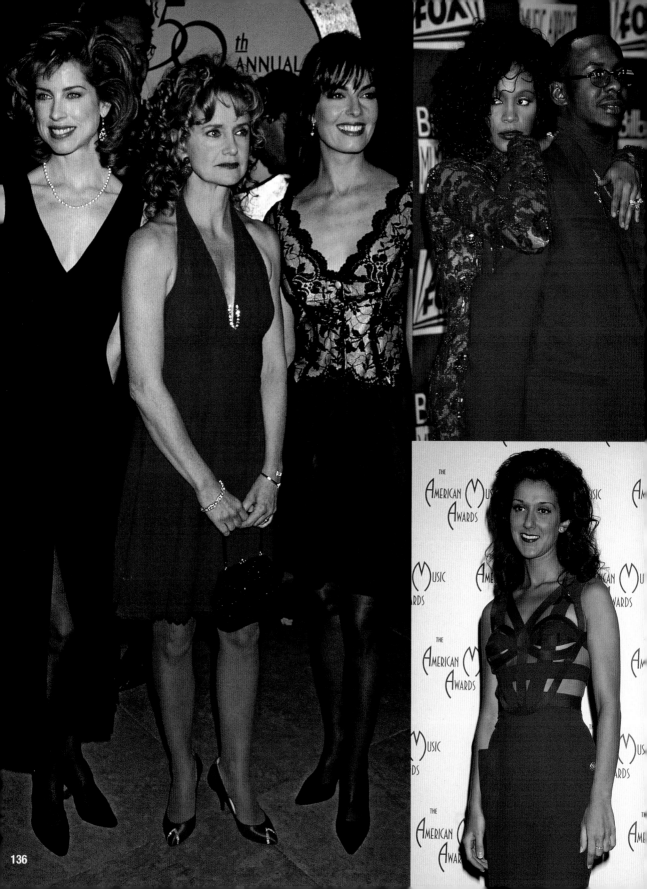

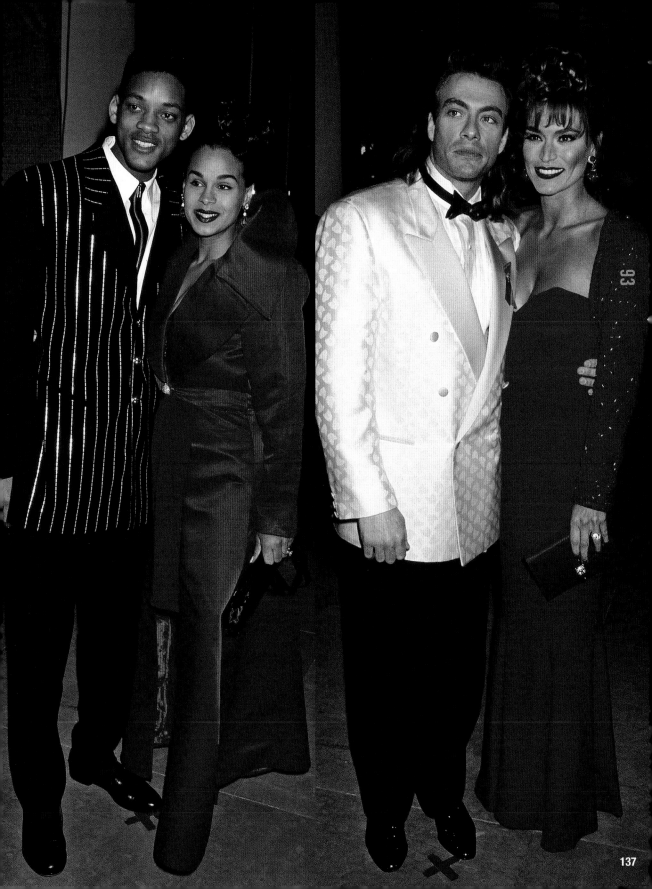

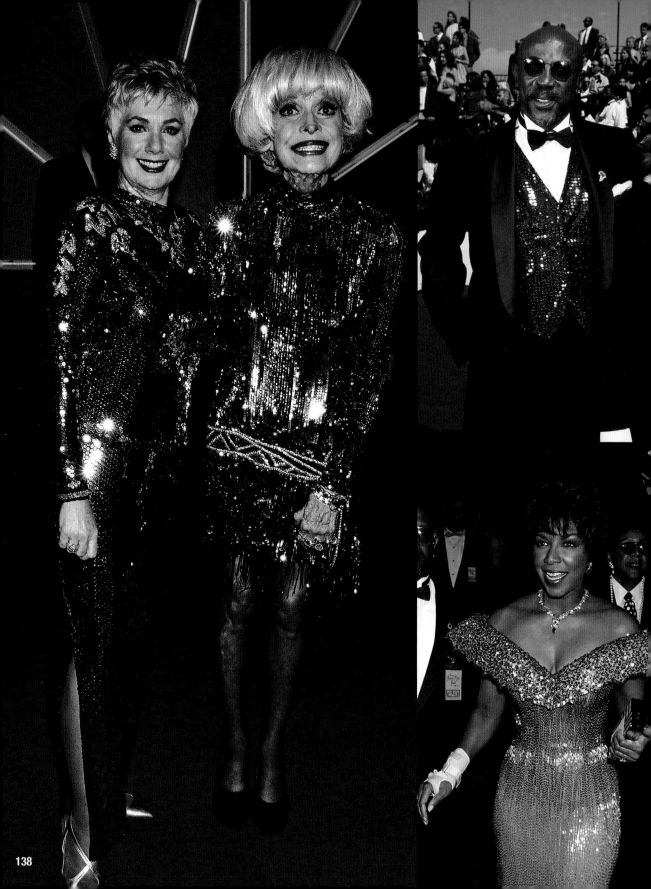

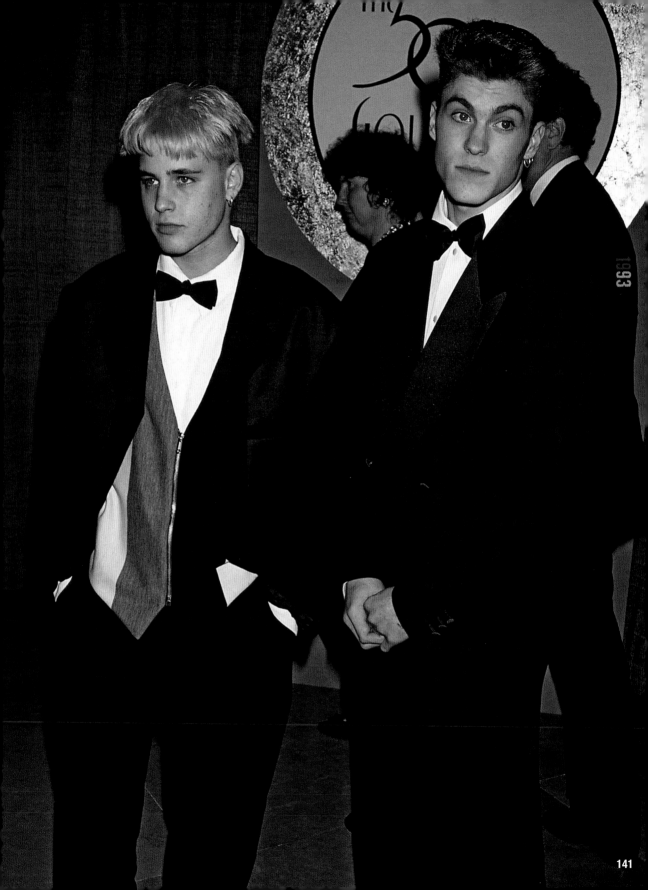

1993

141

1987 1988 1989 1990 1991 1992 **1994** 1993 1995 1996 1997 1998 1999 2000 2001 2002 2003 2004 2005 2006 2007

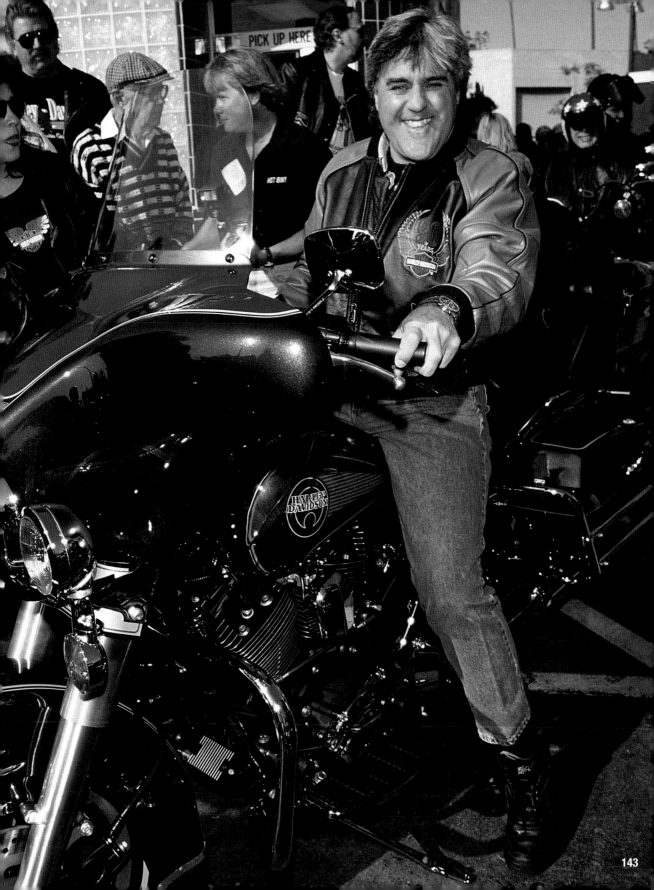

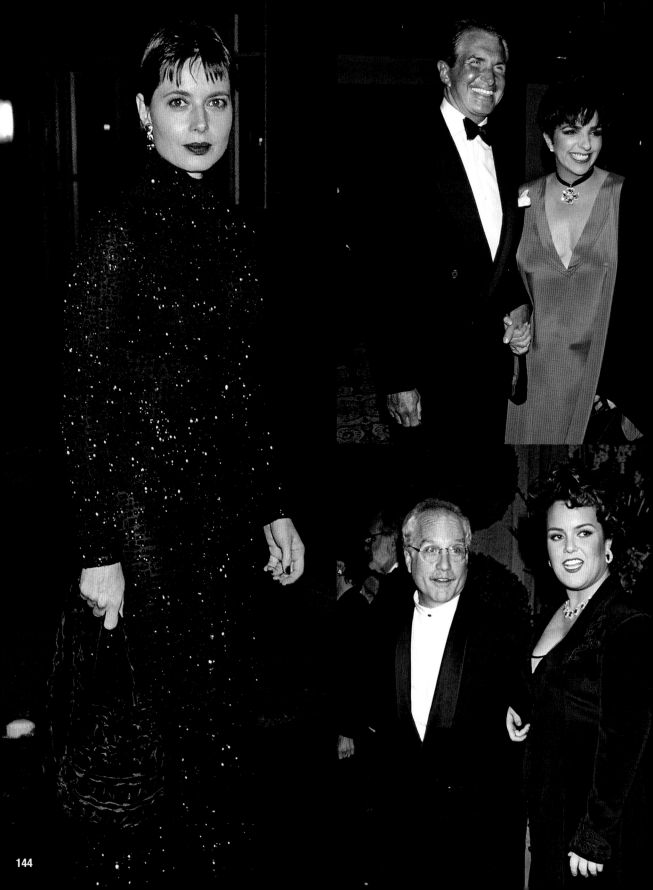

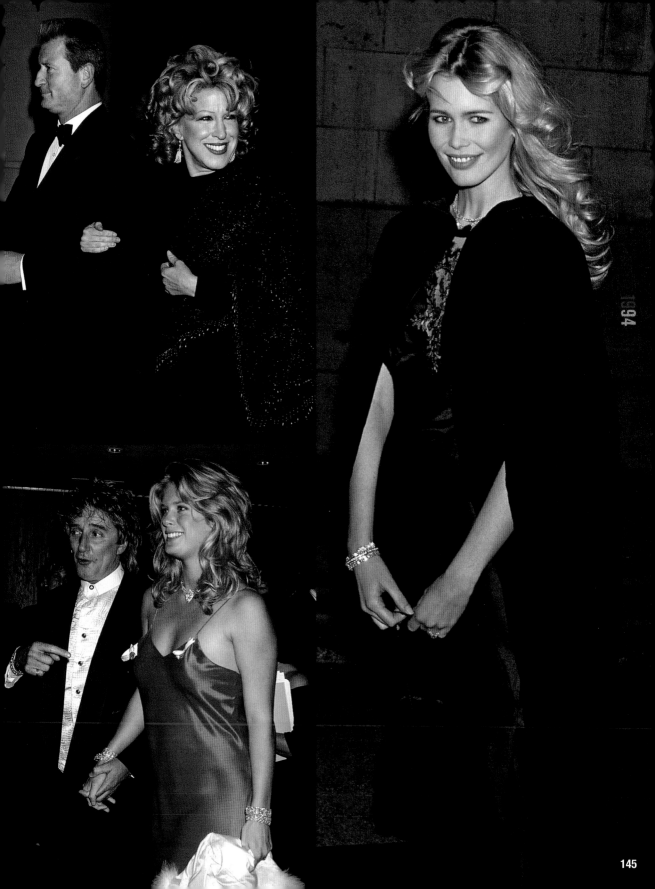

1994

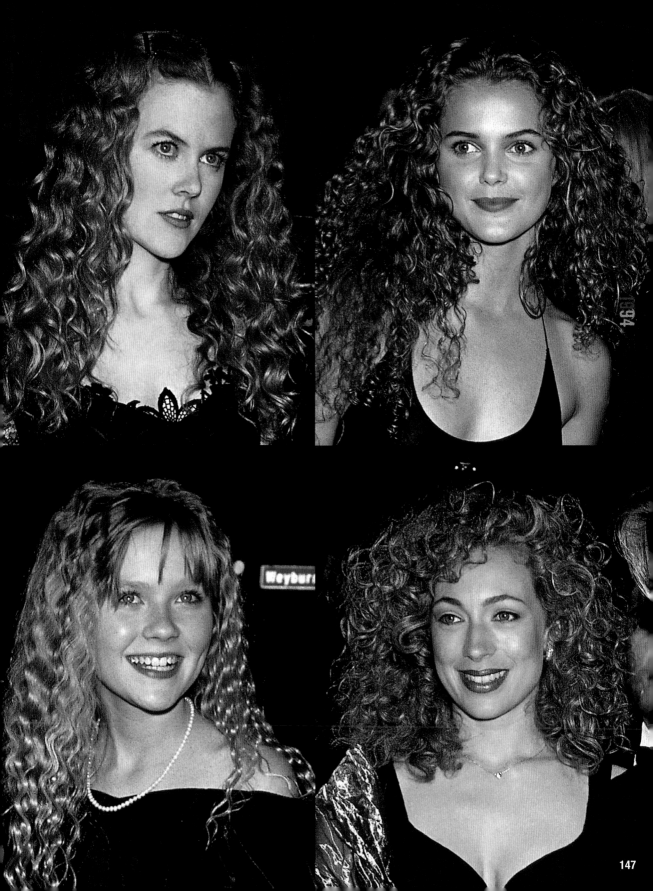

Weybur

1994

147

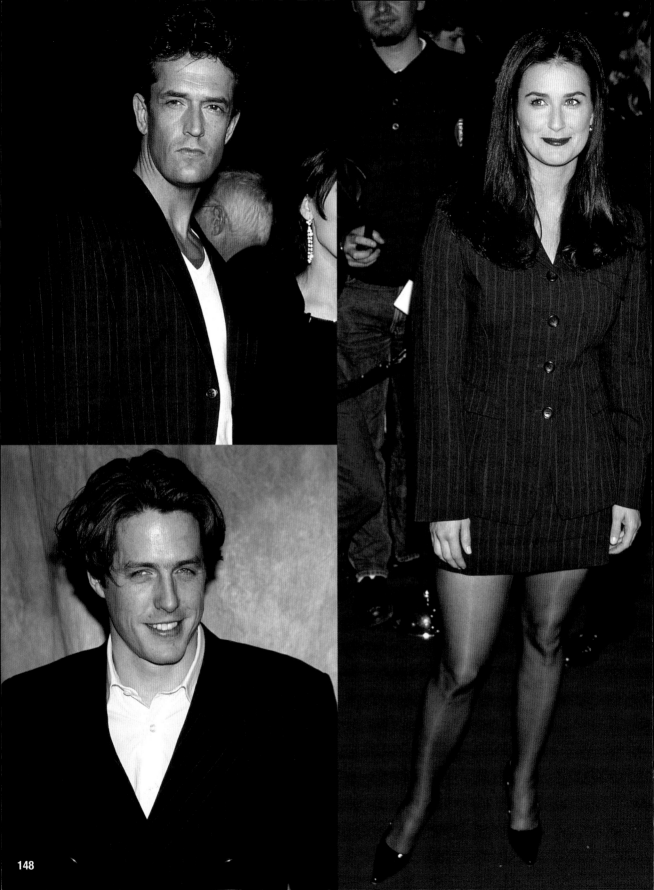

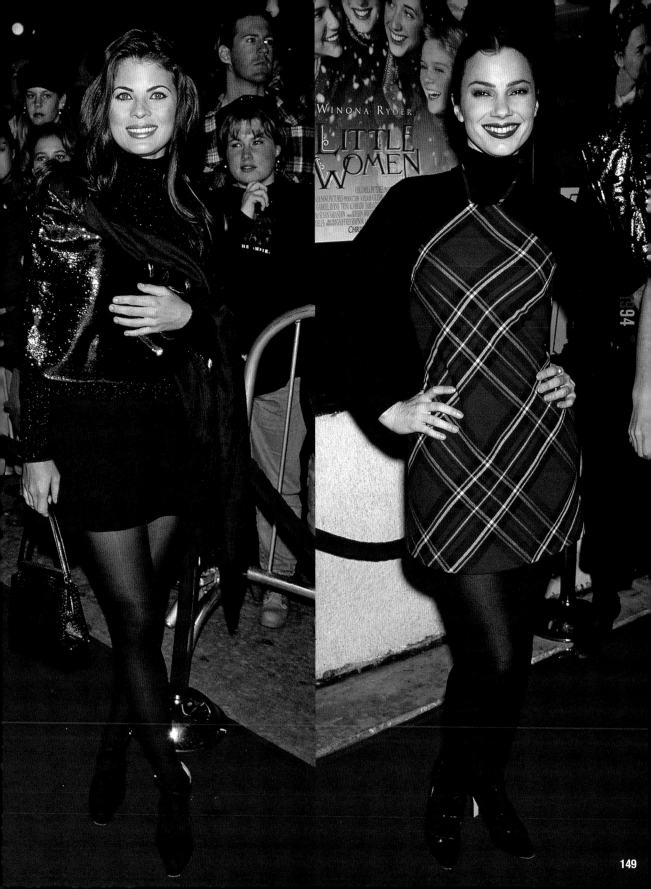

WINONA RYDER

LITTLE
WOMEN

COLUMBIA PICTURES

149

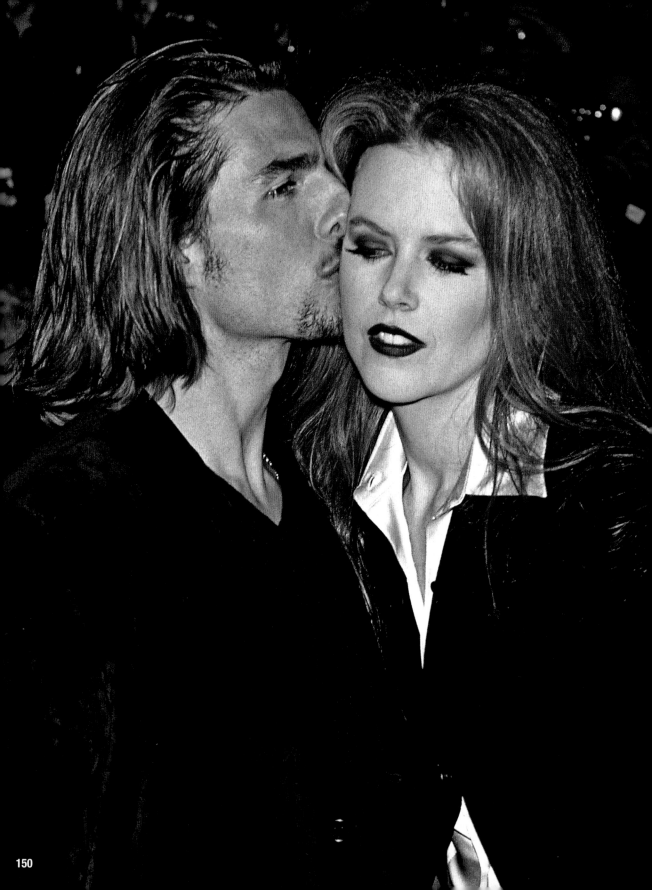

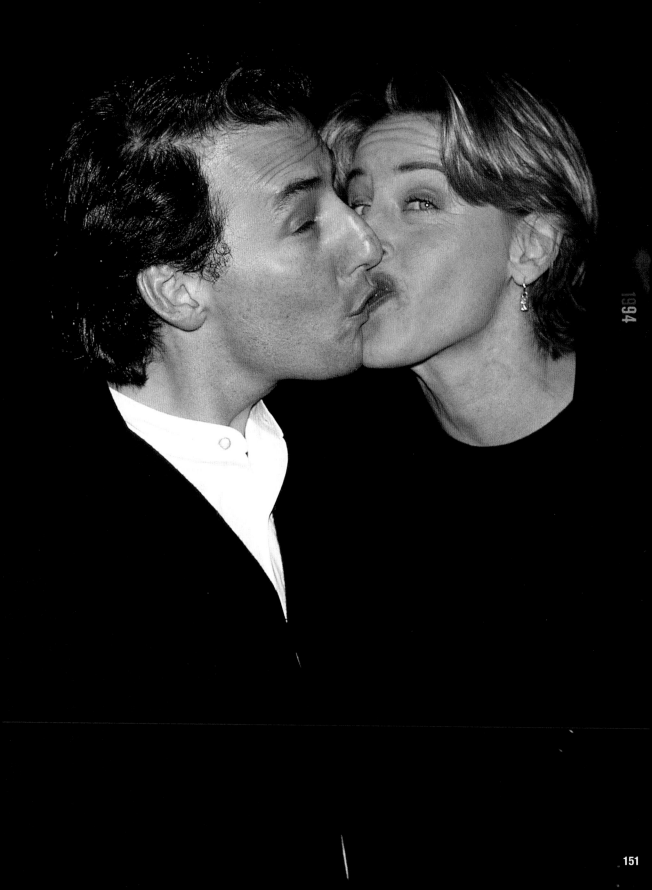

1987 1988 1989
1990 1991 1992
1993 1994 1995
1996 1997 1998
1999 2000 2001
2002 2003 2004
2005 2006 2007

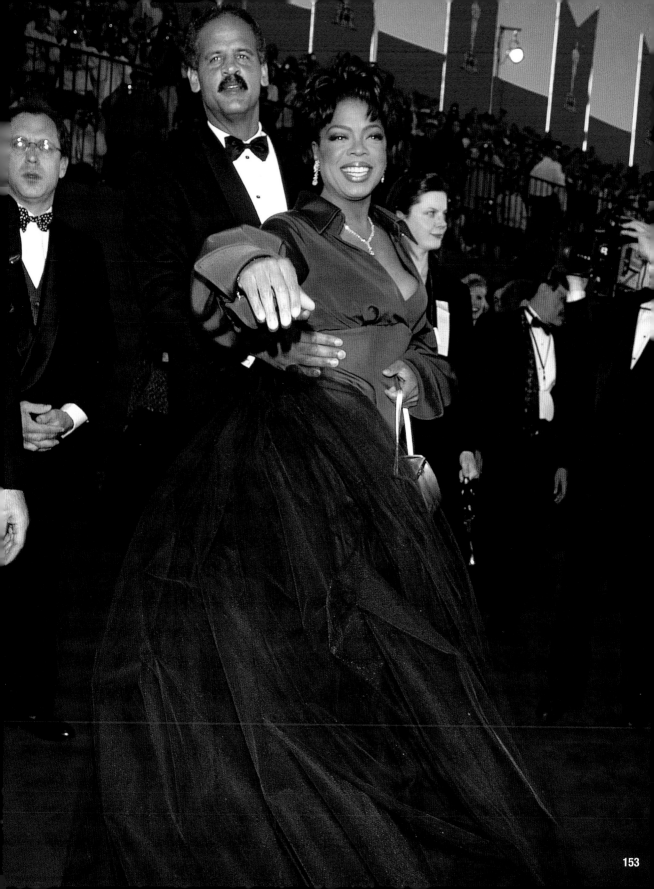

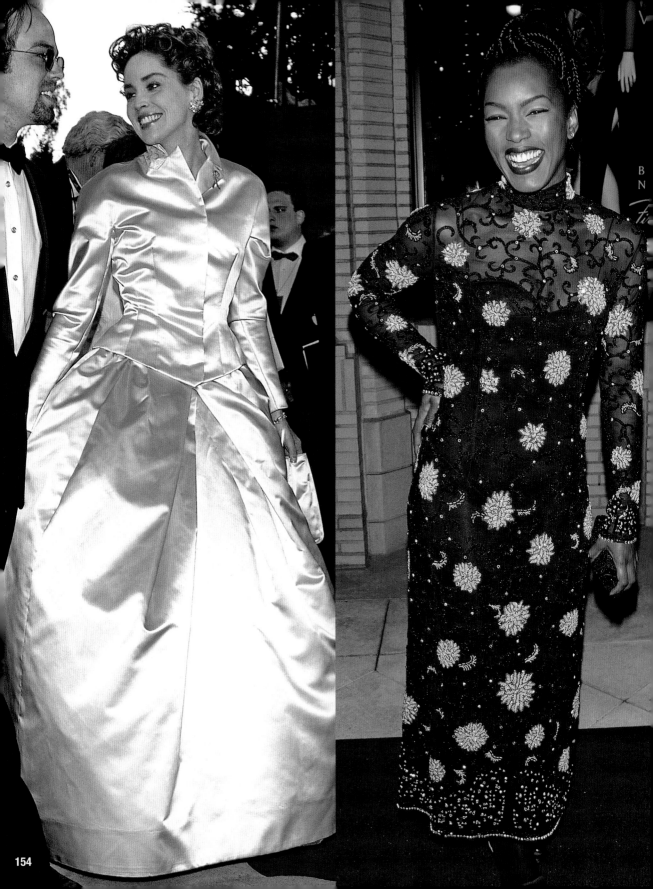

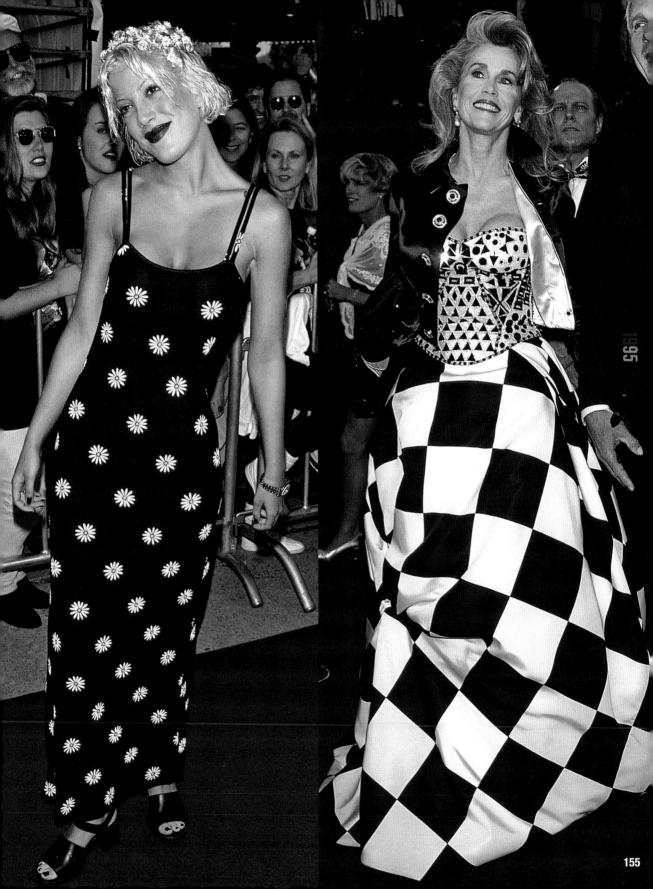

1995

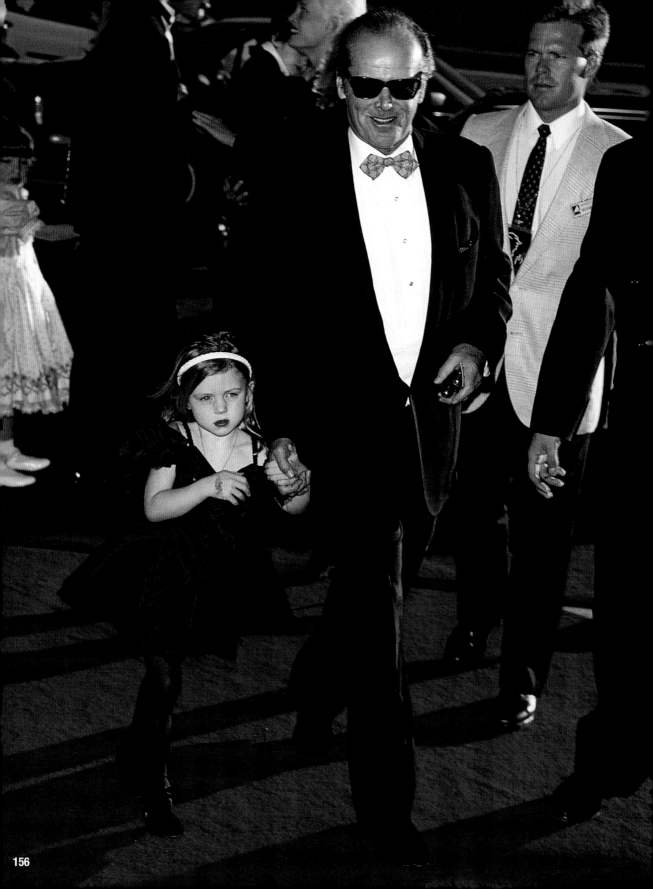

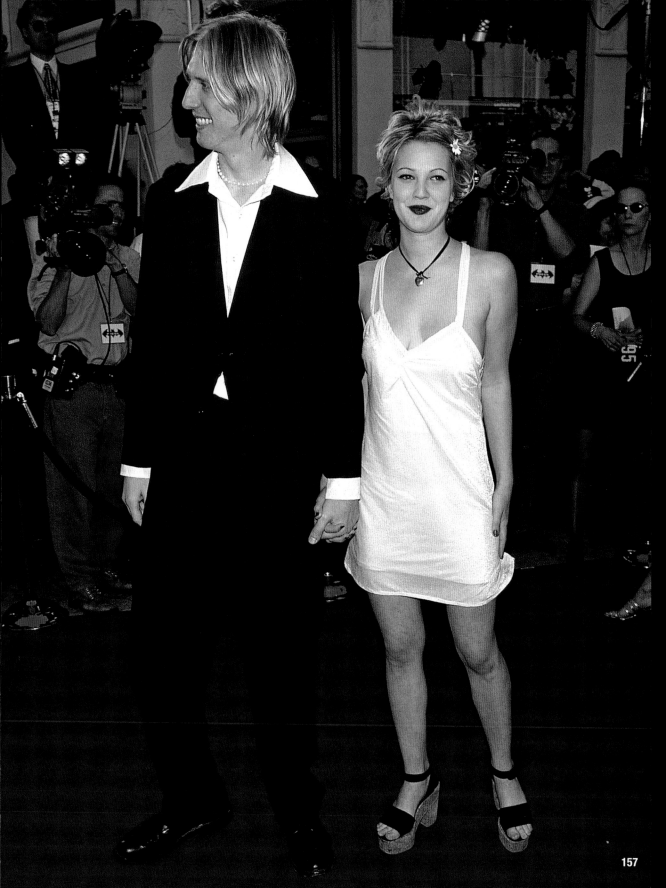

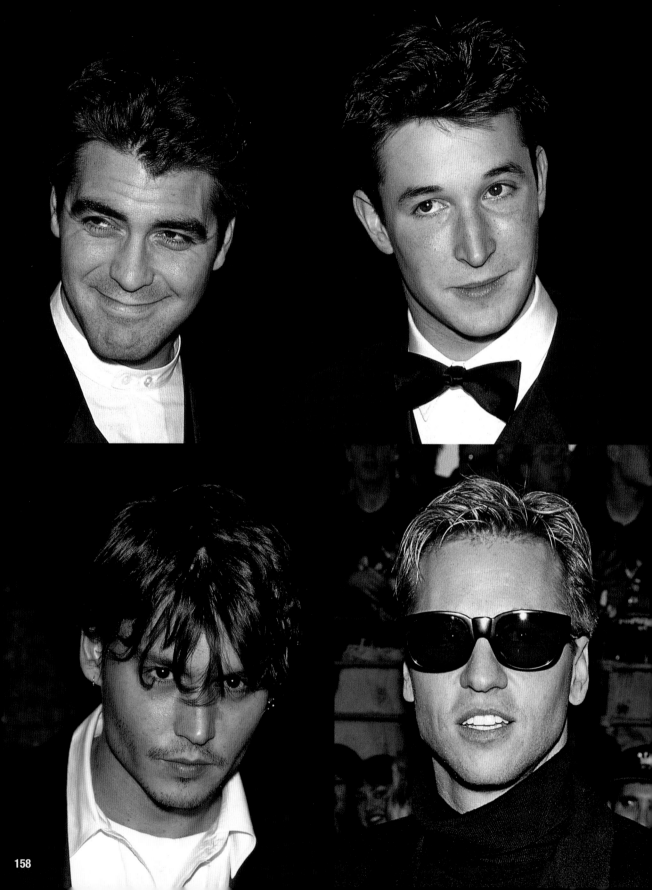

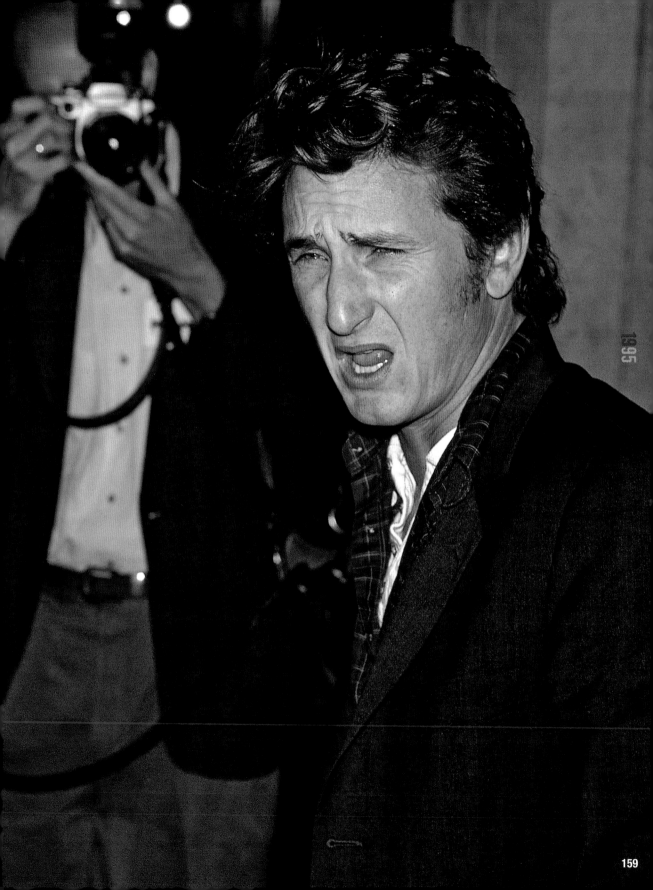

1995

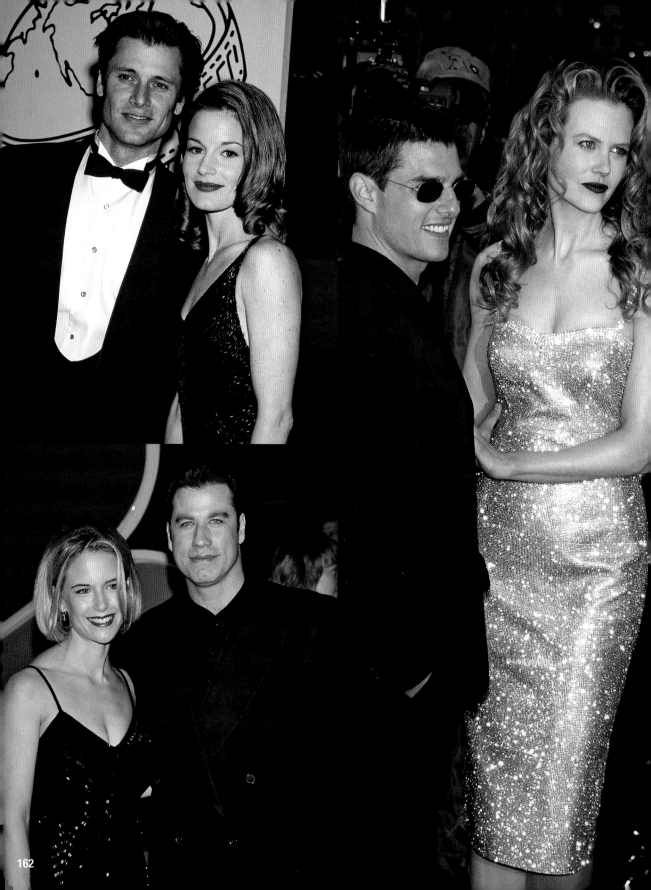

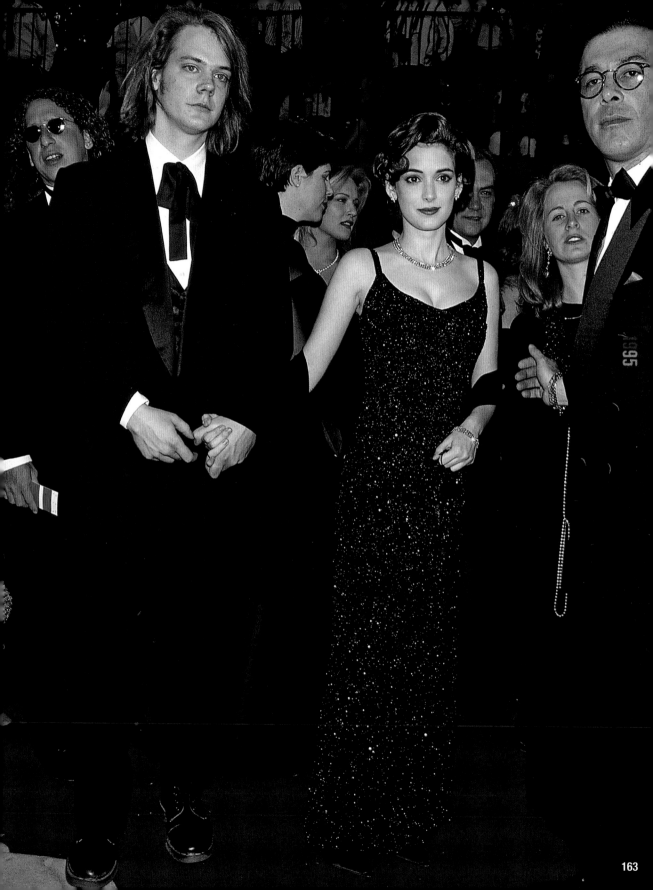

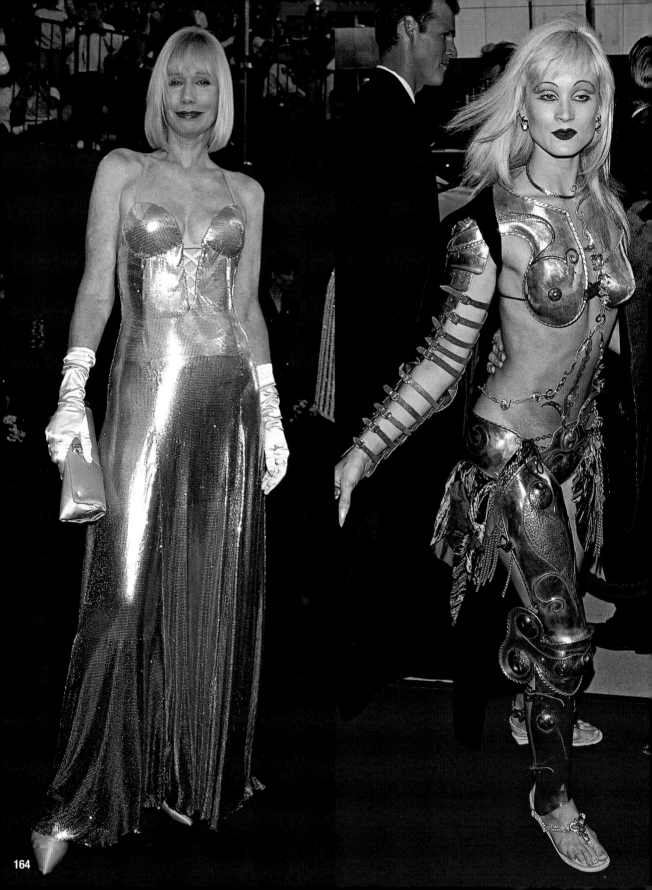

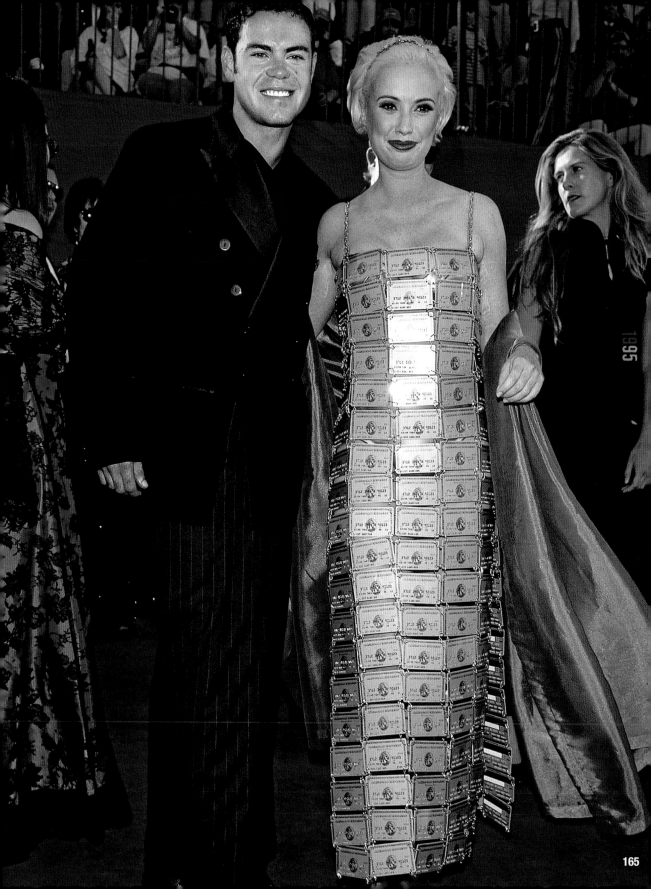

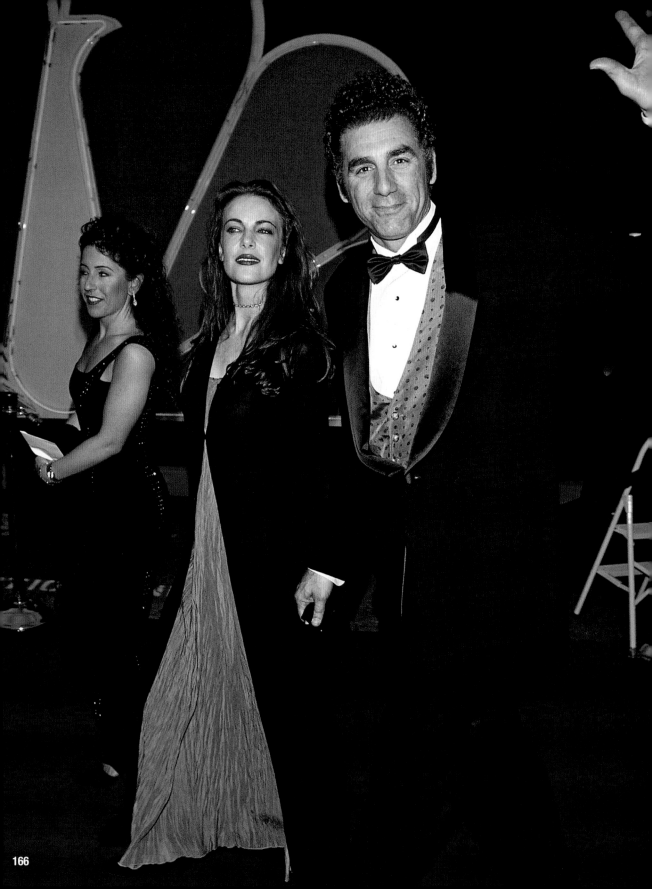

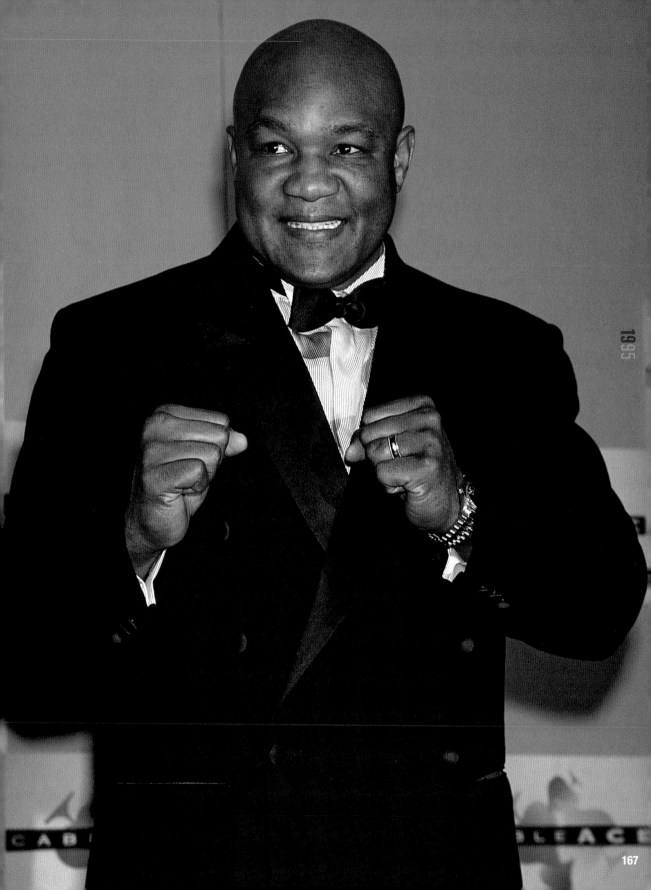

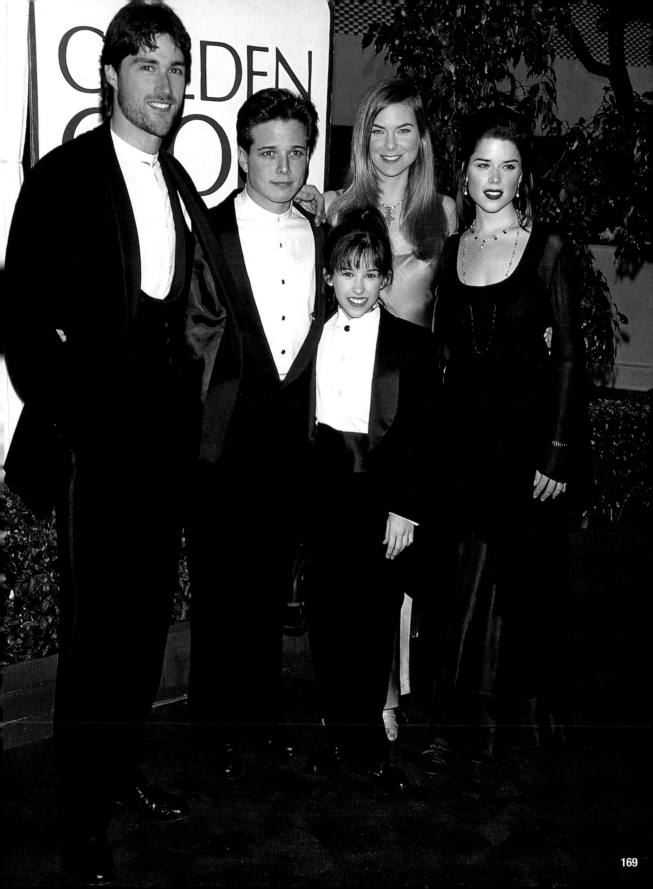

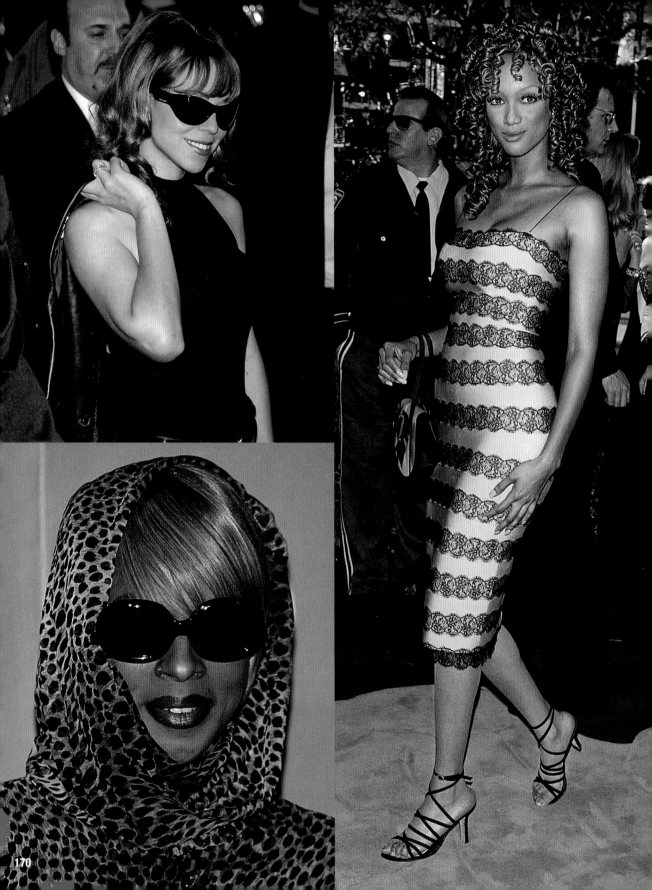

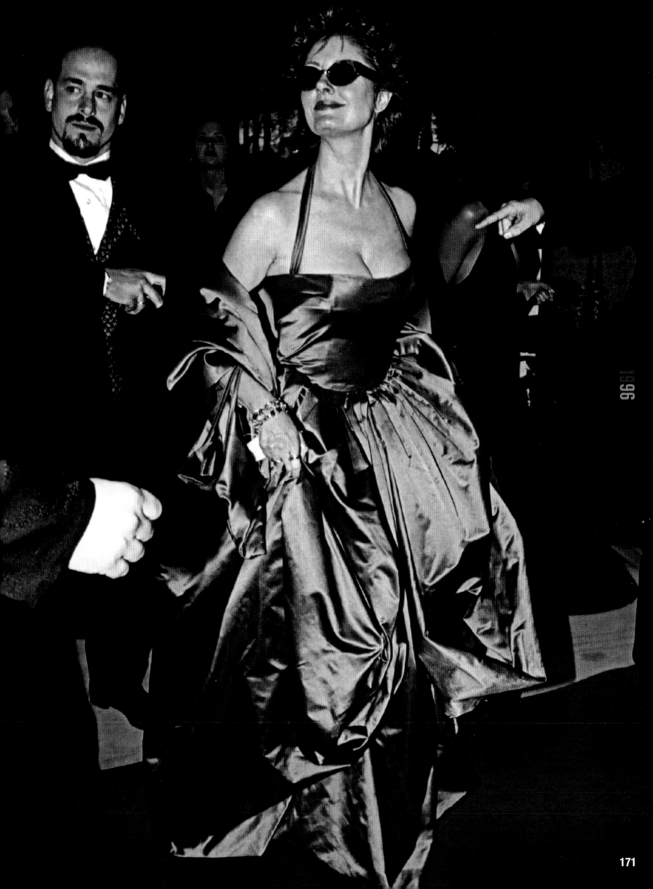

1996

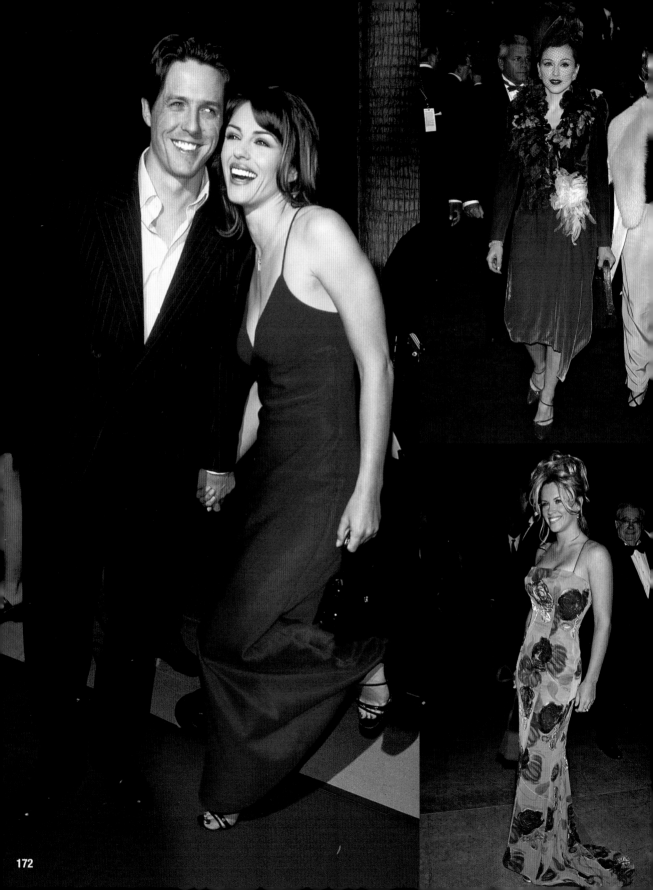

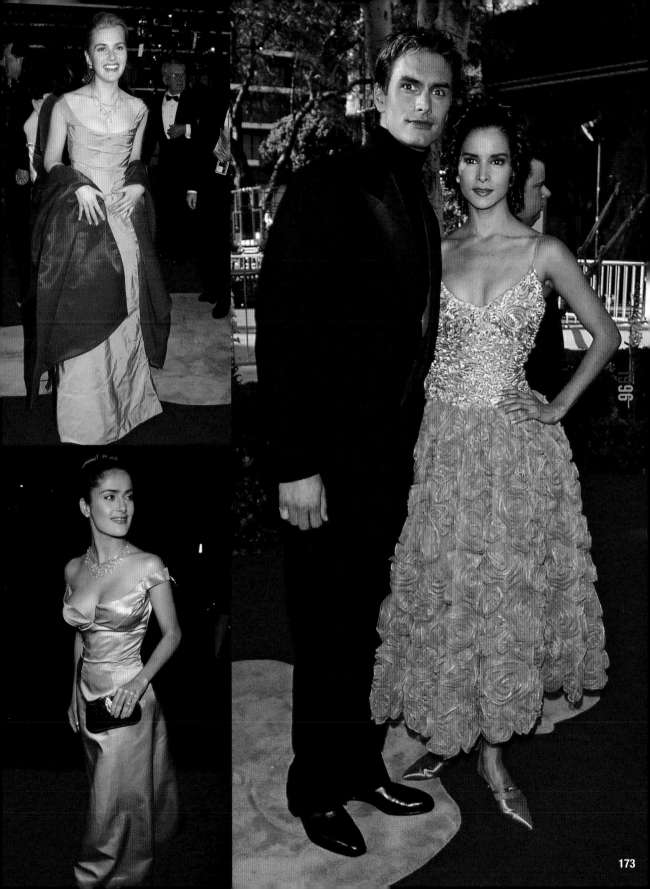

1996

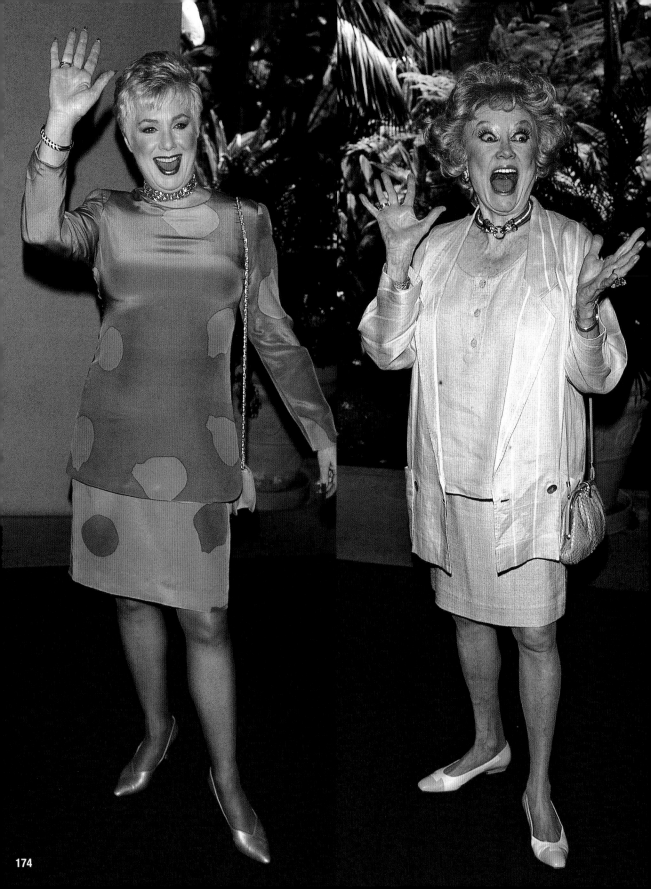

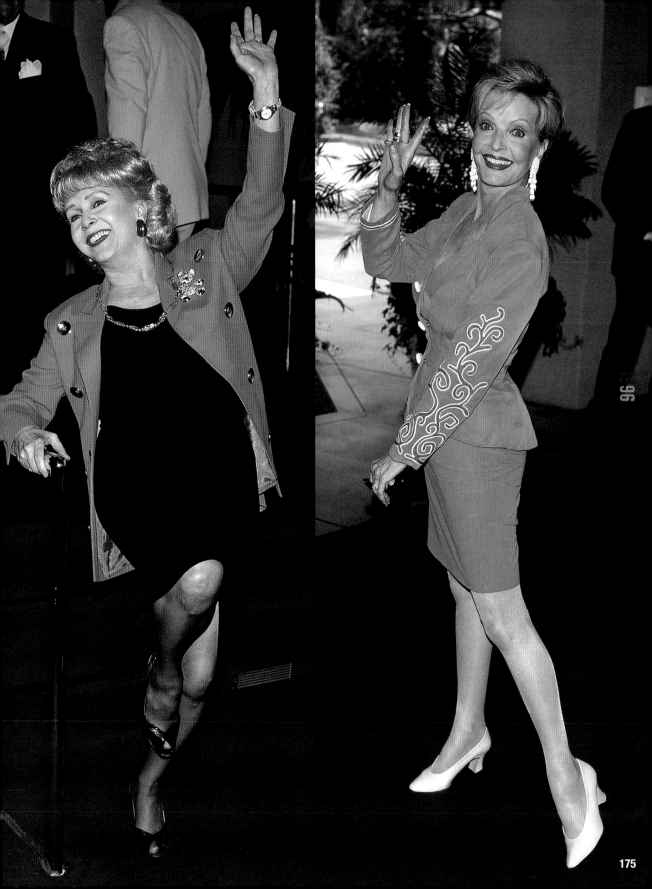

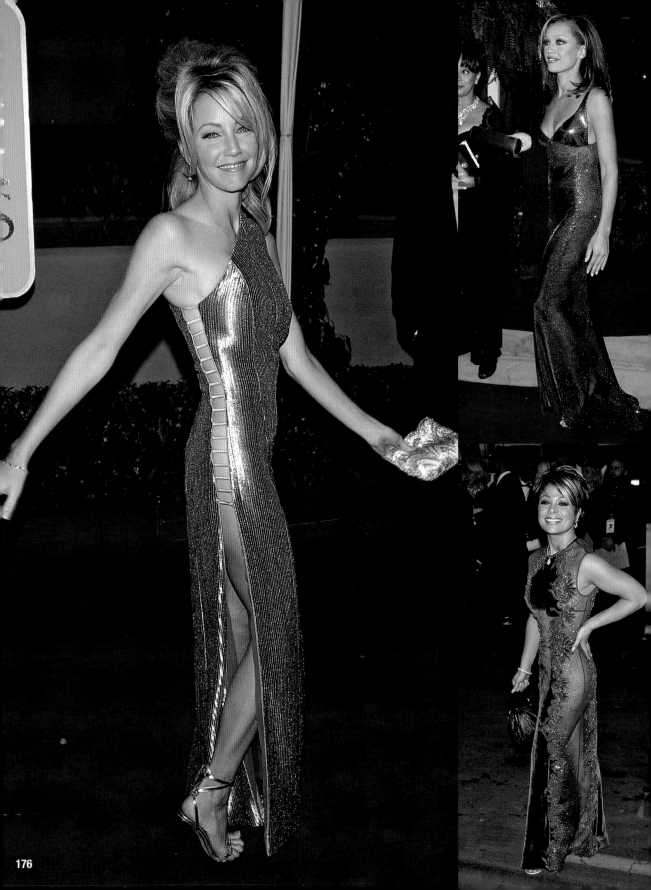

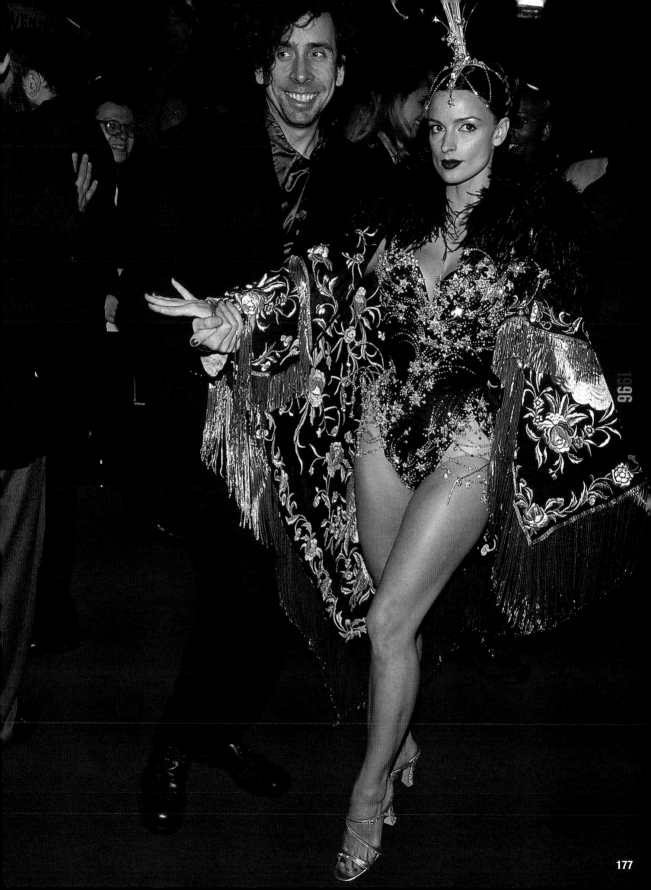

1996

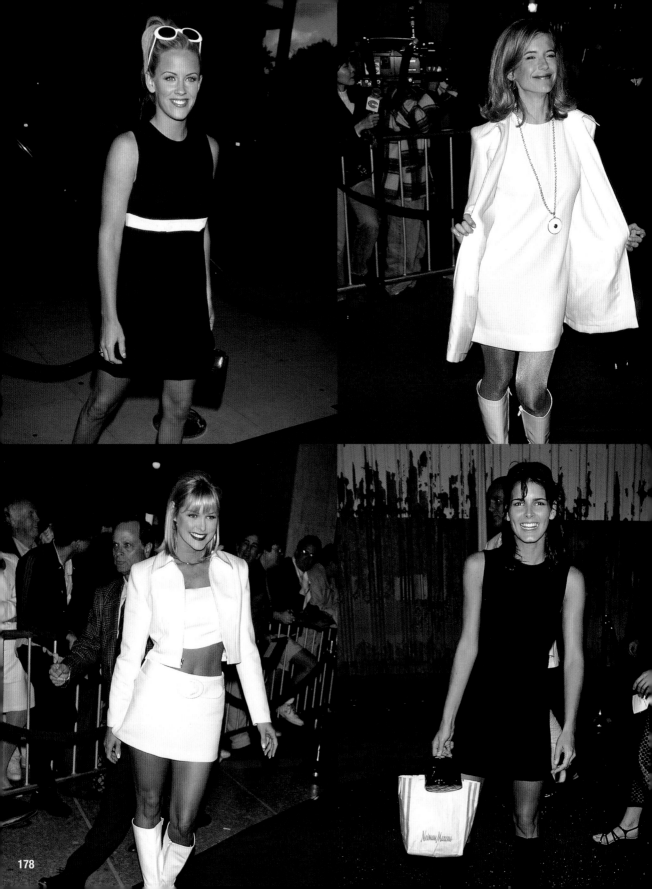

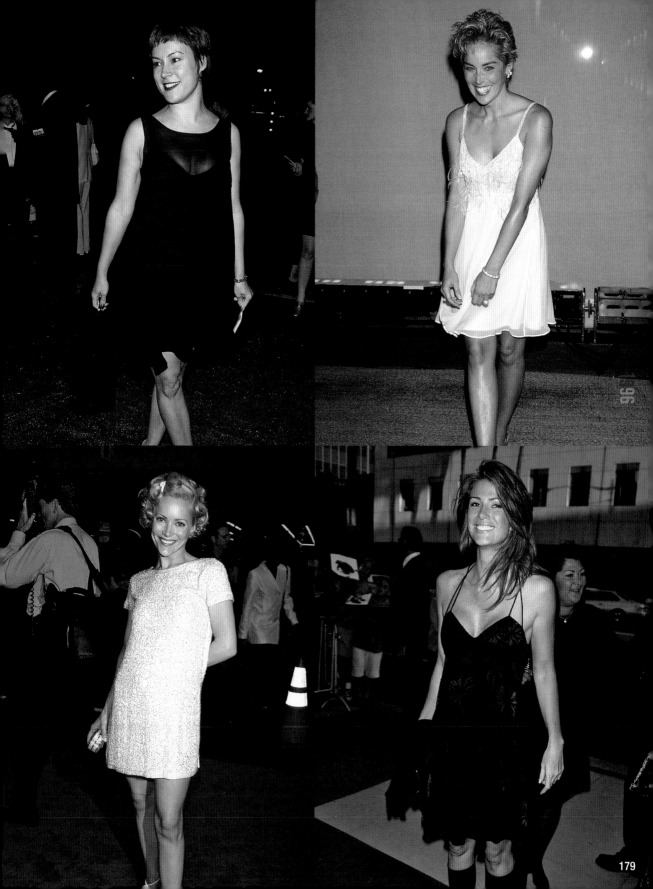

179

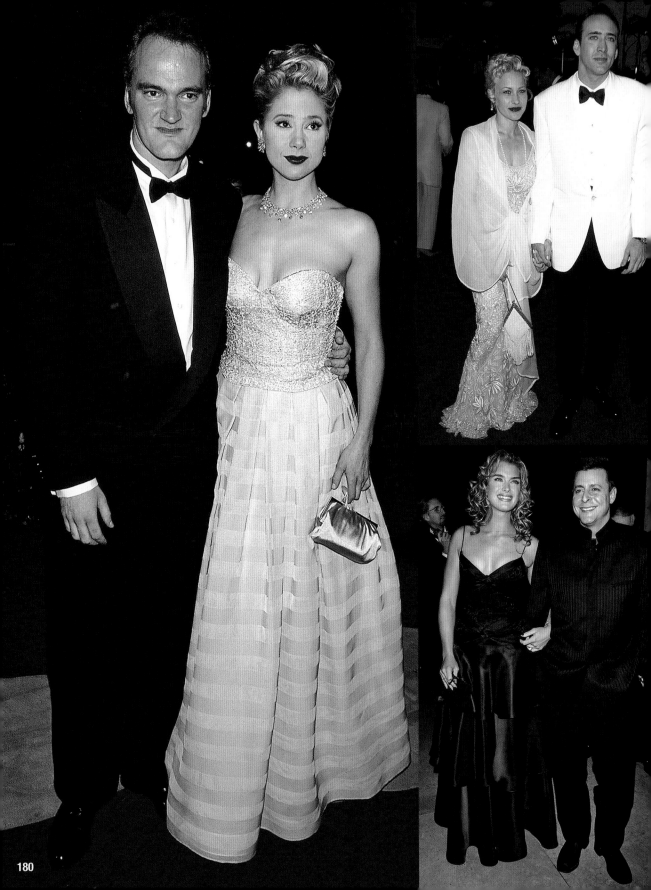

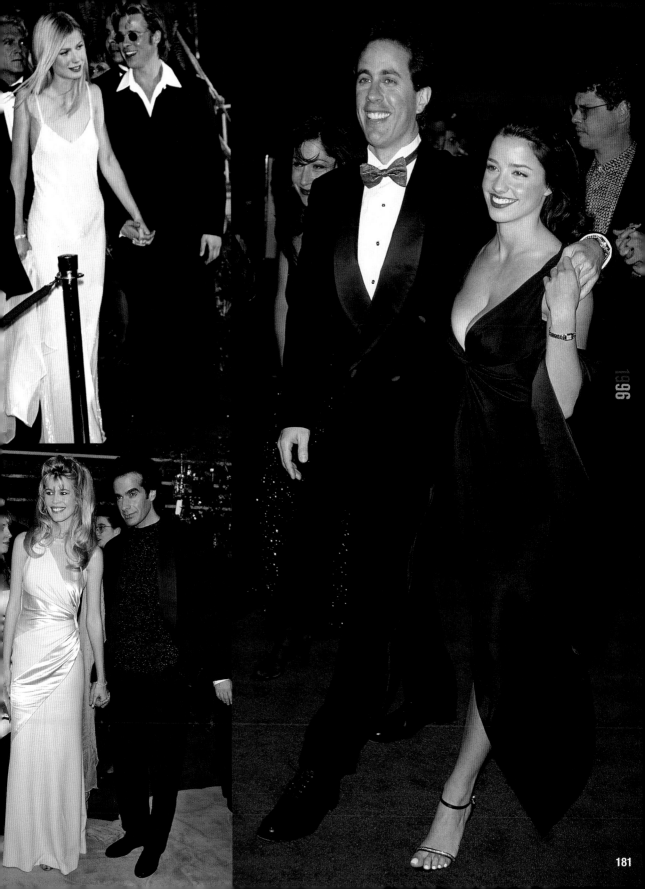

1996

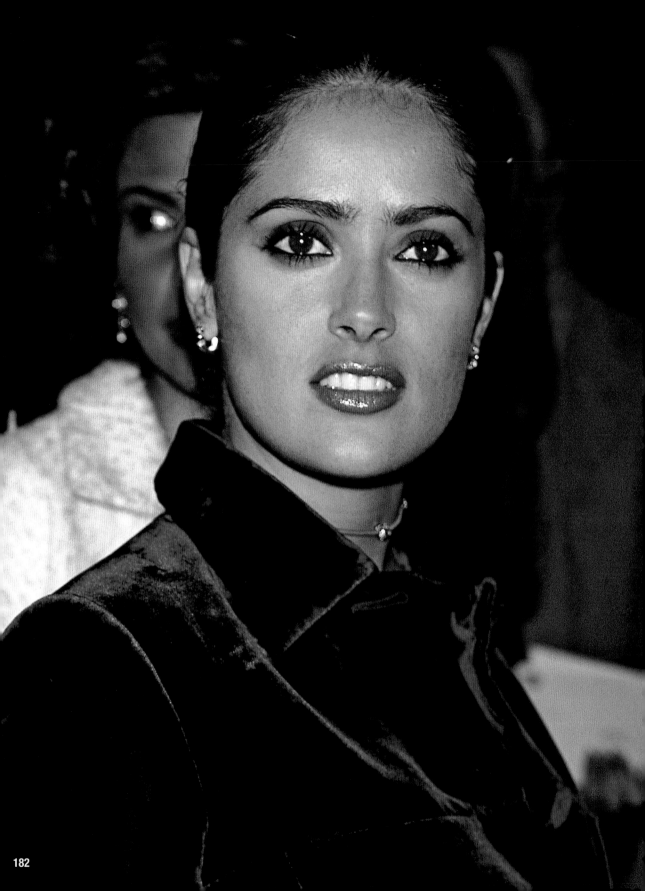

183

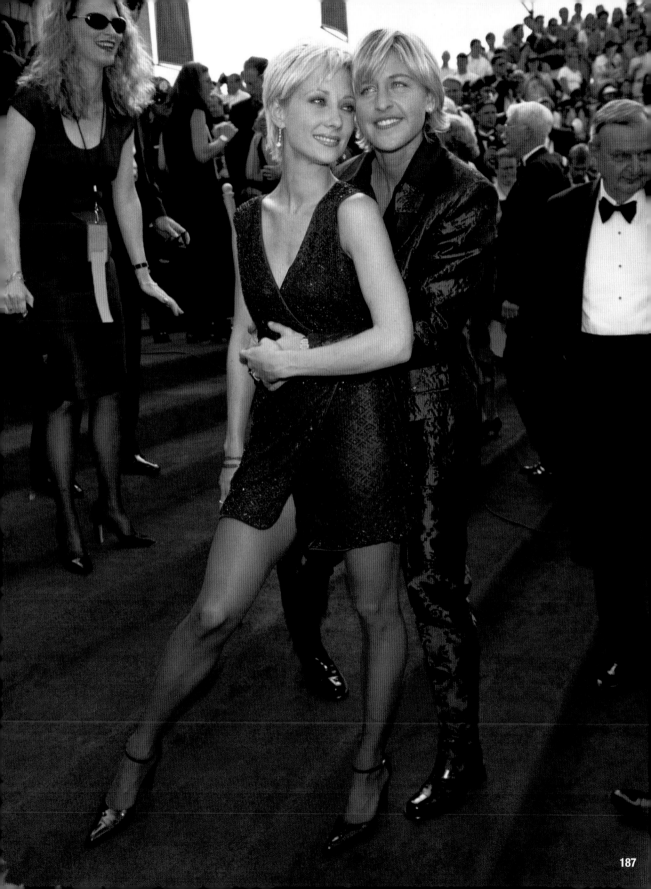

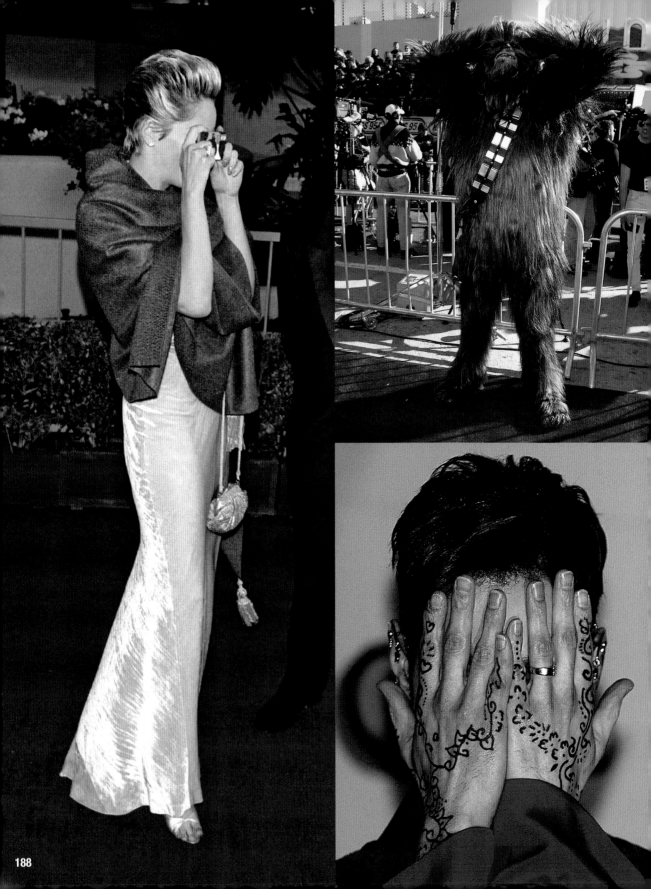

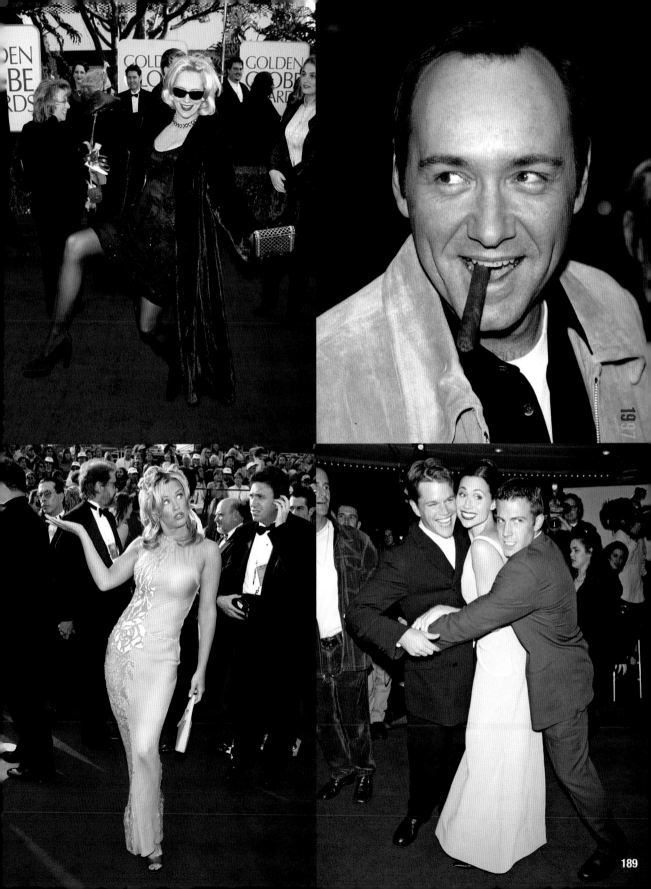

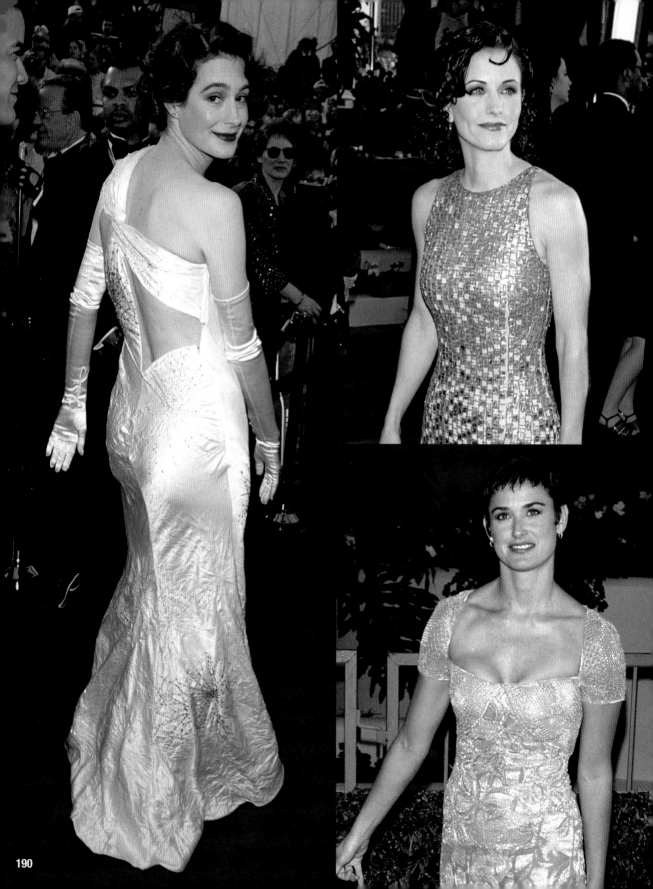

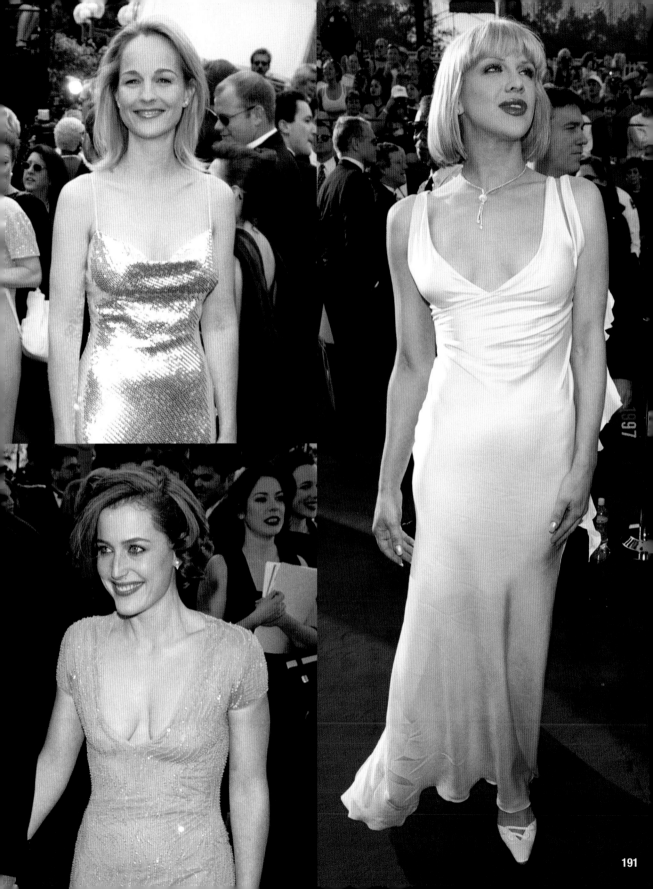

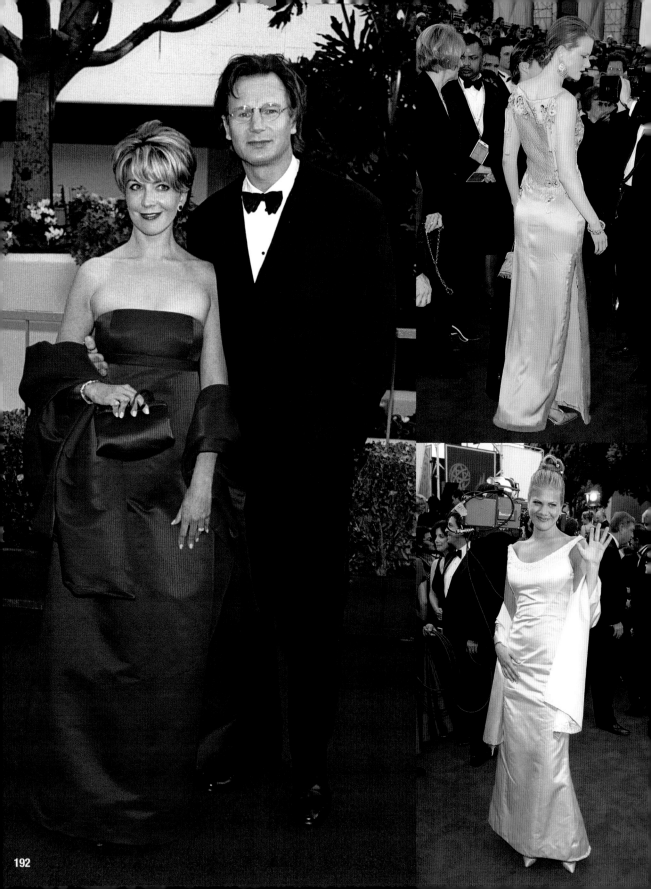

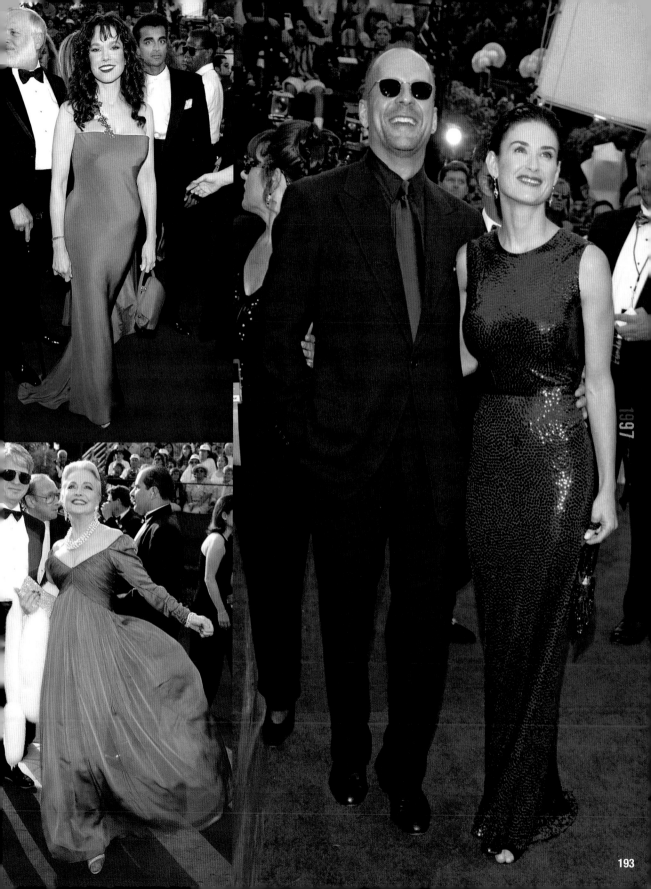

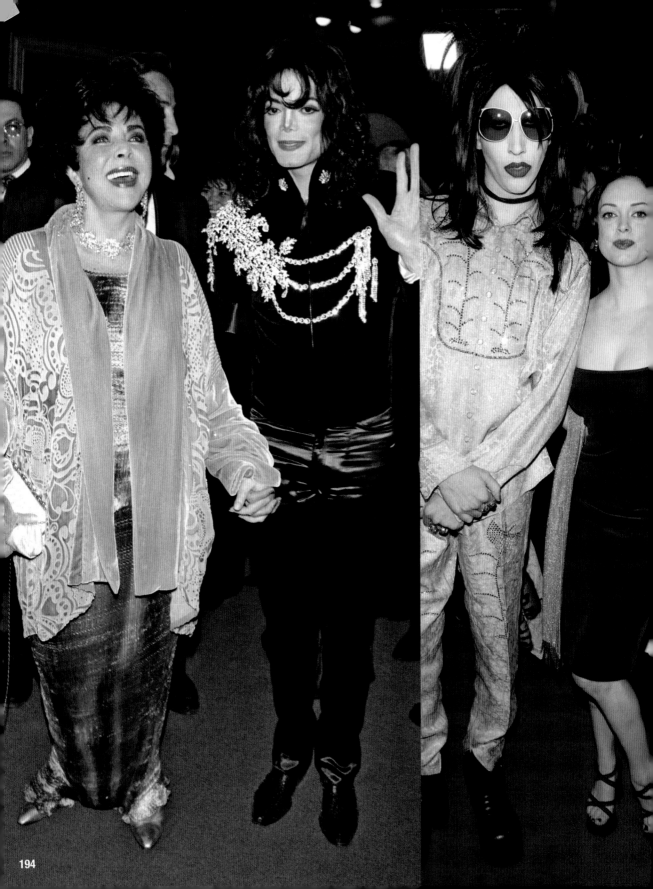

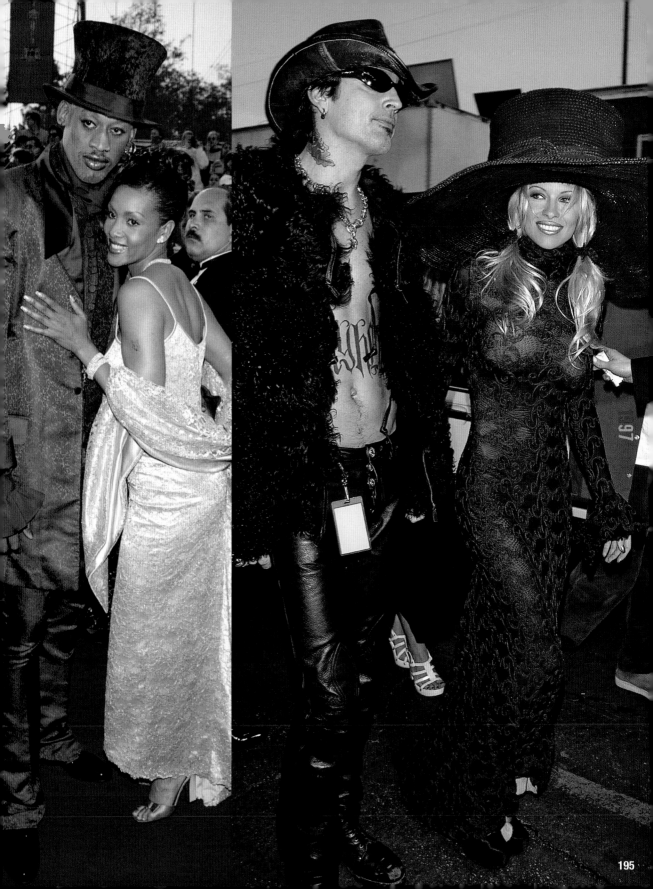

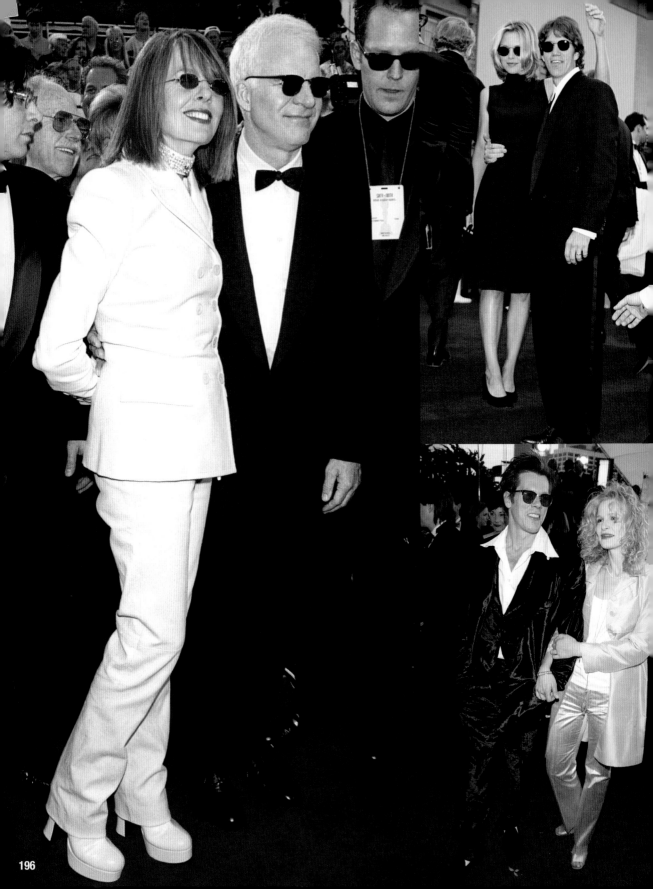

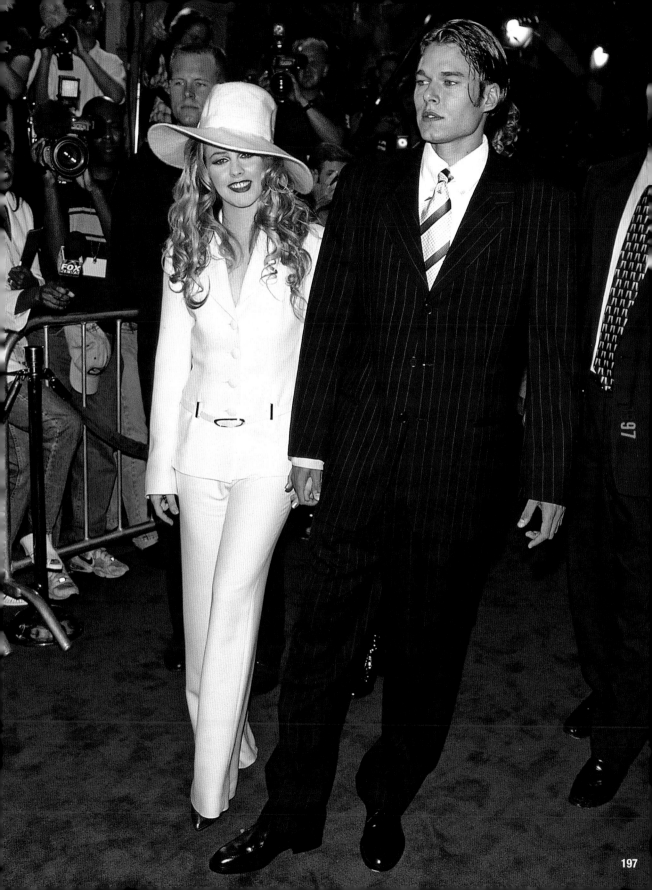

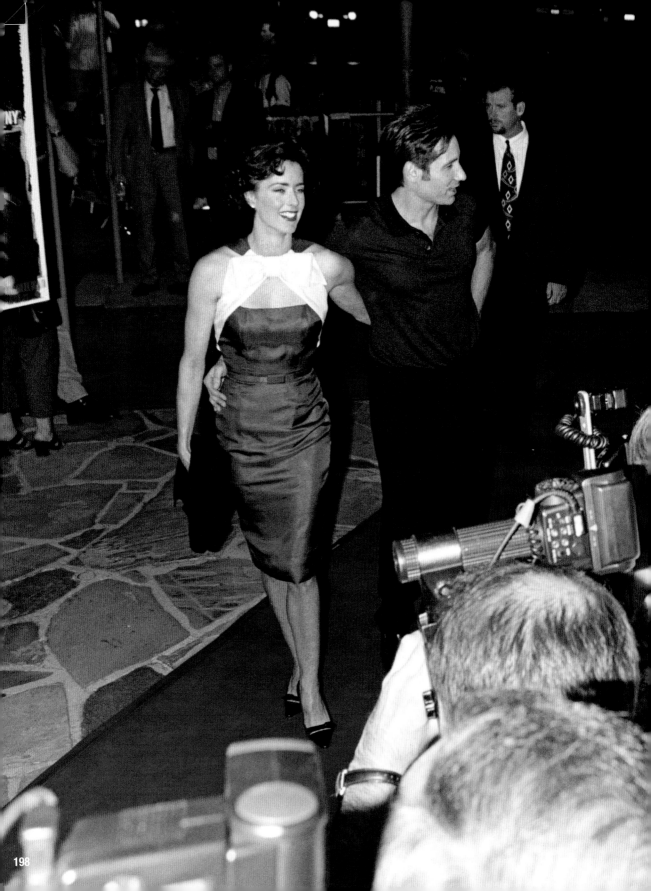

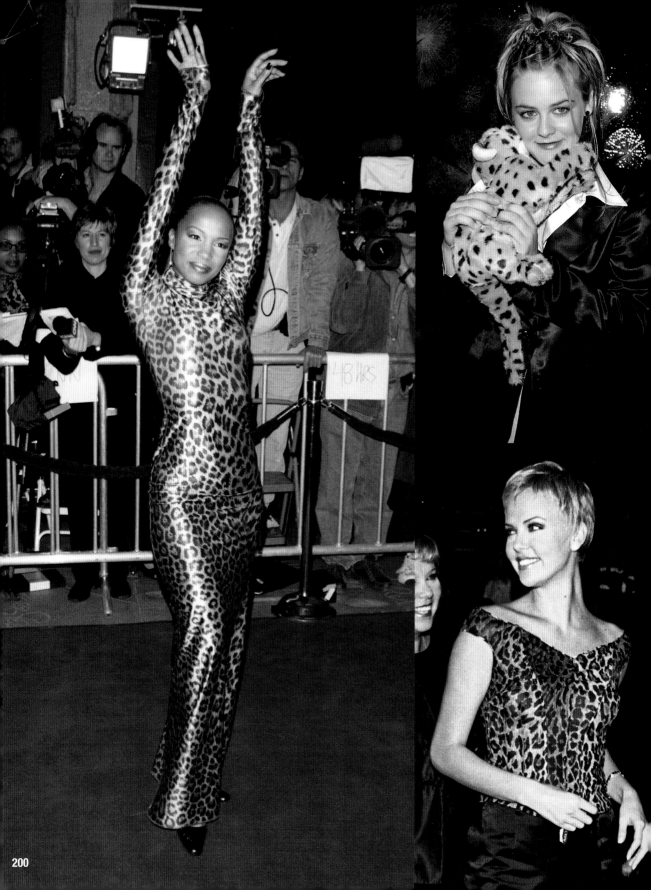

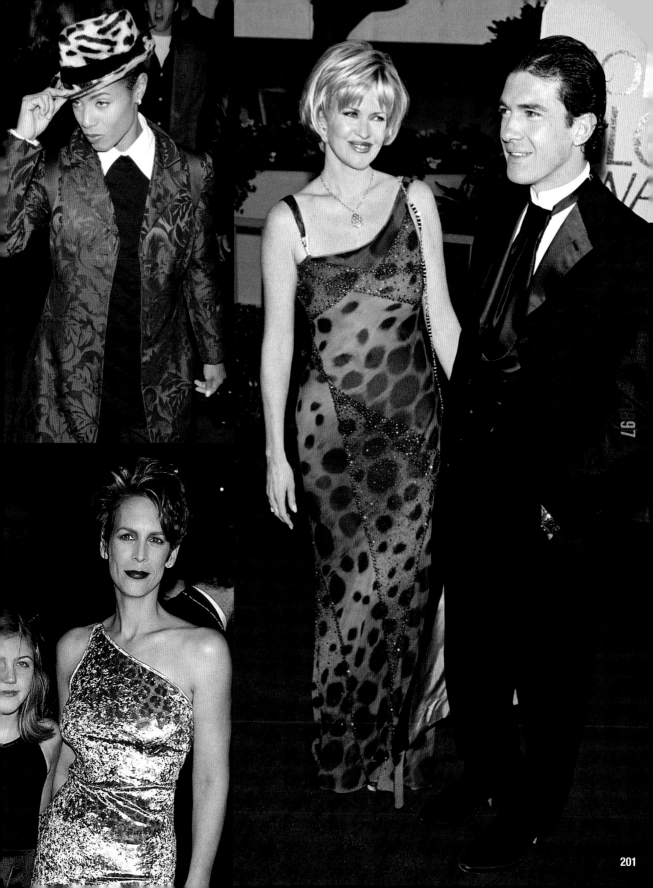

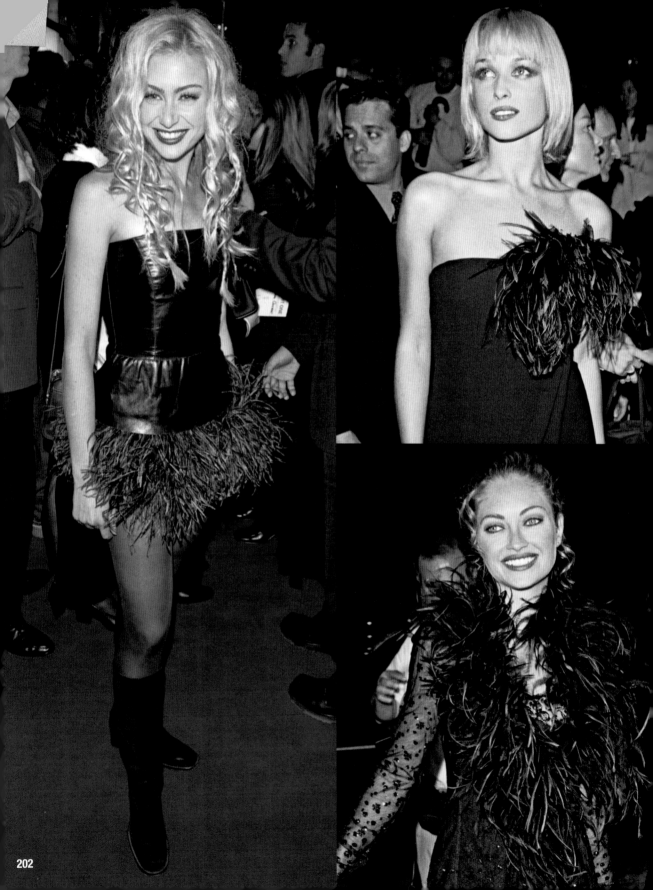

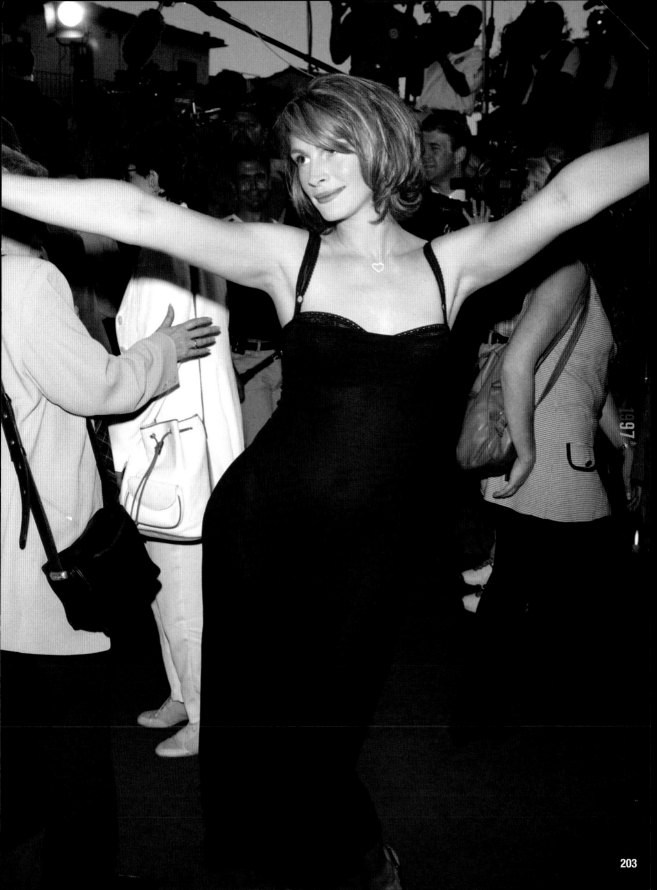

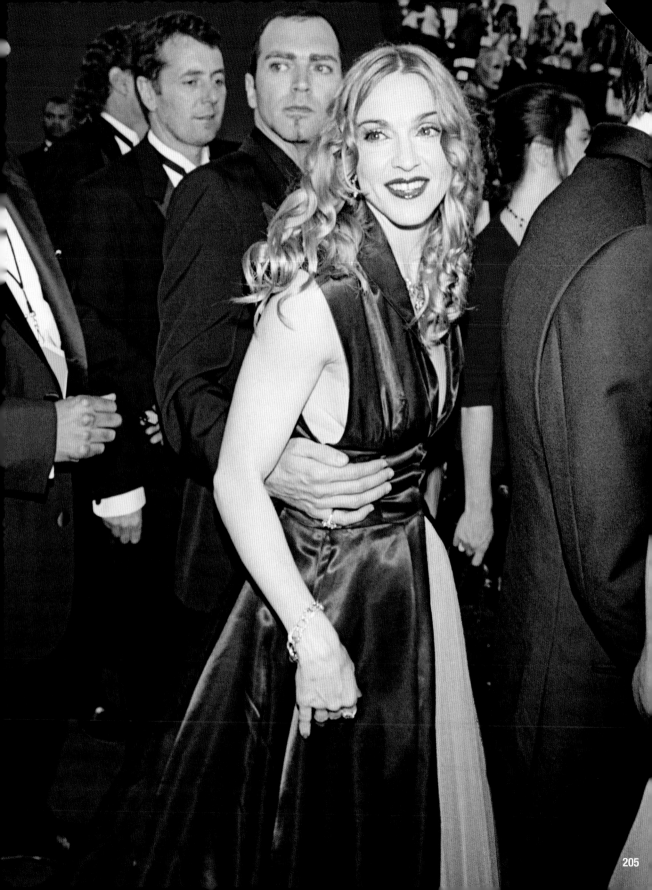

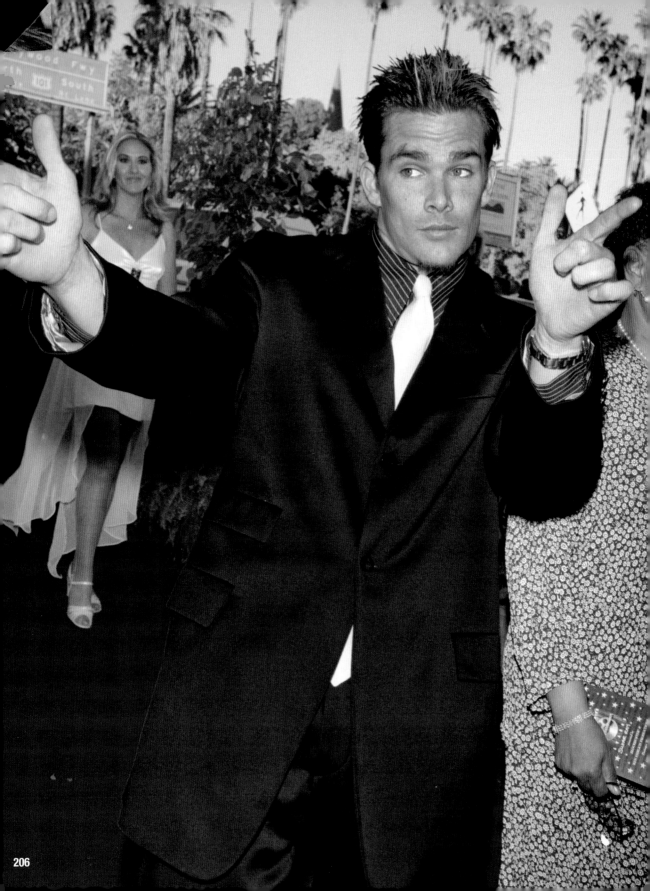

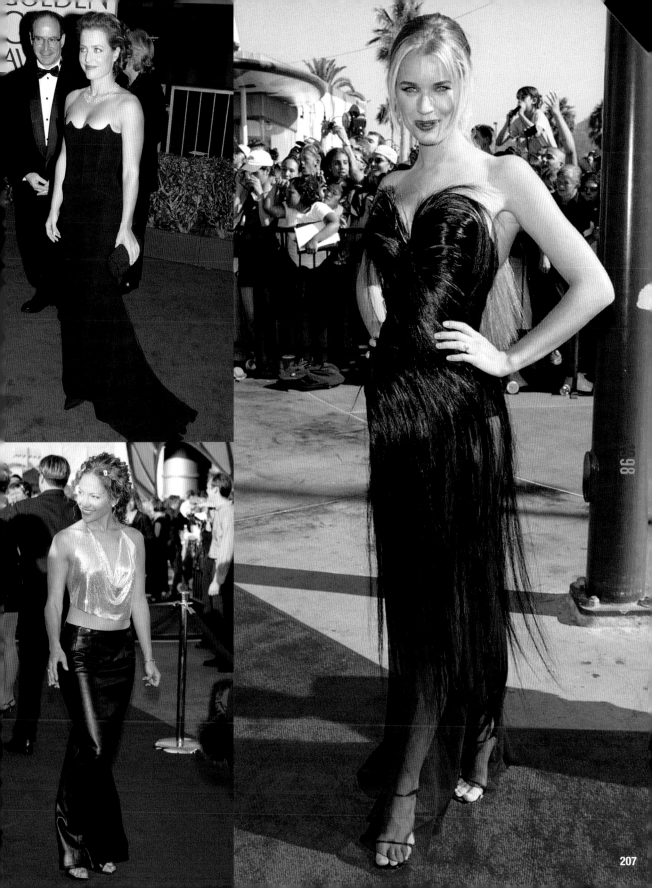

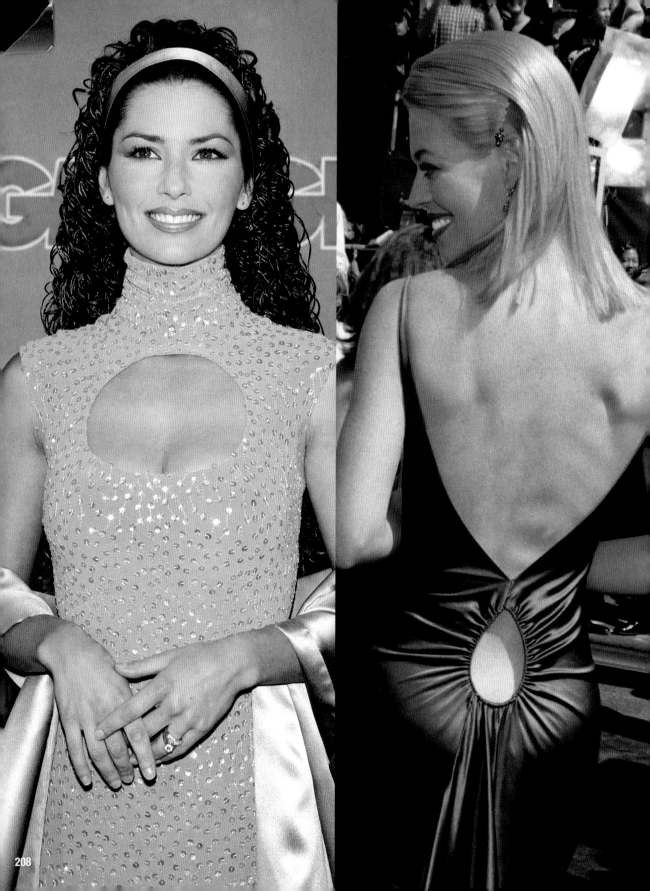

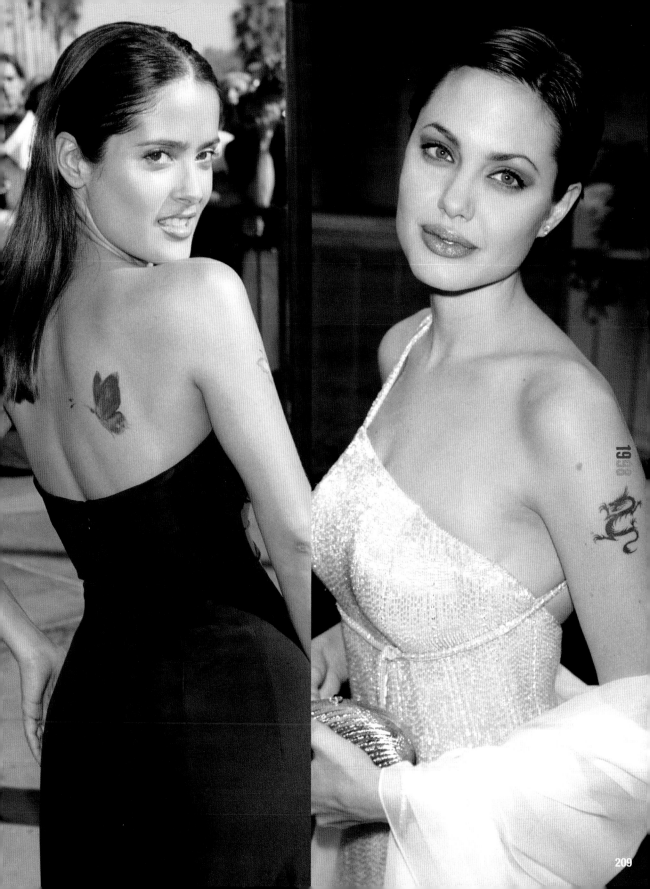

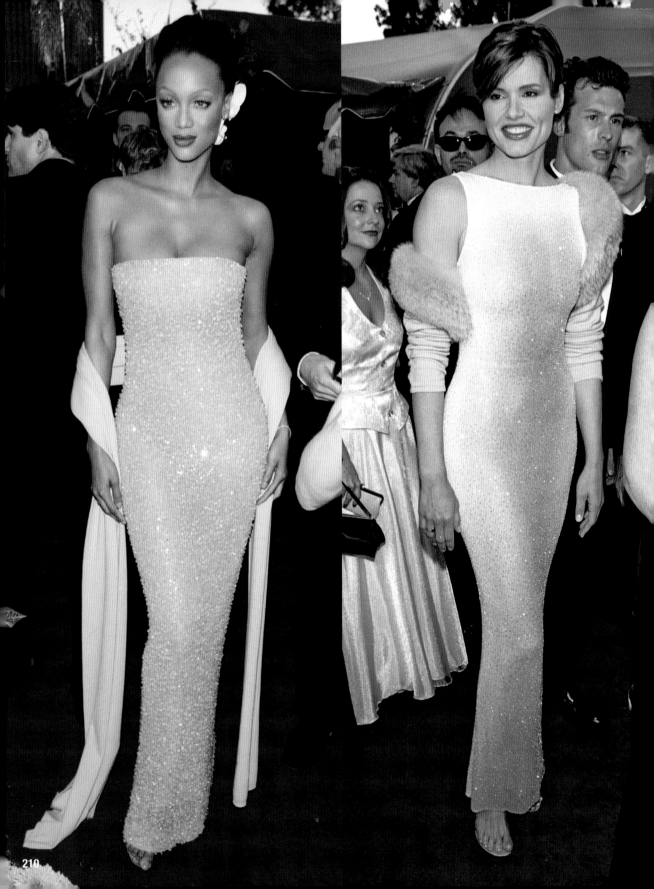

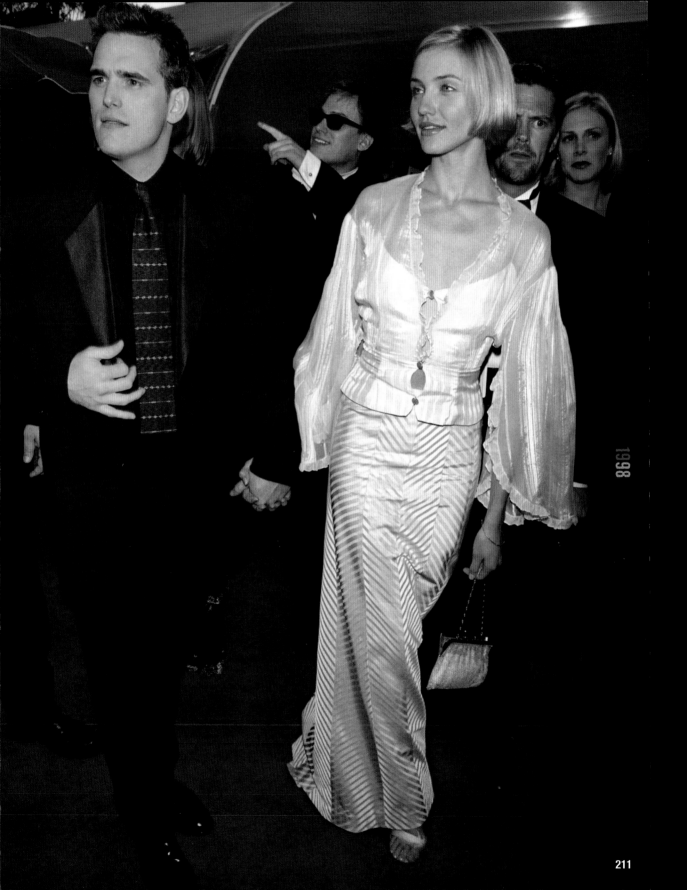

1998

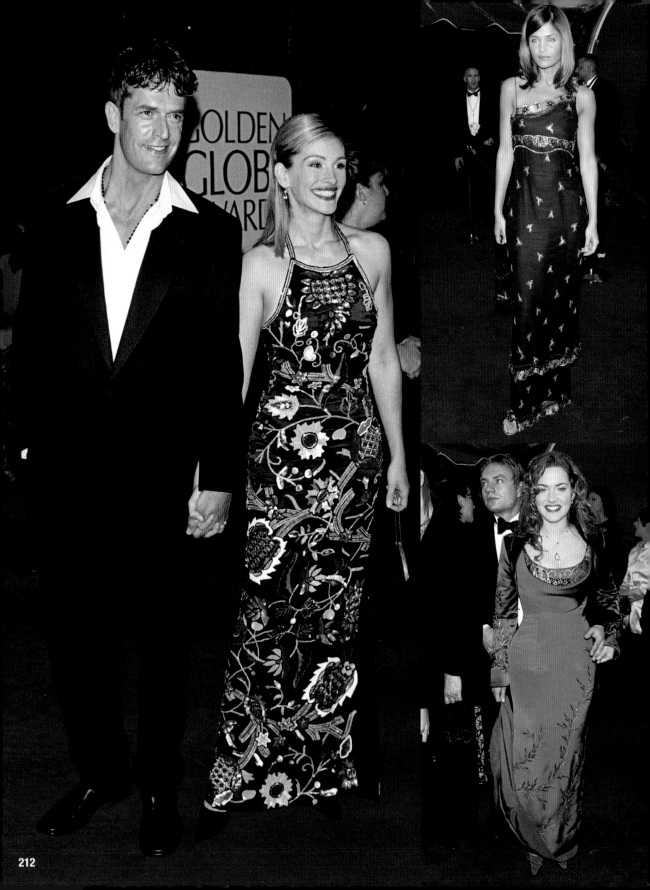

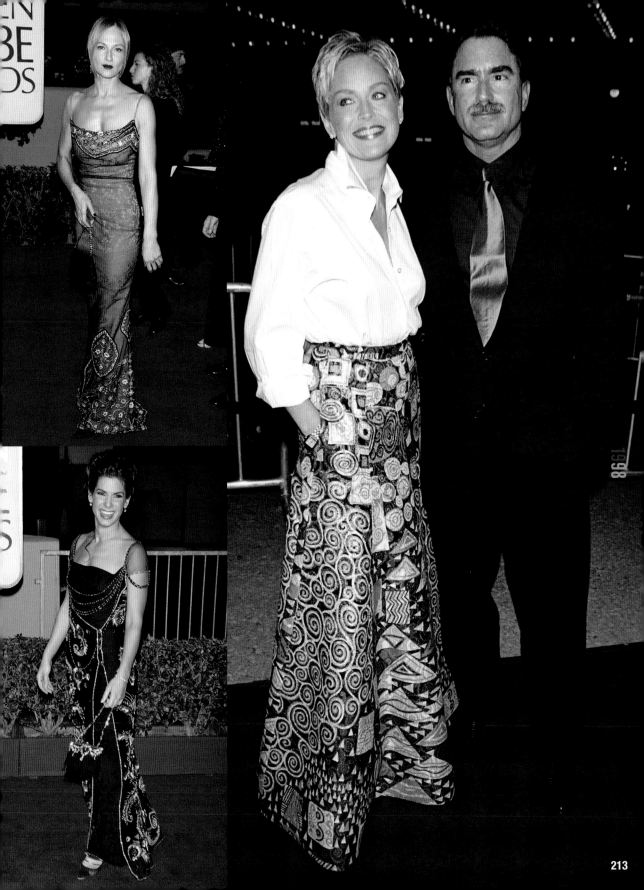

213

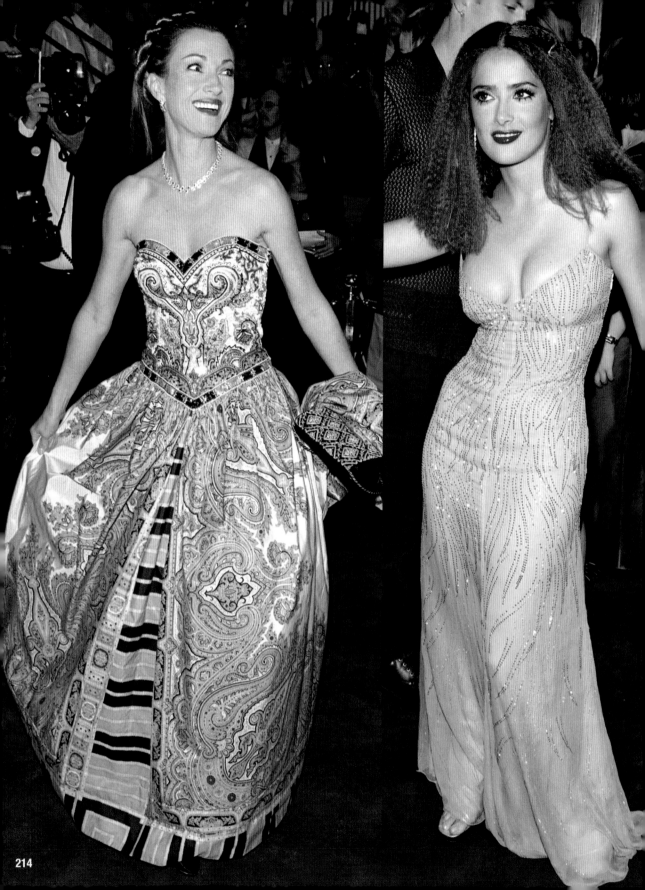

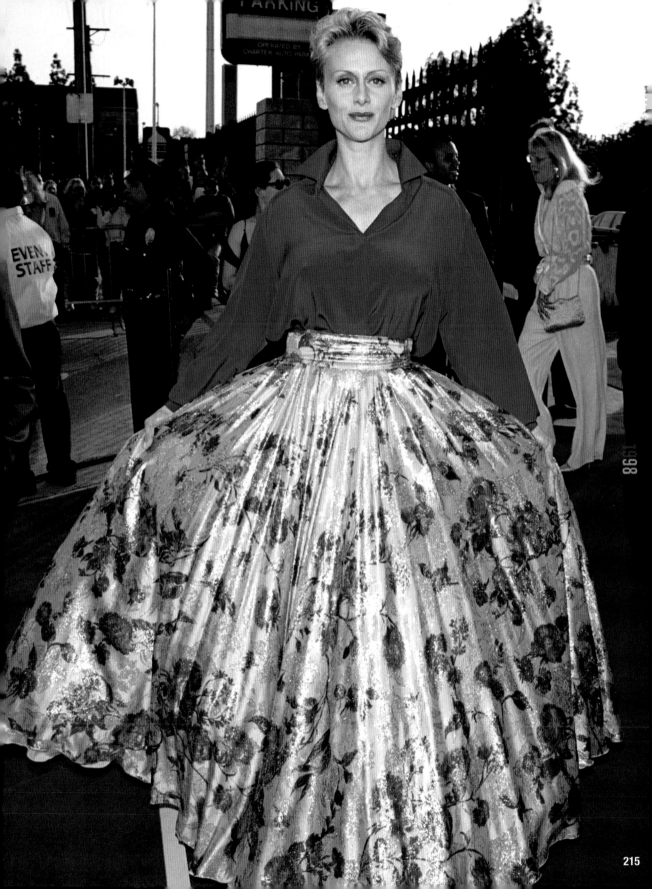

PARKING

OPERATED BY
CHARTER AUTO PARK

EVENT
STAFF

1998

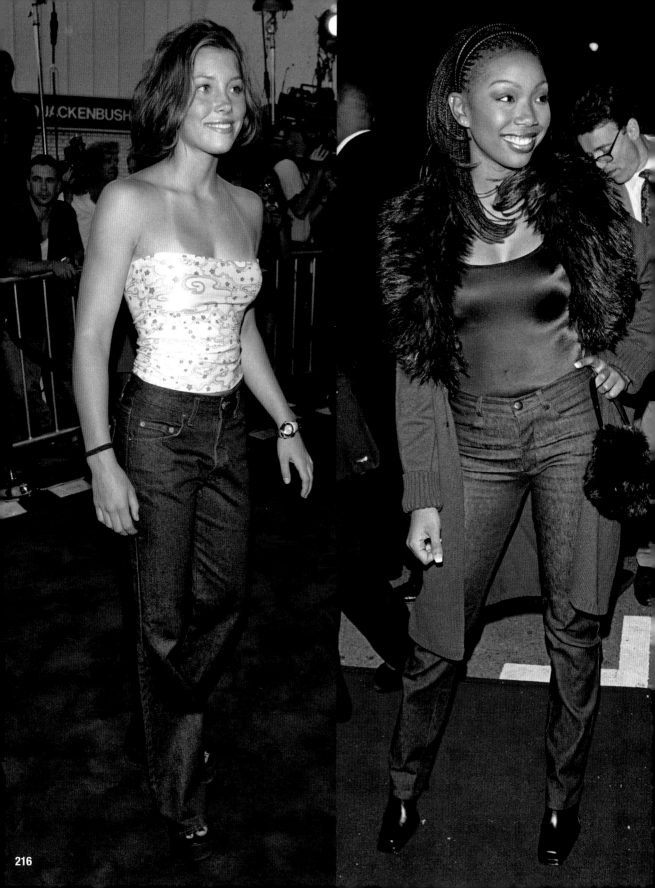

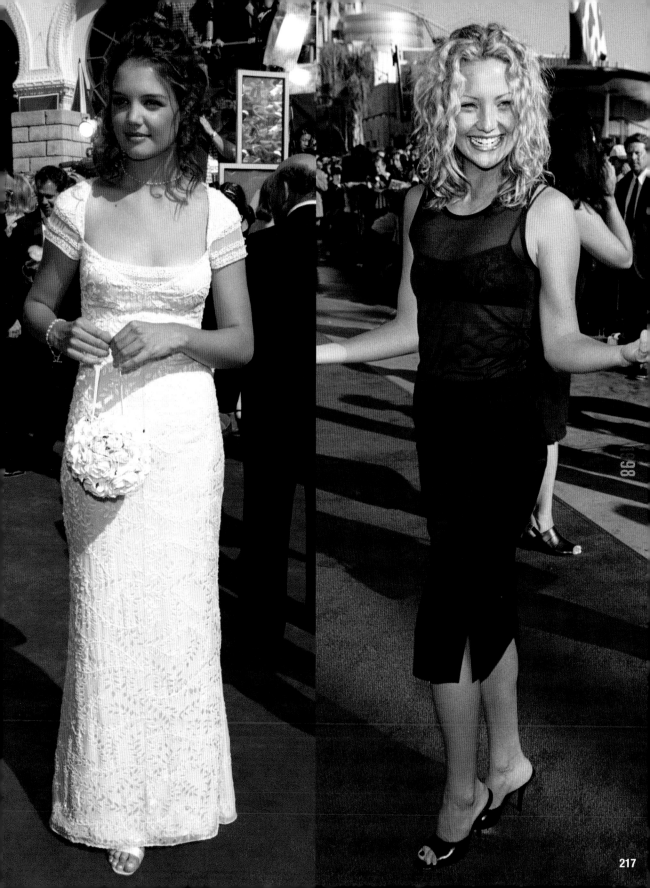

217

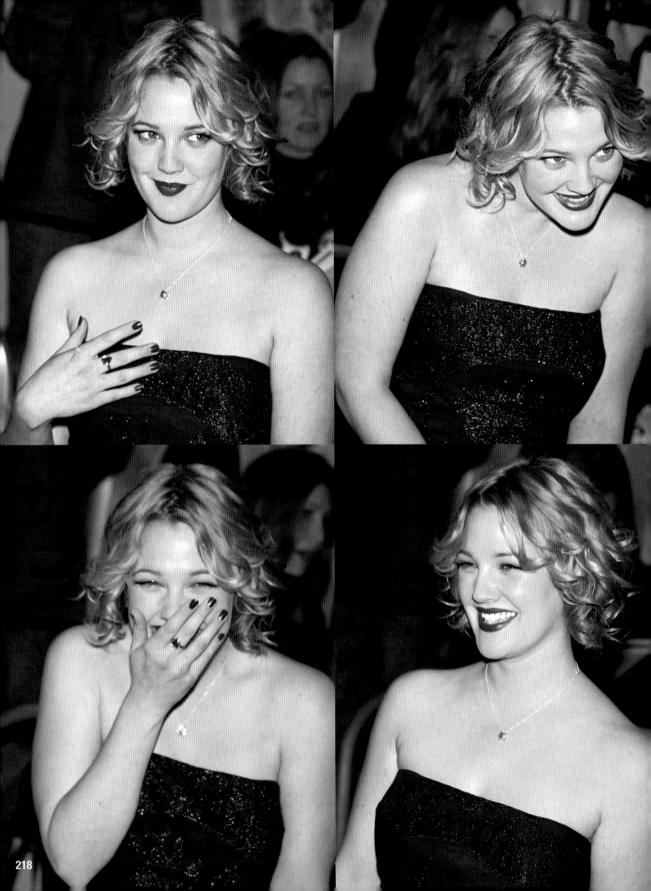

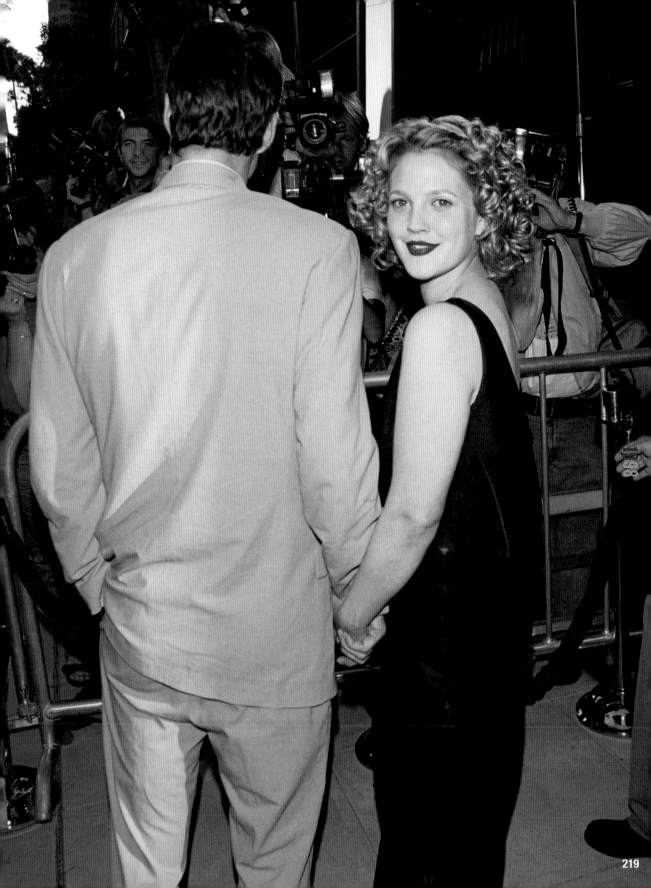

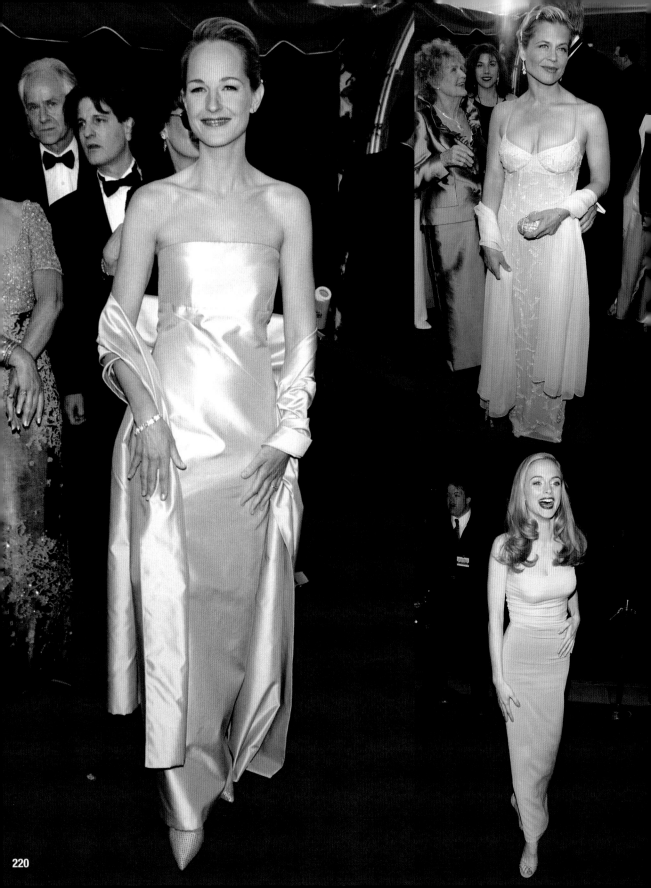

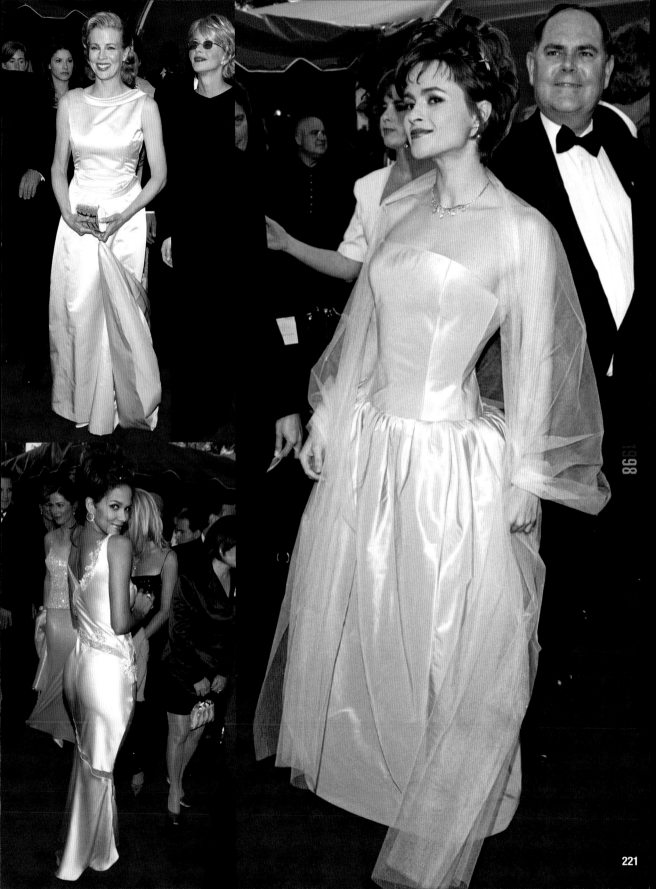

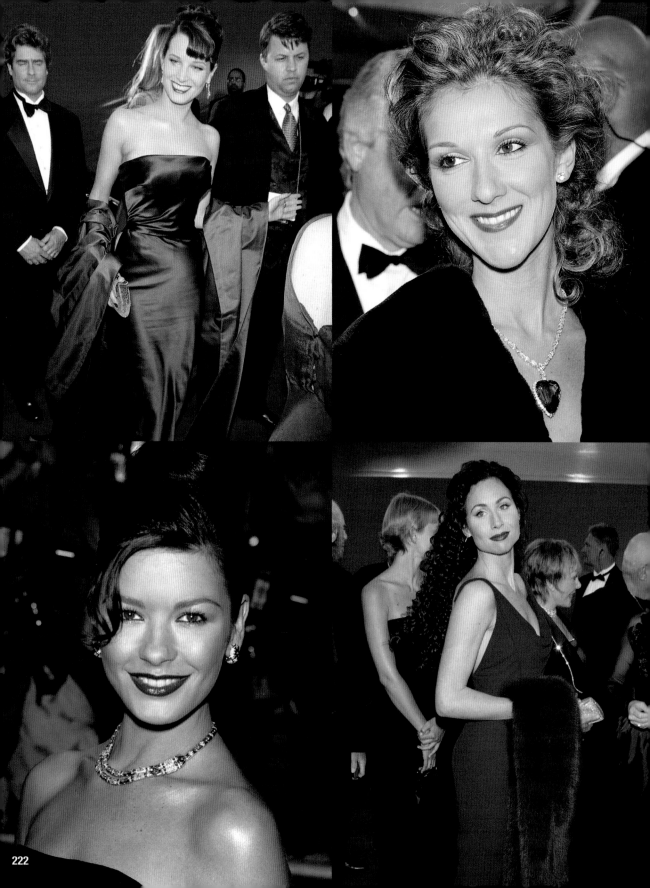

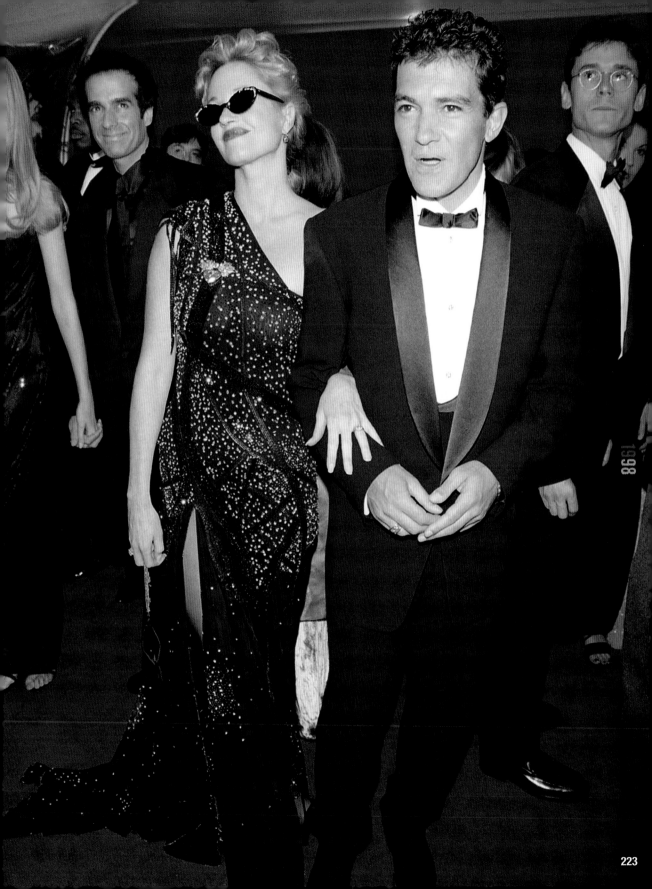

1998

223

1987 1988 1989
1990 1991 1992
1993 1994 1995
1996 1997 1998
1999 2000 2001
2002 2003 2004
2005 2006 2007

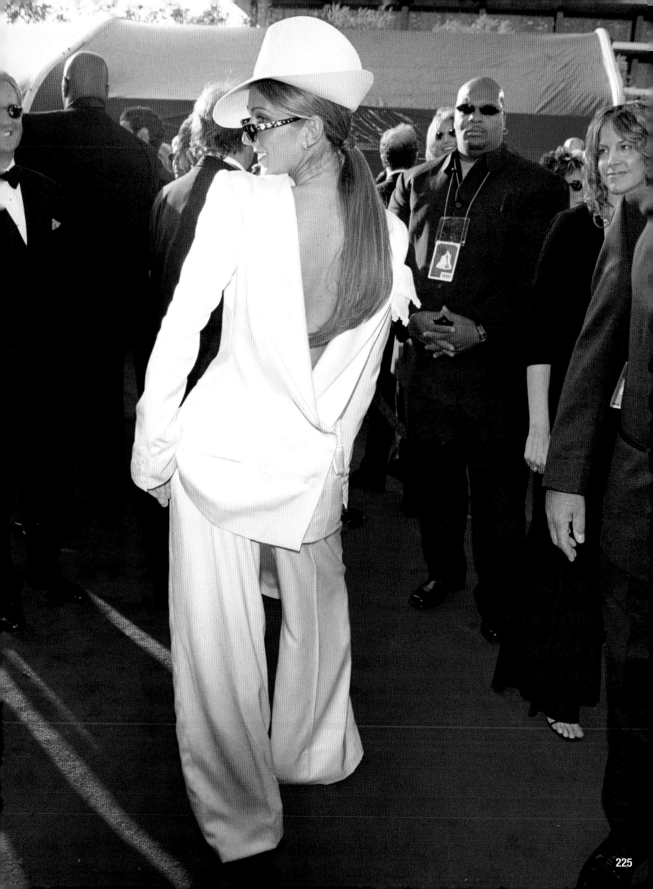

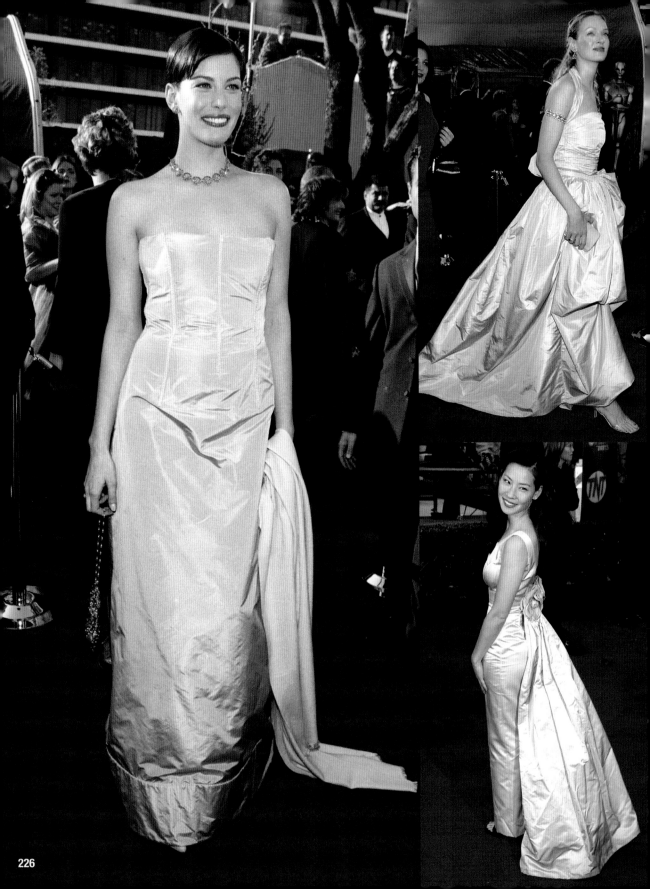

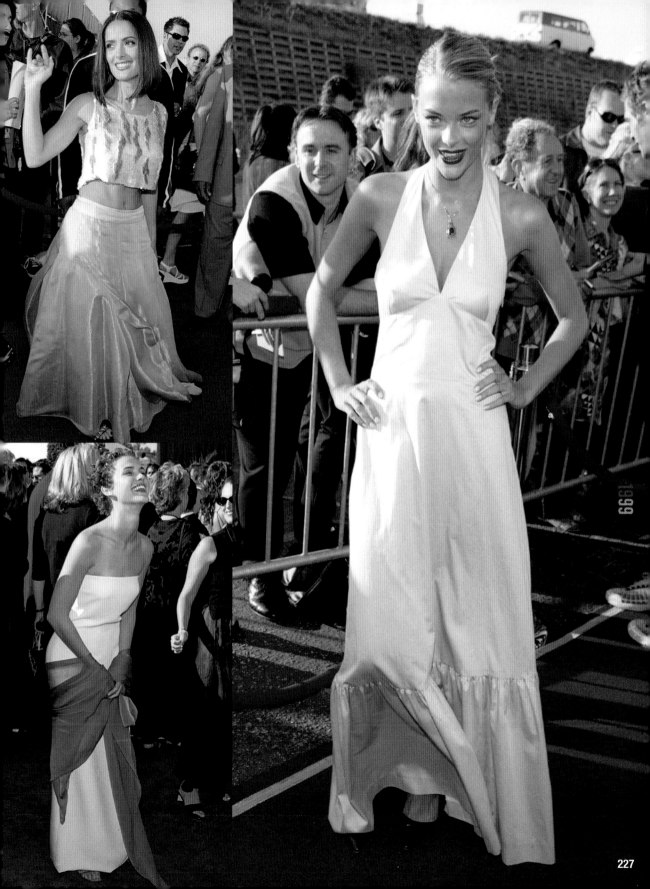

1999

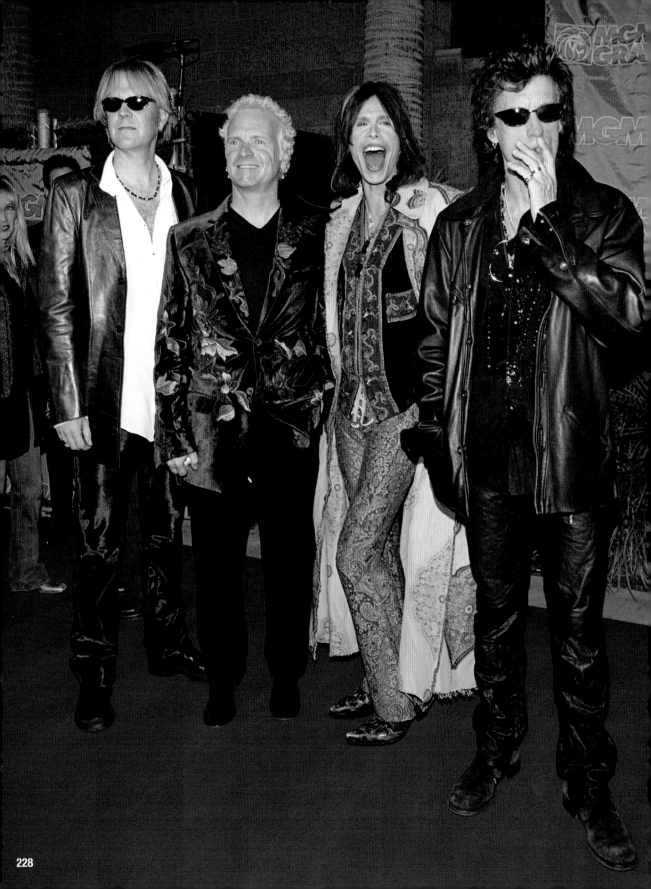

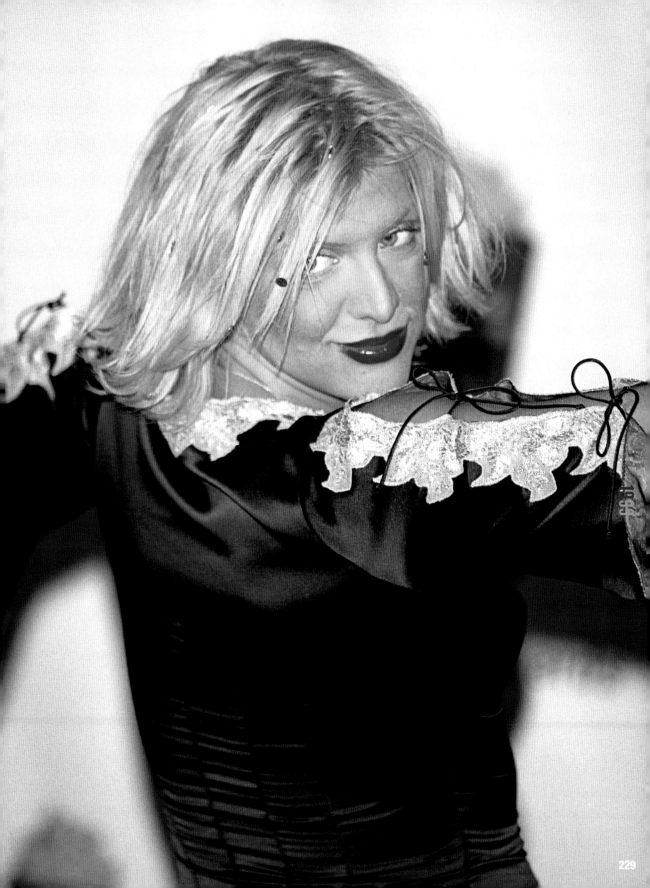

229

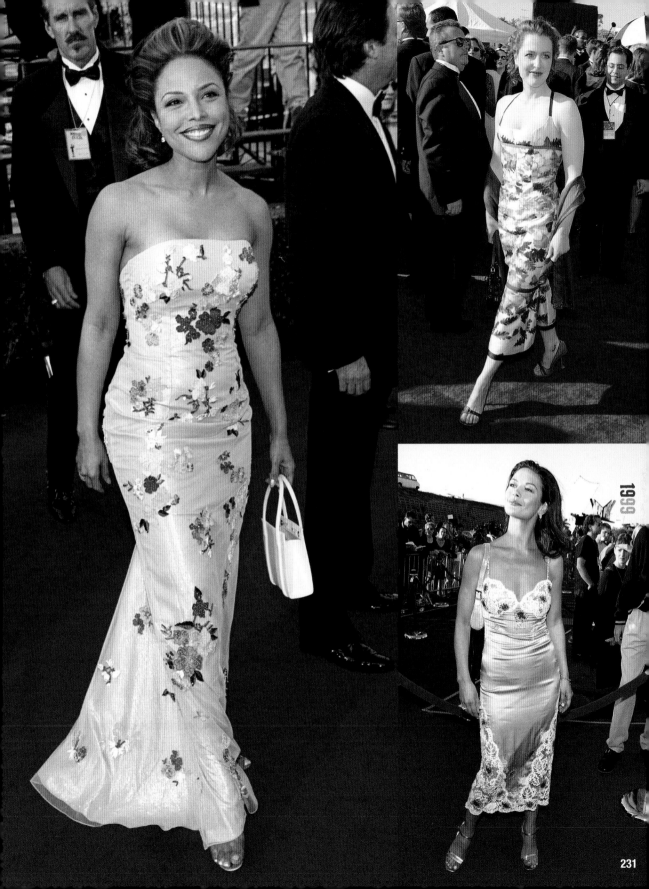

1999

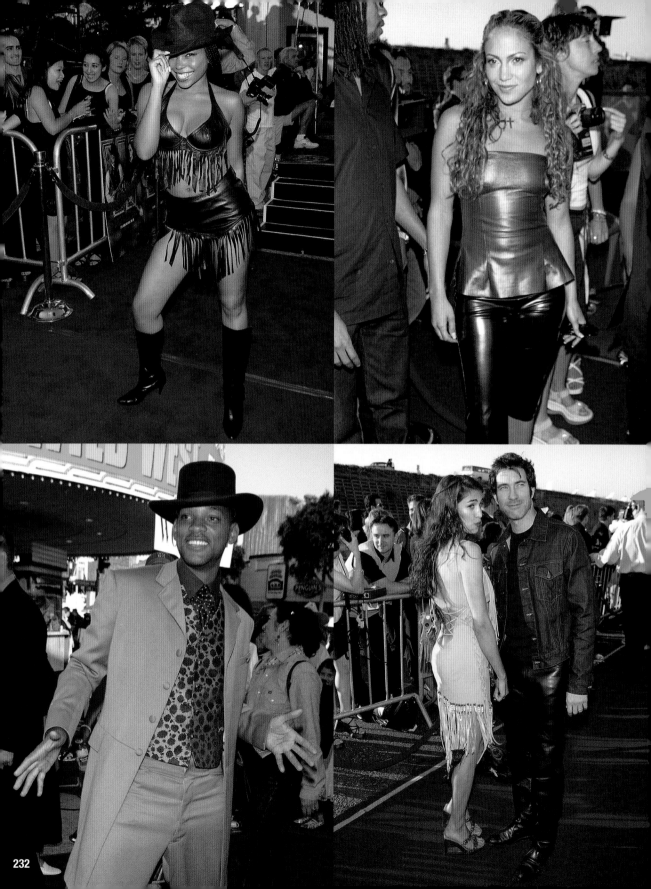

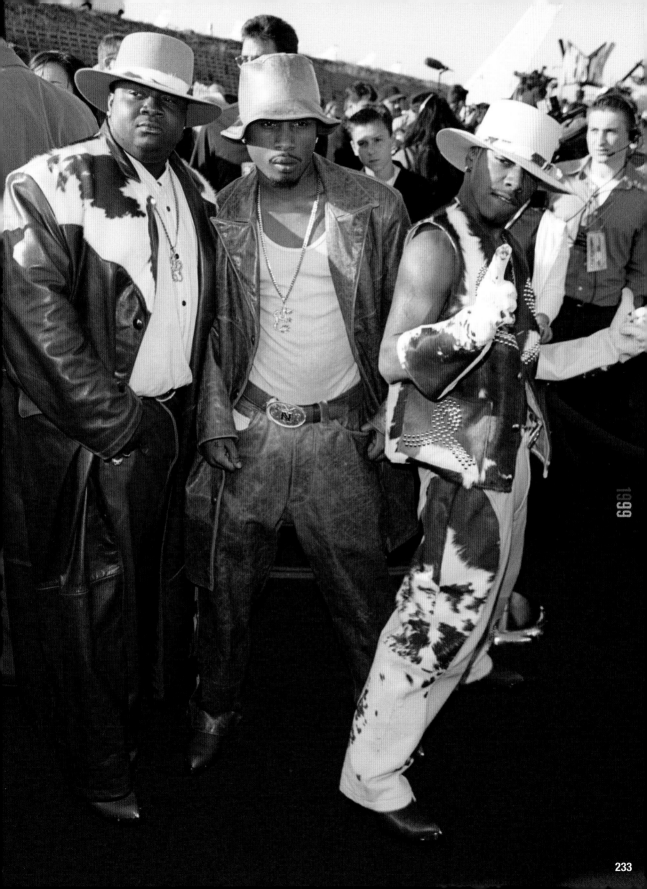

1999

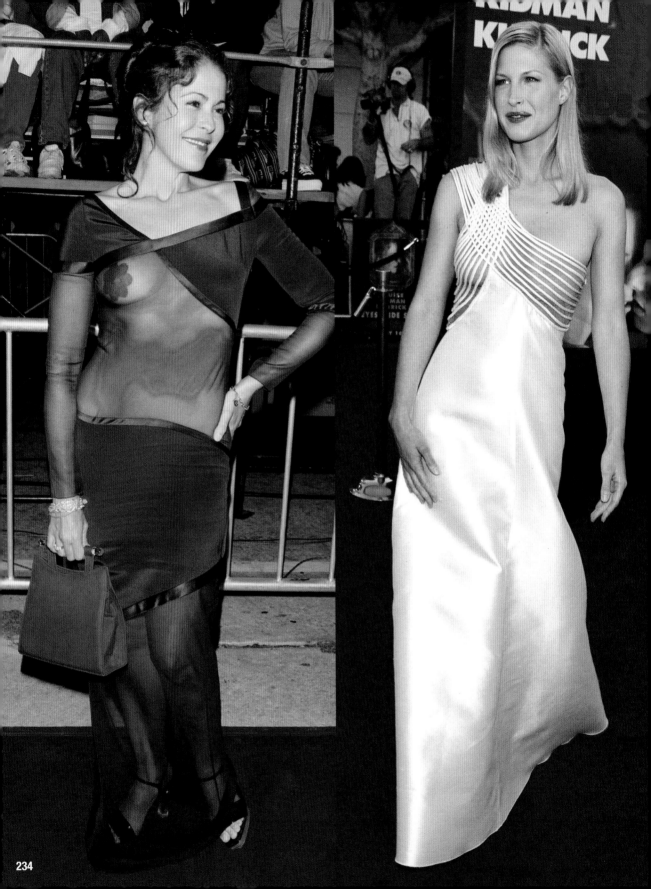

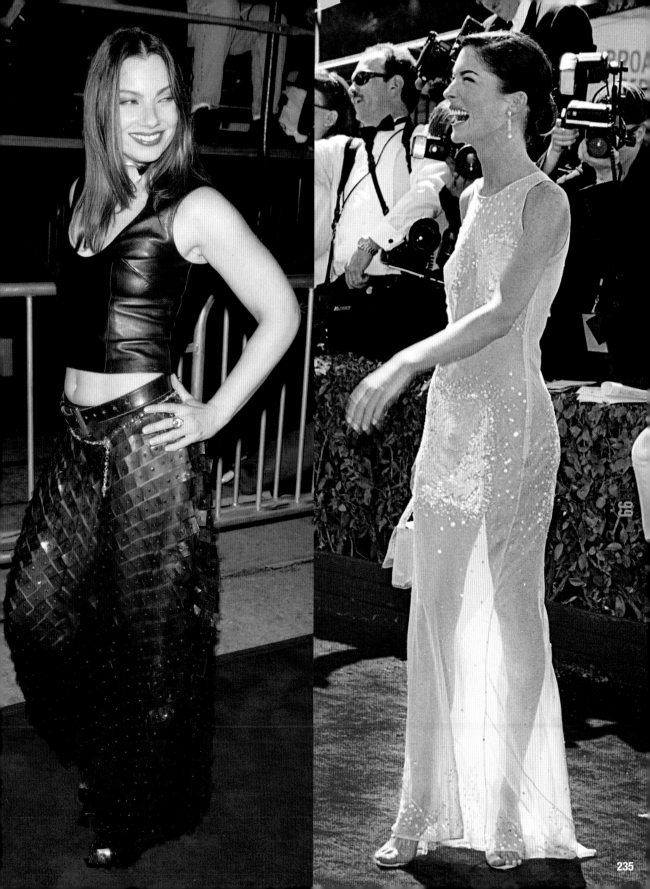

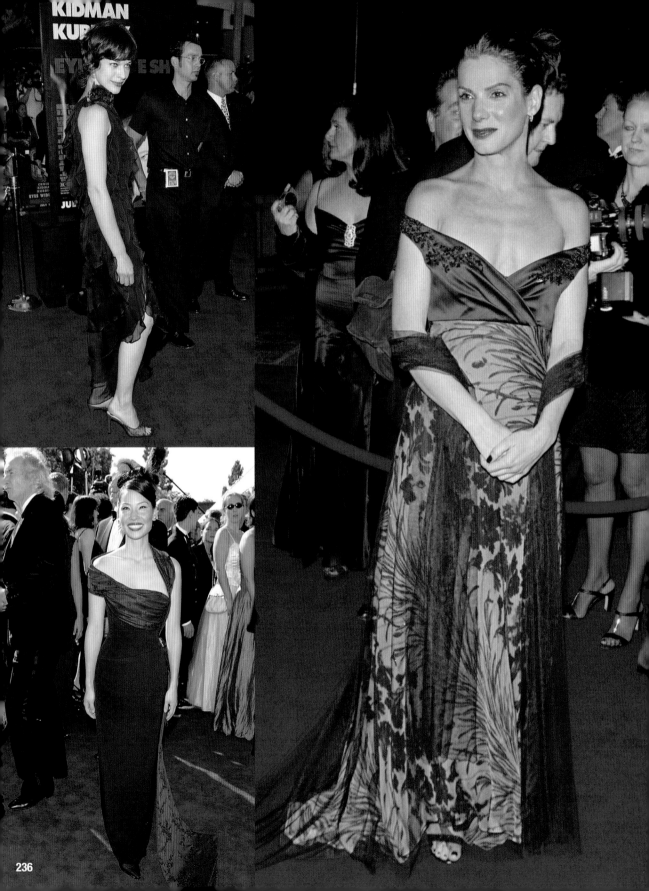

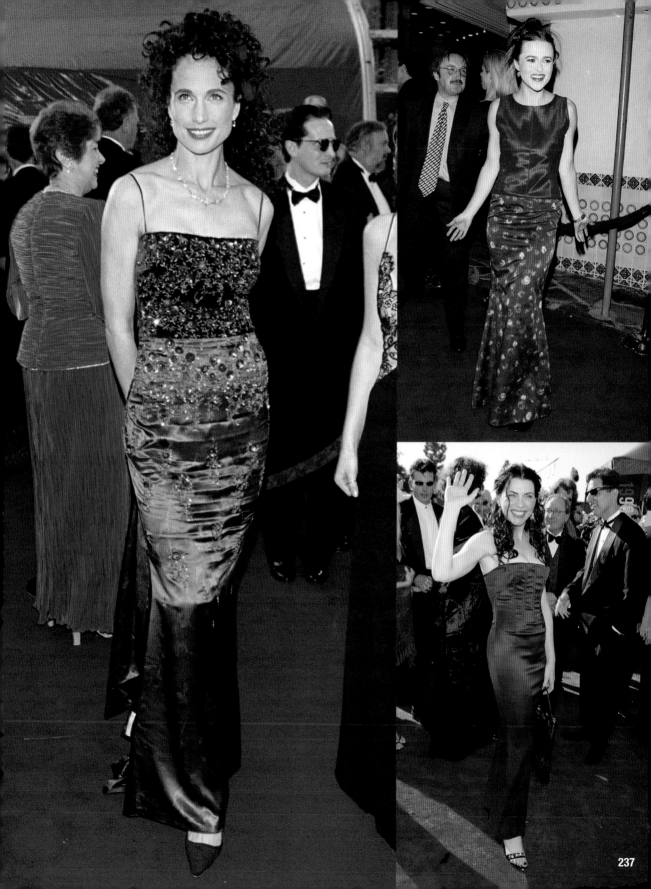

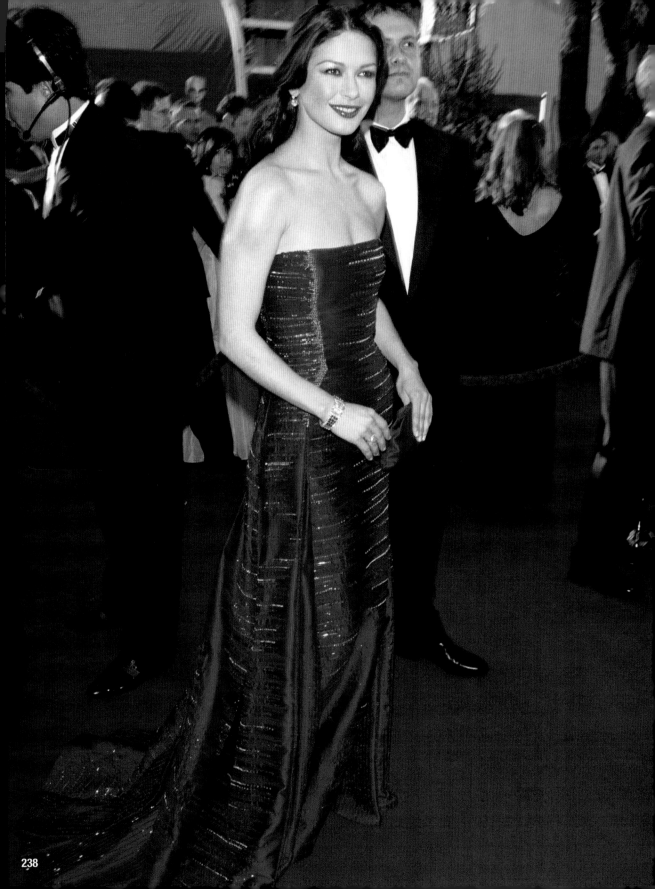

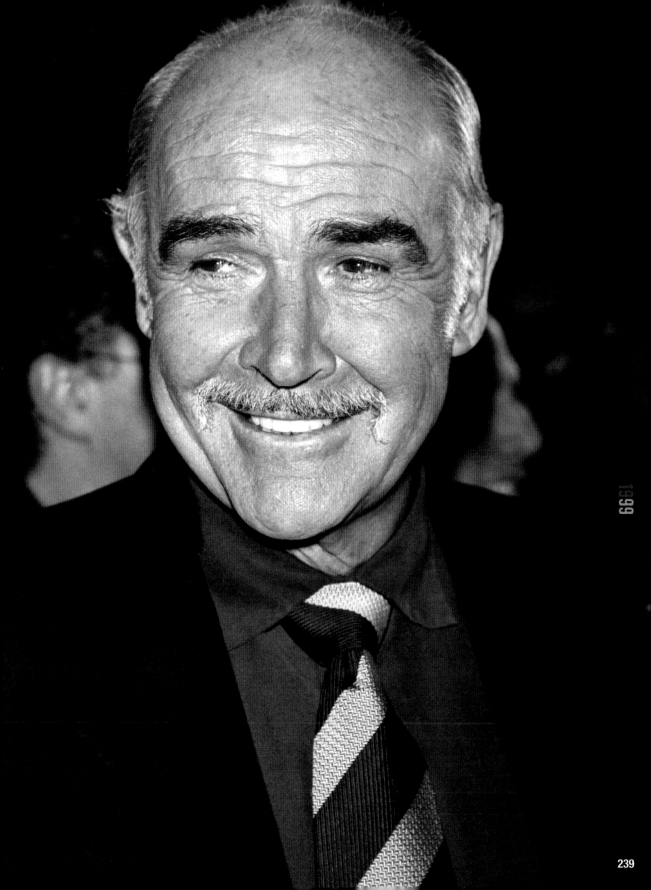

1999

239

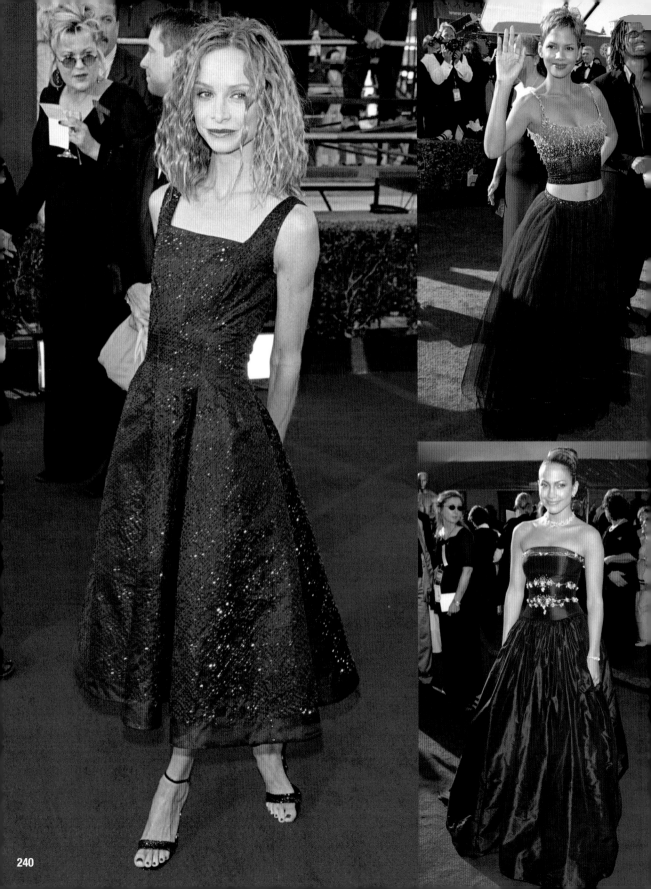

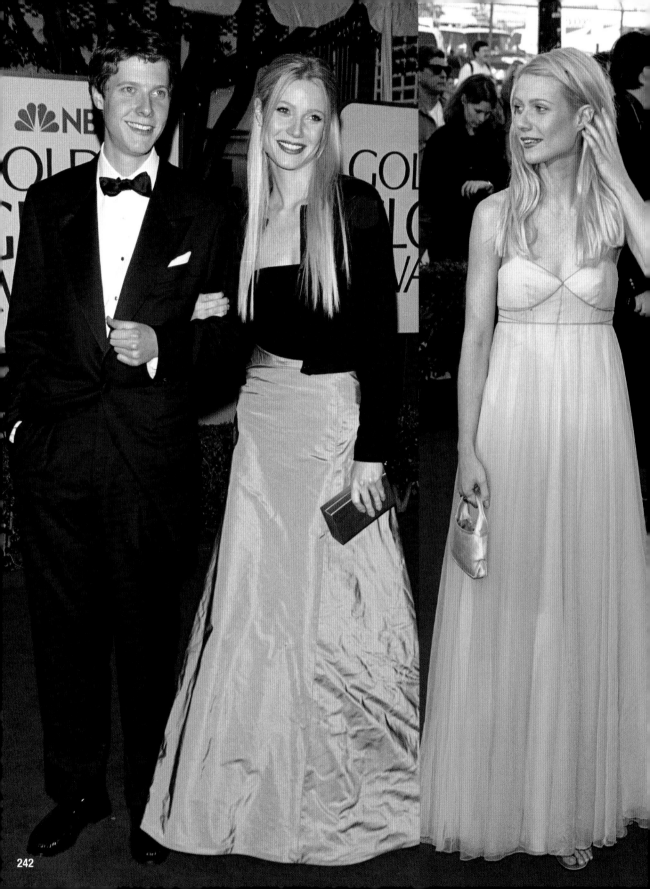

1999

243

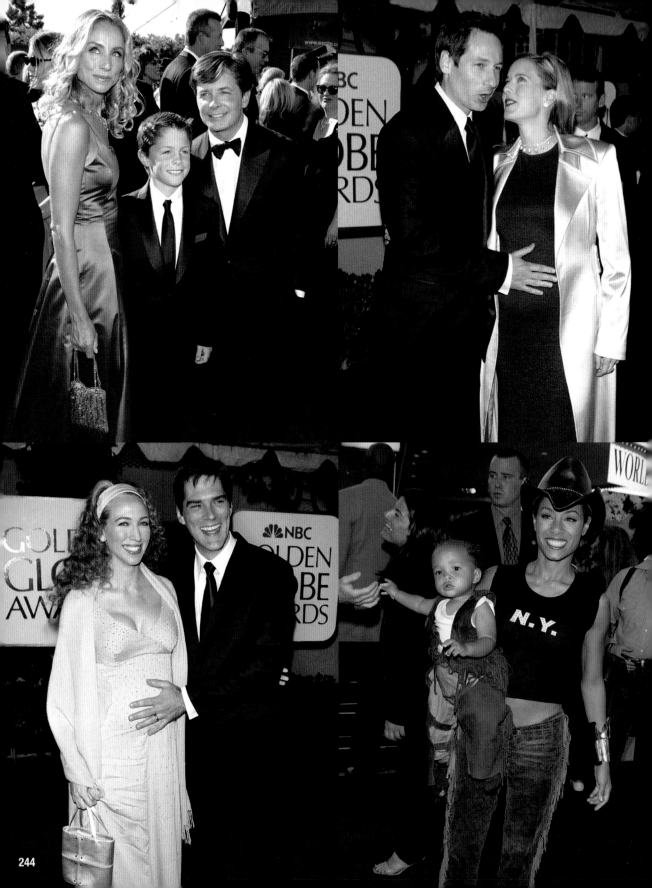

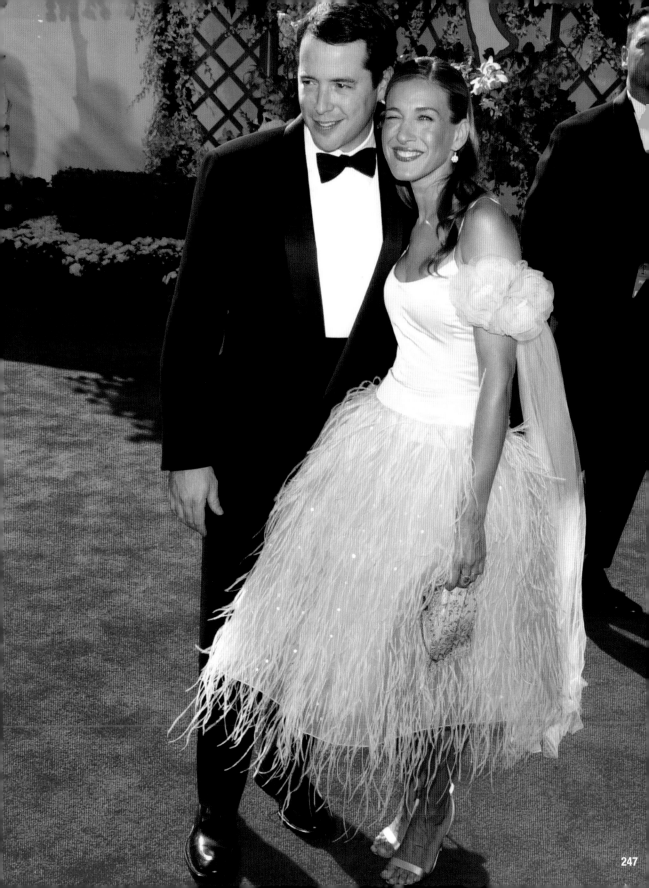

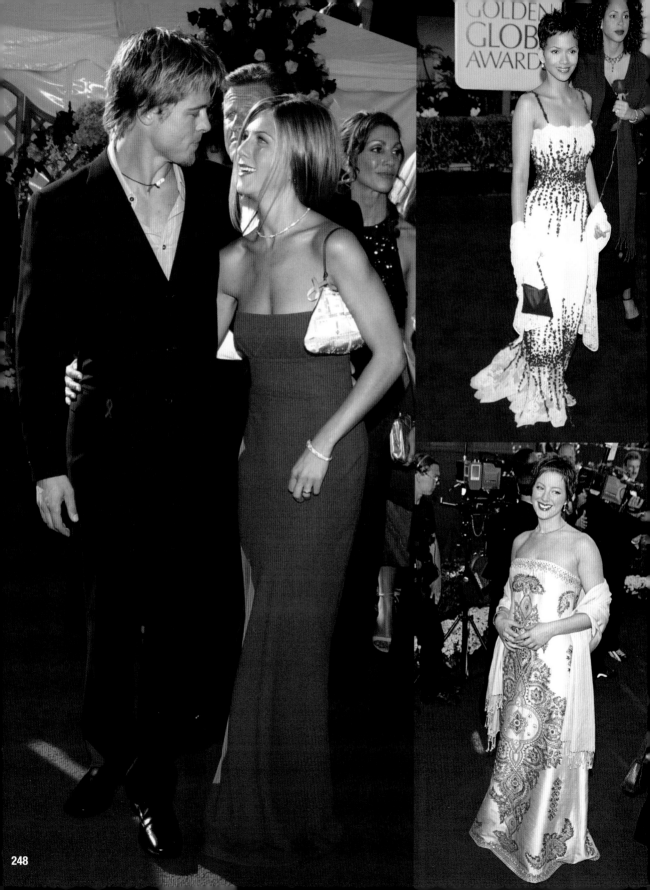

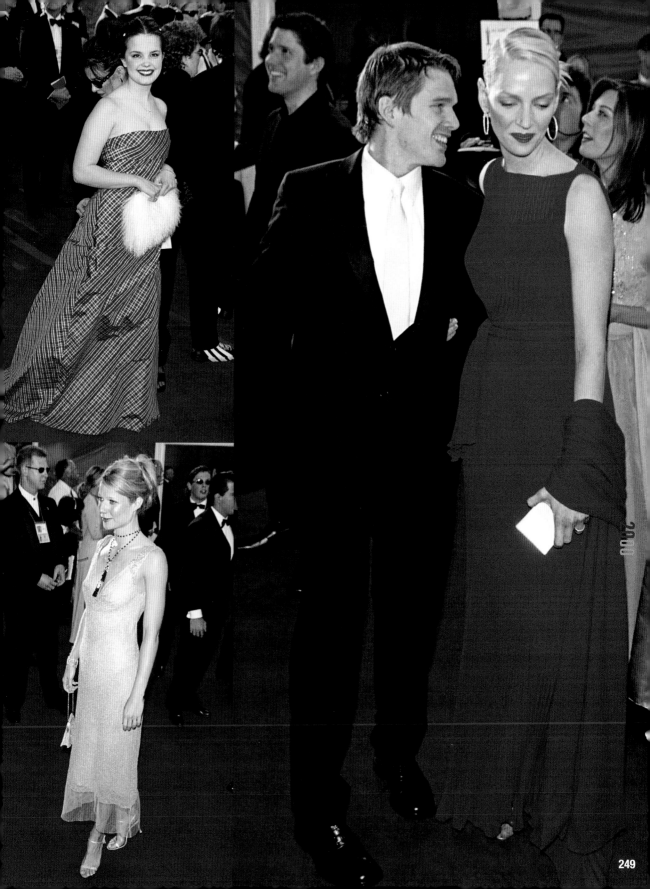

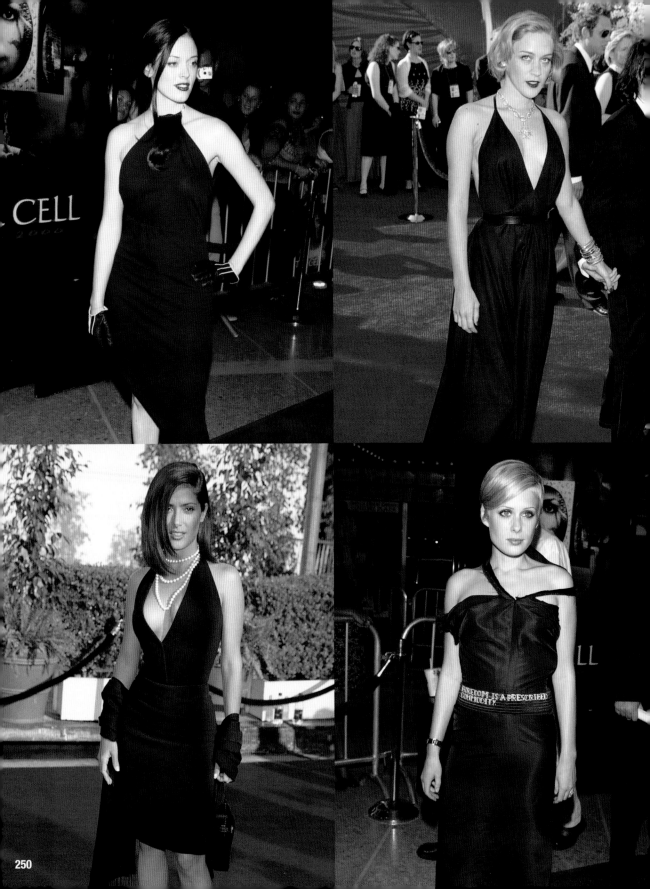

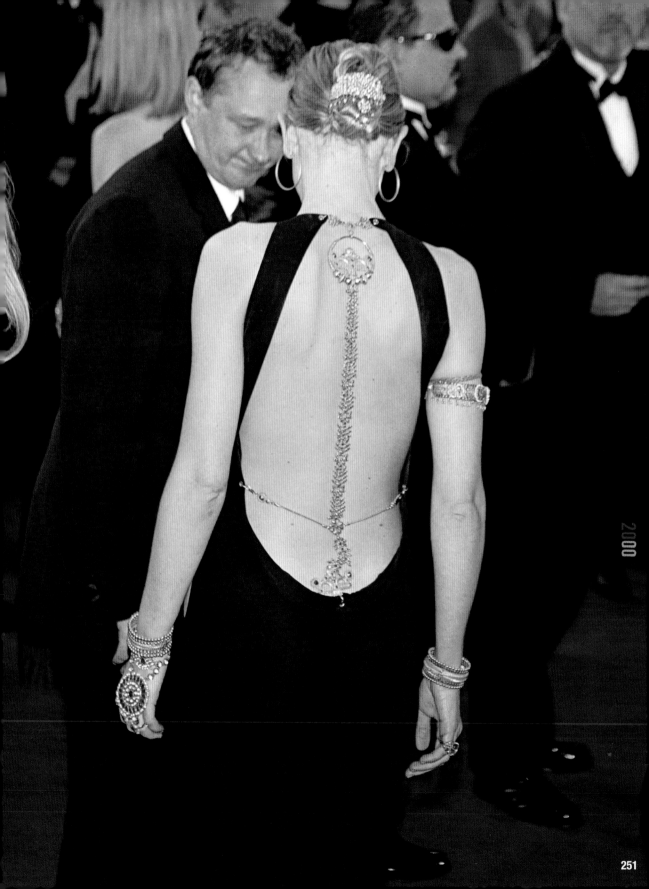

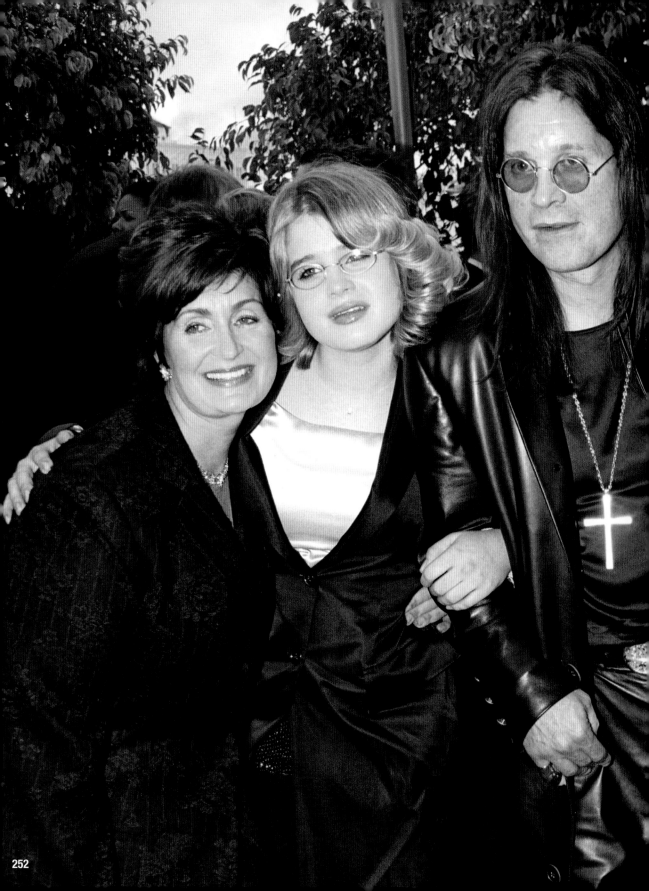

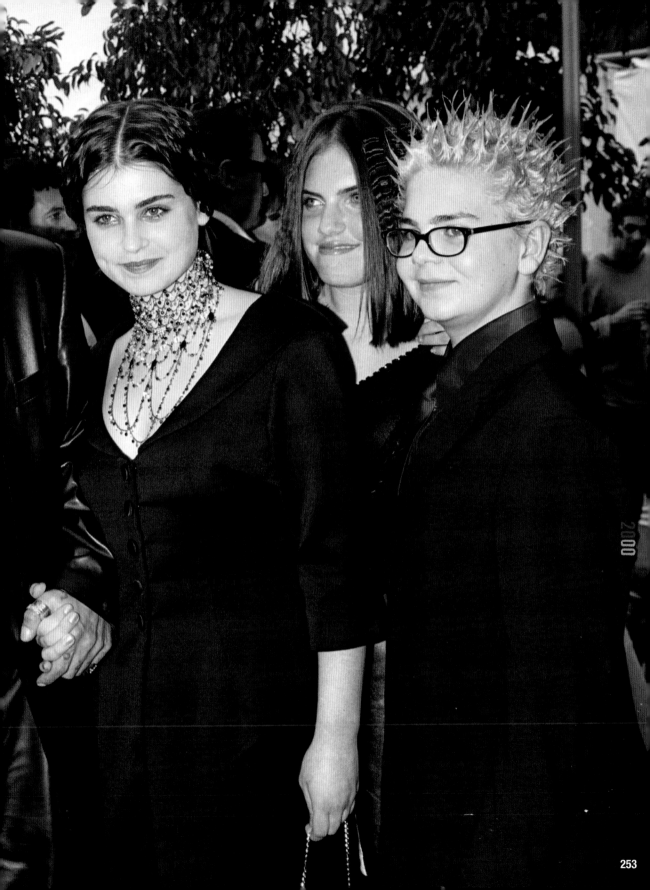

2000

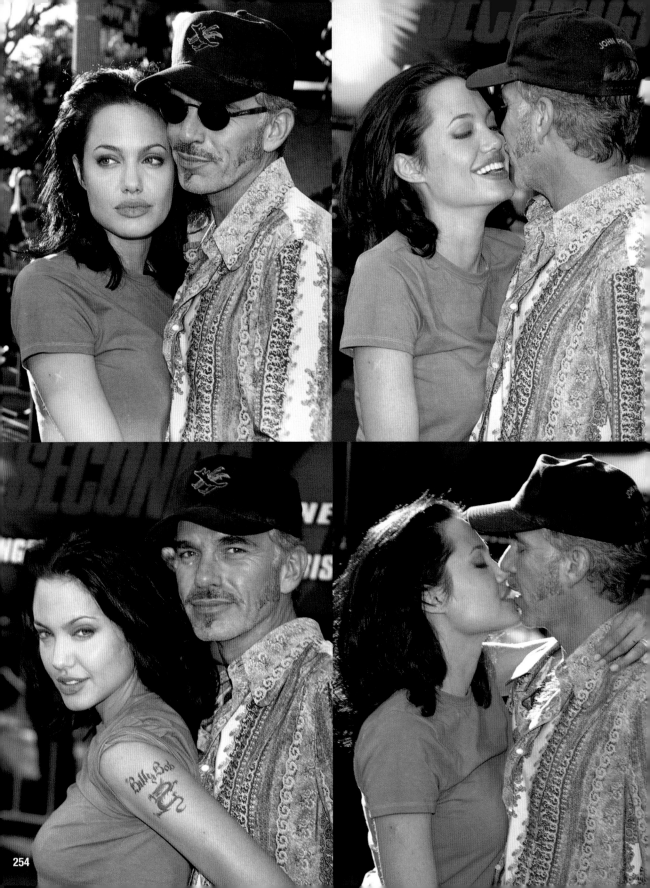

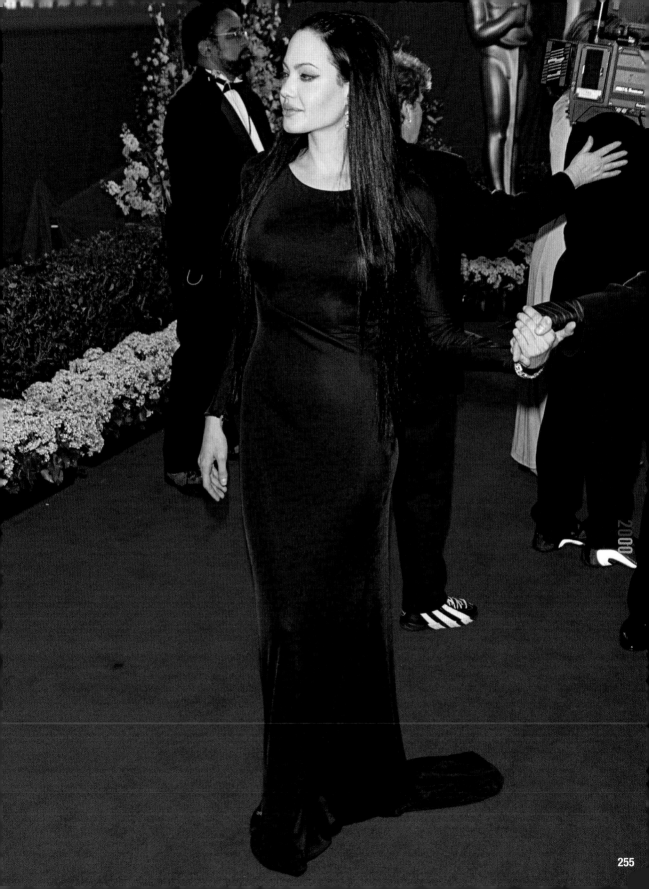

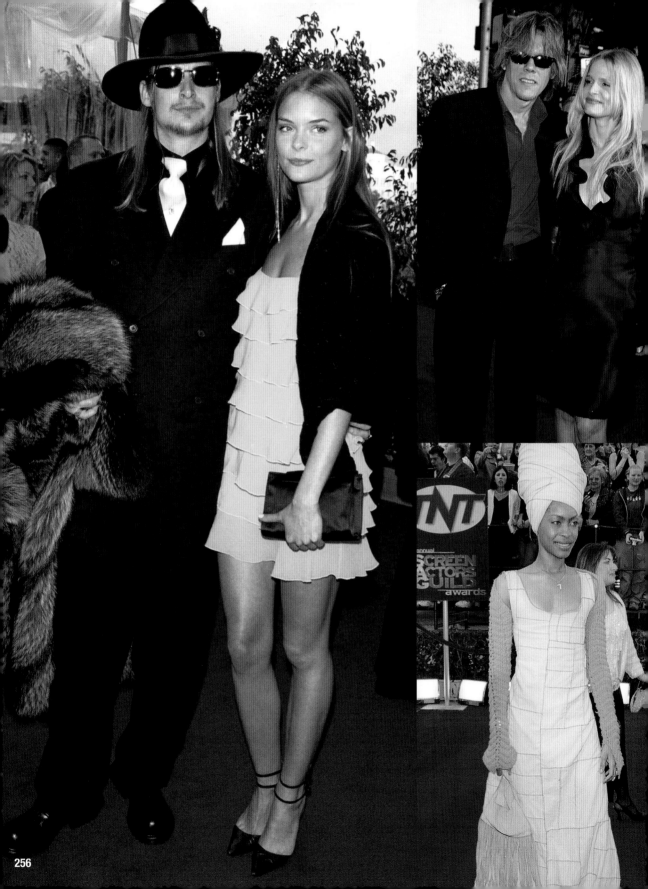

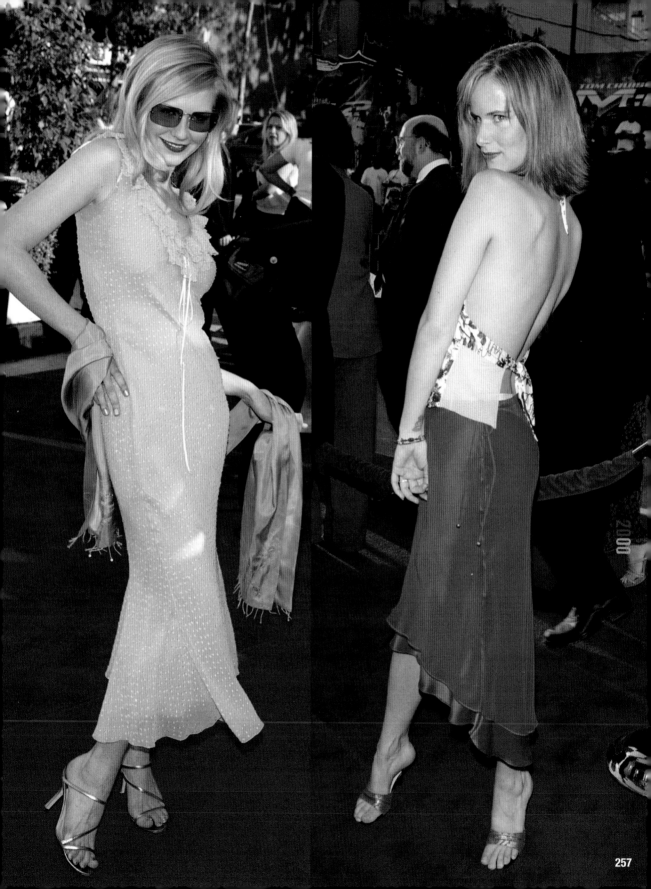

2000

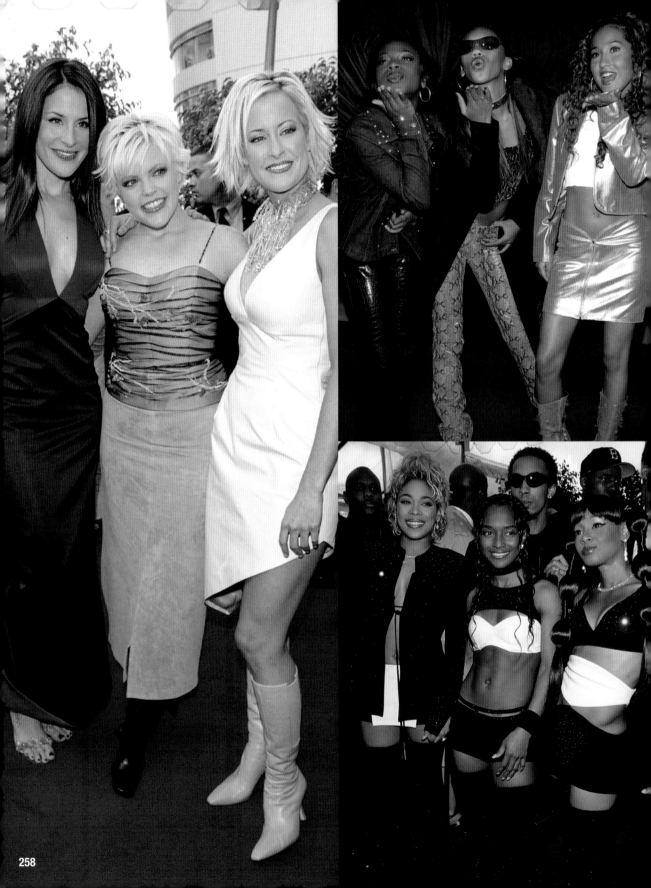

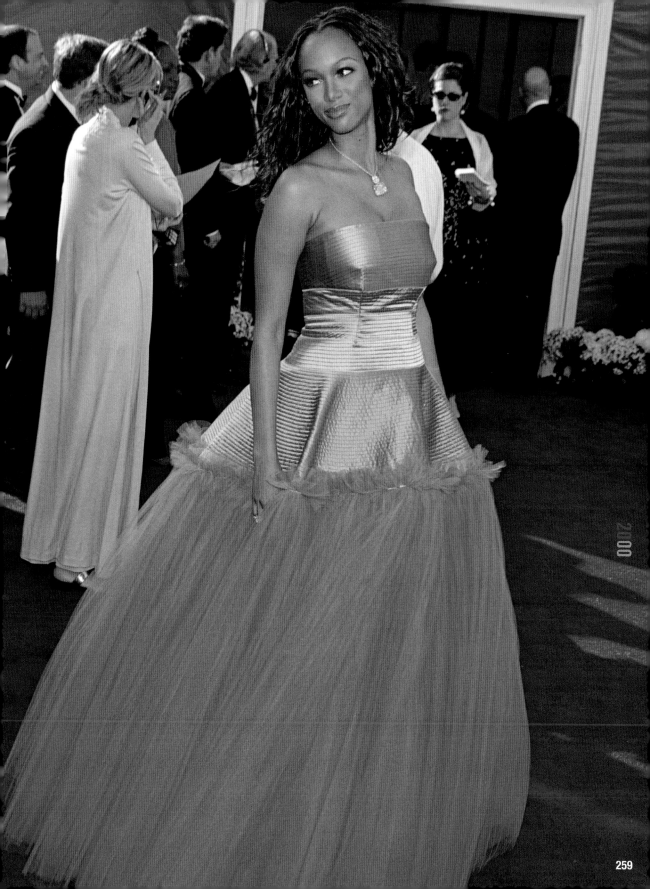

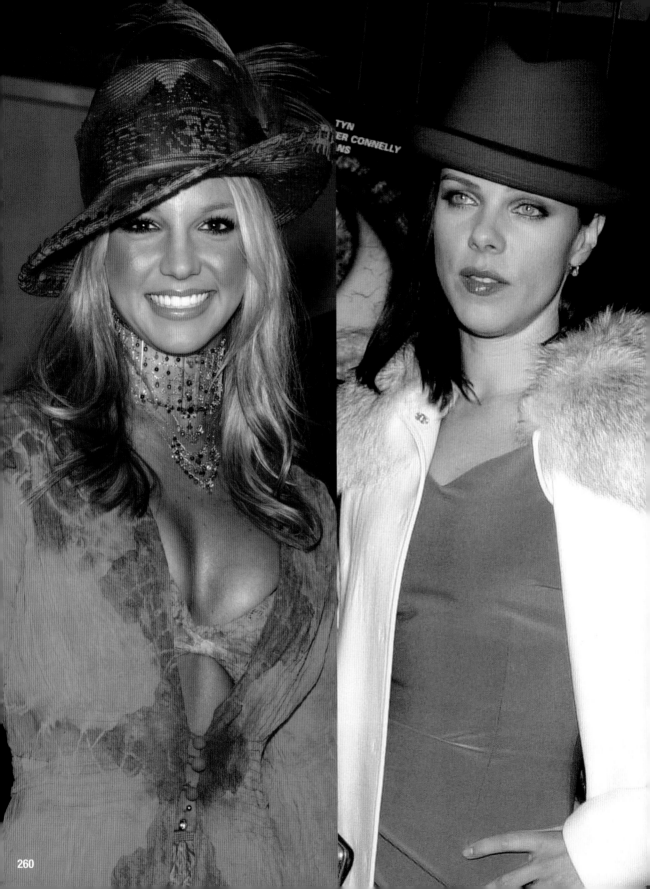

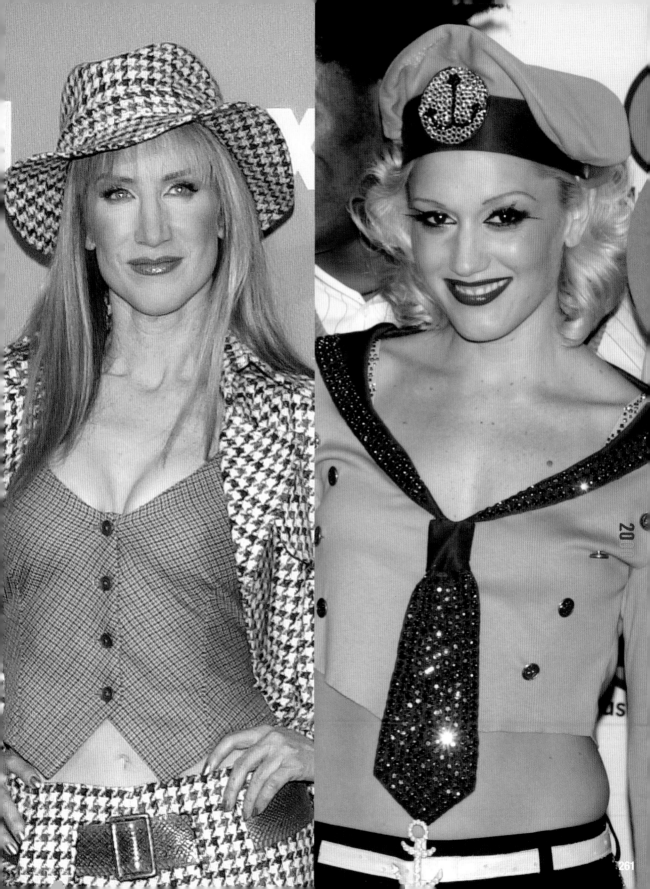

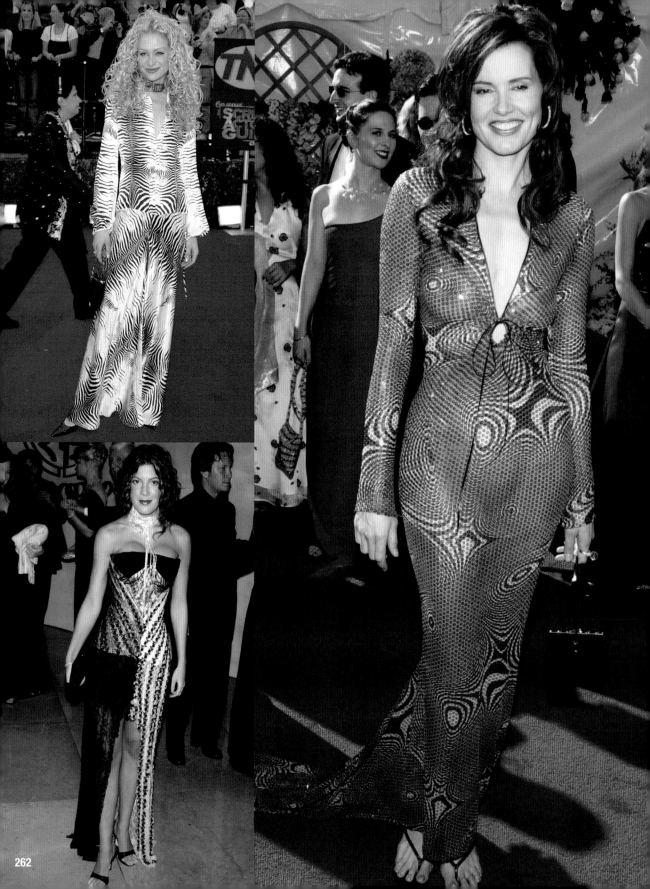

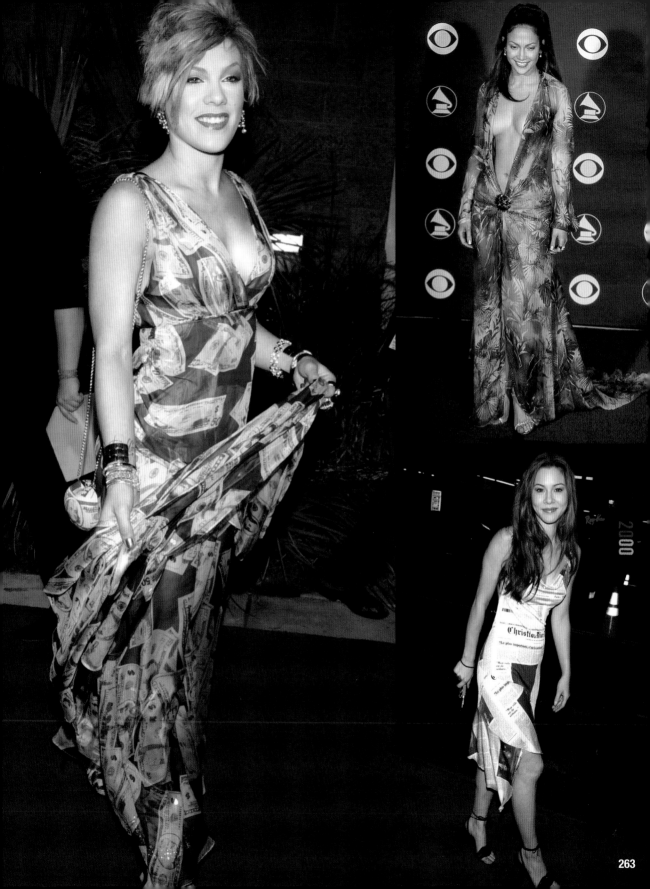

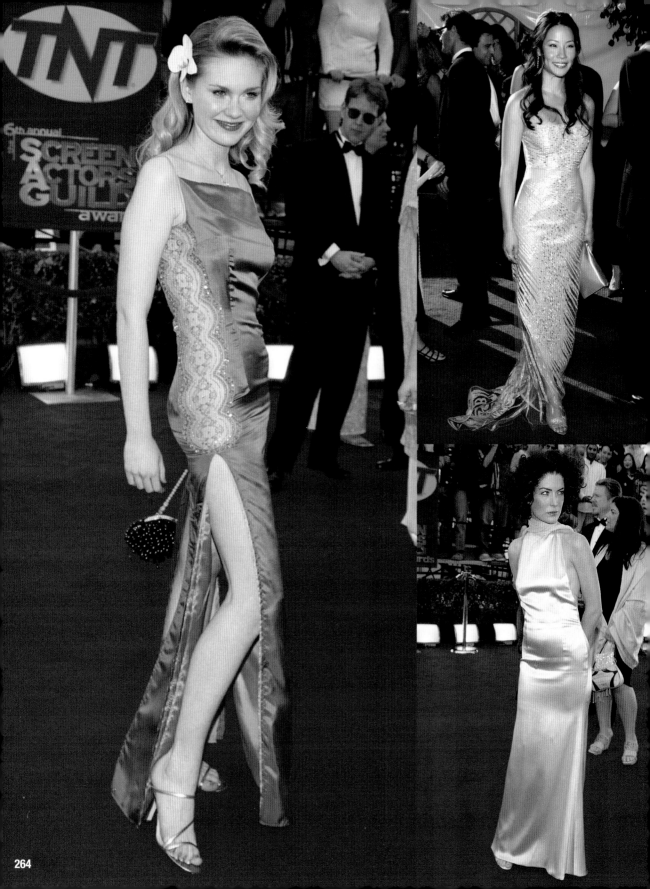

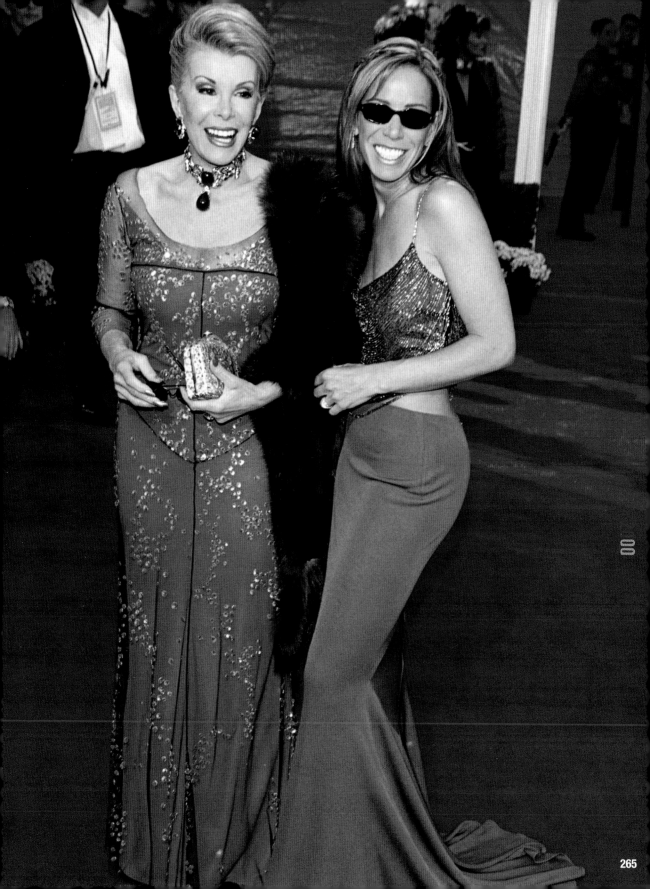

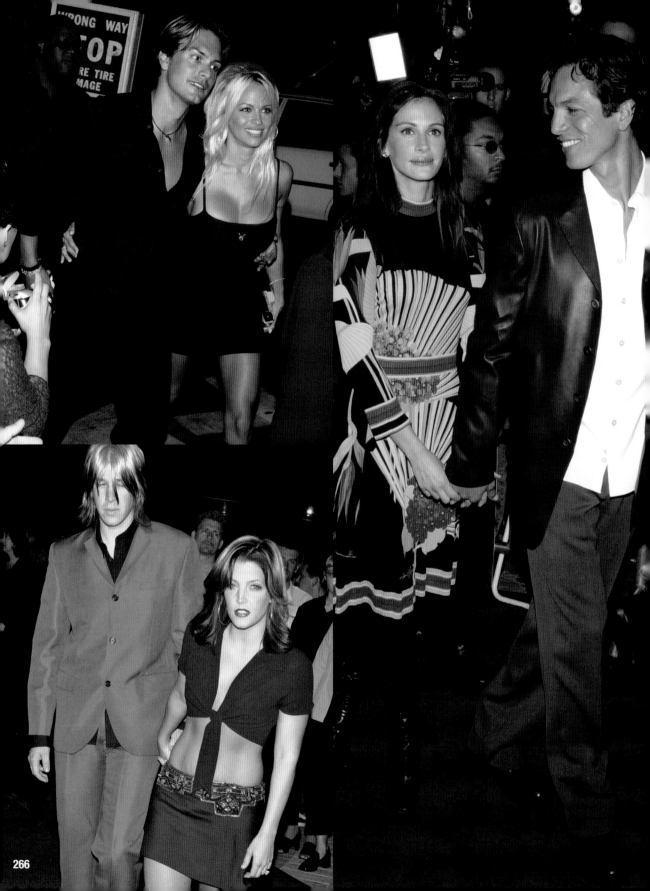

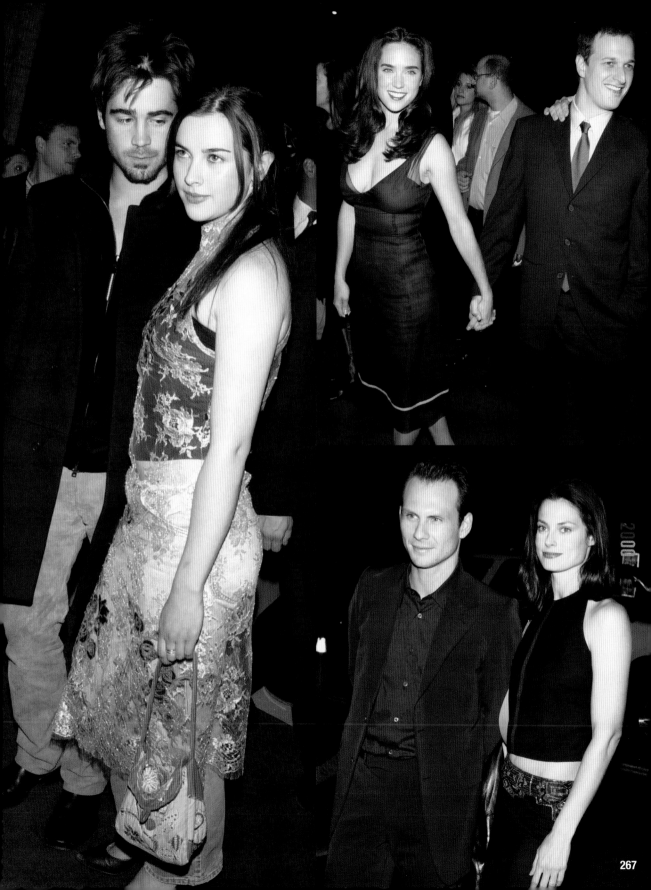

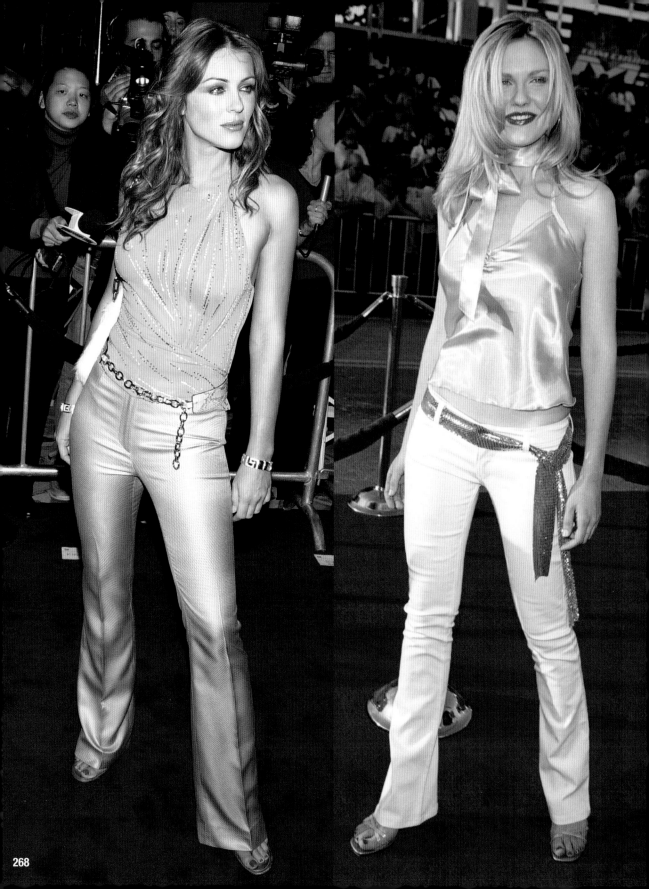

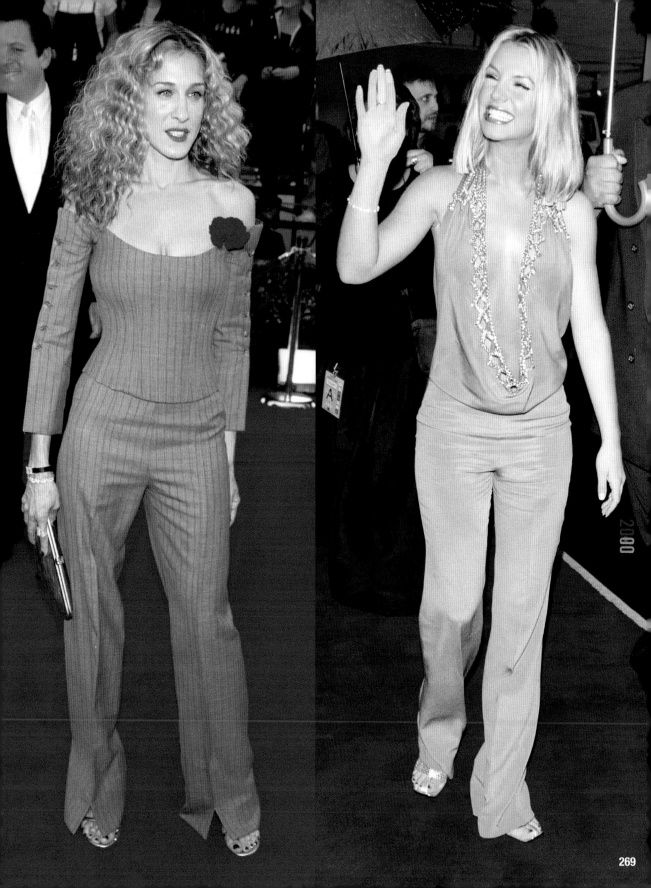

2000

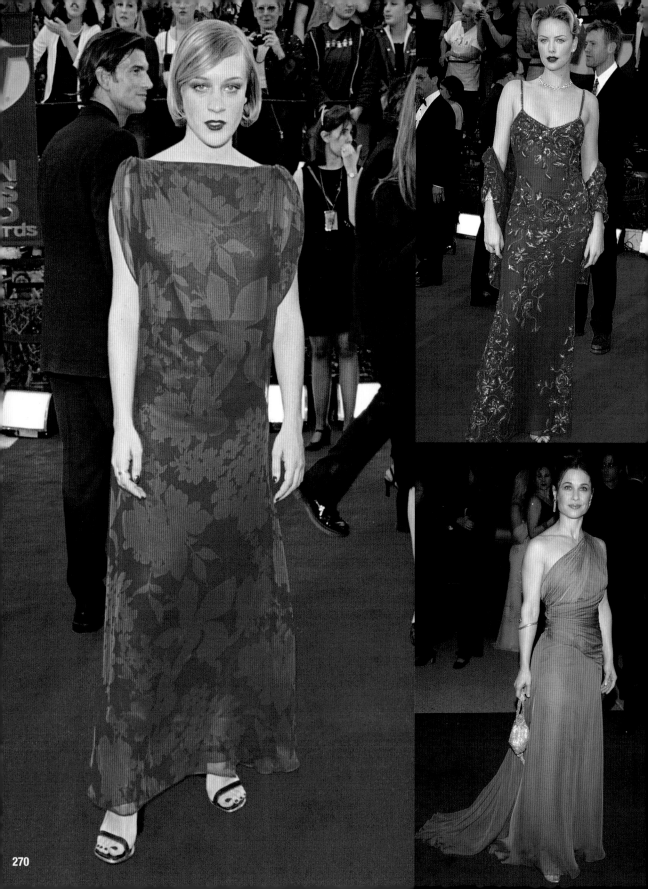

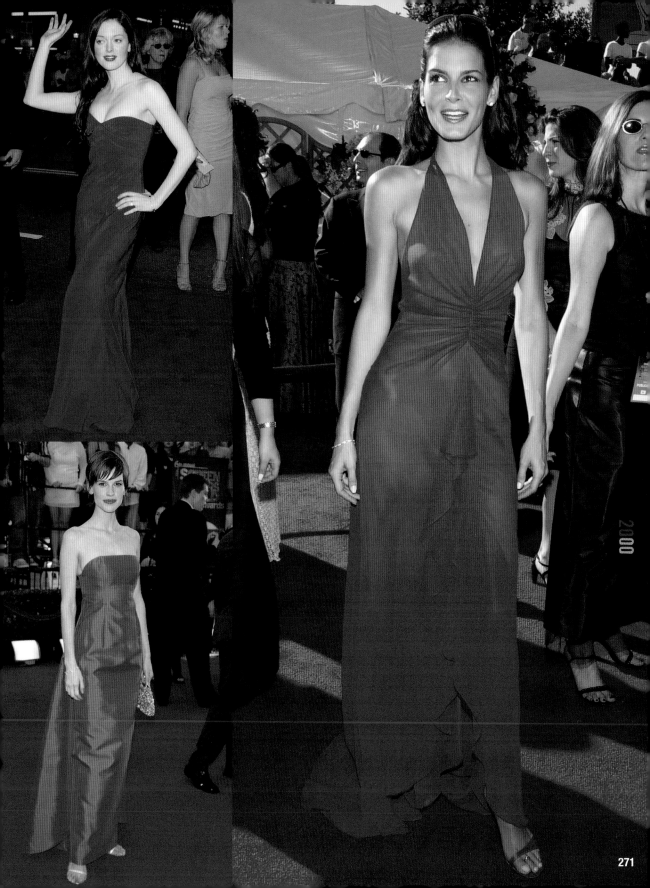

2000

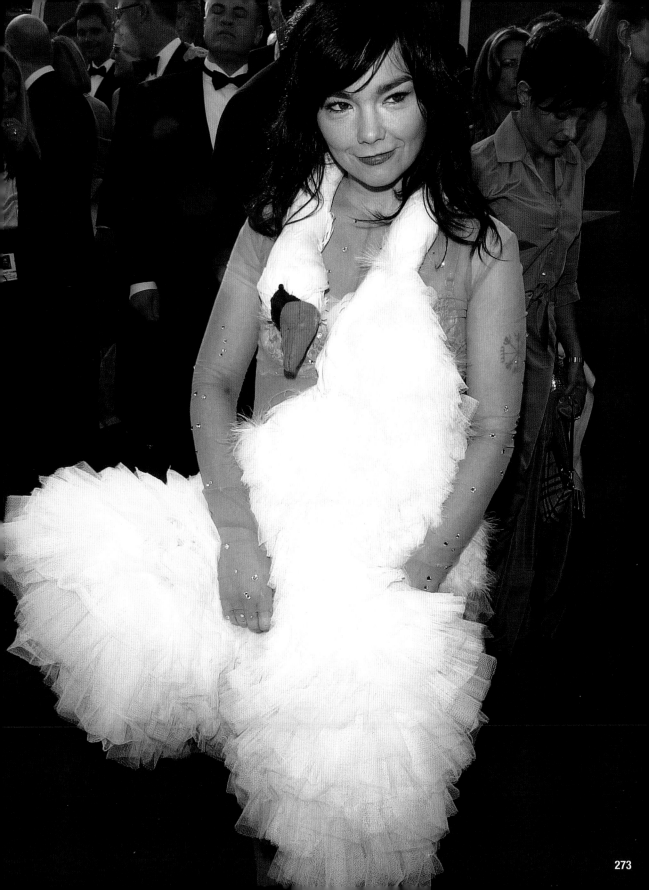

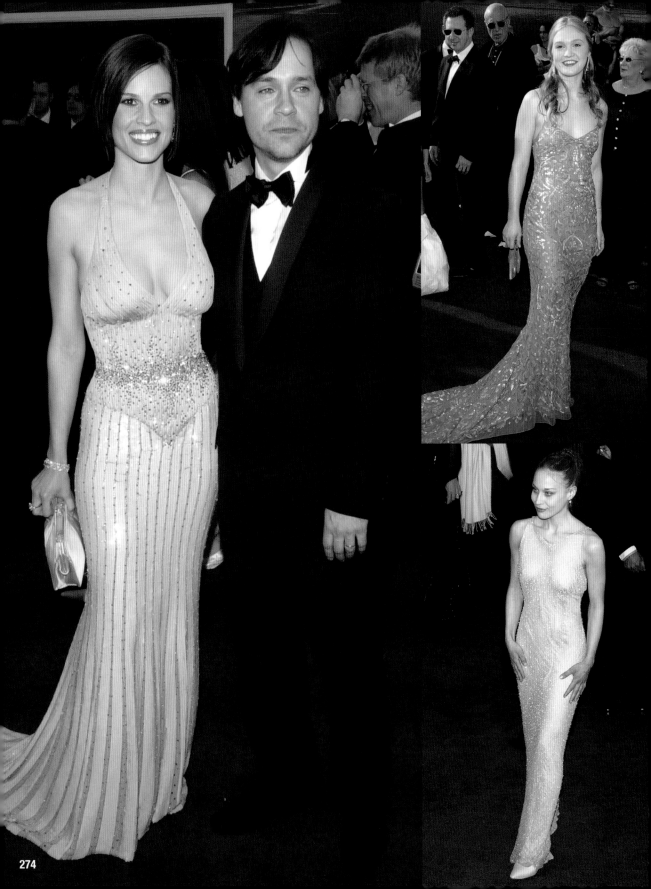

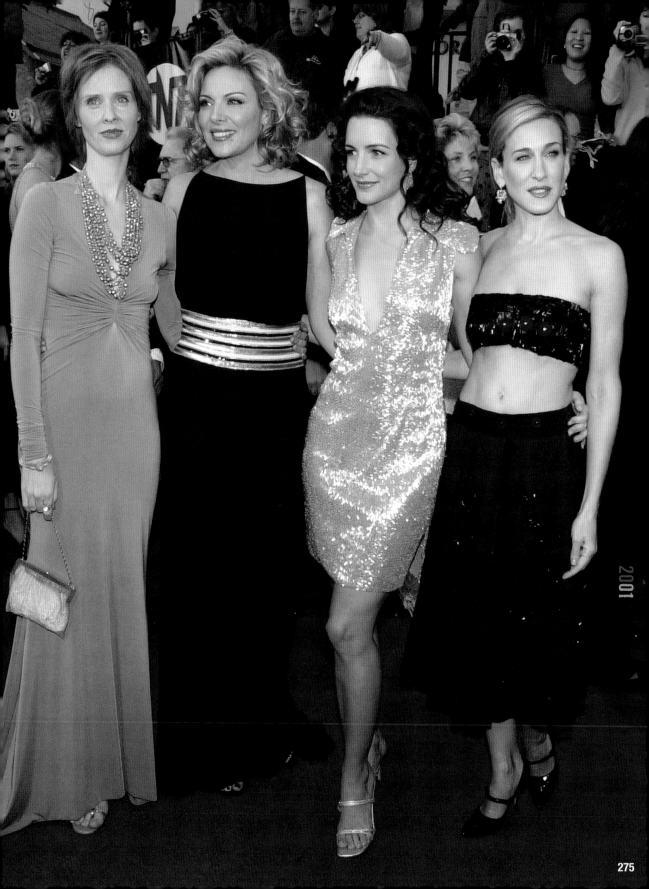

2001

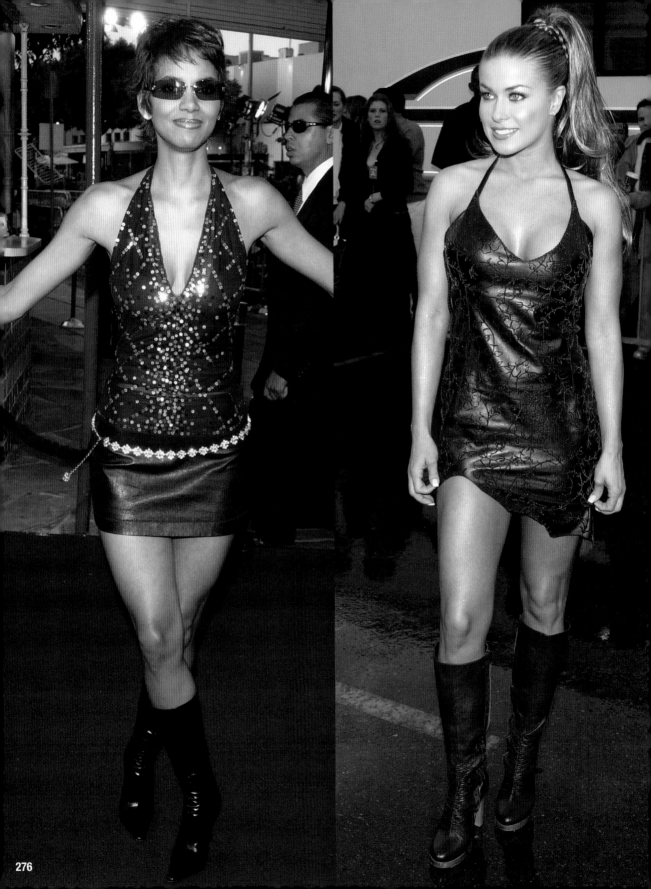

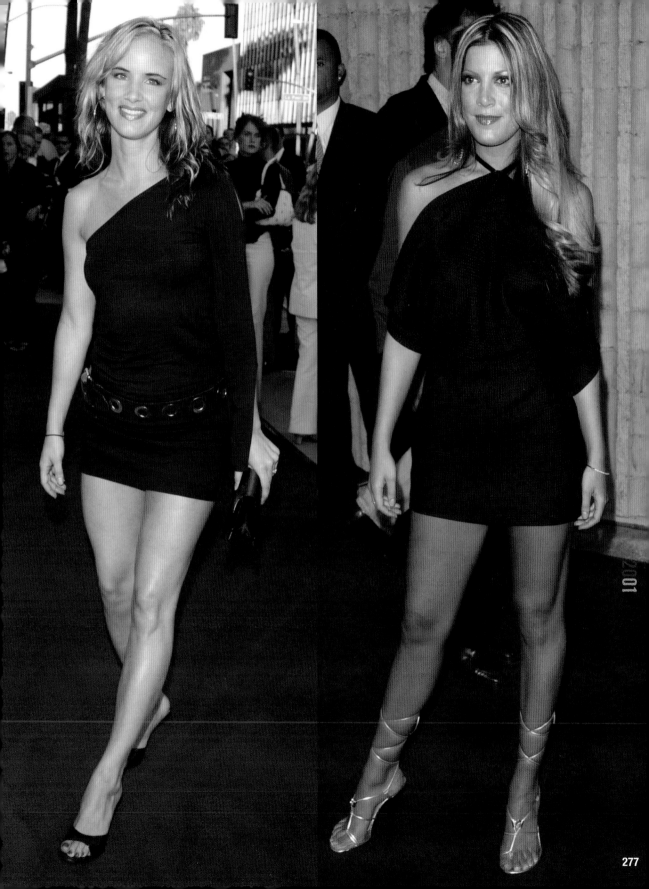

2001

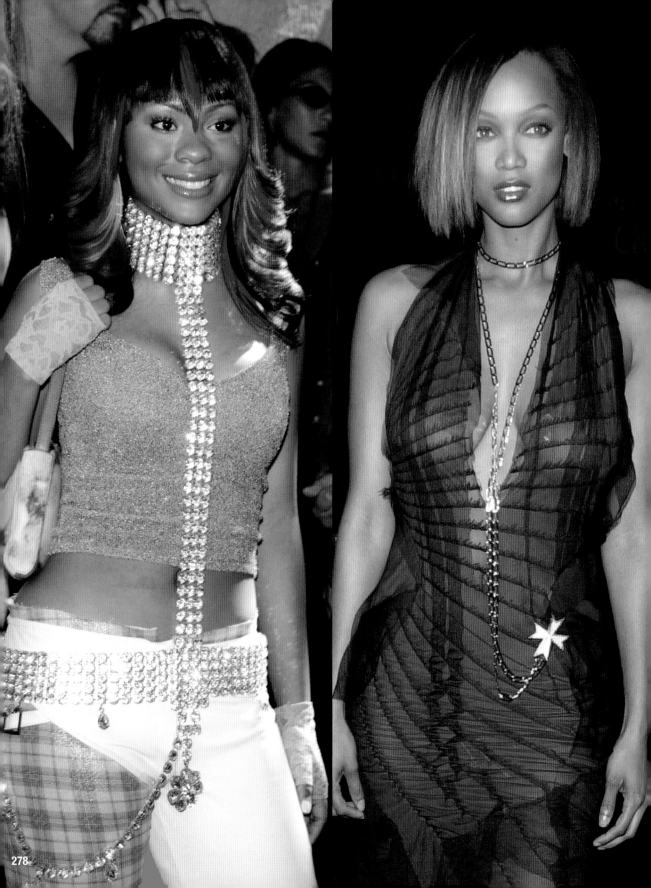

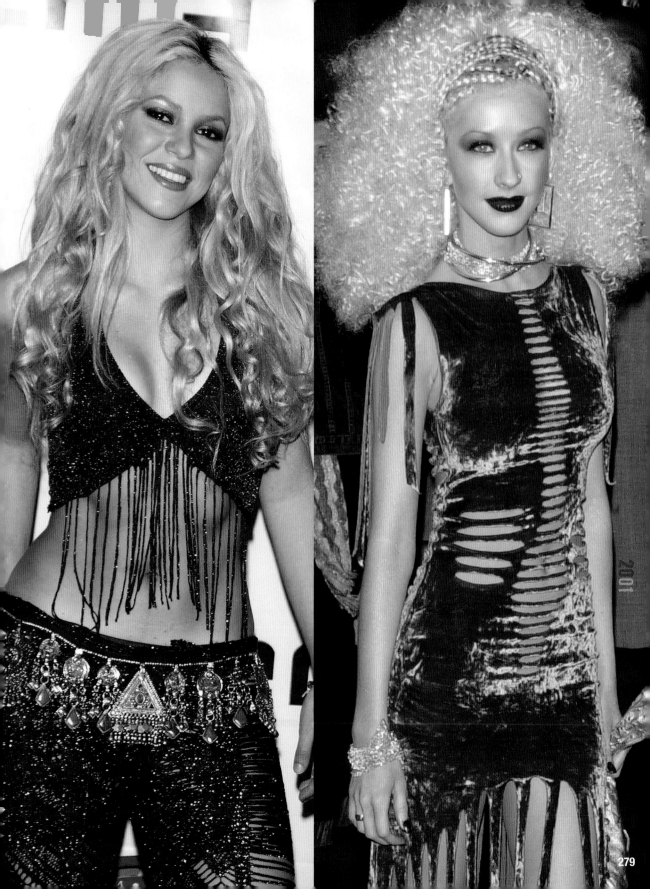

2001

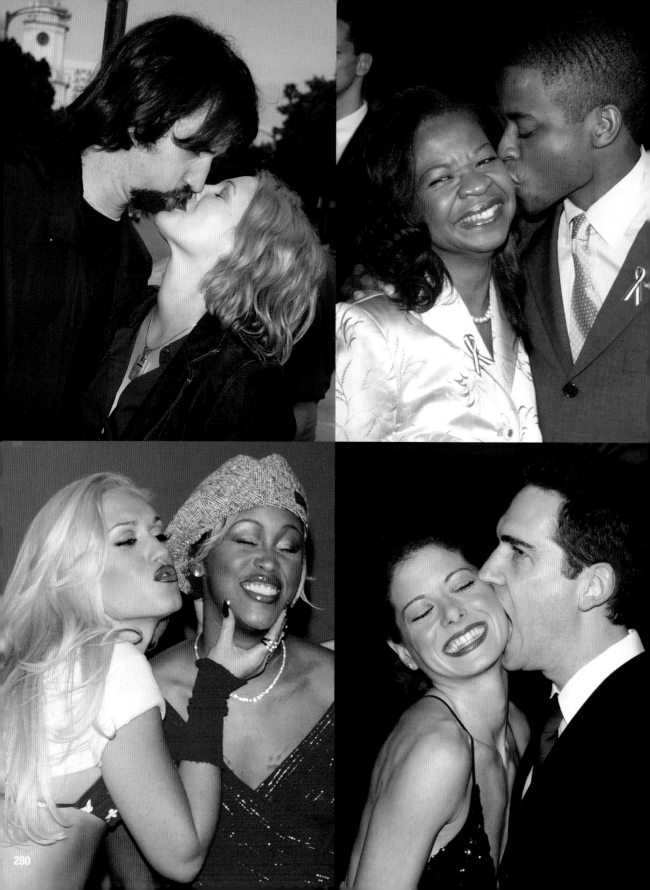

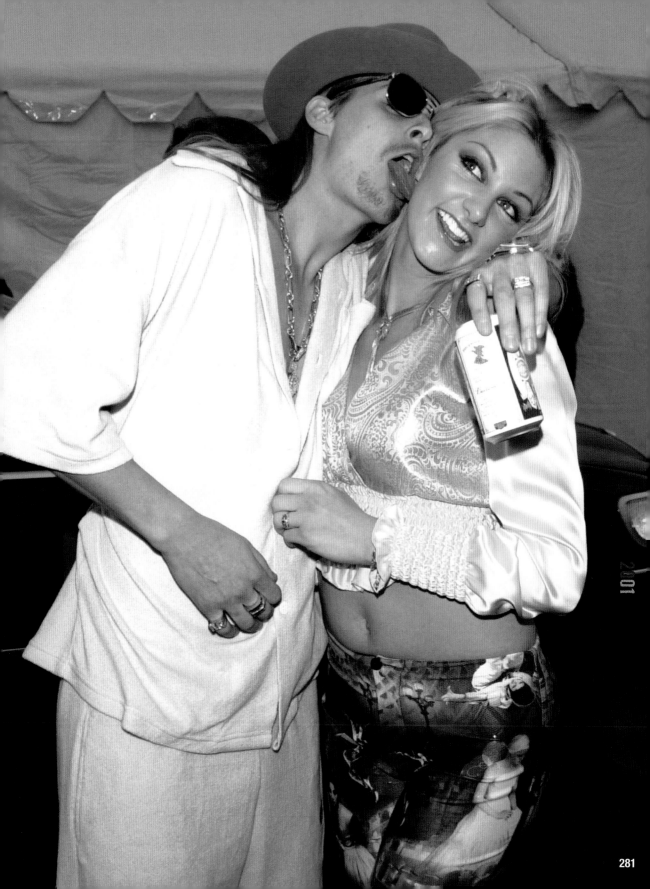

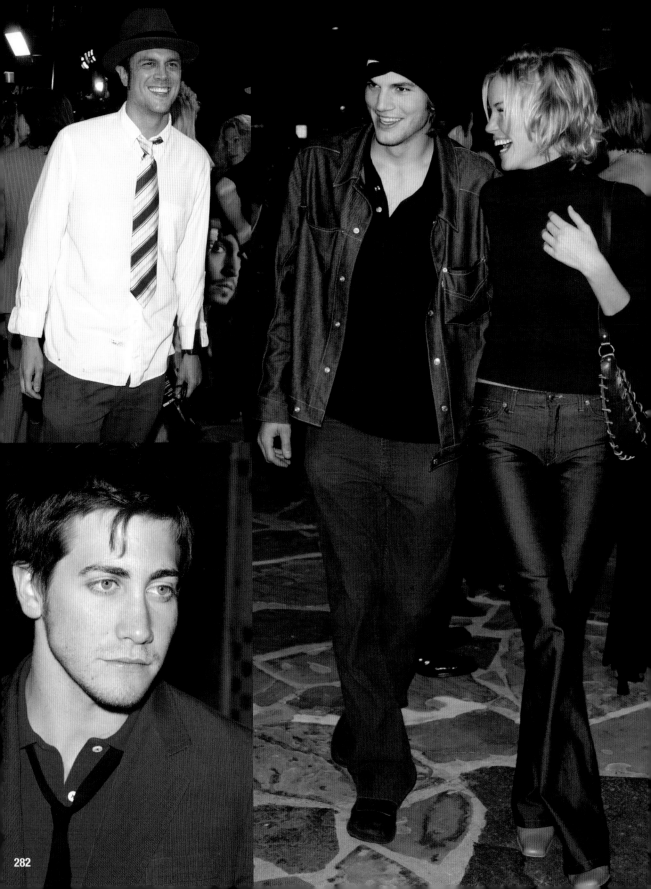

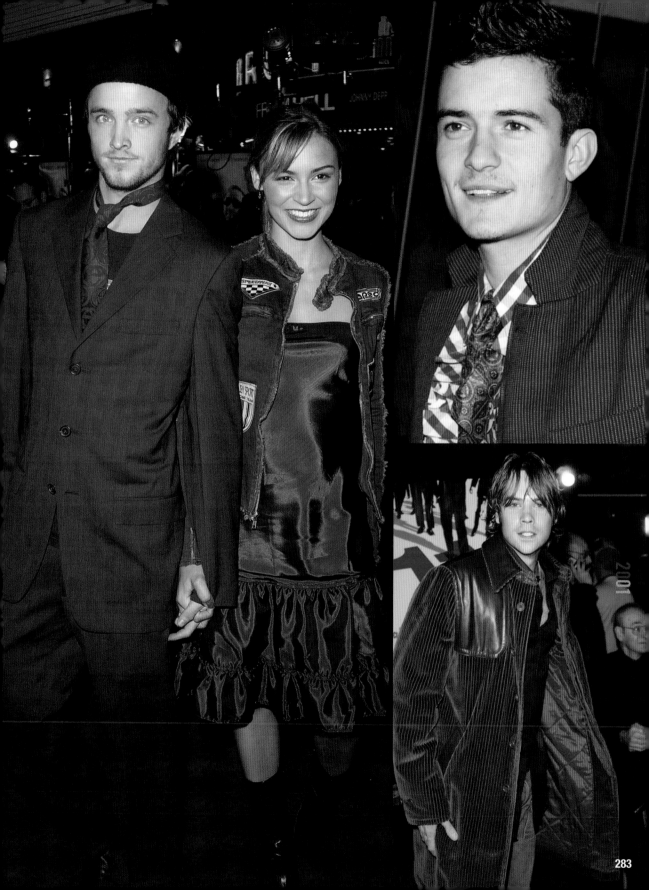

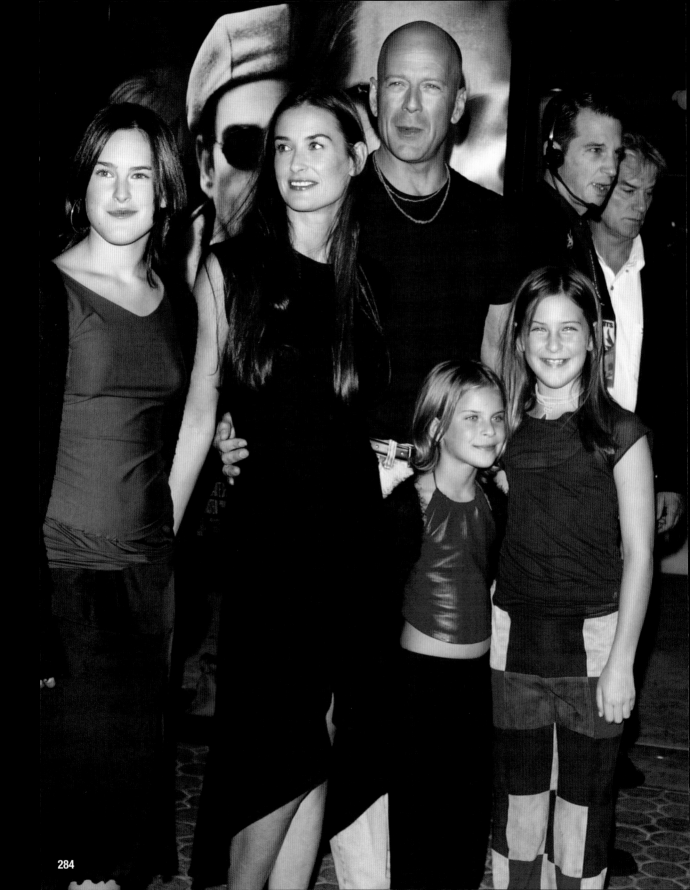

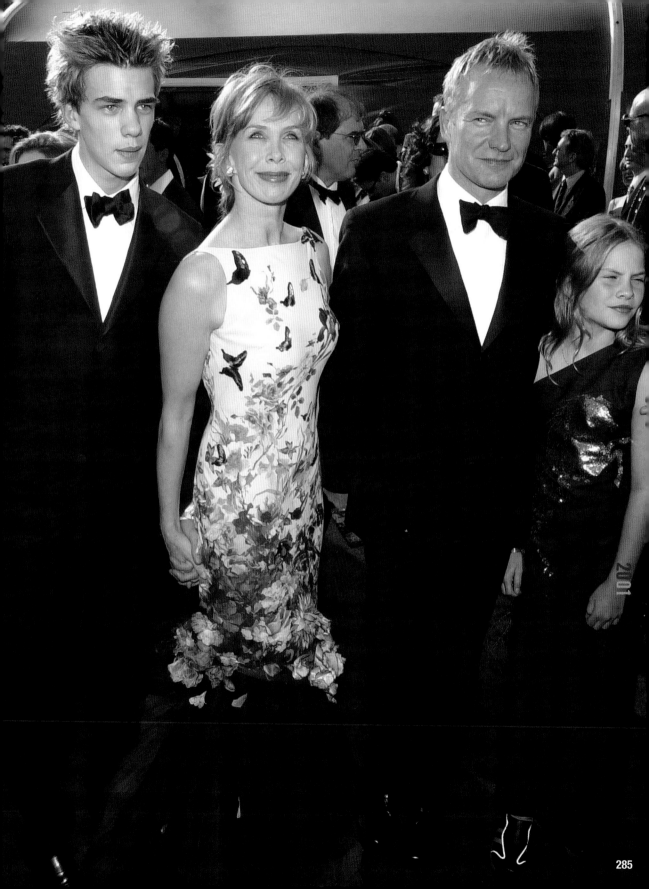

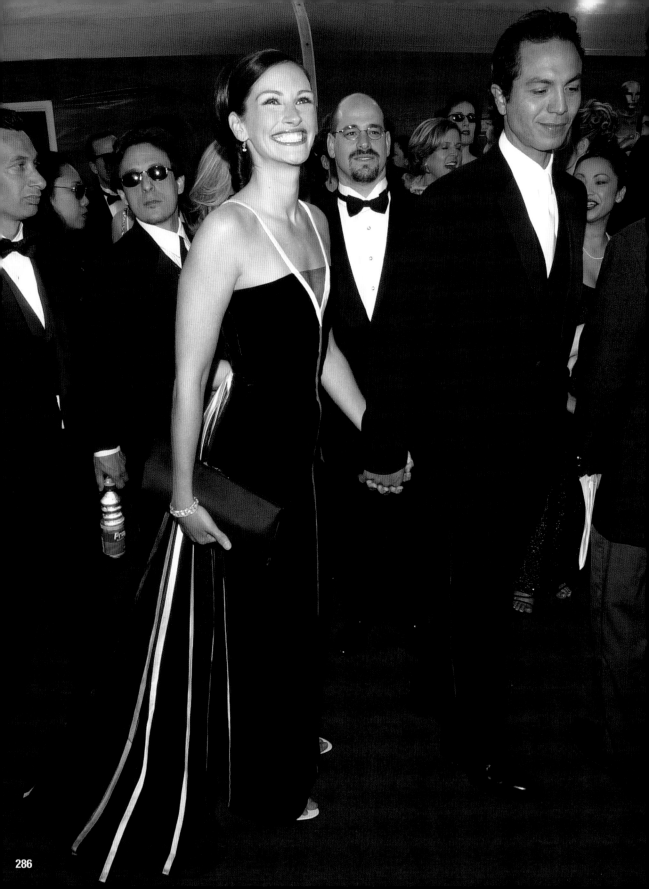

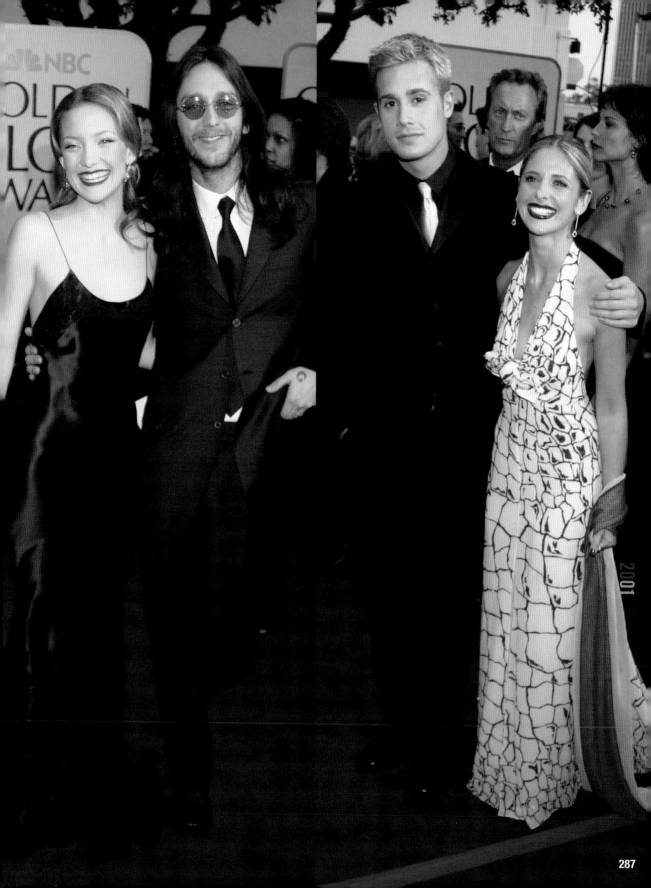

2001

287

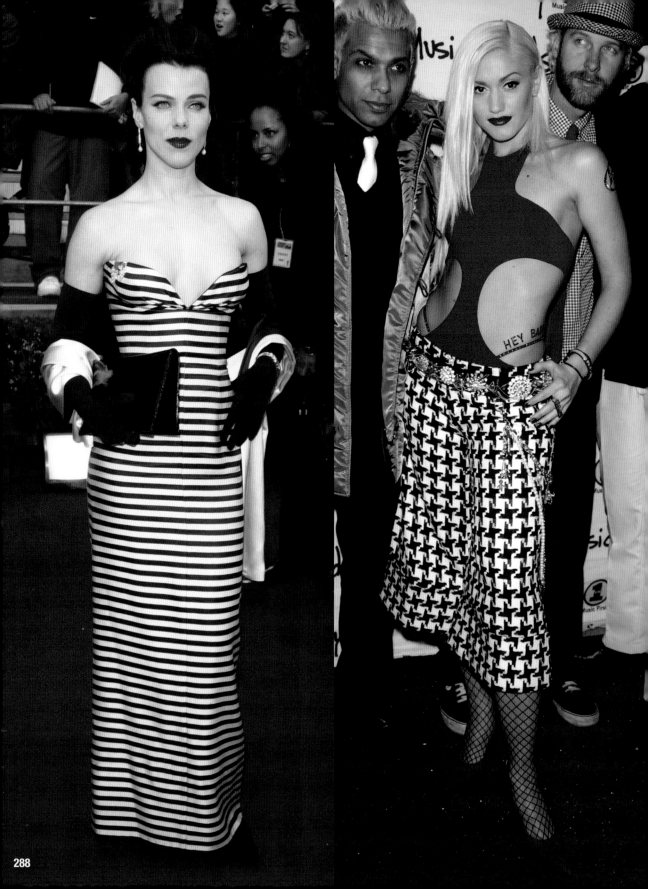

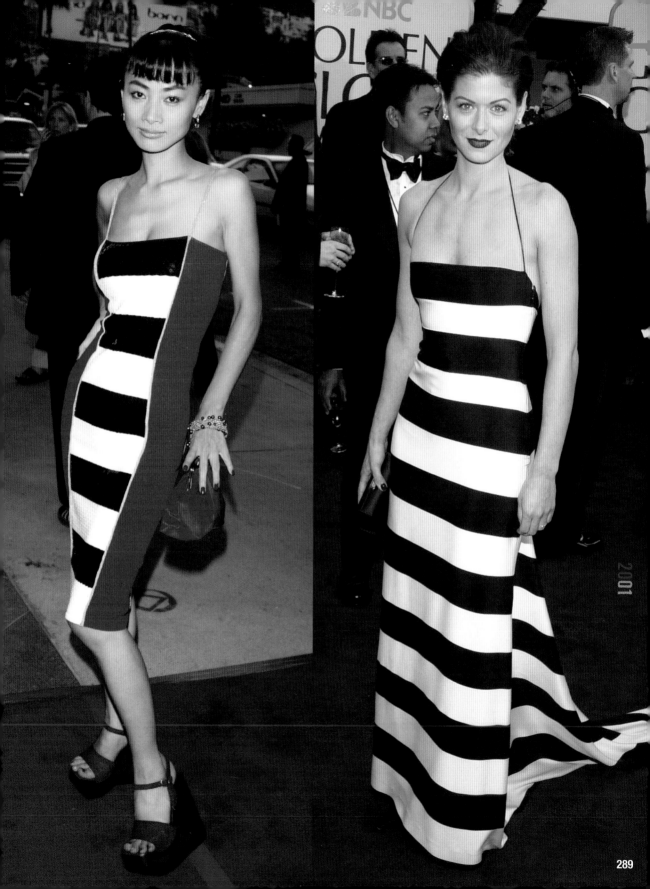

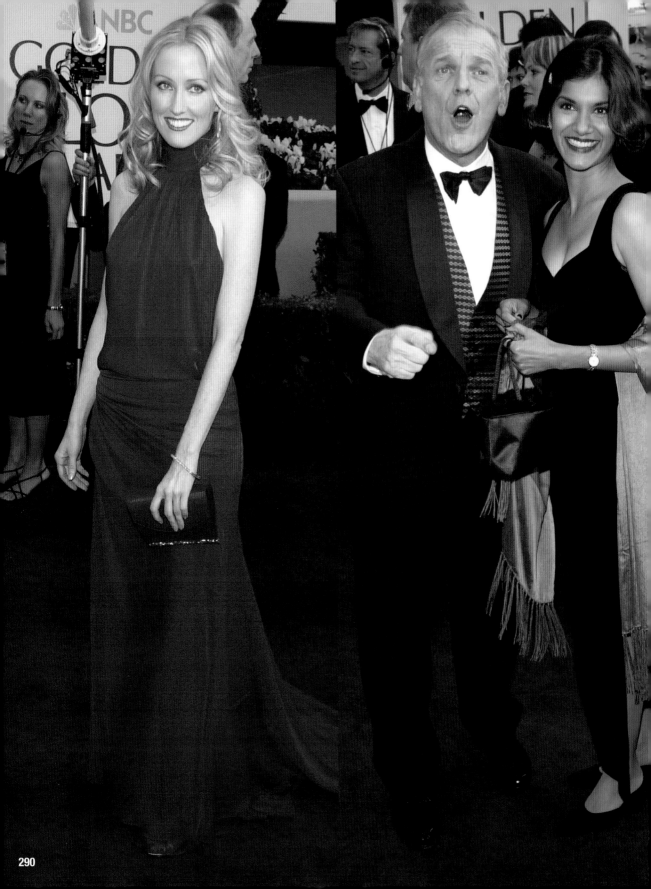

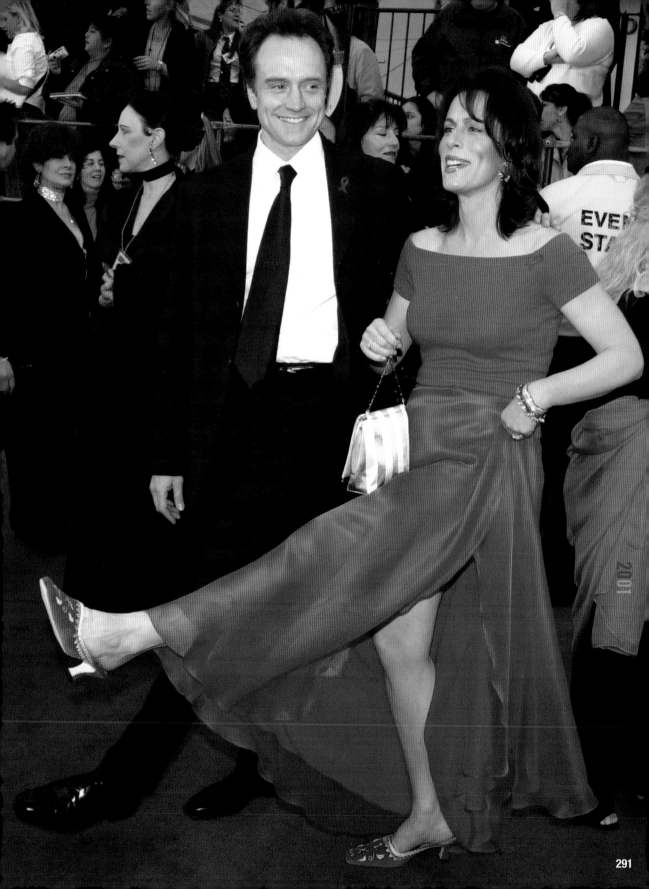

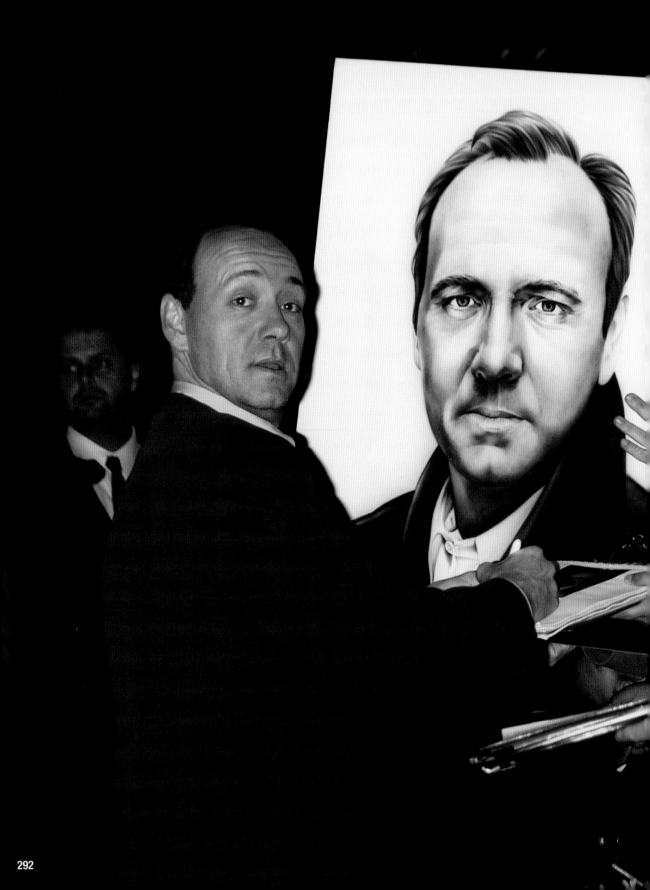

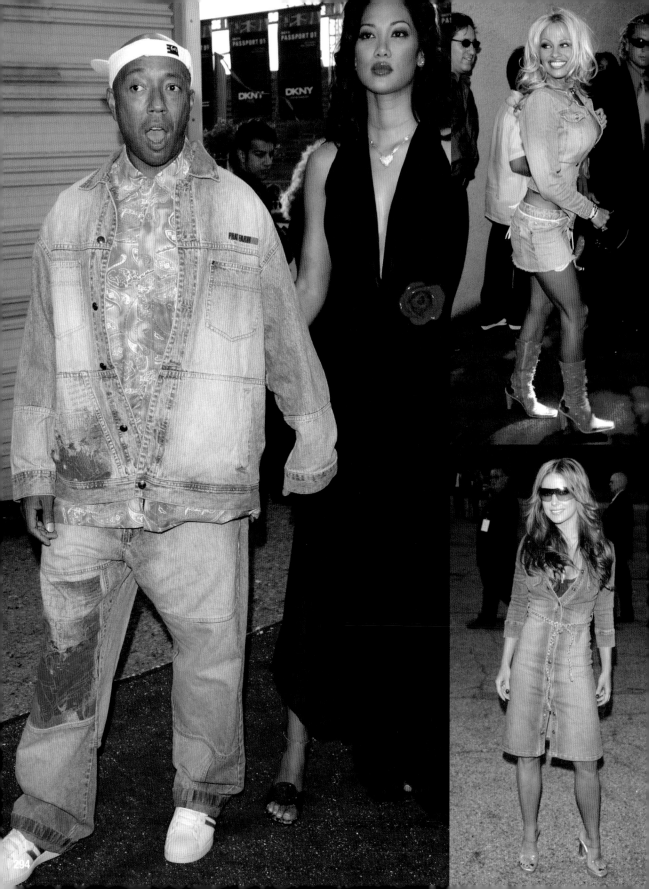

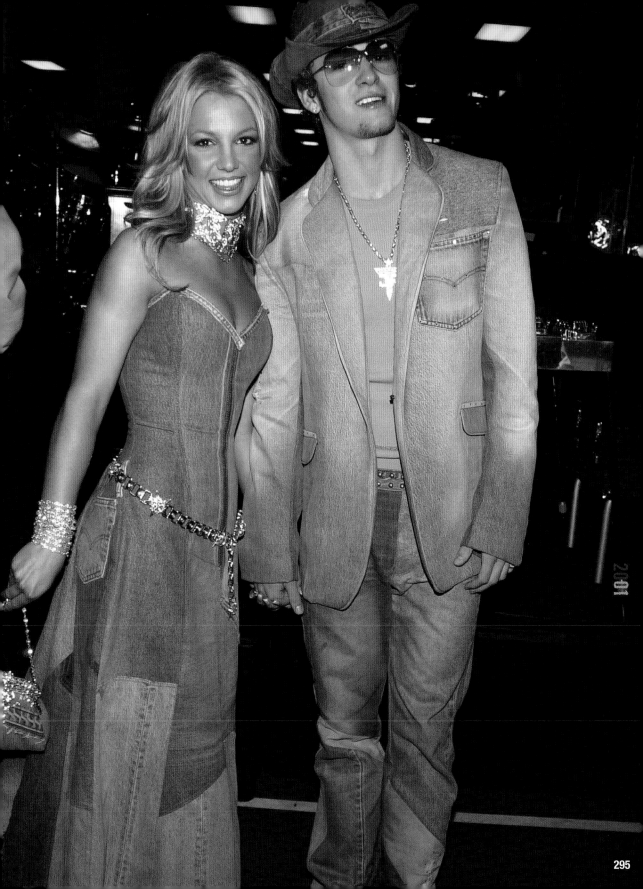

2001

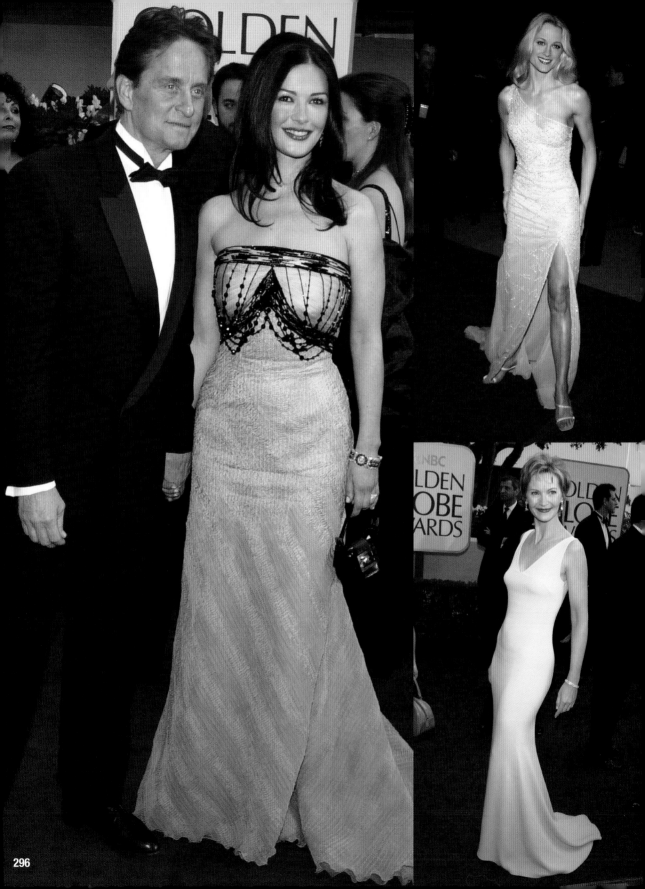

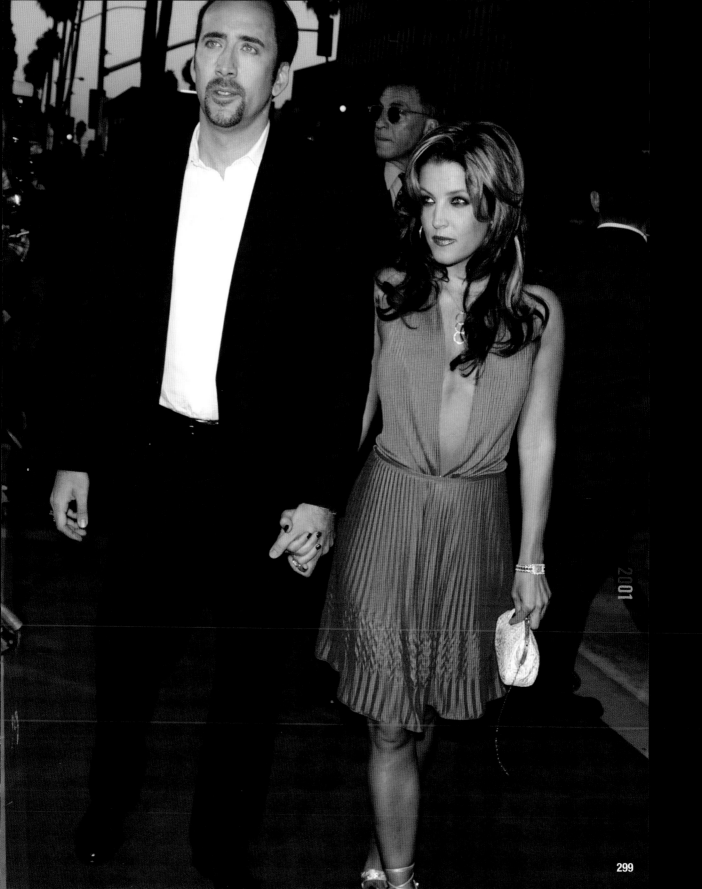

2001

1987 1988 1989
1990 1991 1992
1993 1994 1995
1996 1997 1998
1999 2000 2001
2002 2003 2004
2005 2006 2007

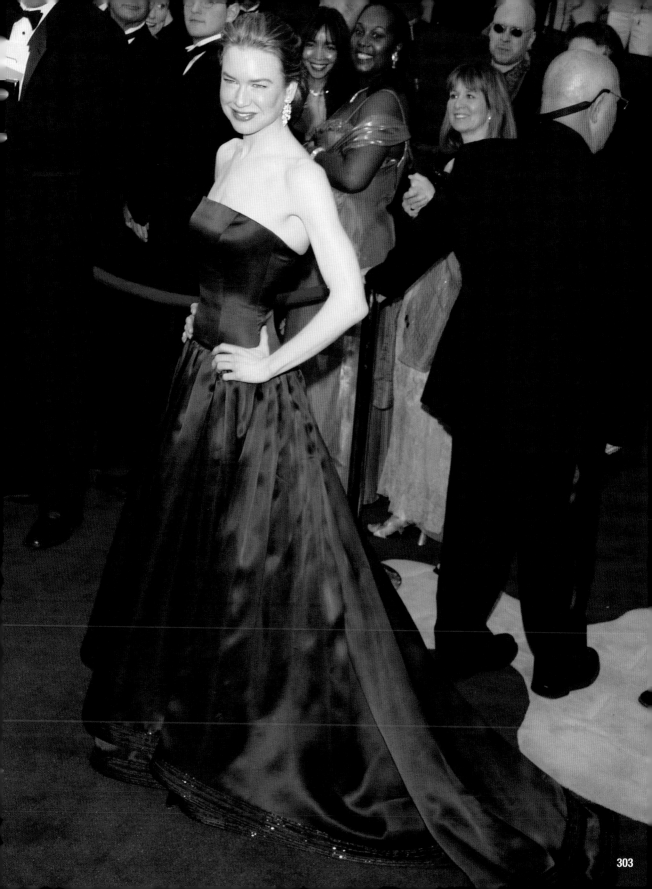

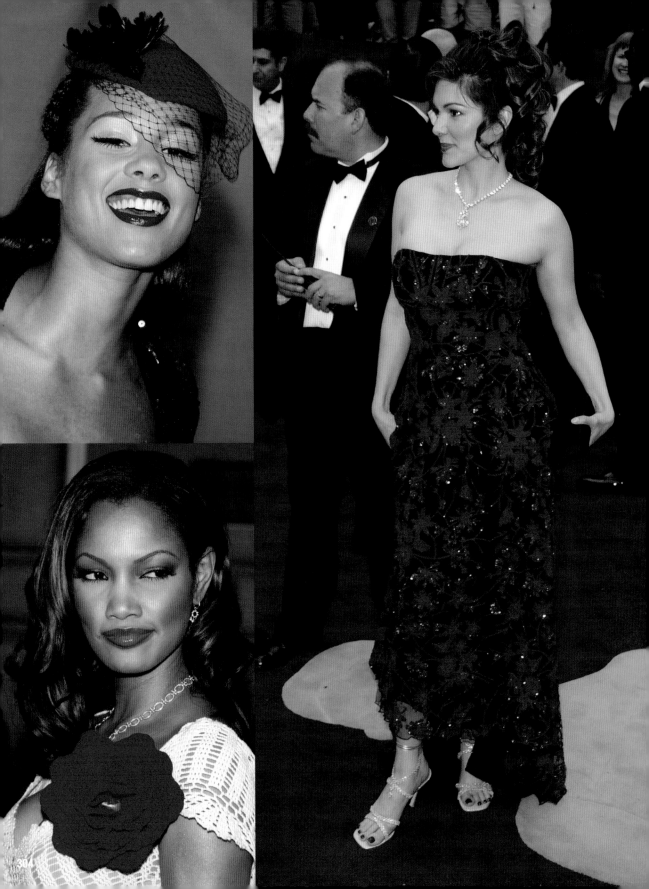

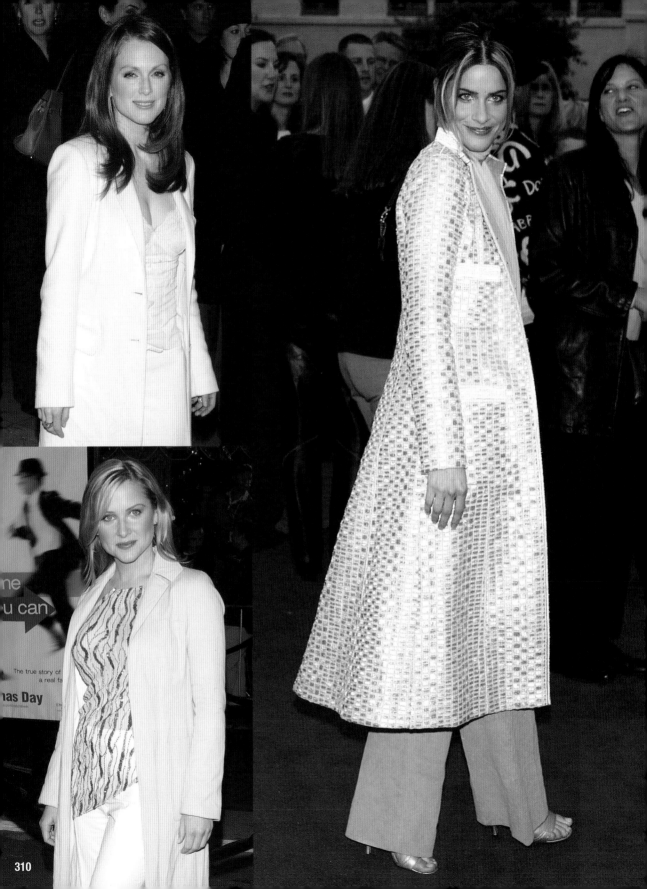

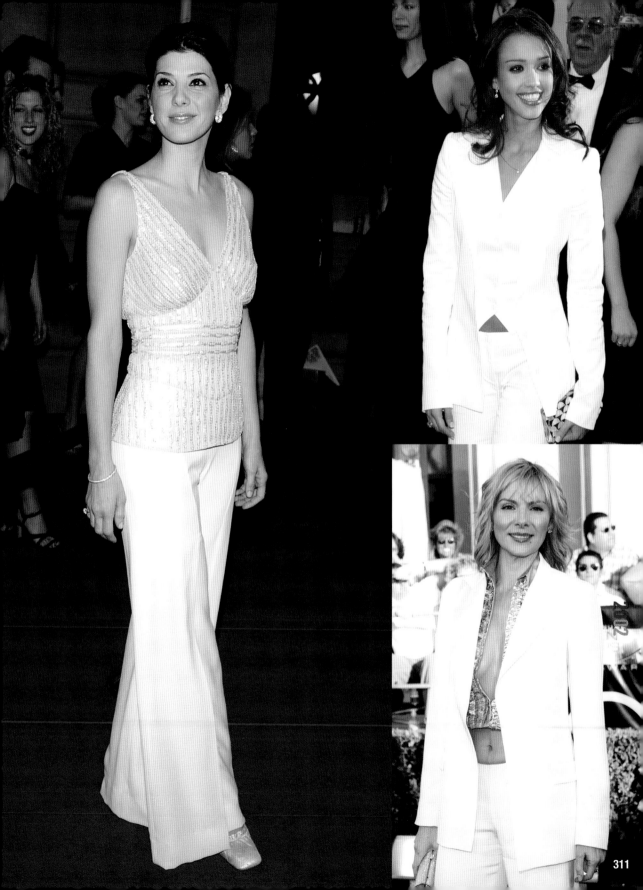

311

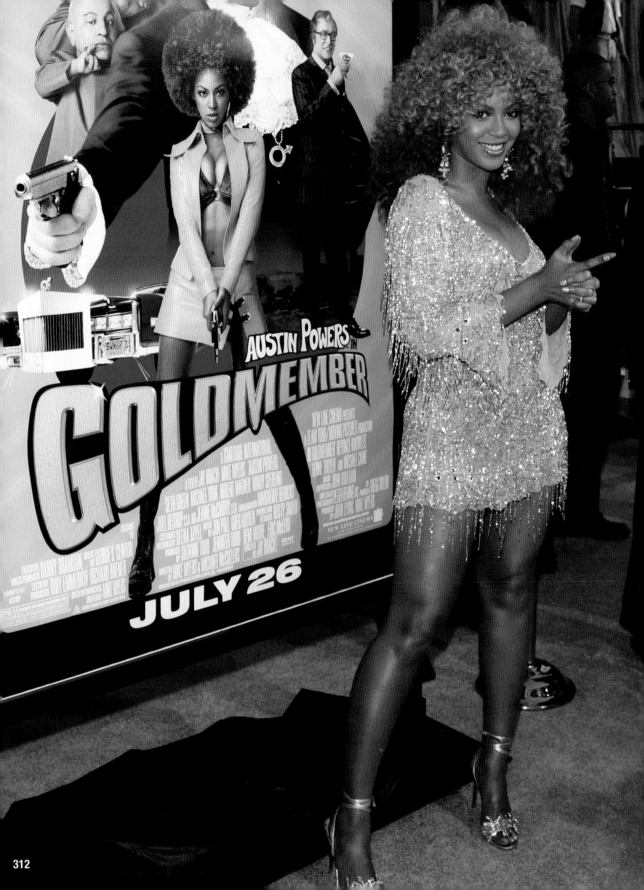

AUSTIN POWERS in
GOLDMEMBER

JULY 26

312

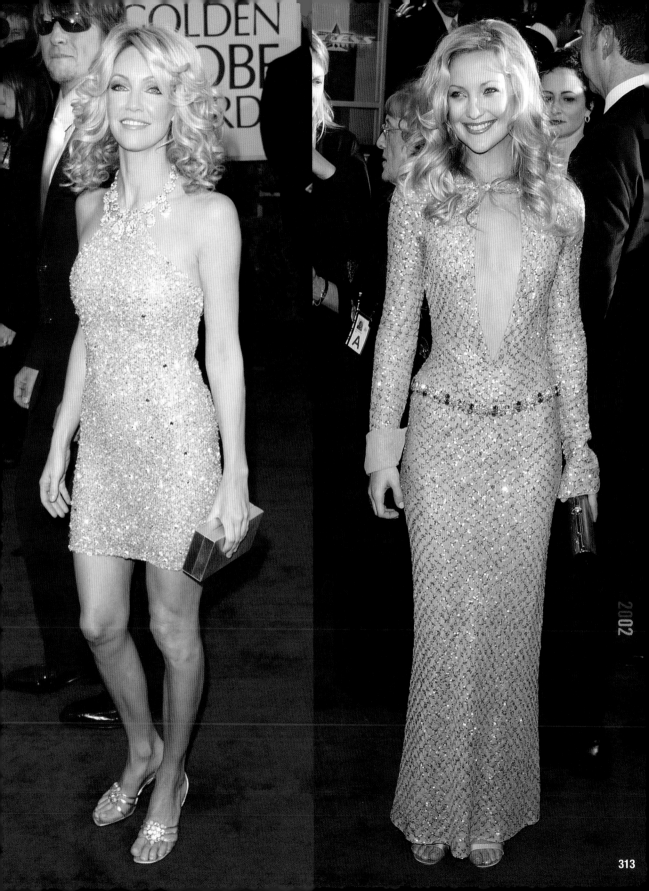

2002

313

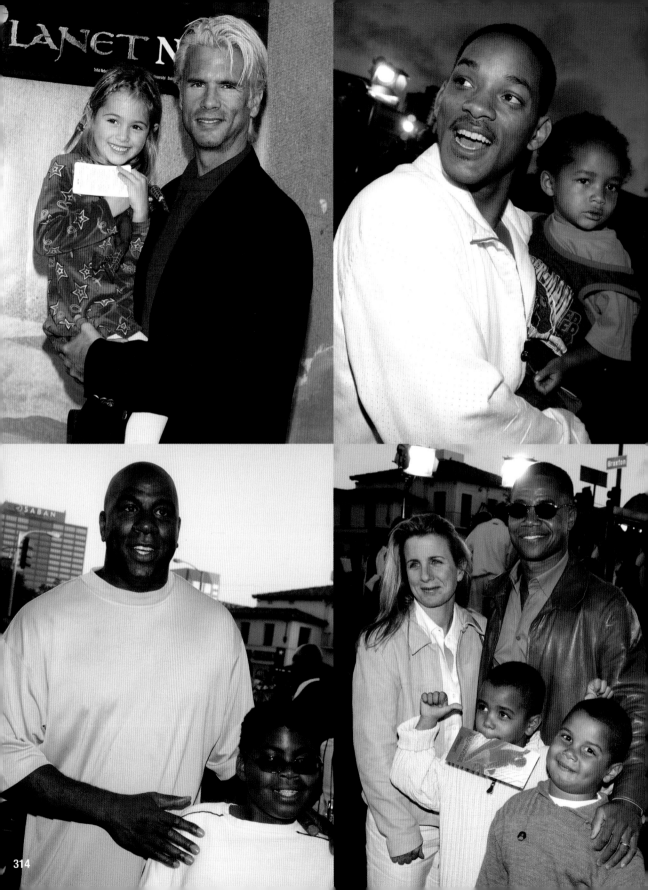

316

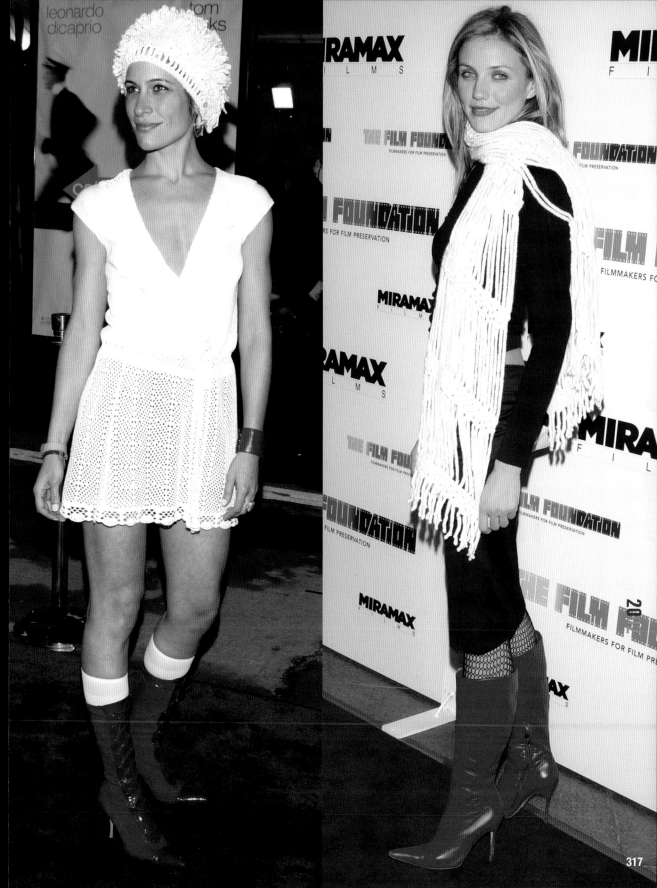

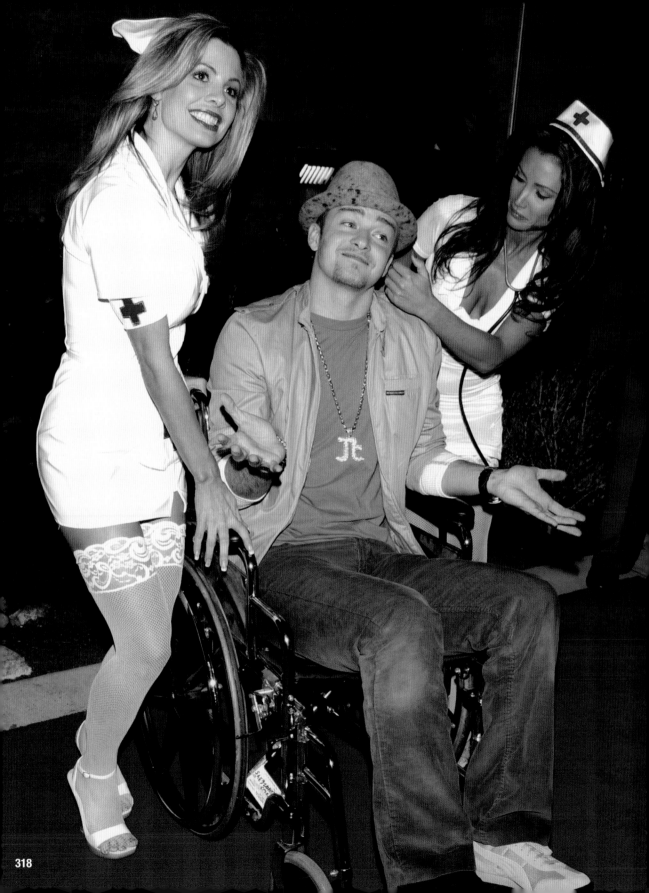

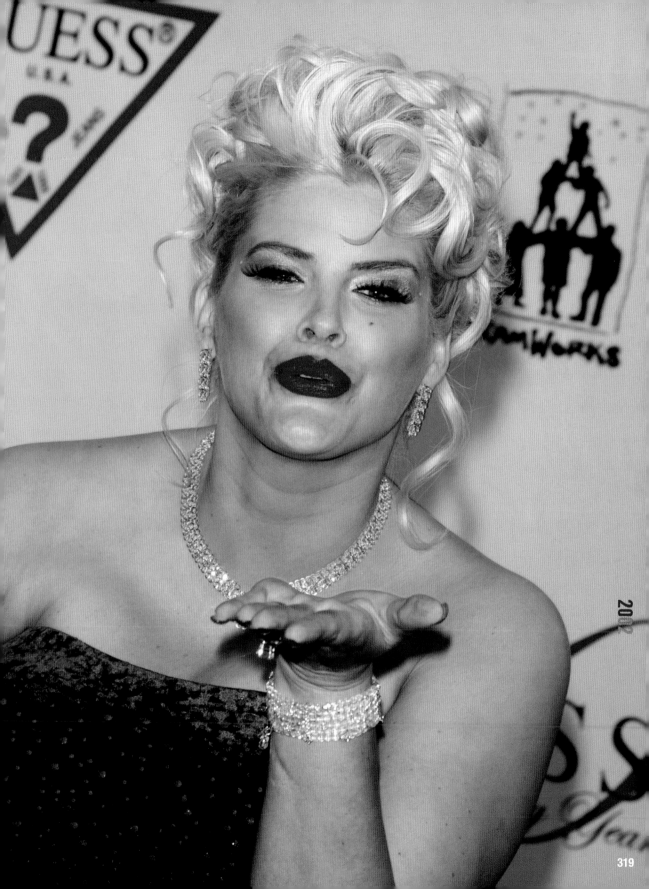

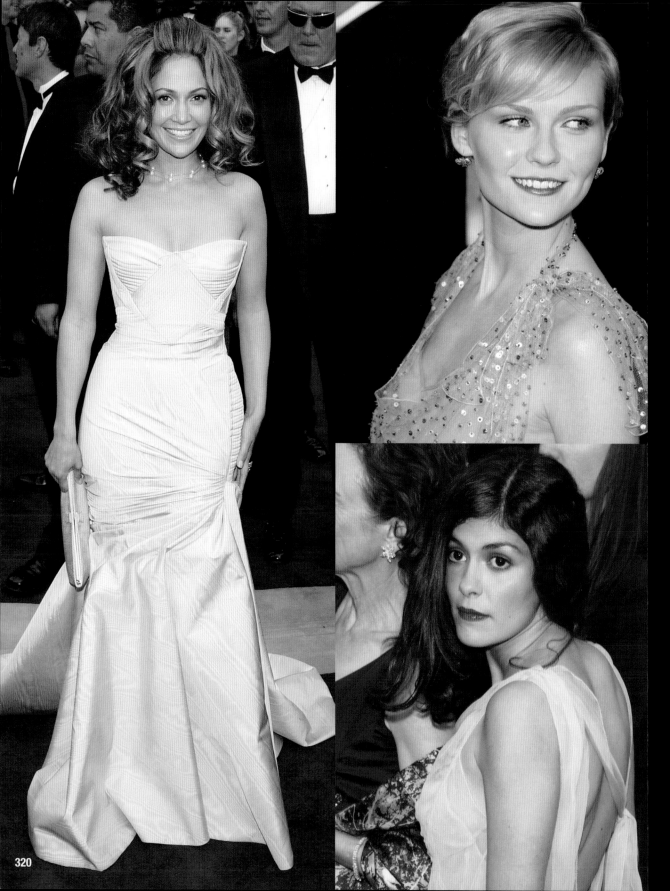

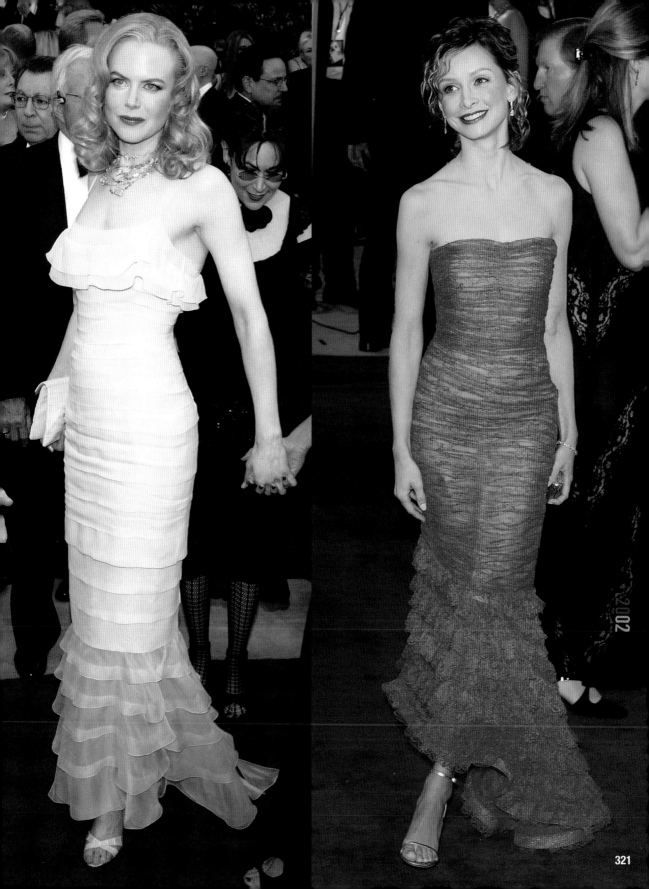

2002

323

2002

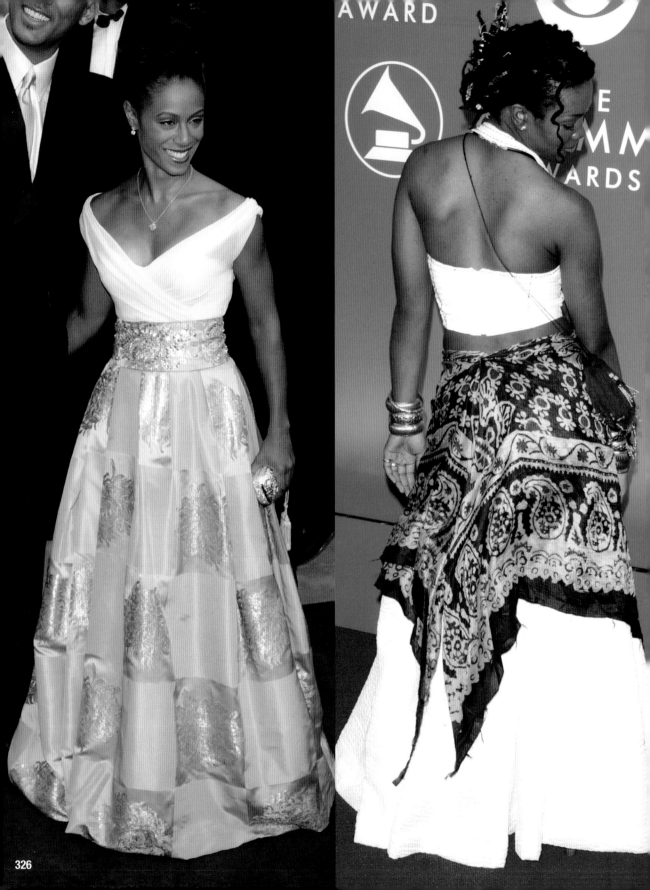

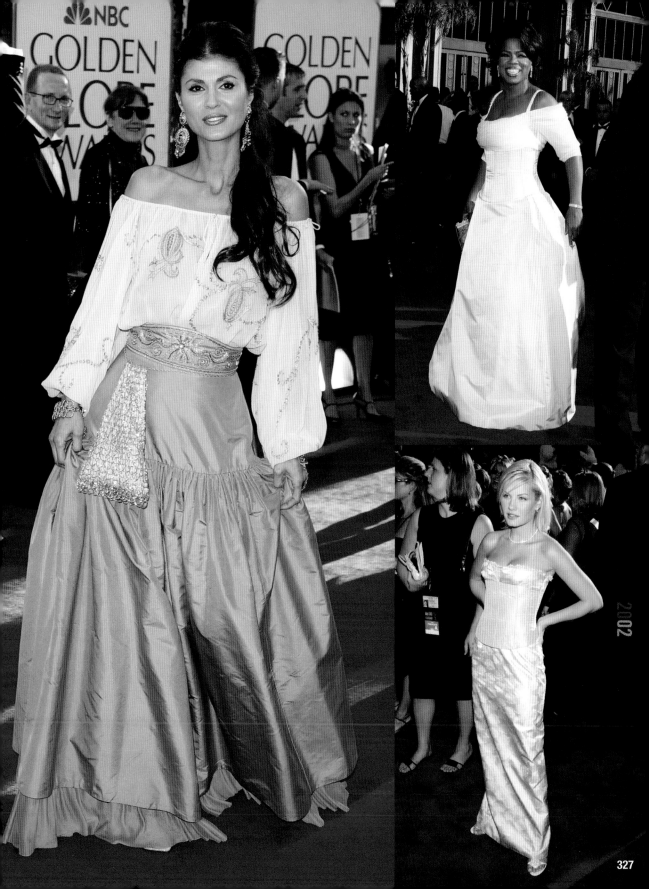

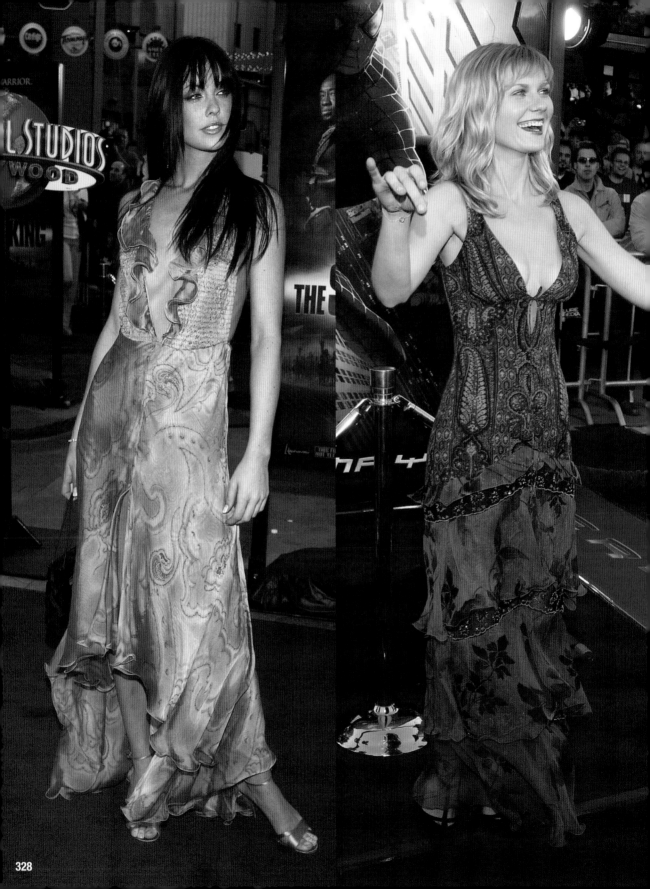

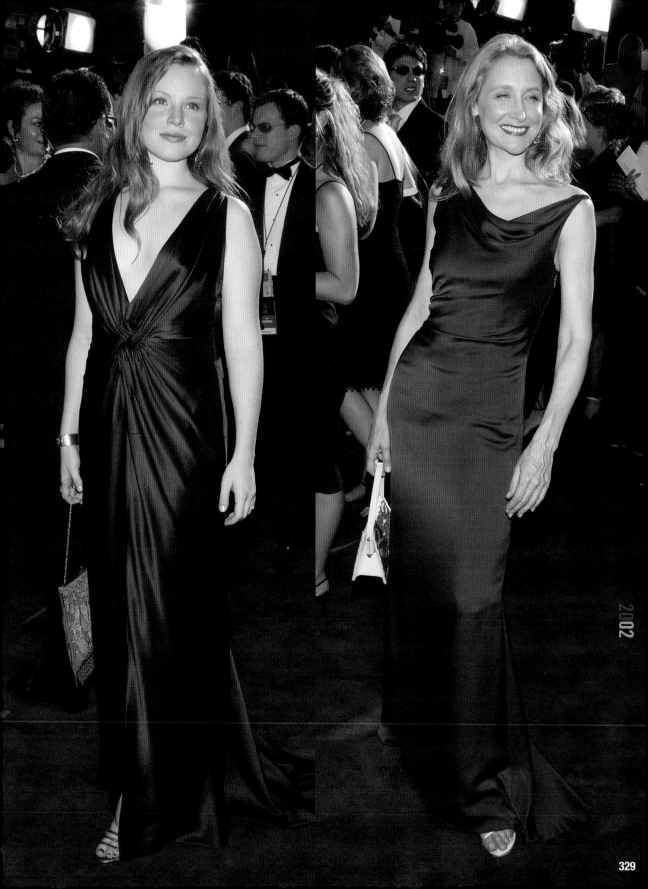

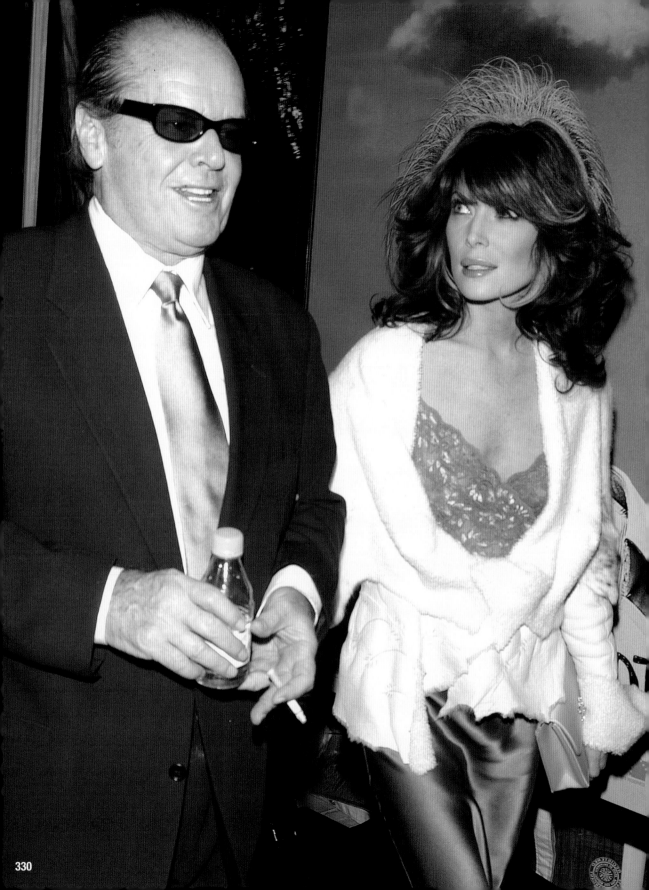

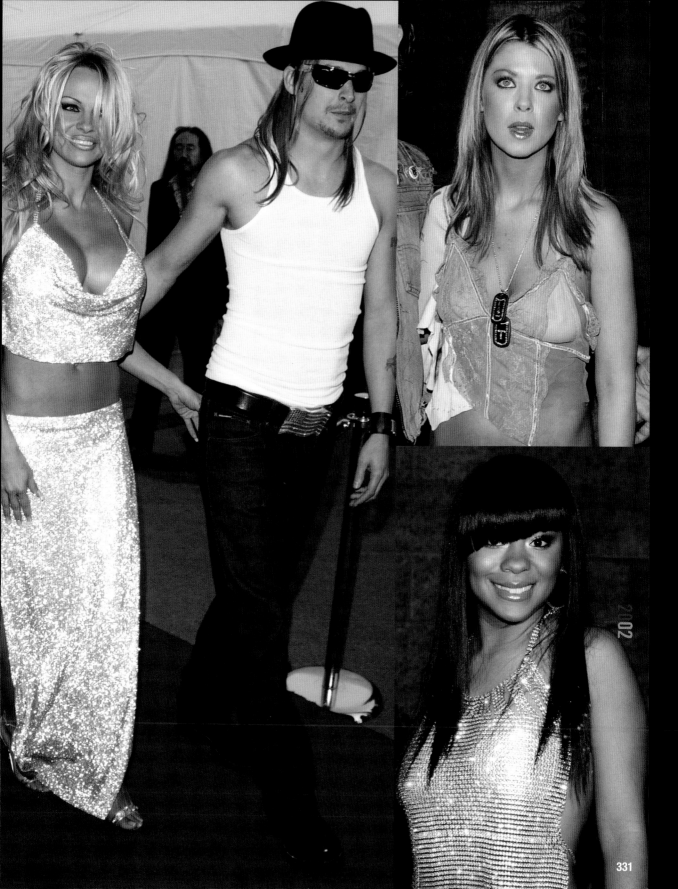

2002

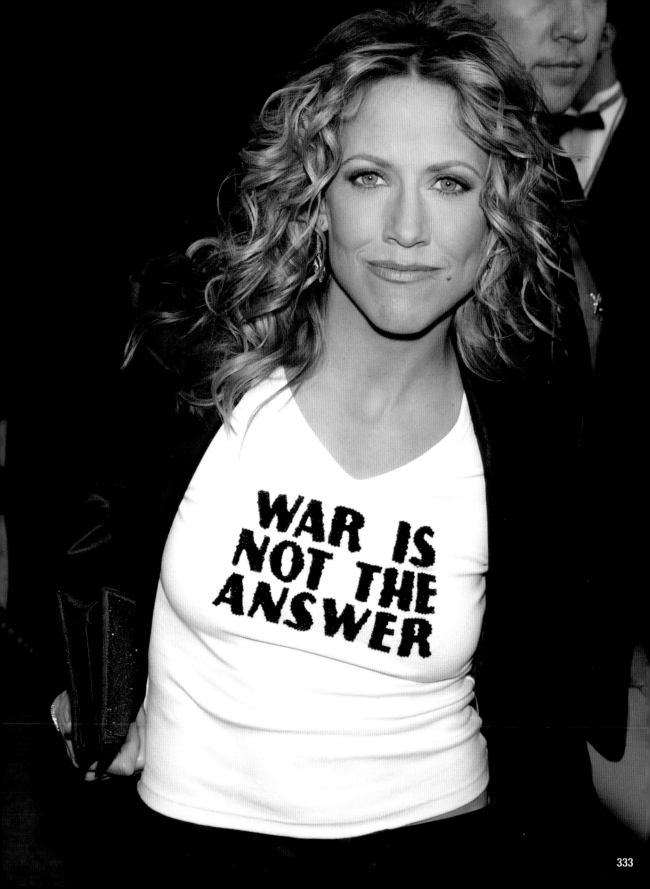

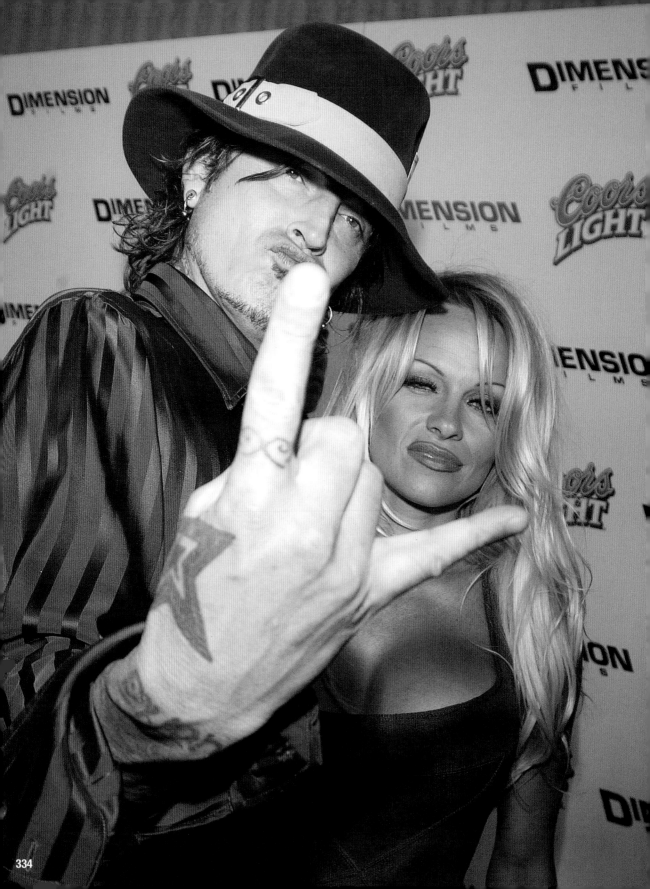

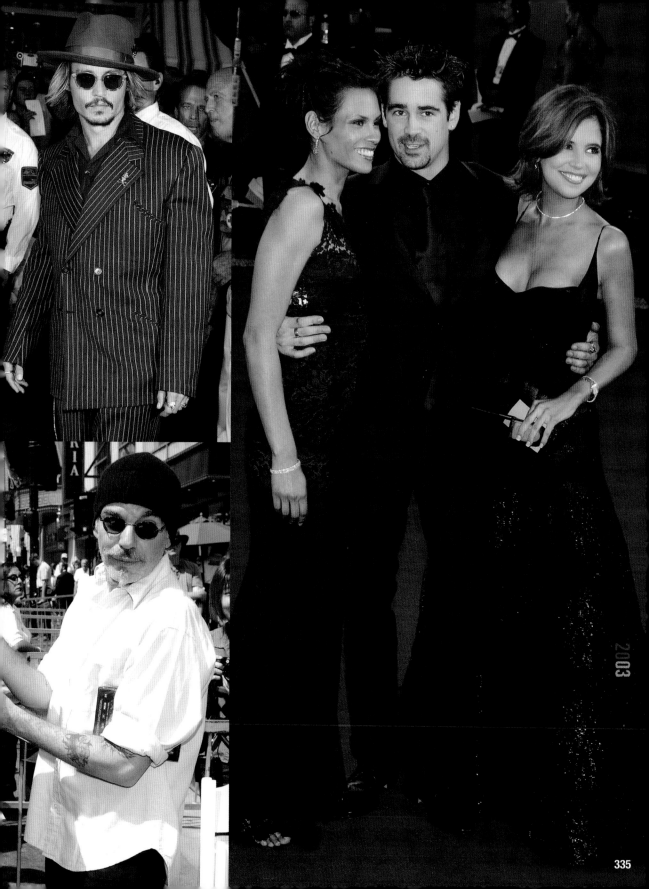

2003

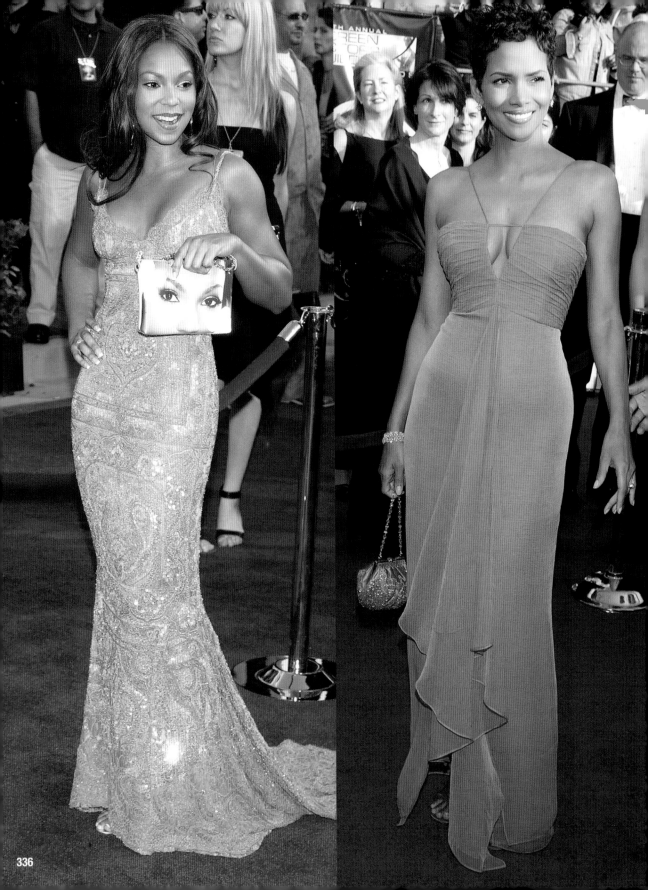

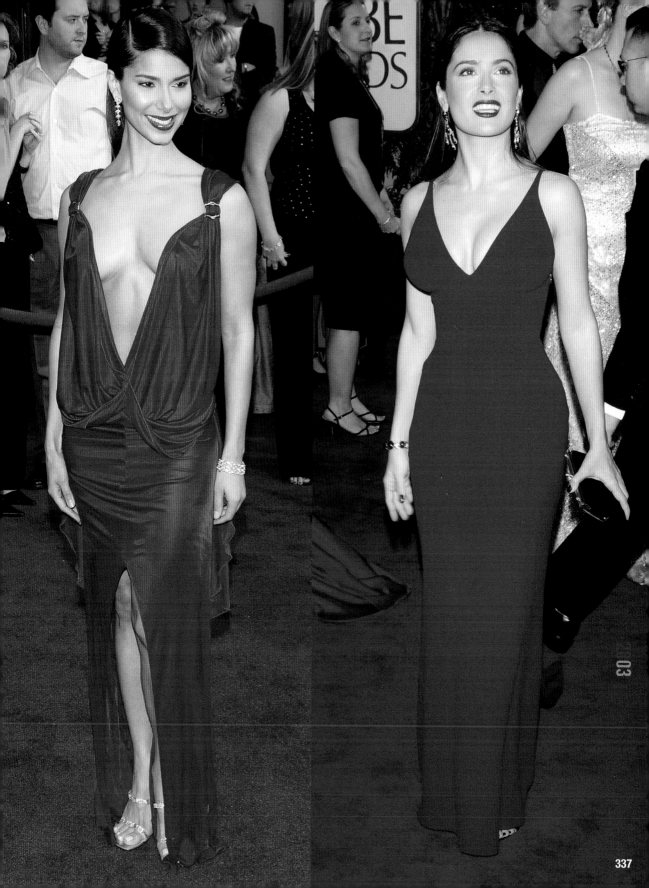

337

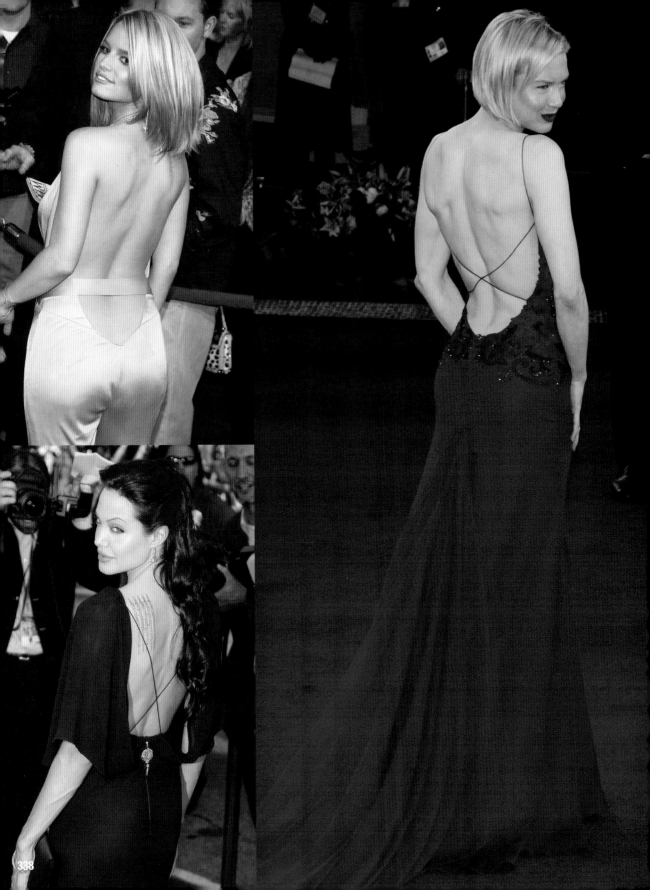

2003

339

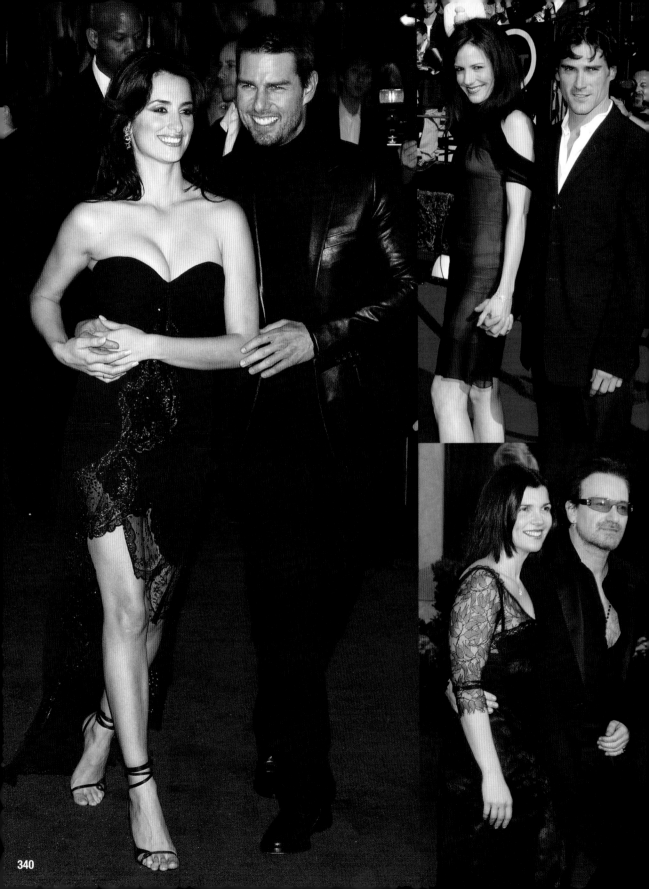

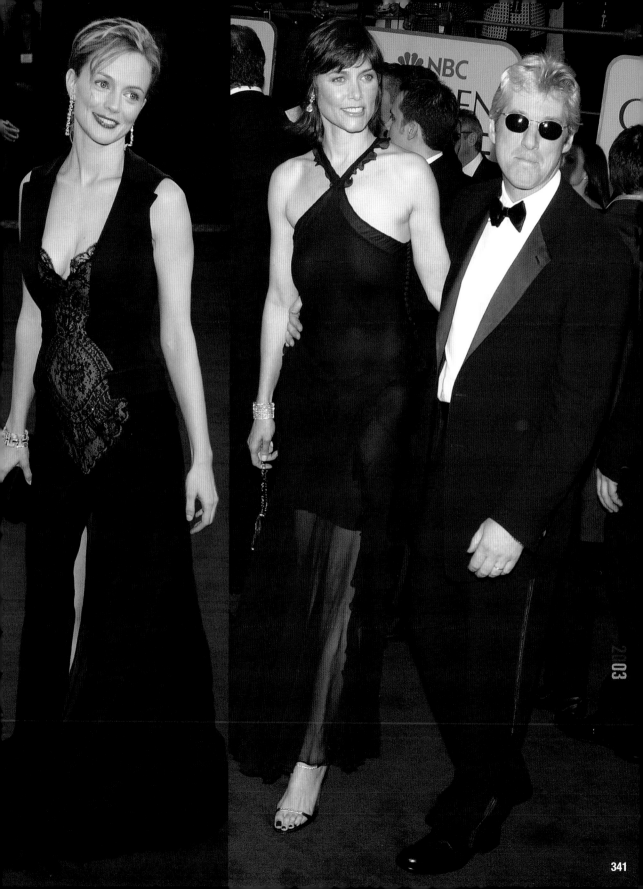

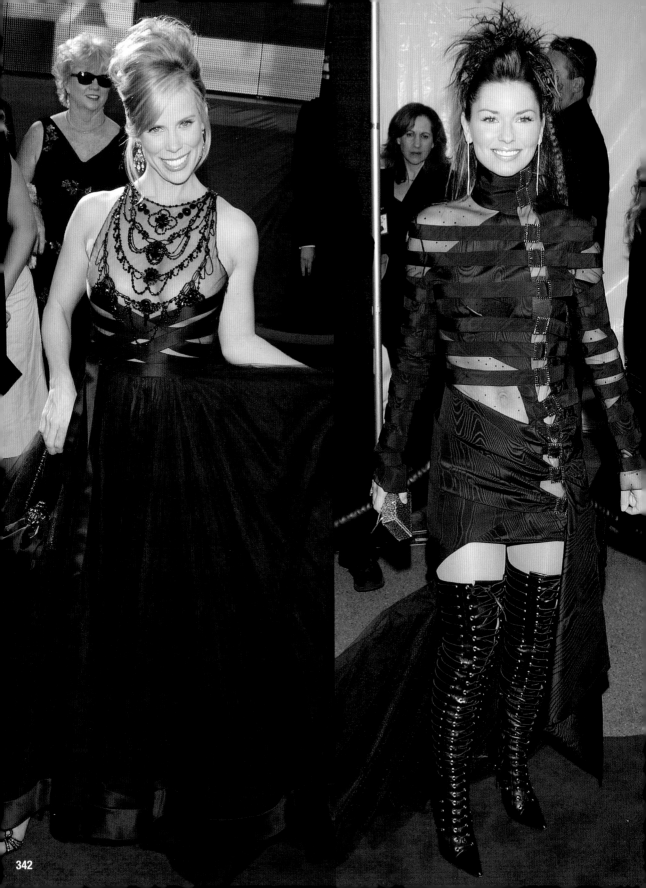

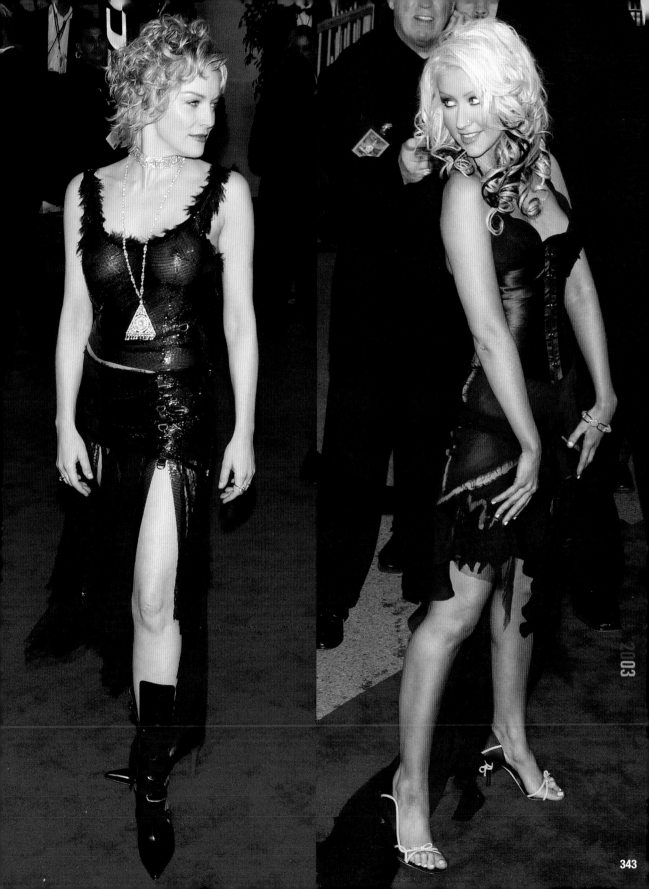

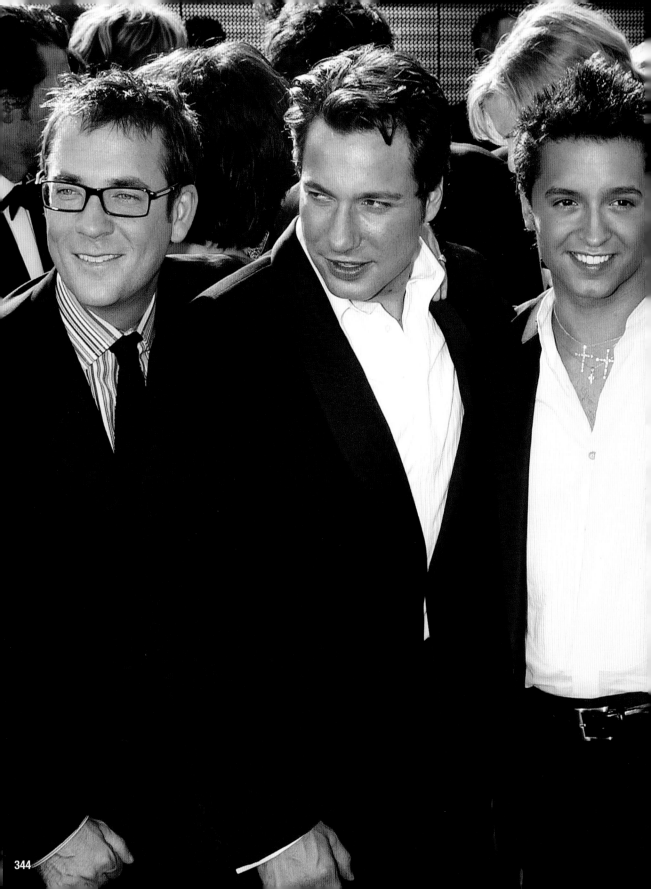

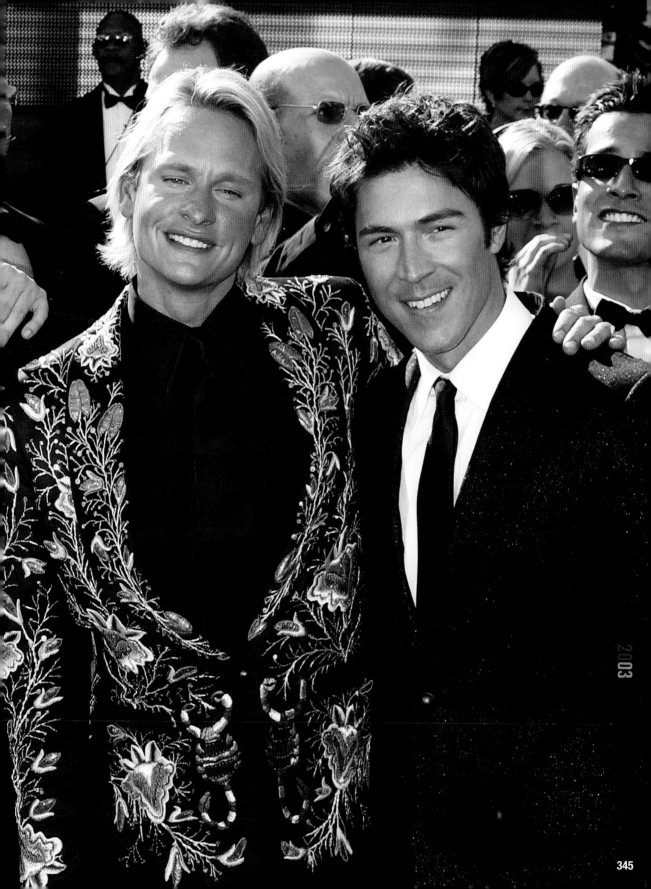

2003

345

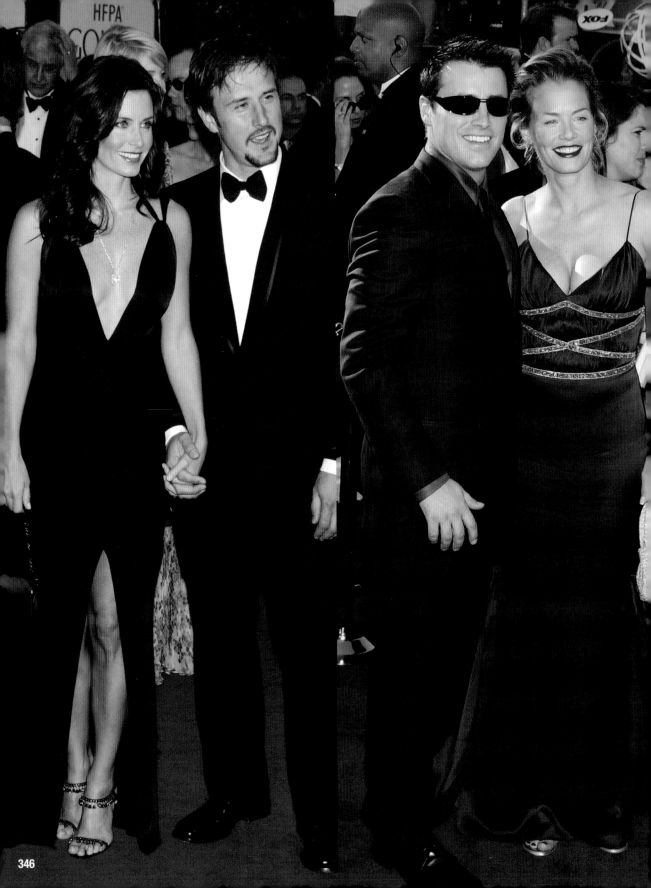

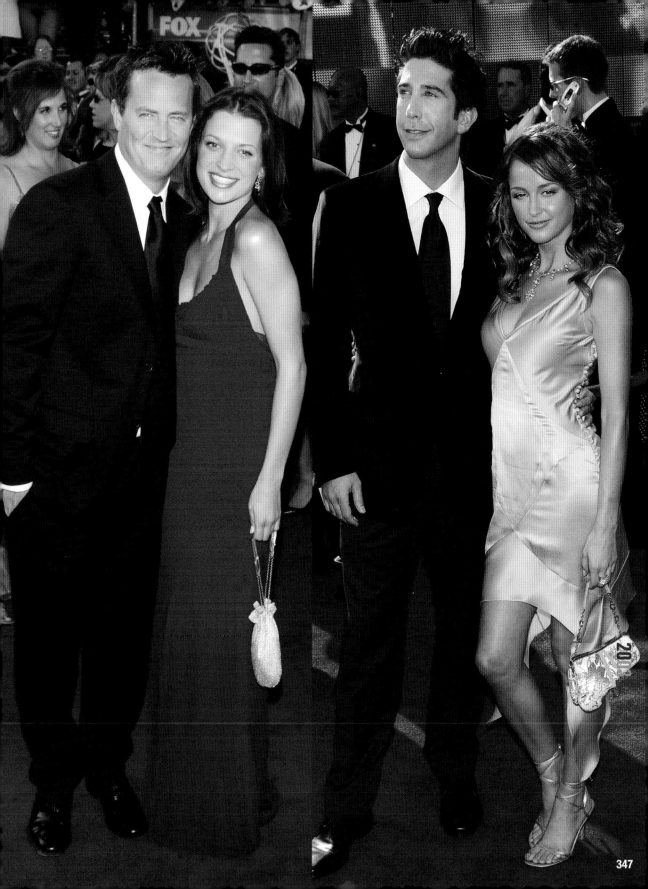

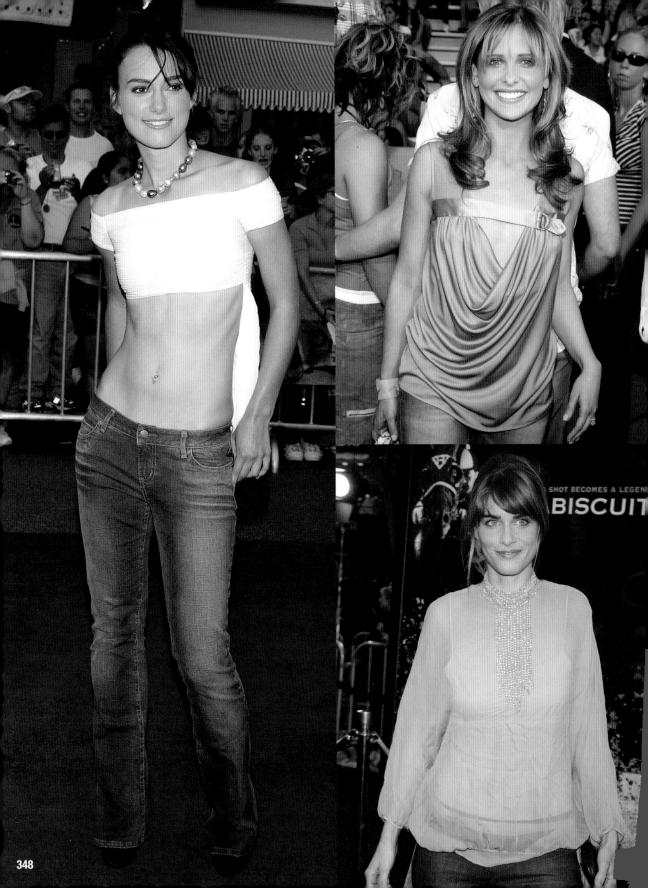

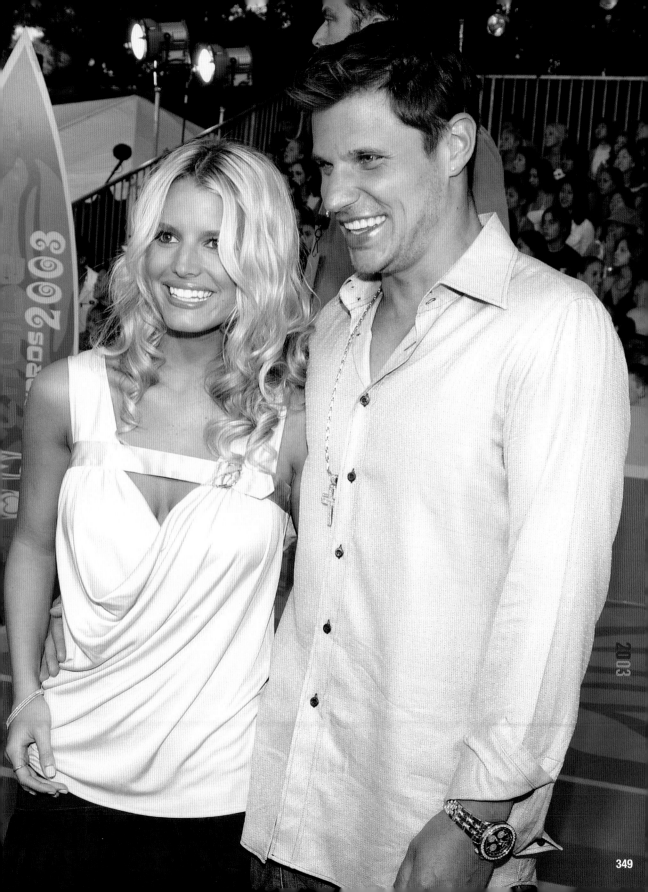

2003

349

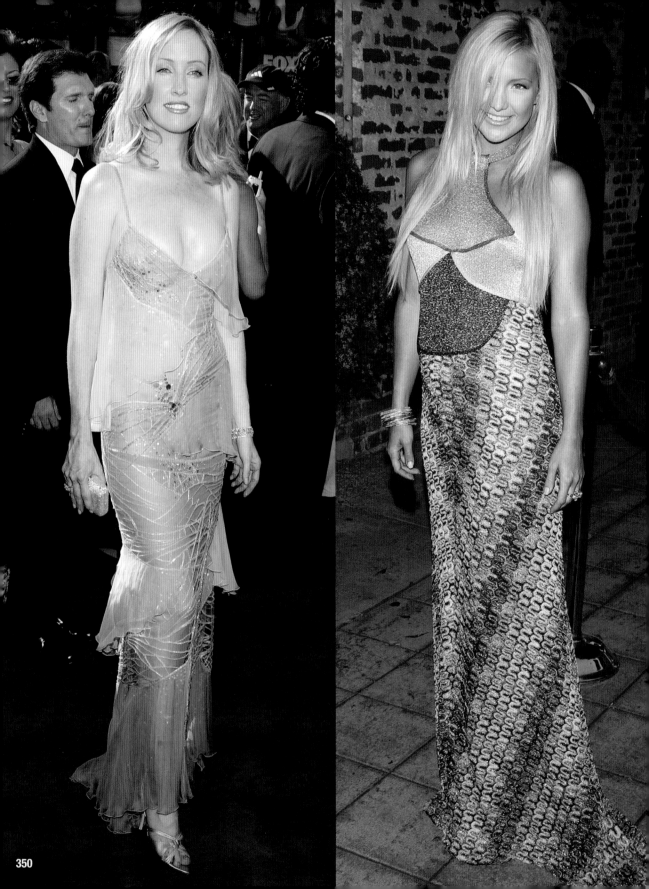

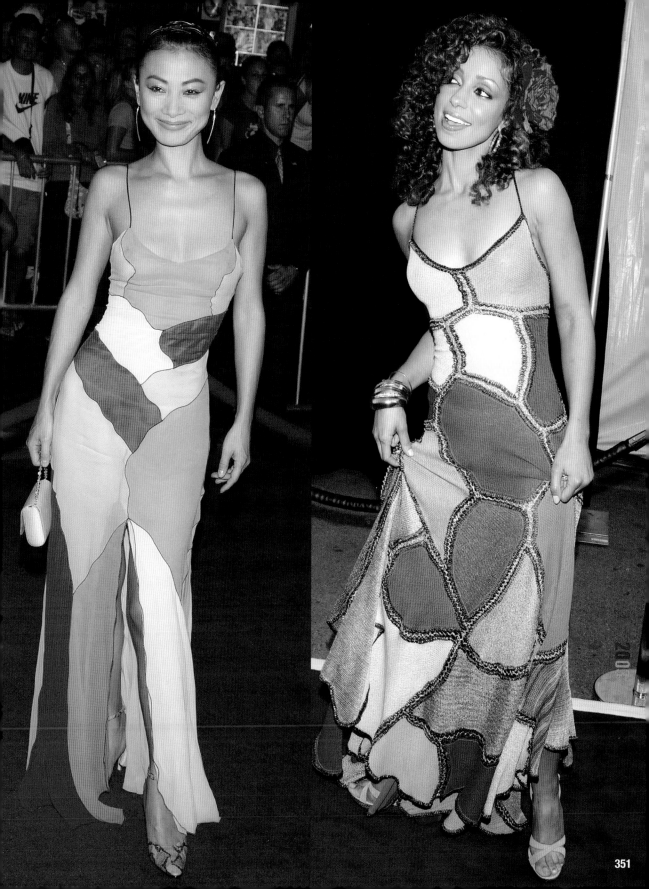

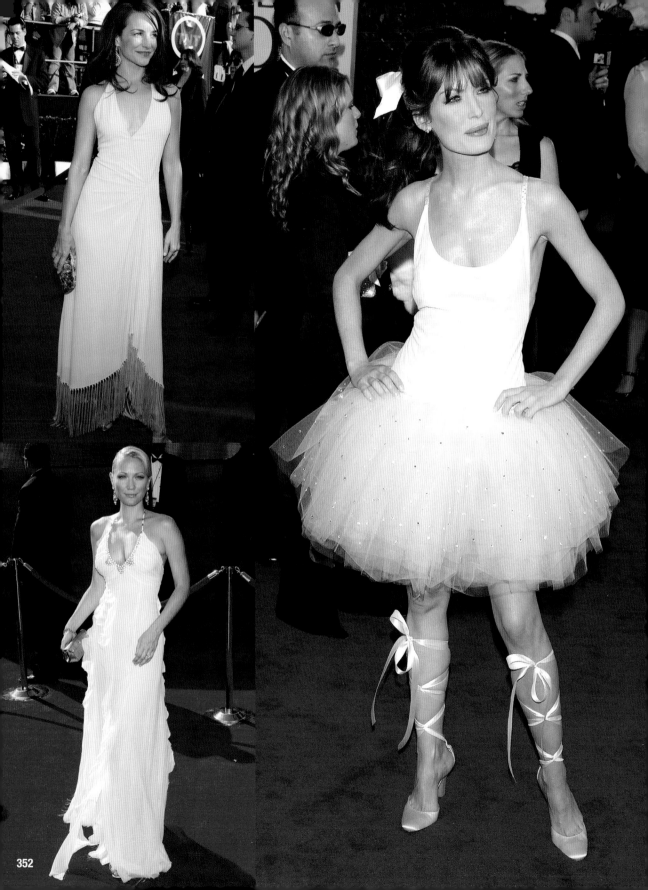

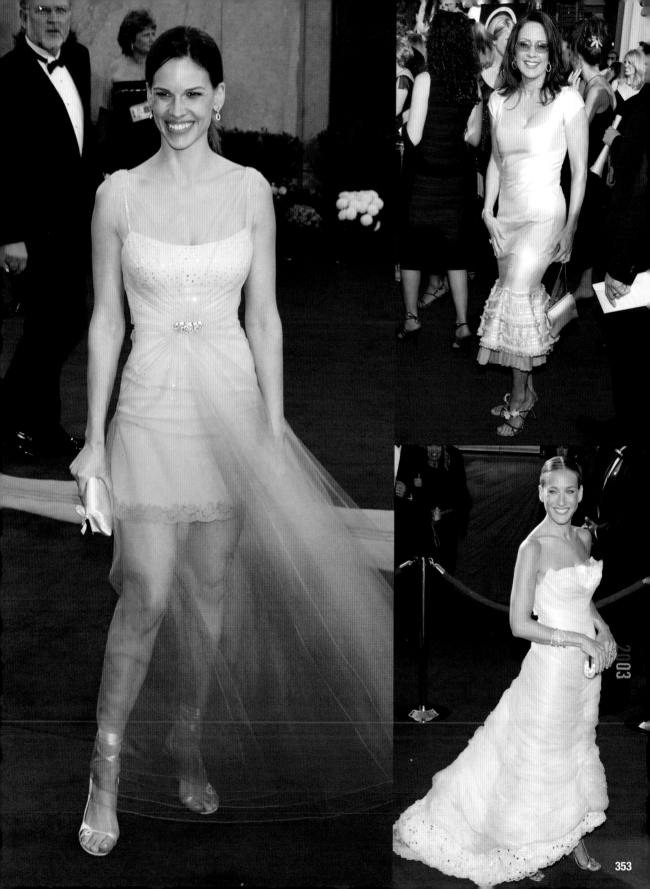

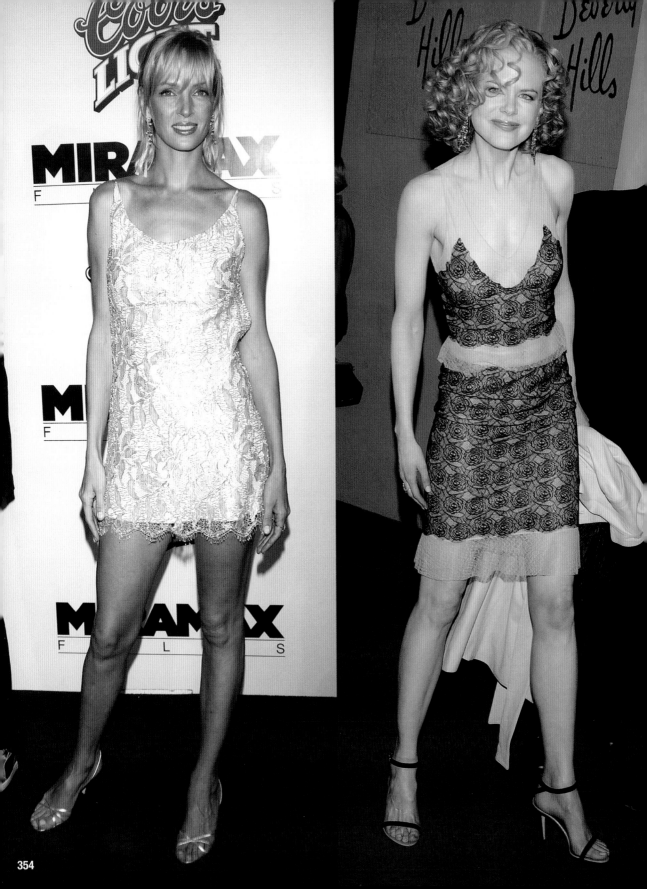

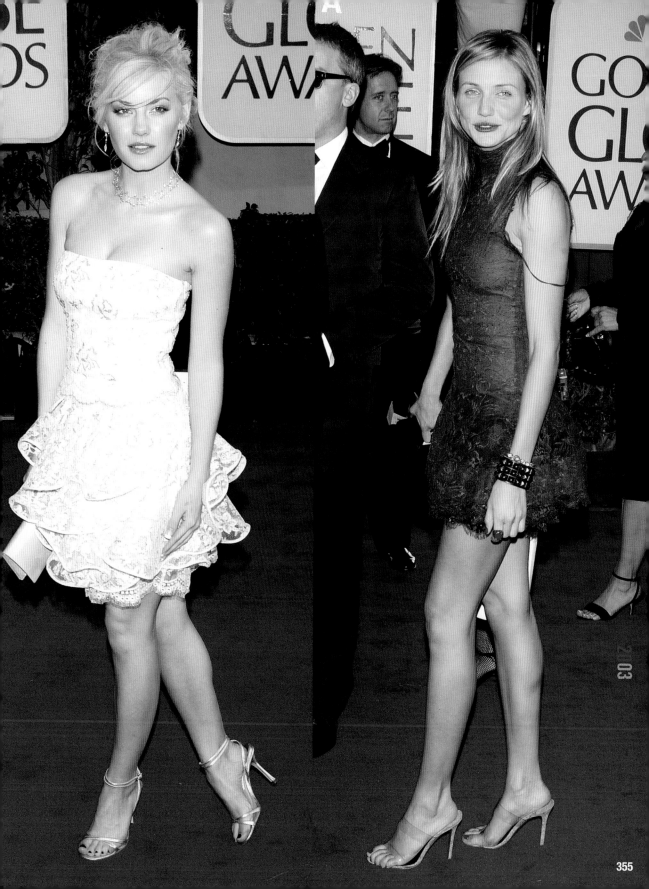

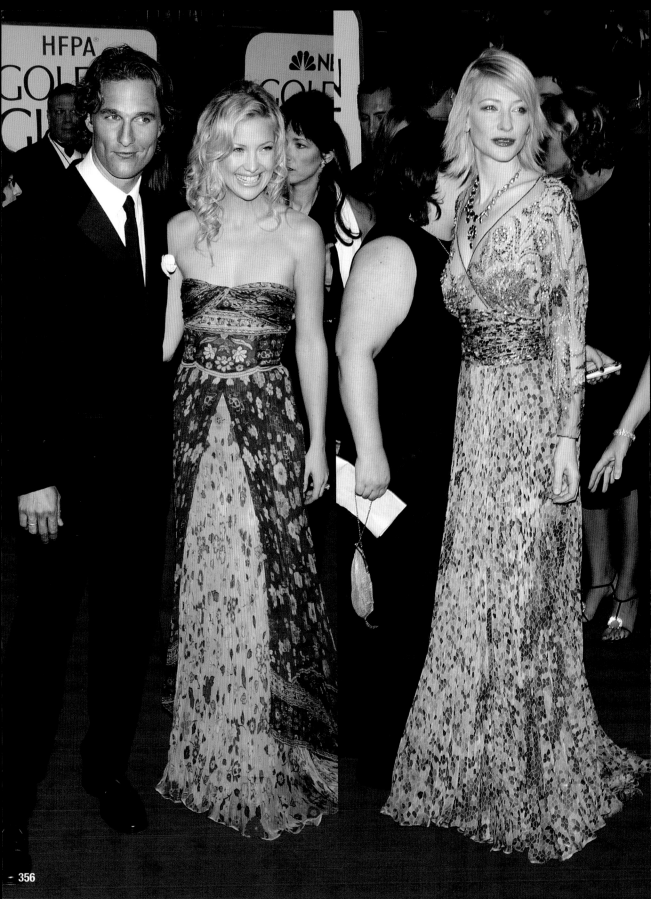

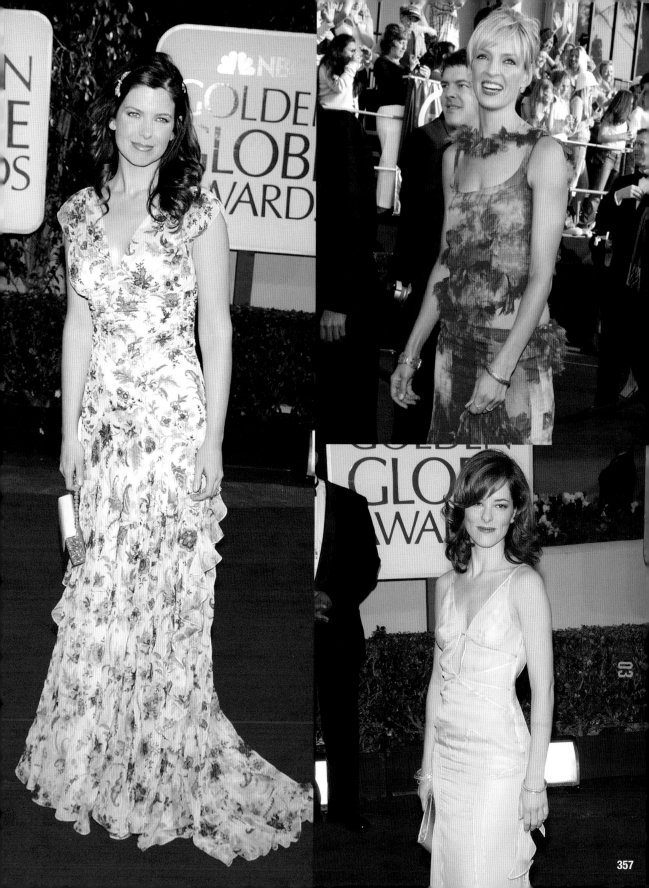

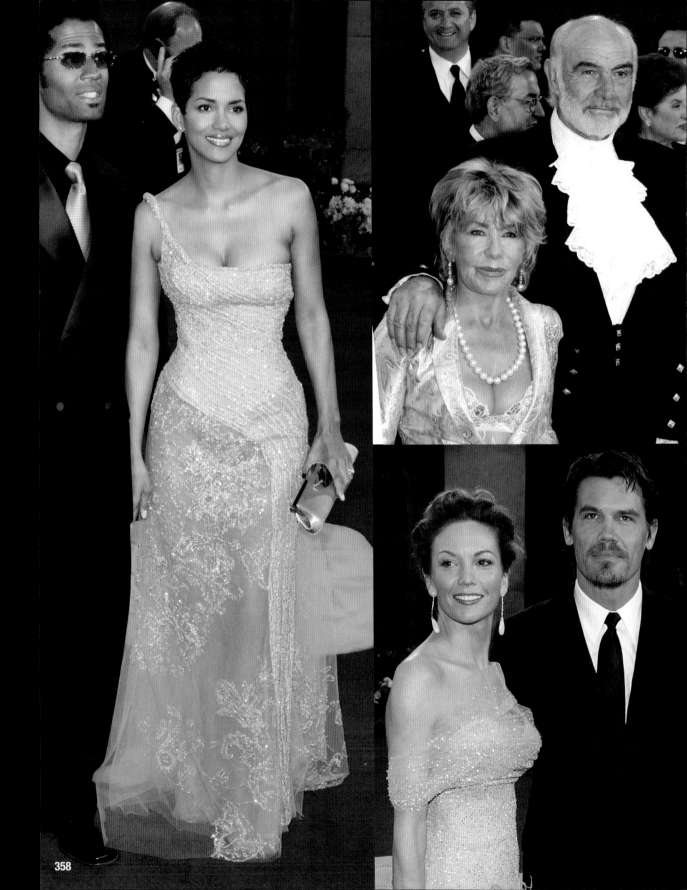

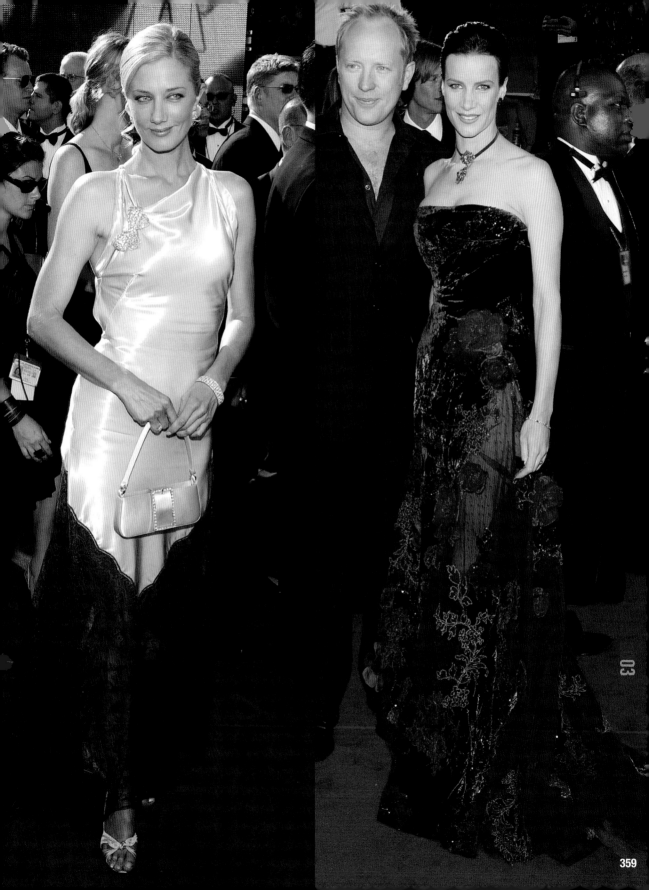

03

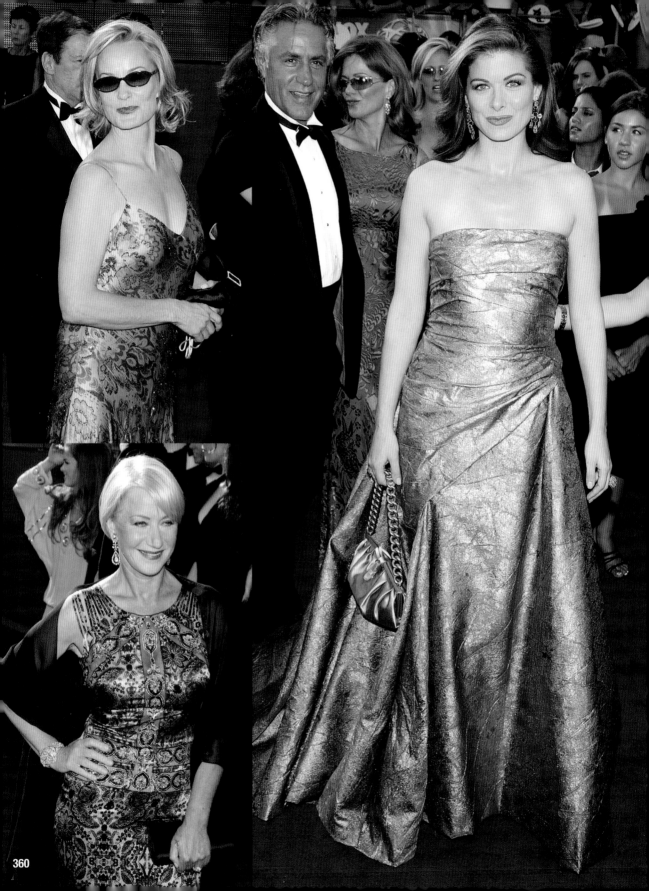

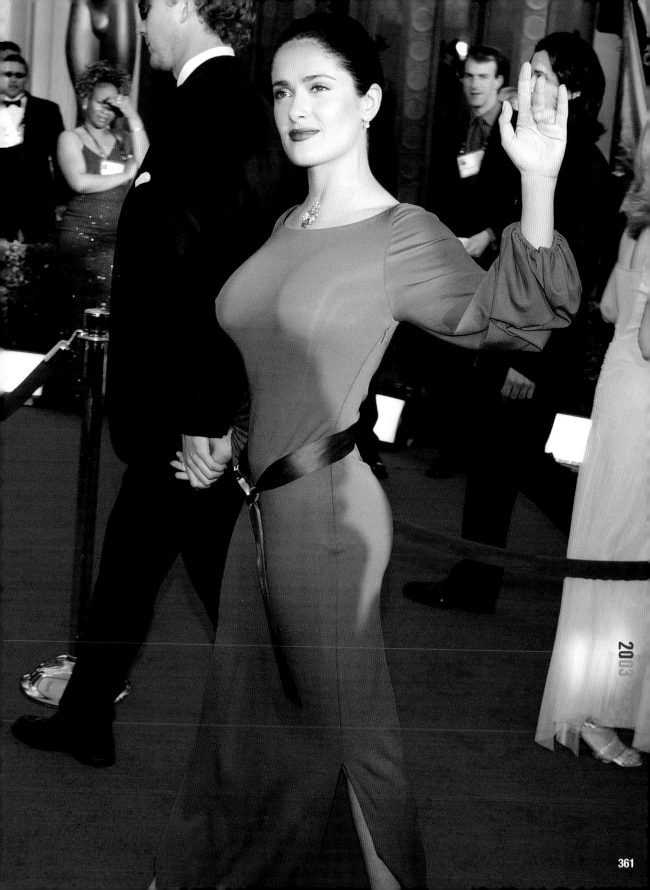

2003

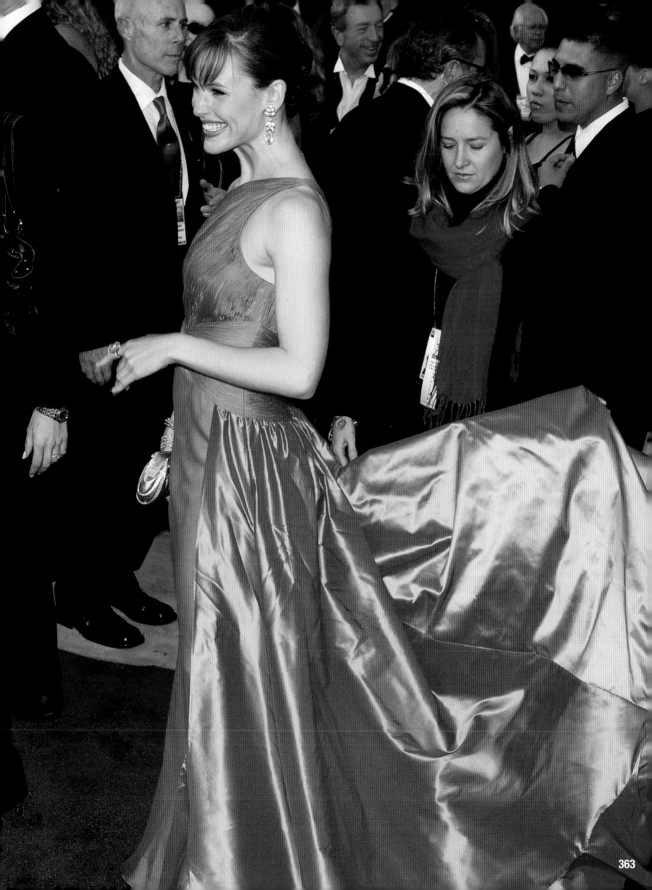

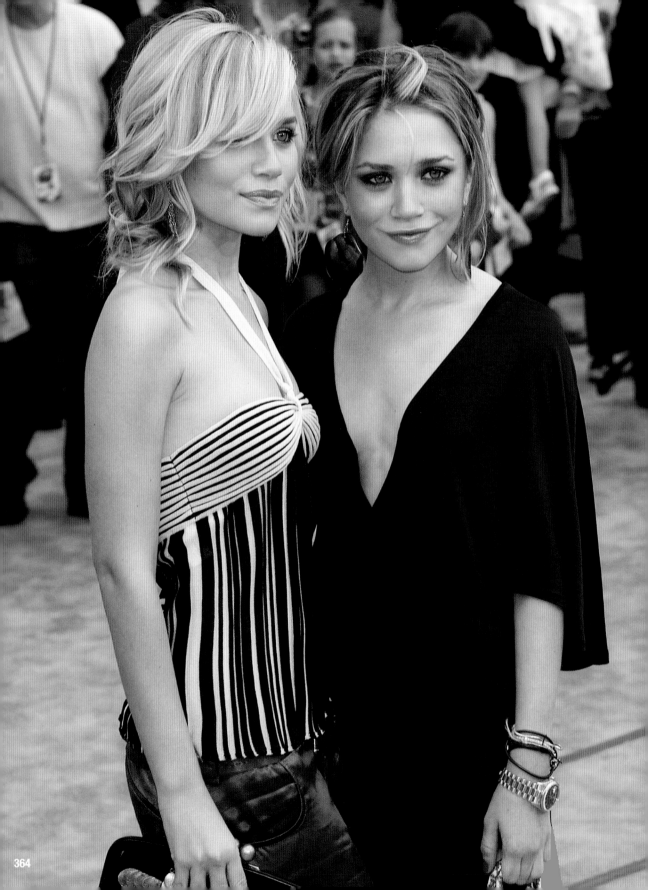

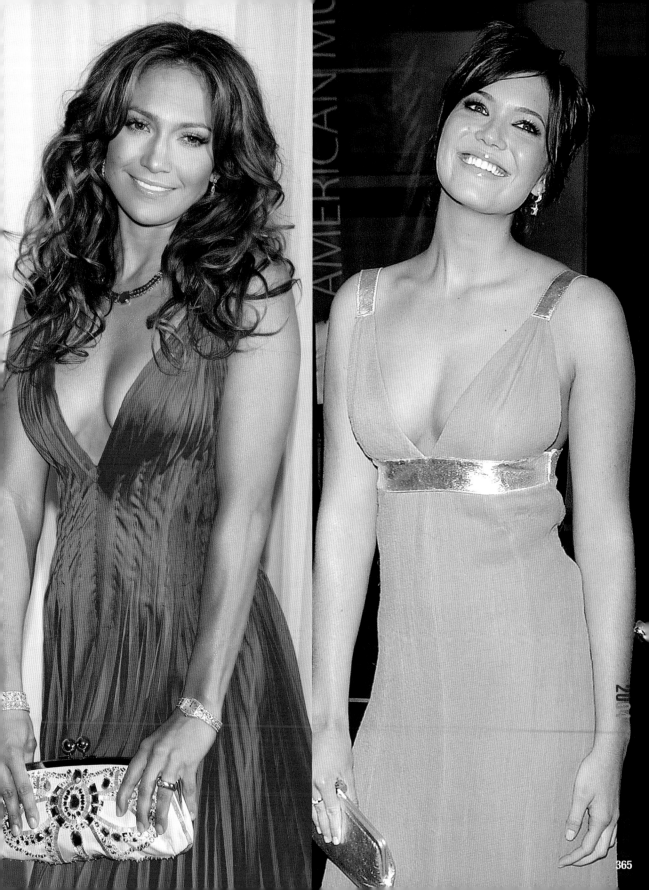

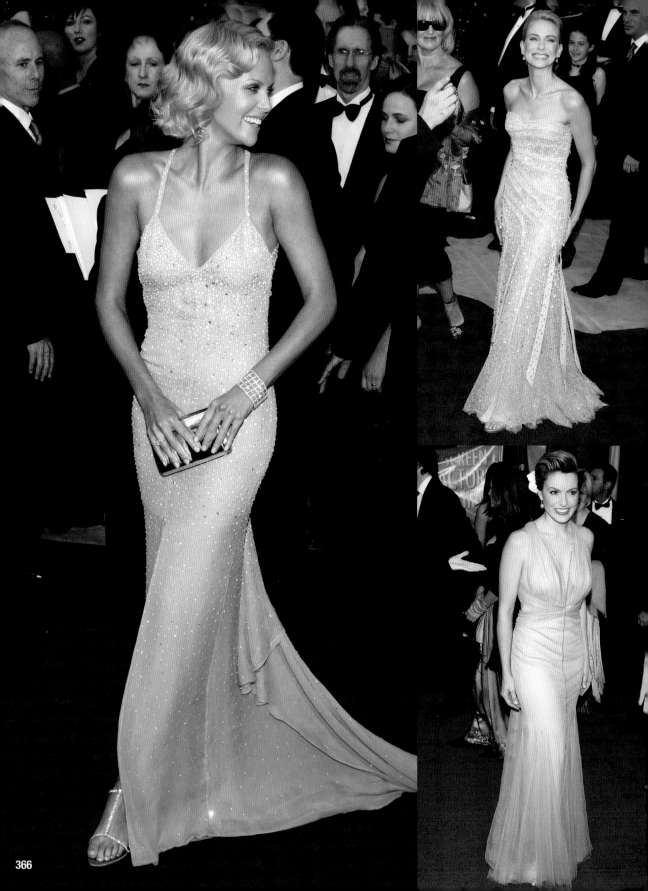

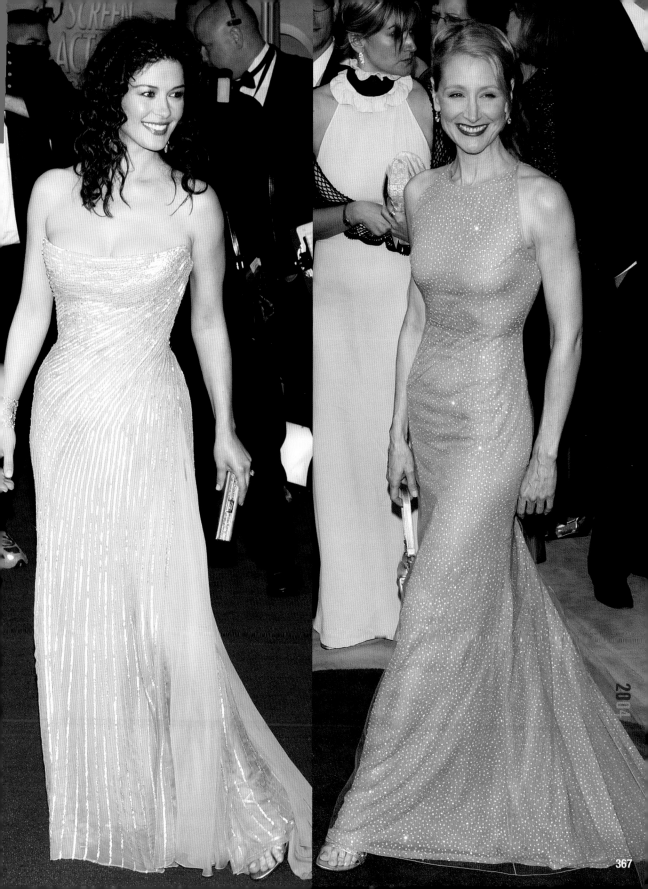

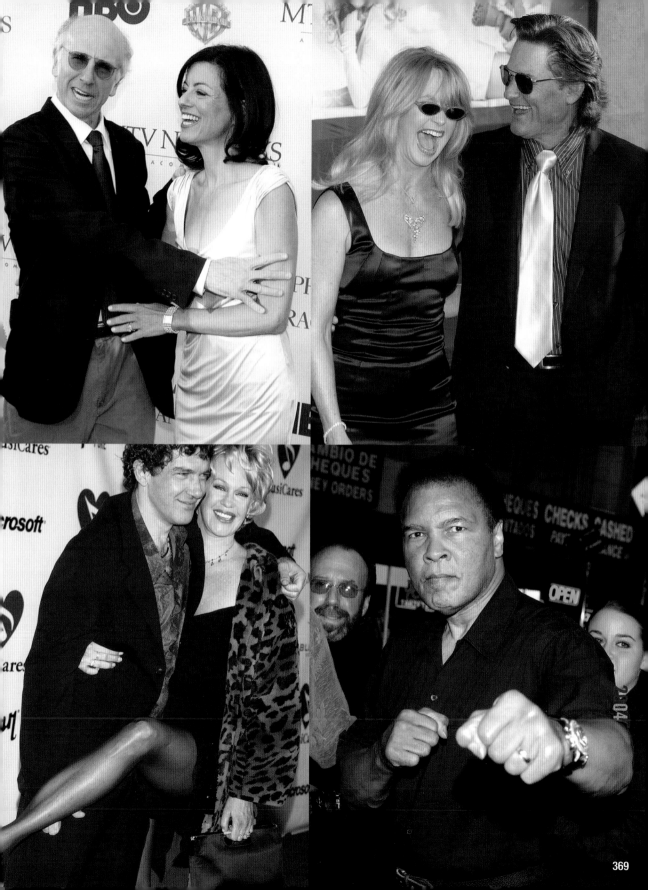

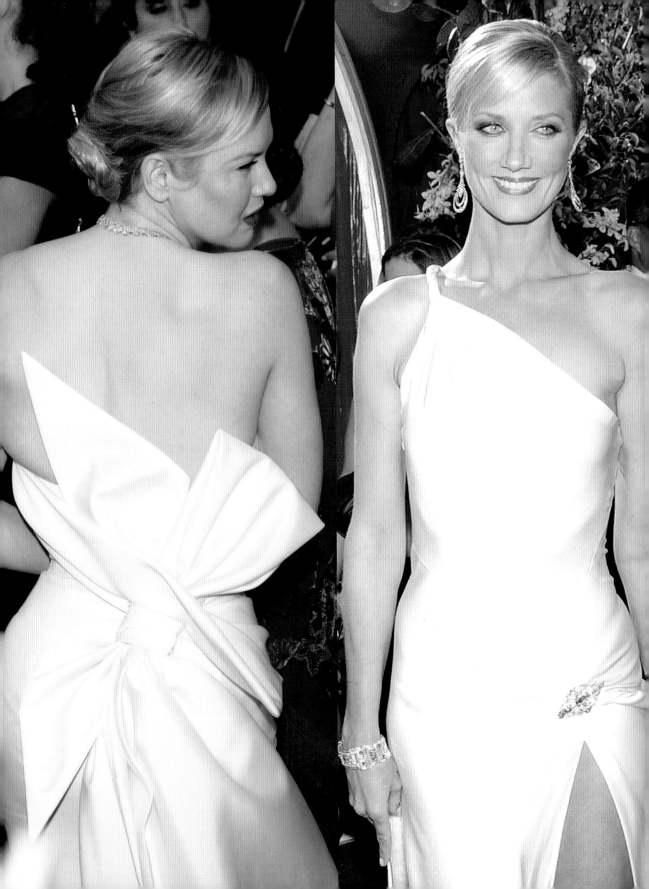

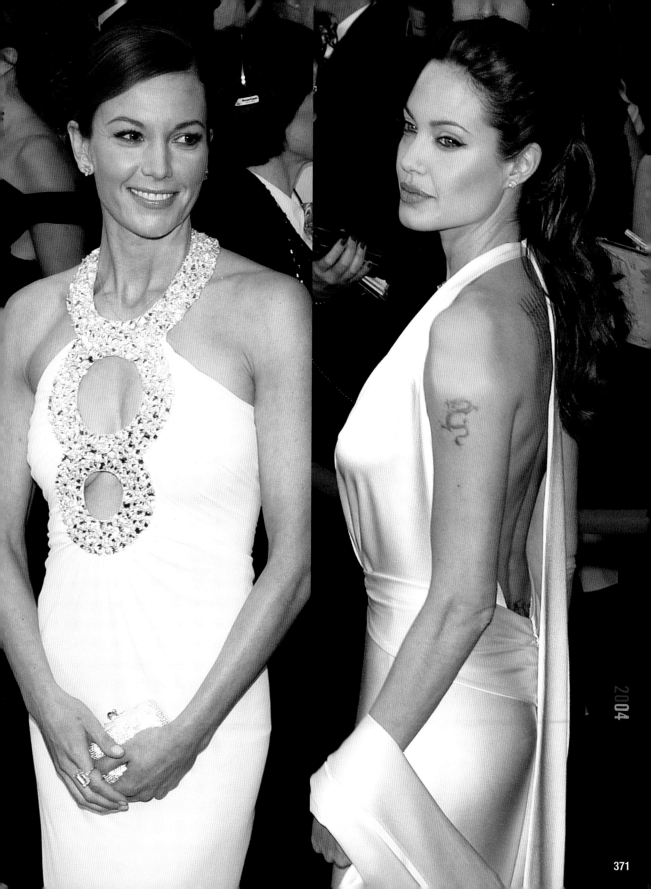

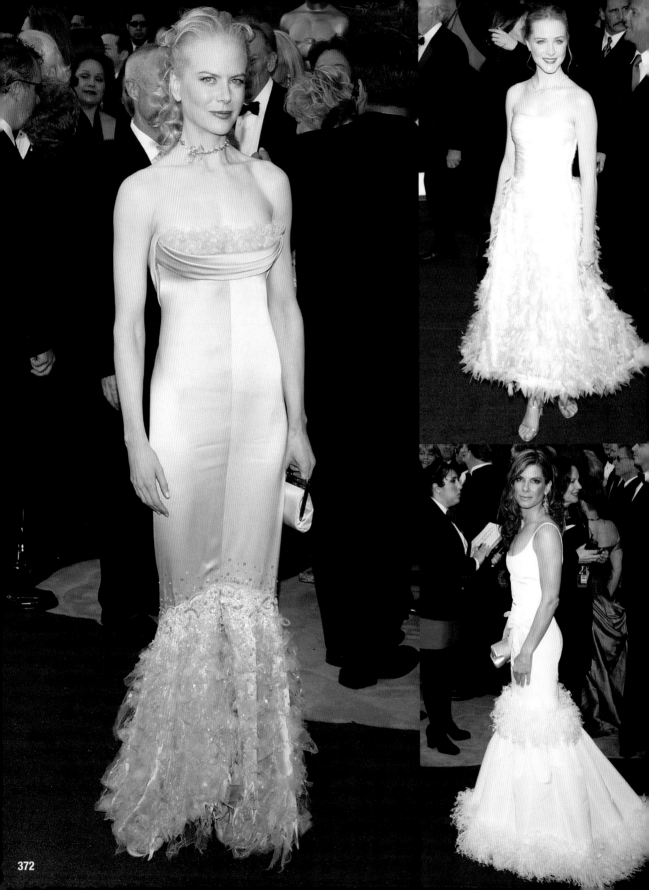

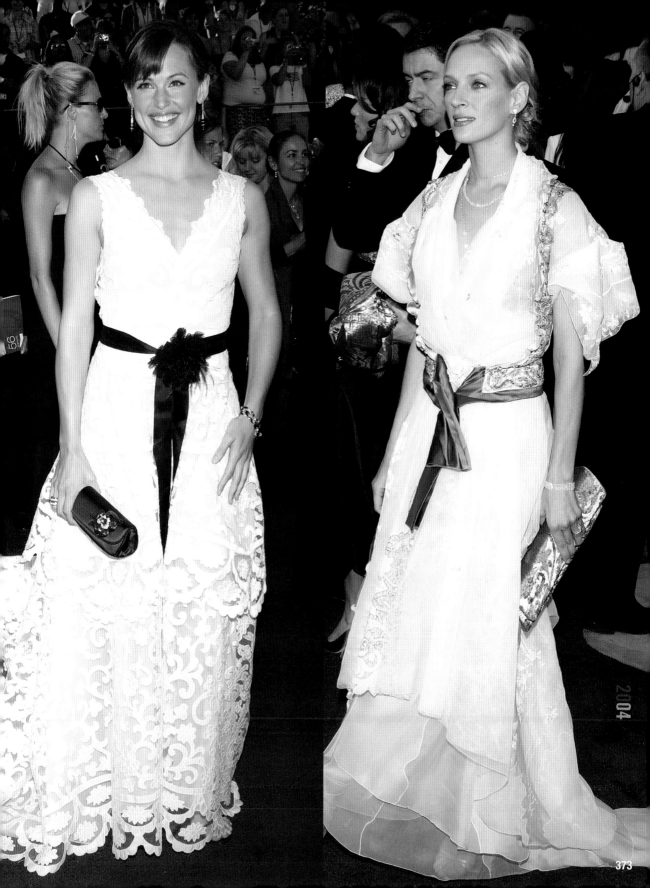

2004

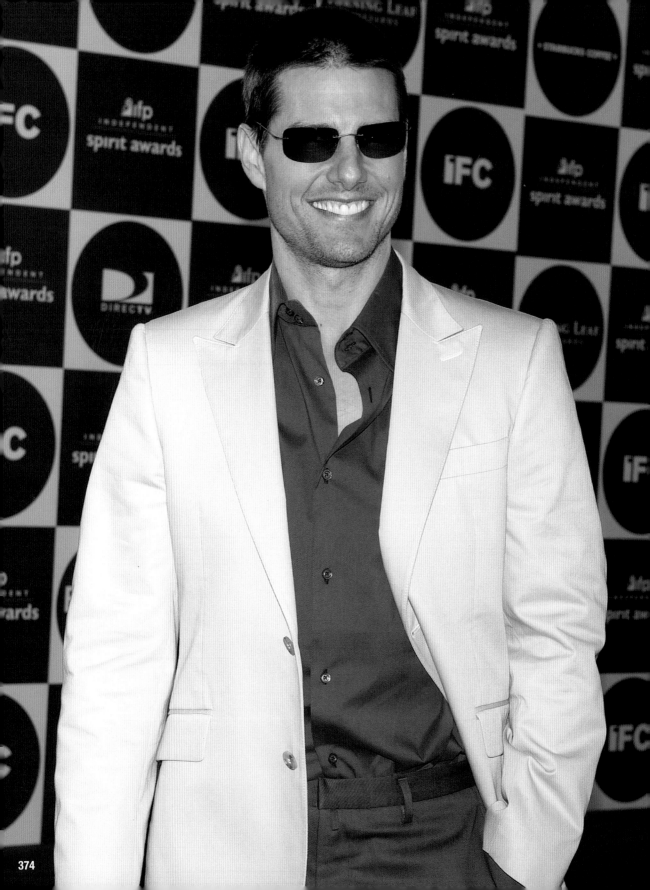

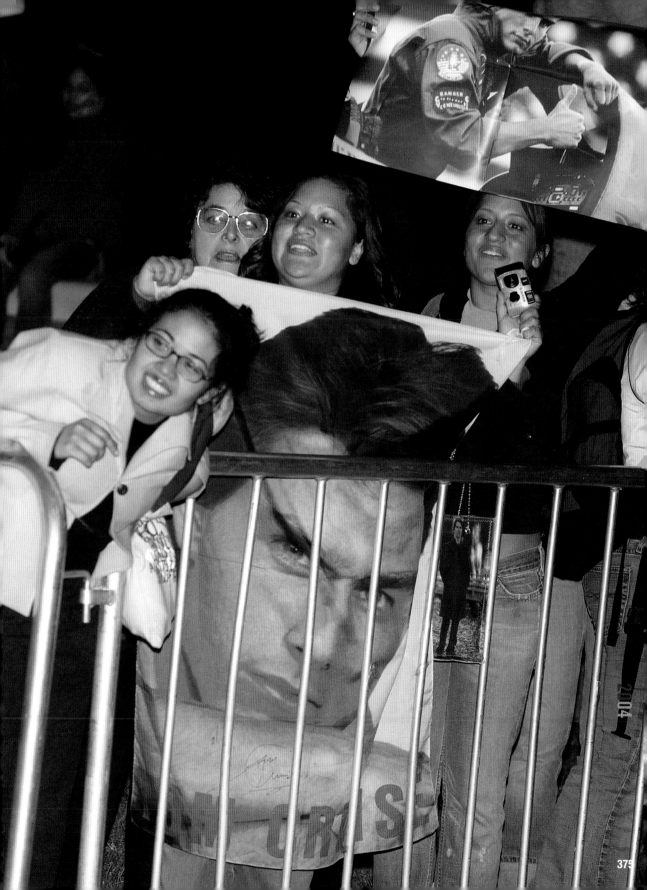

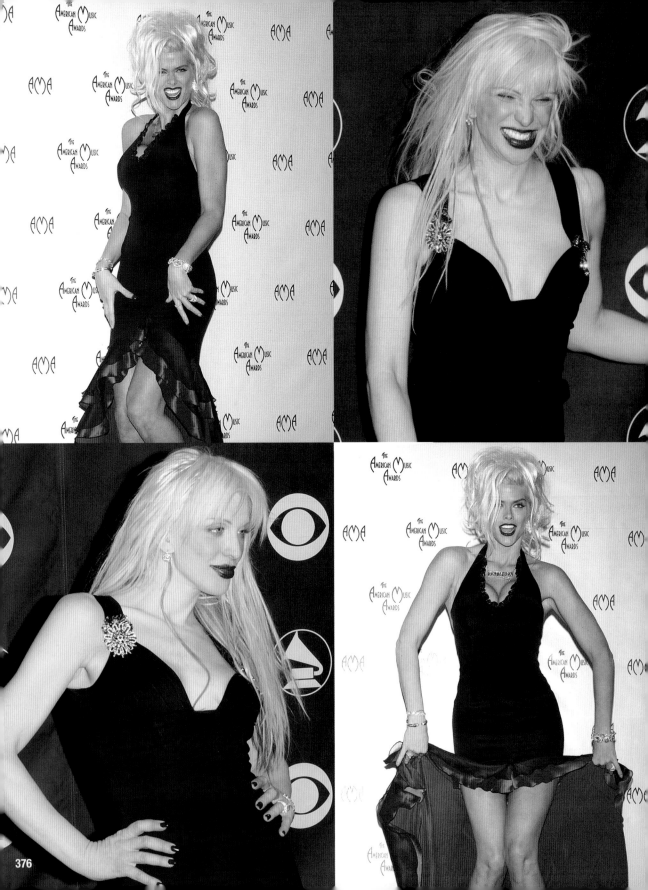

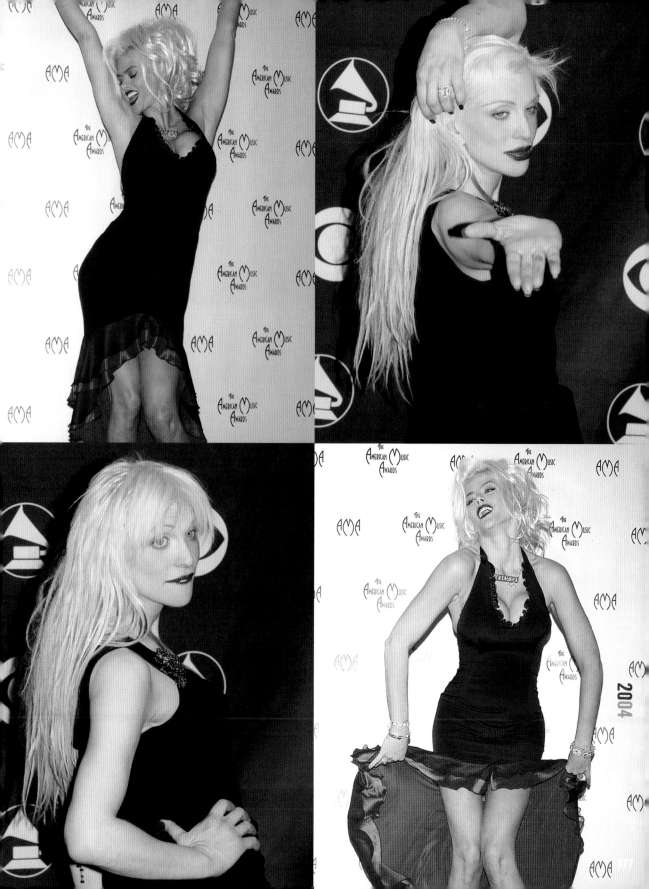

2004

2004

379

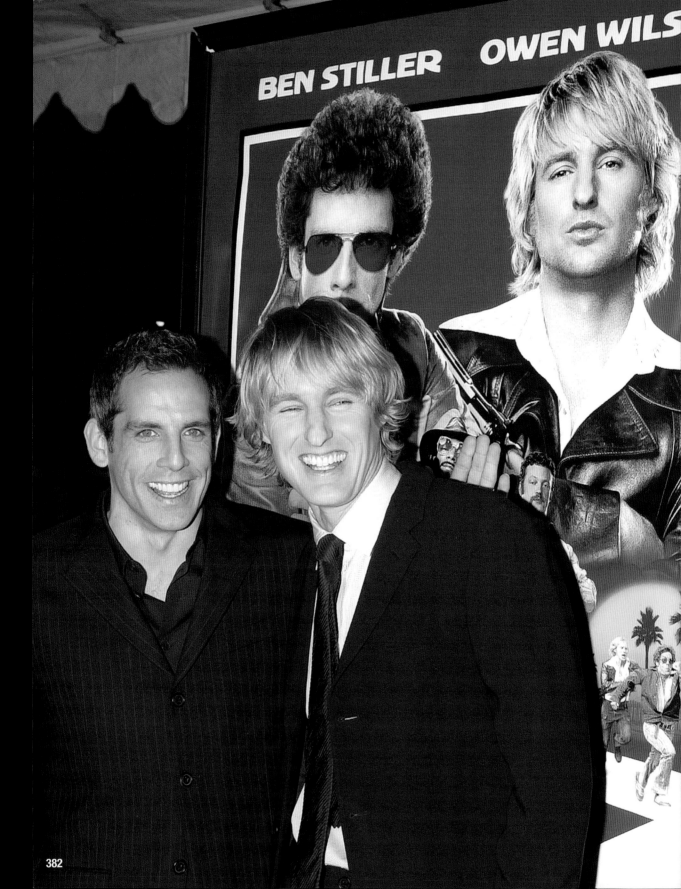

BEN STILLER OWEN WILS

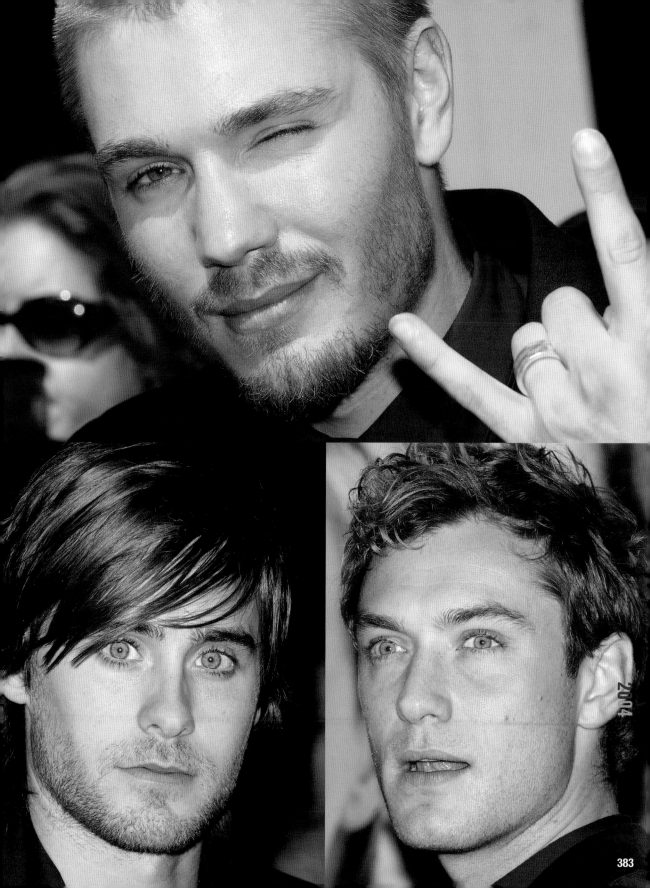

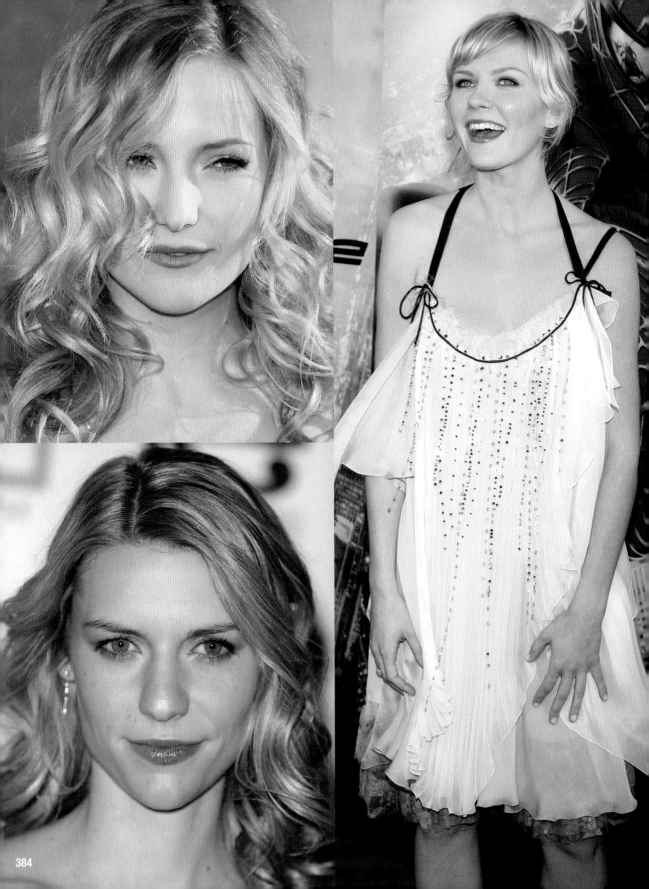

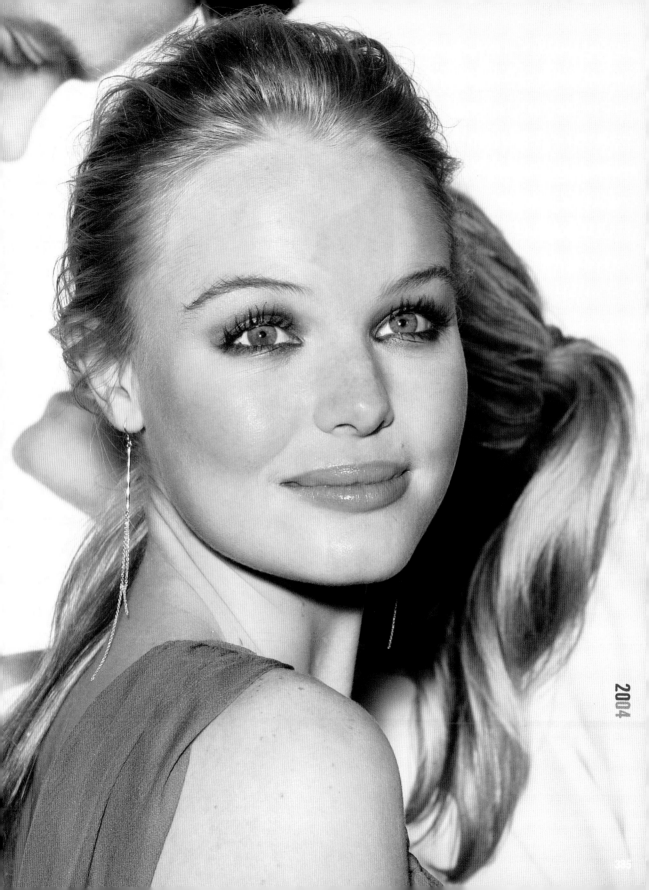

2004

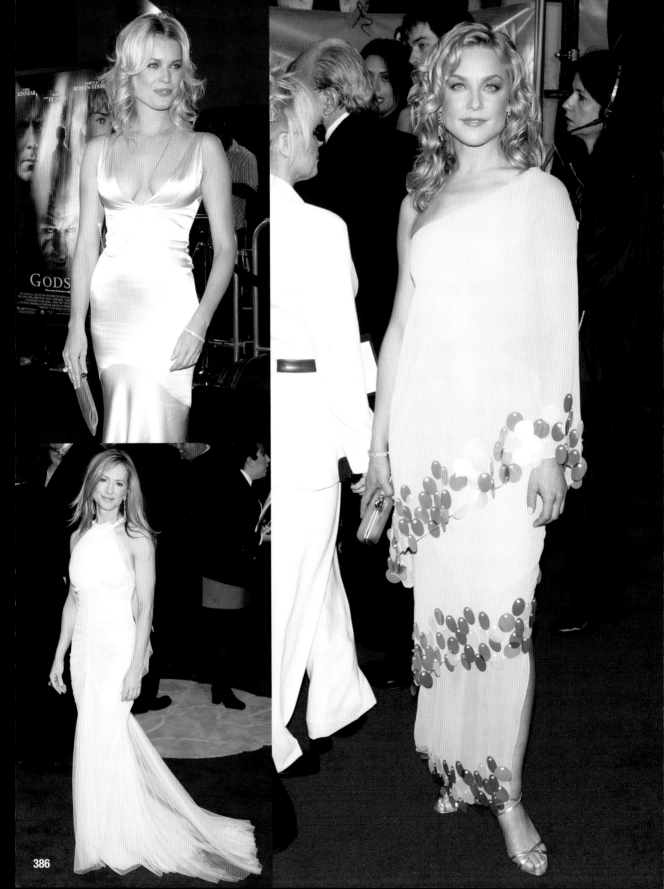

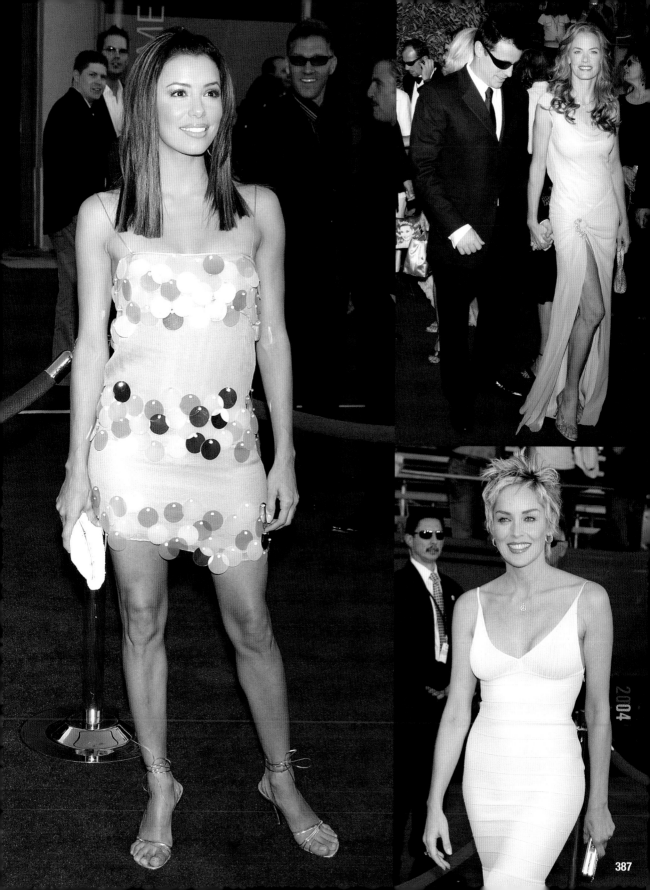

2004

387

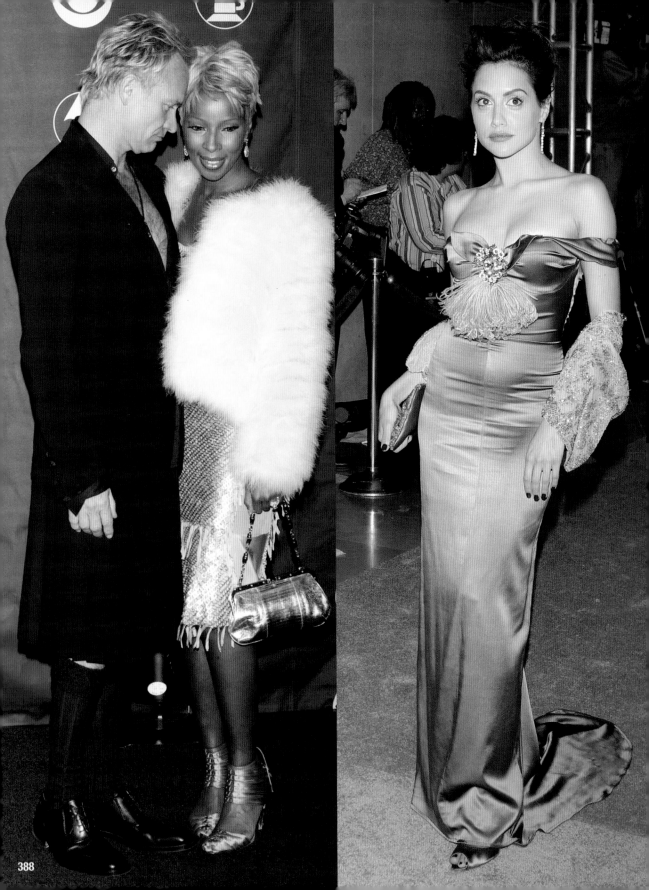

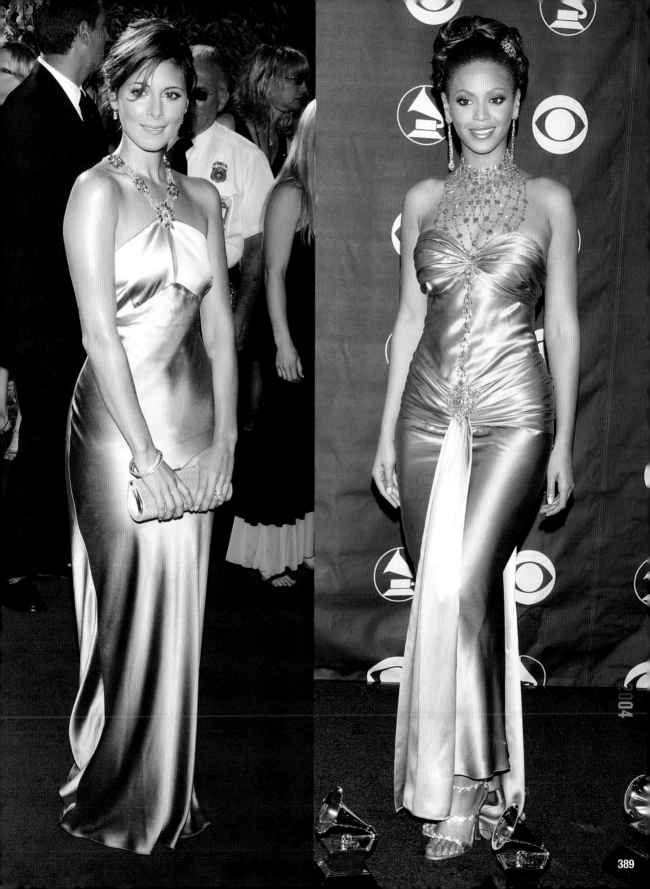

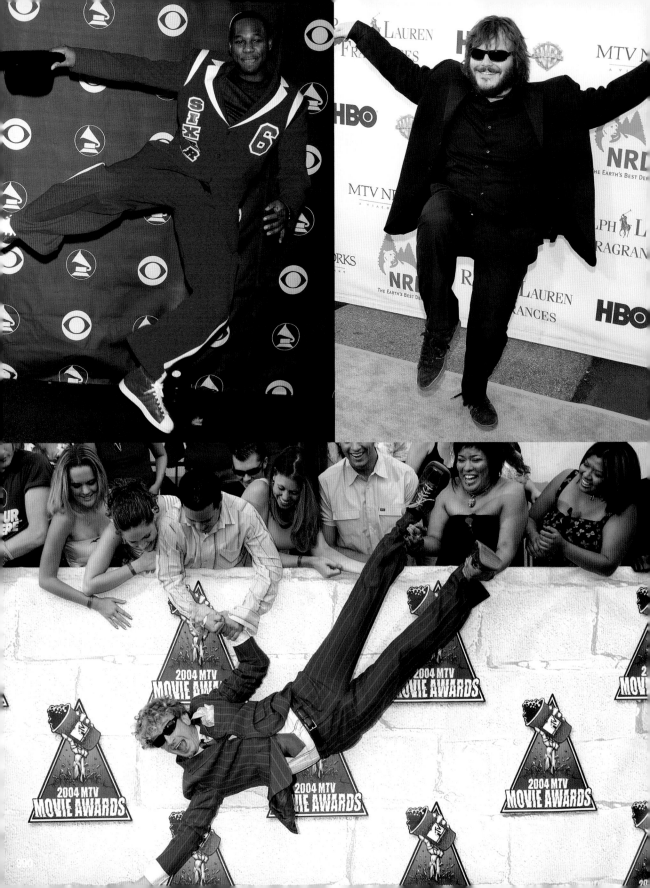

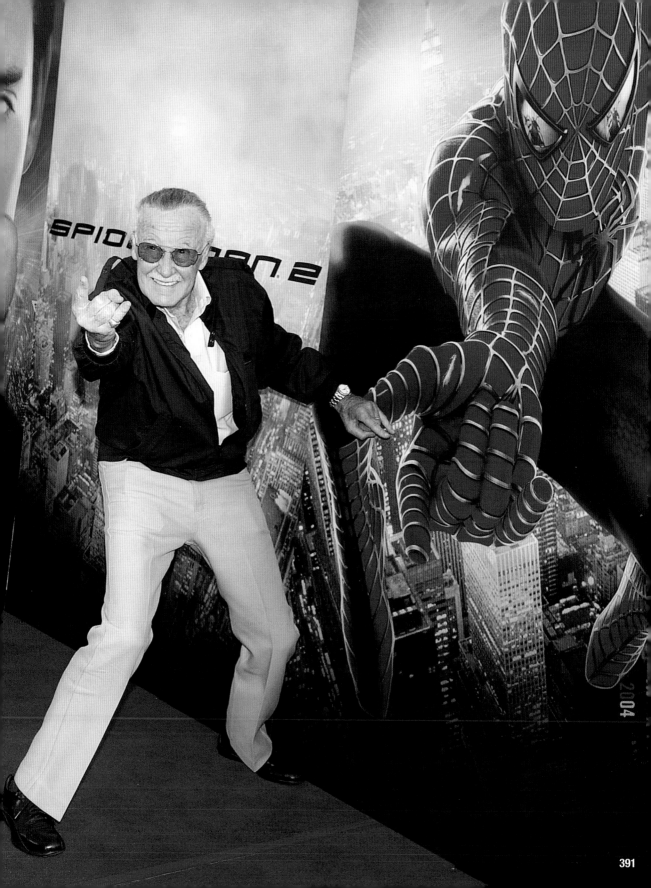

SPIDER-MAN 2

2004

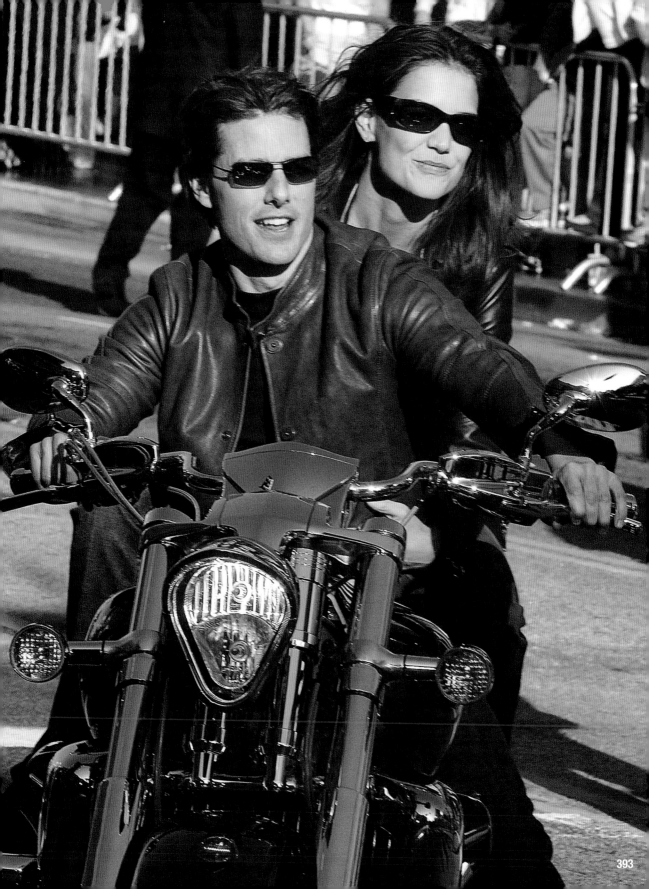

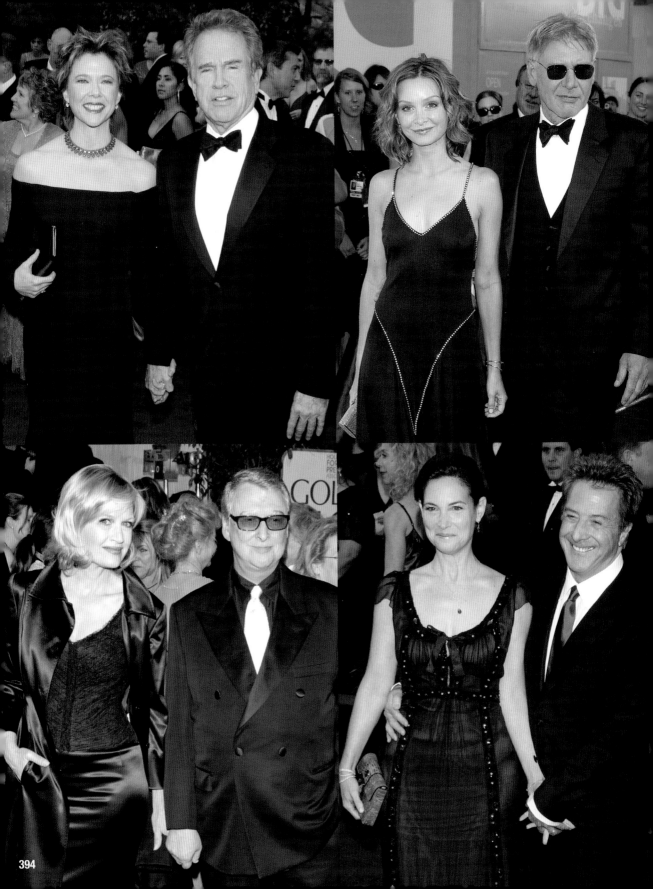

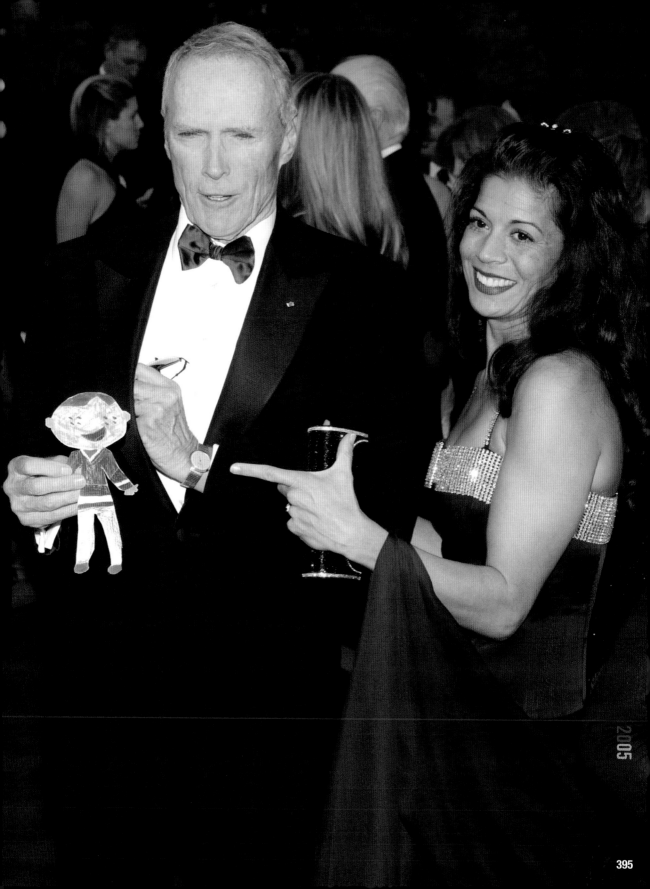

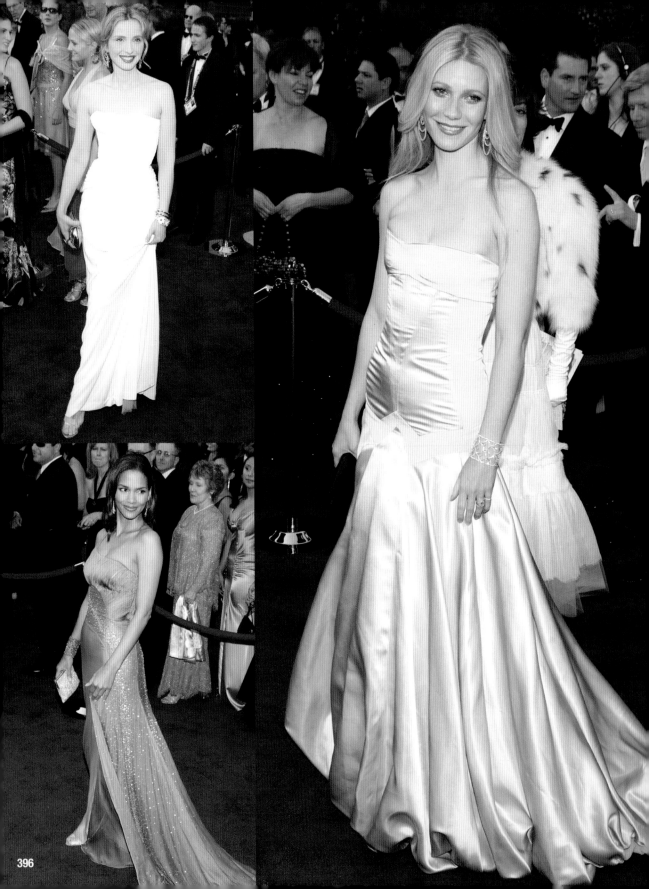

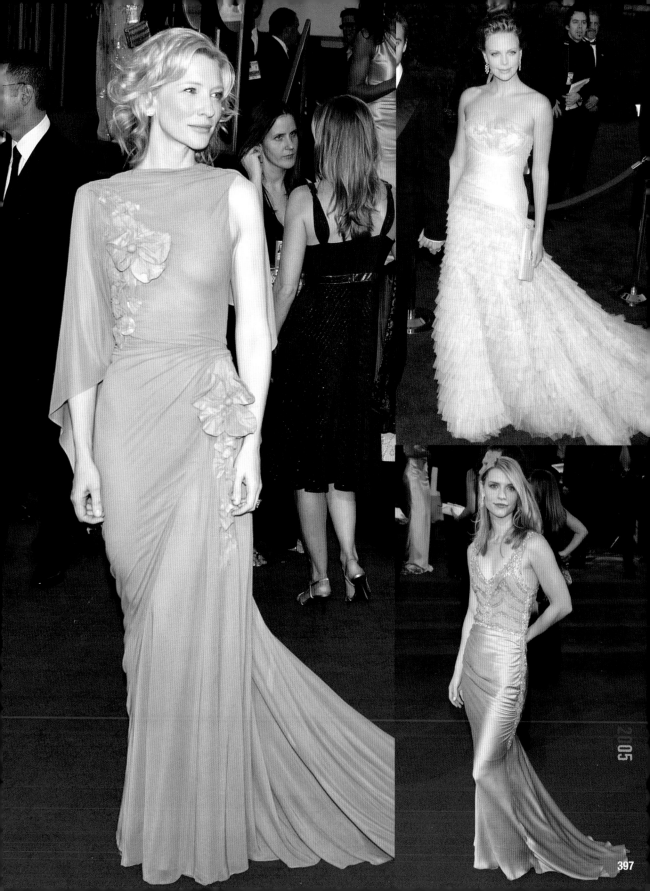

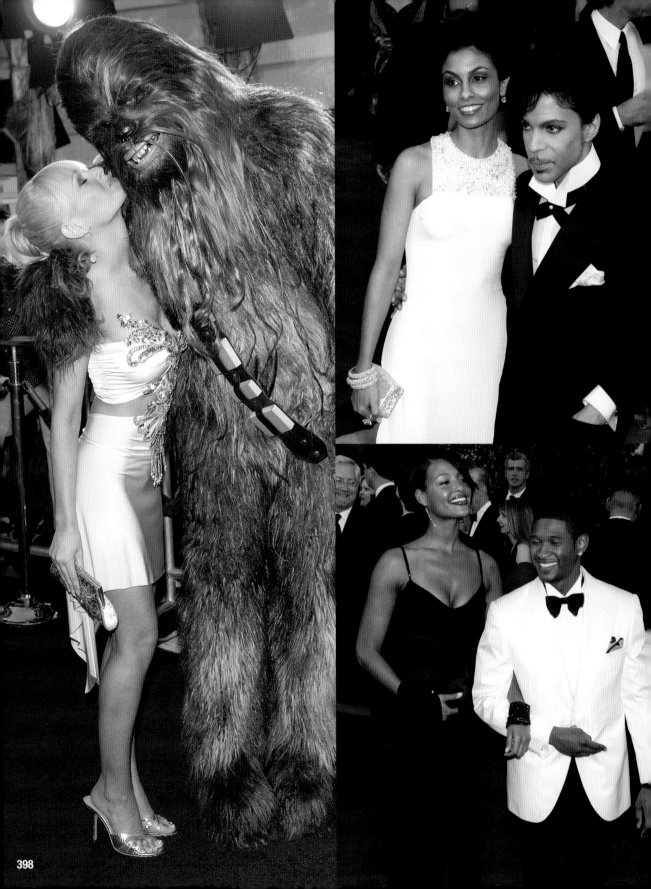

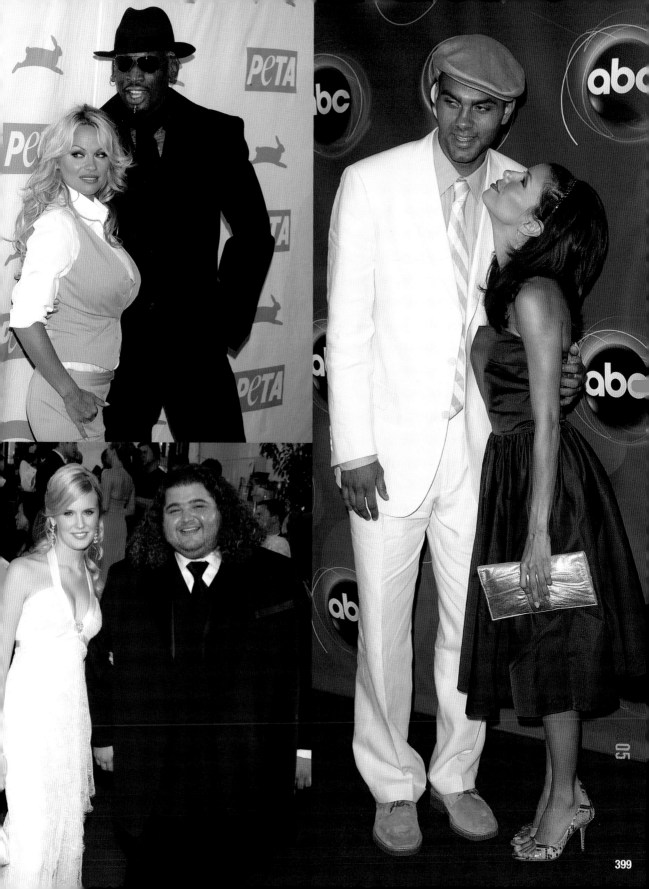

2003

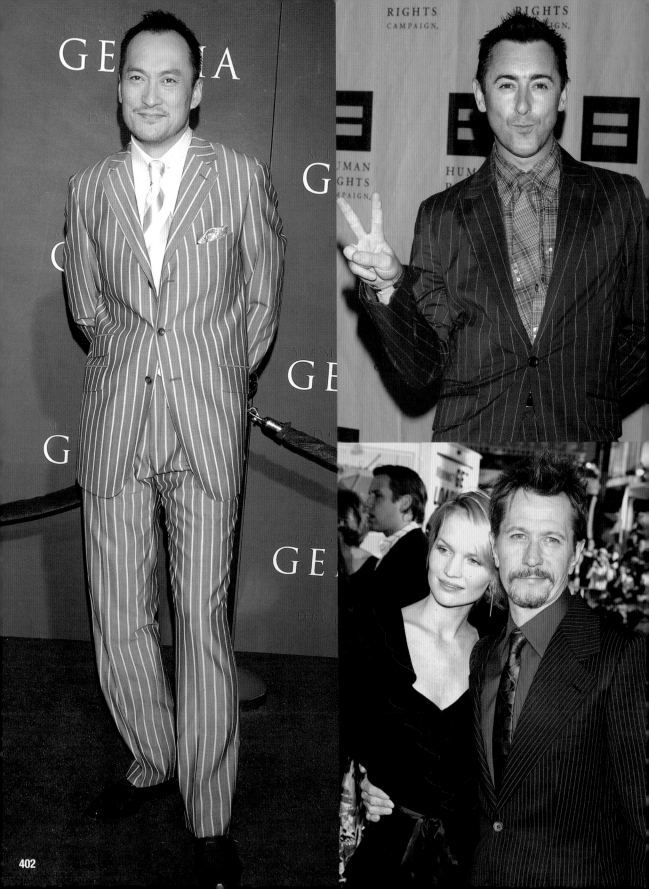

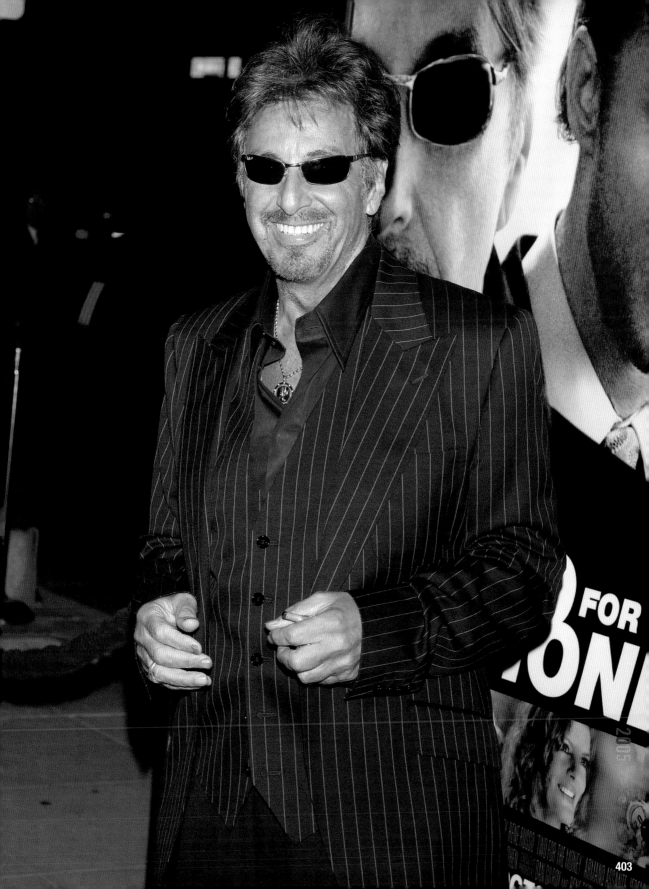

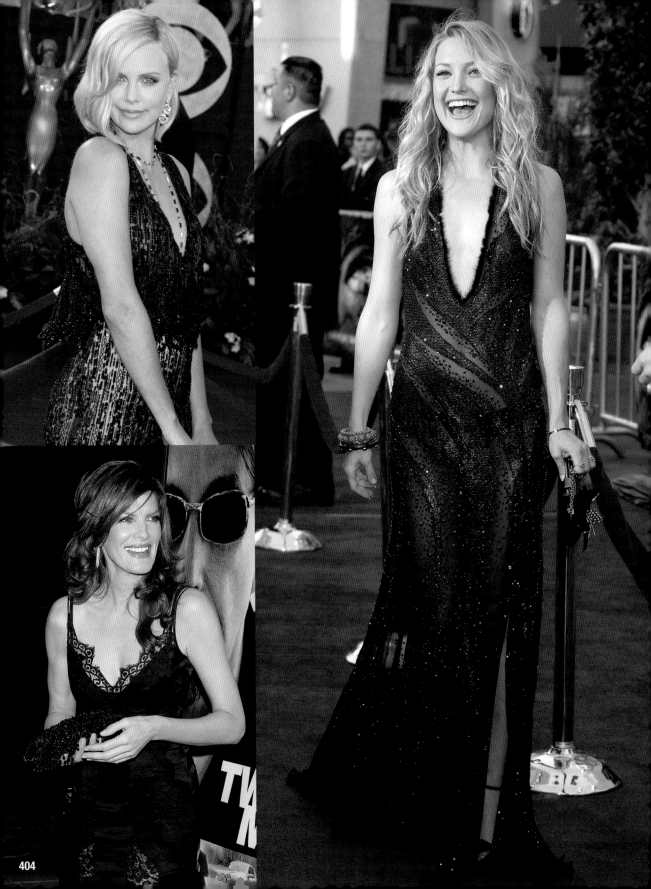

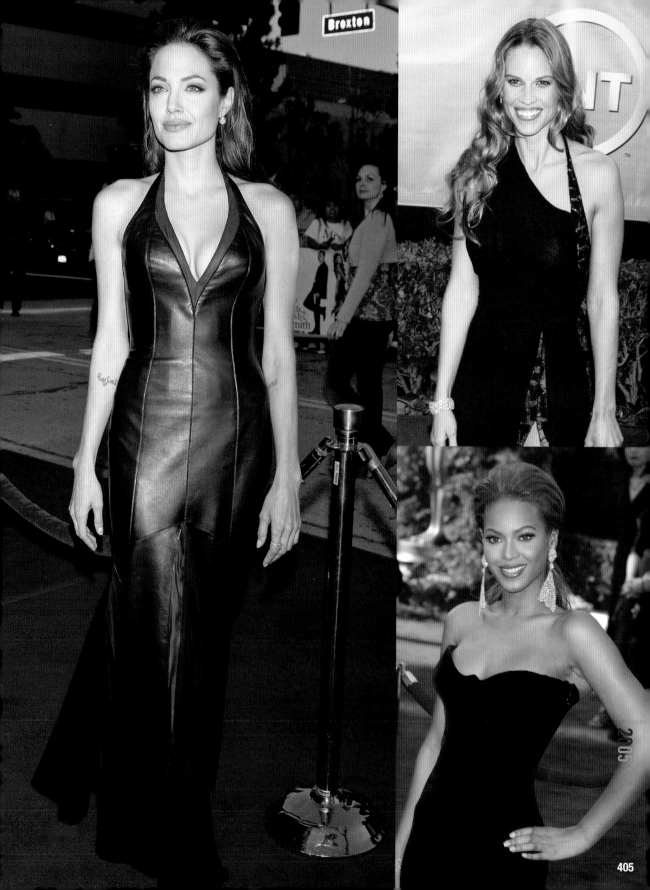

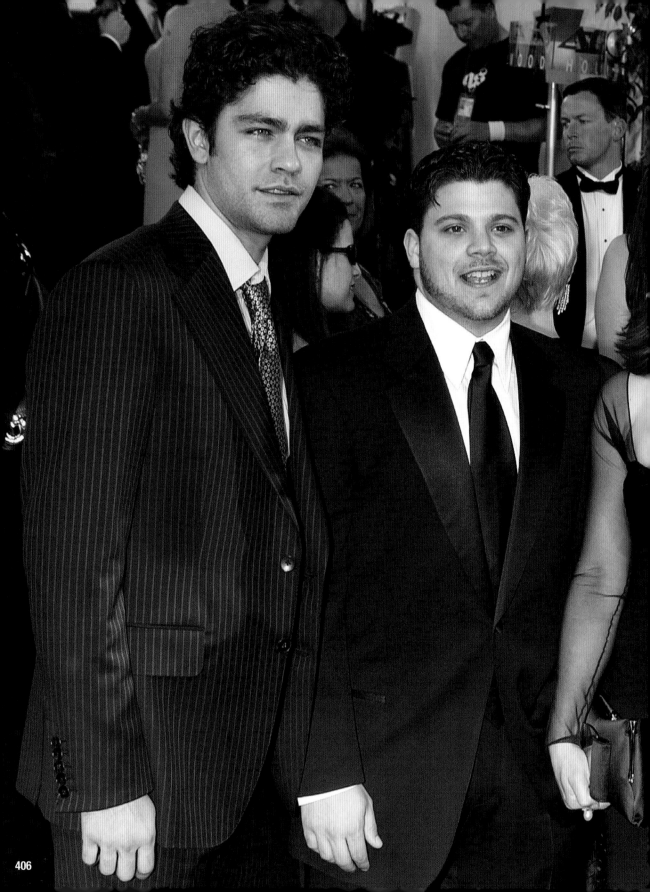

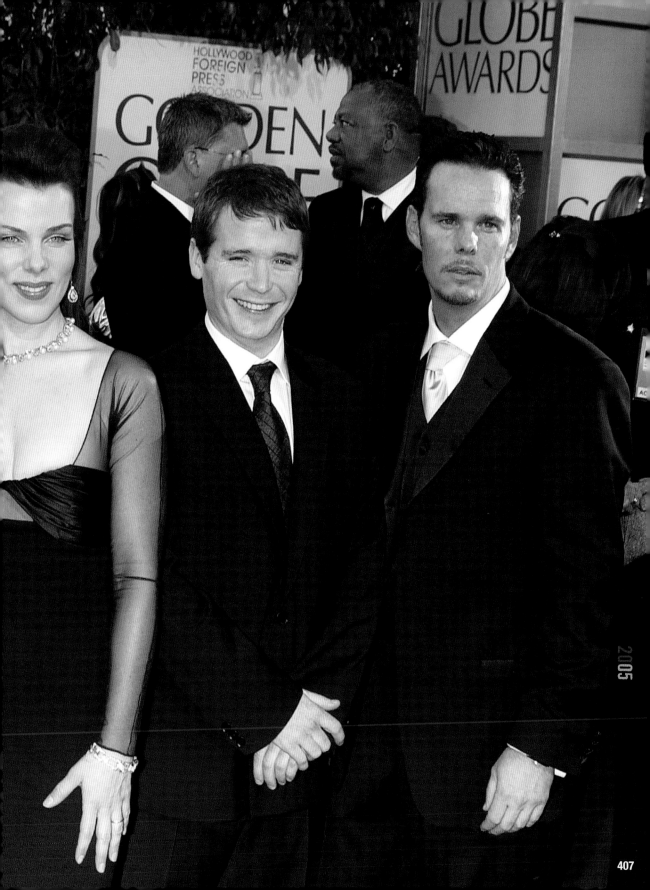

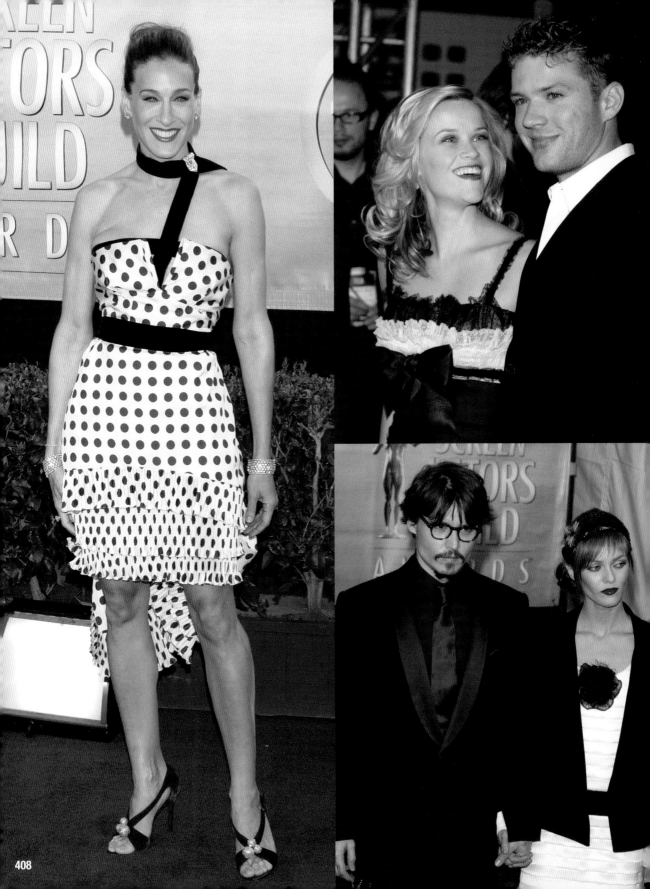

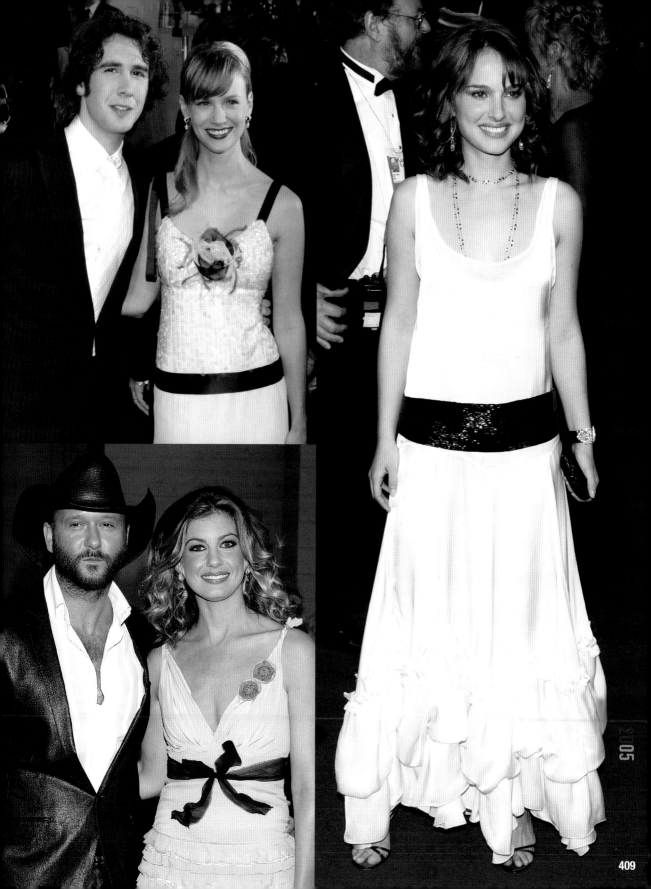

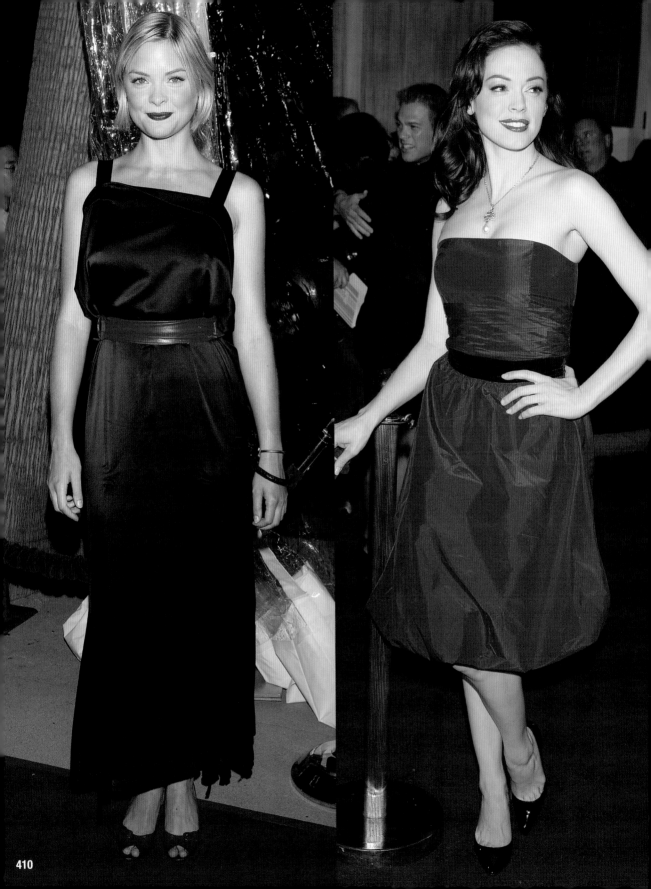

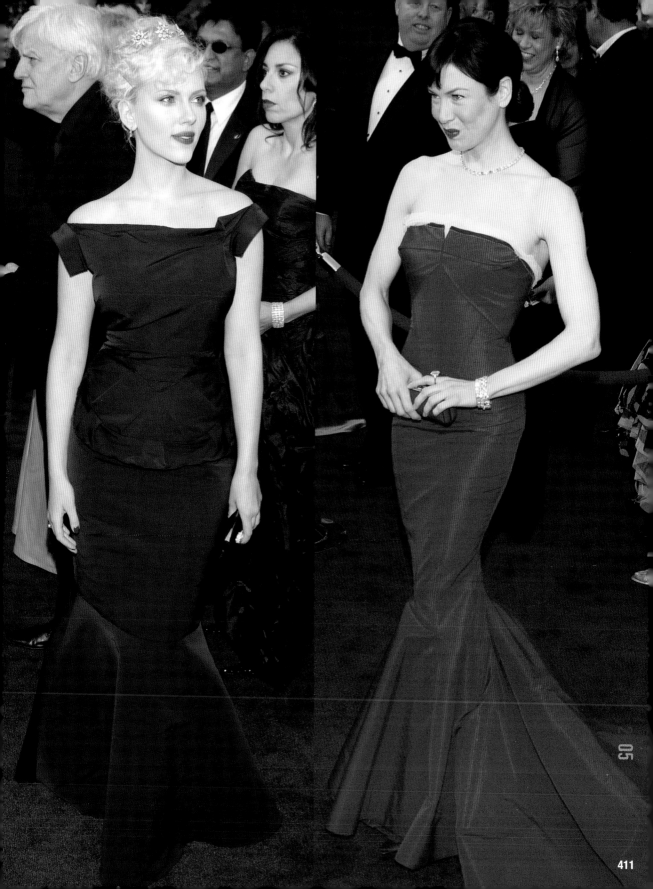

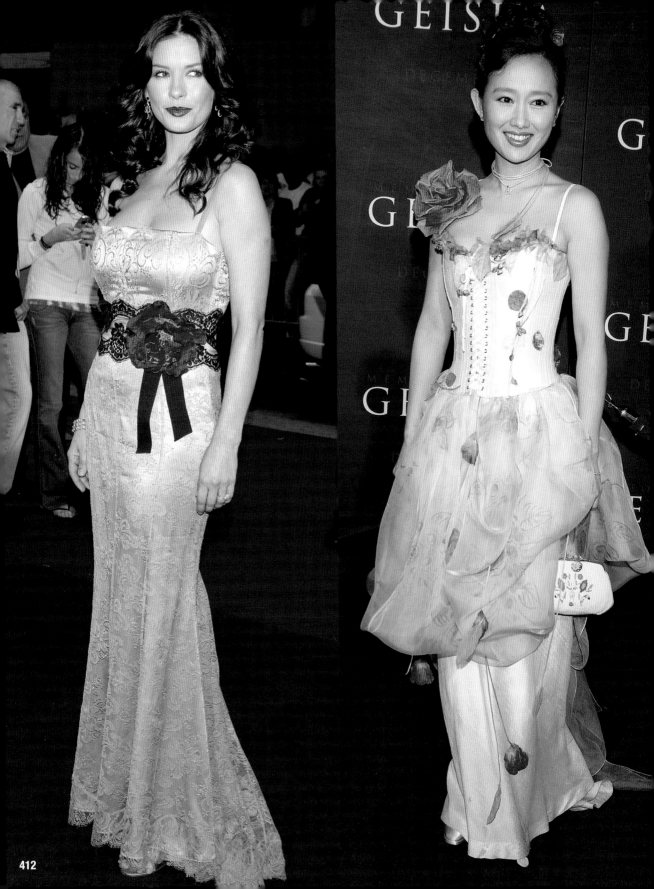

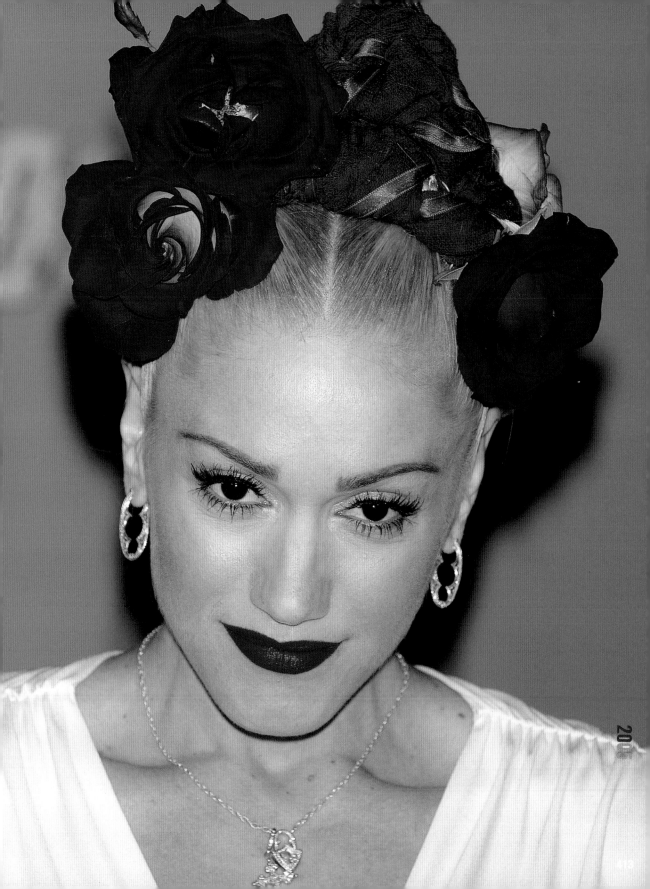

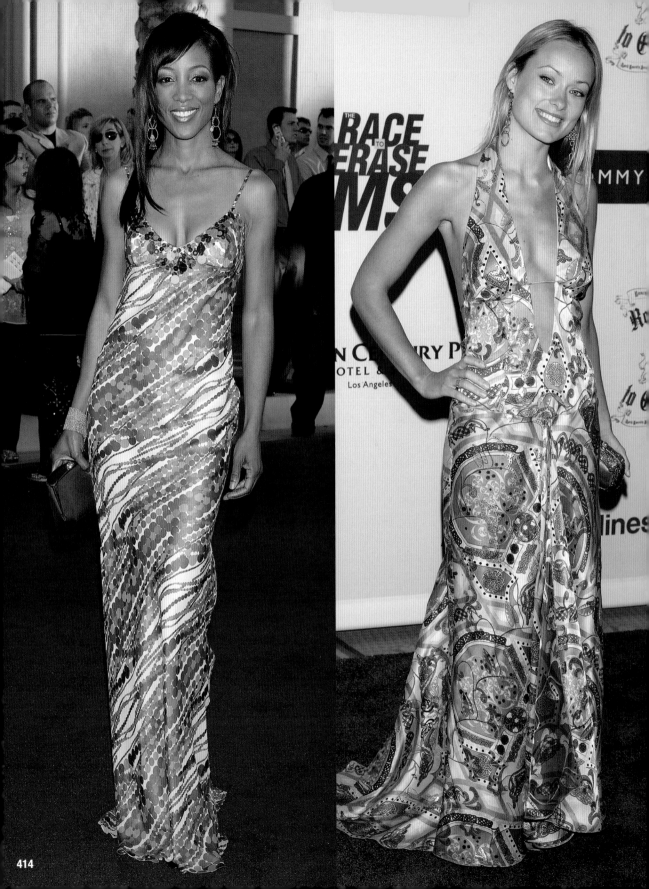

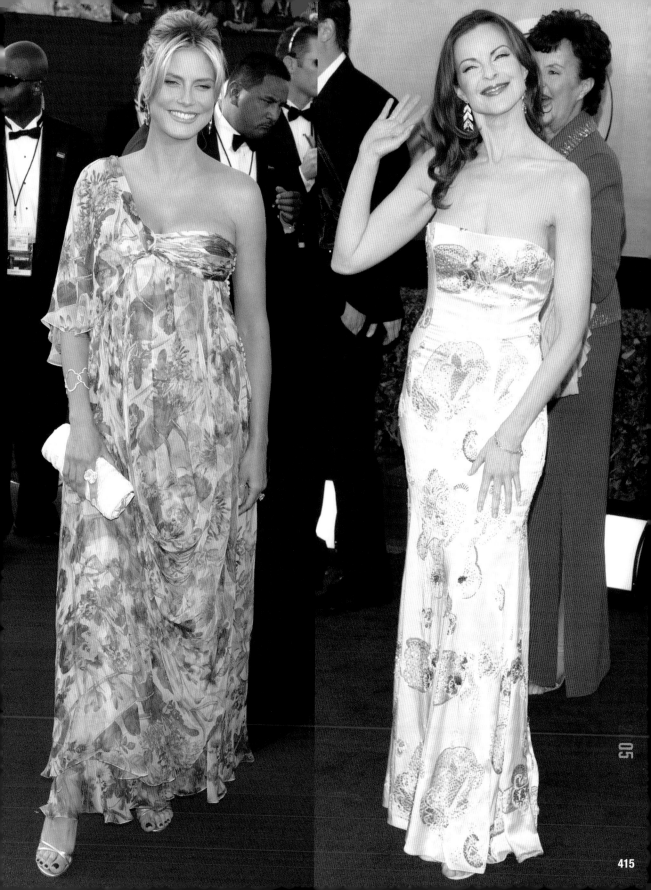

05

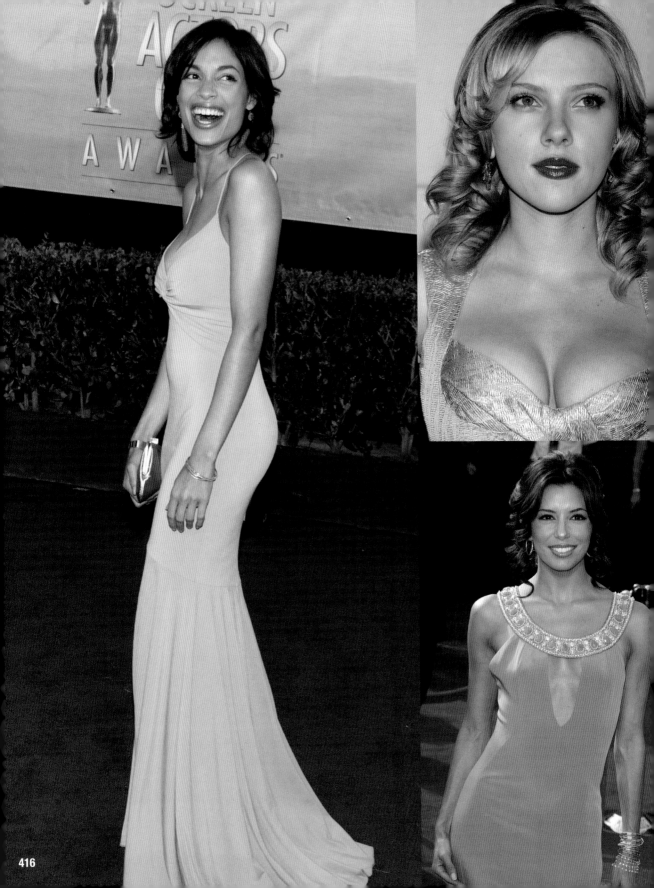

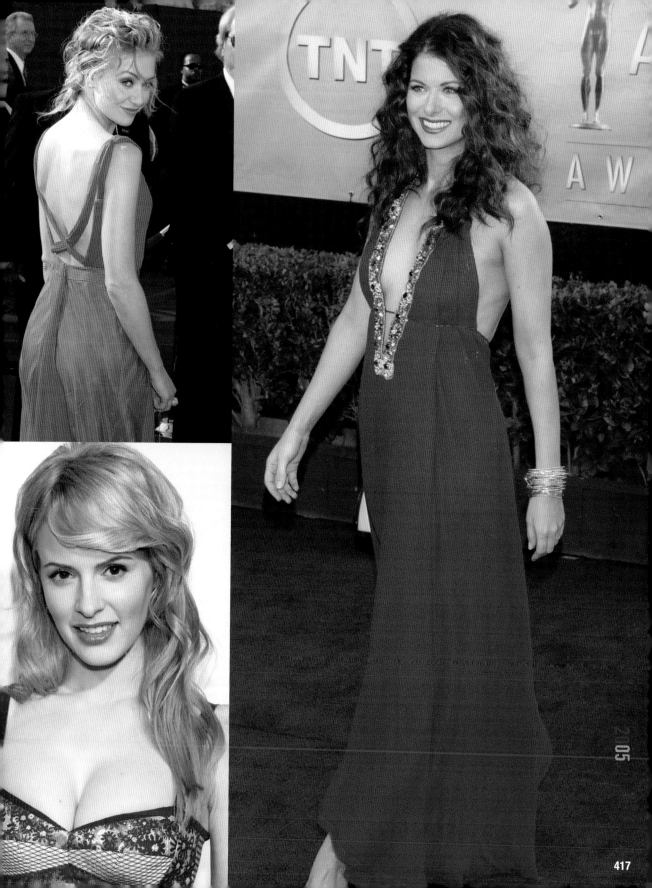

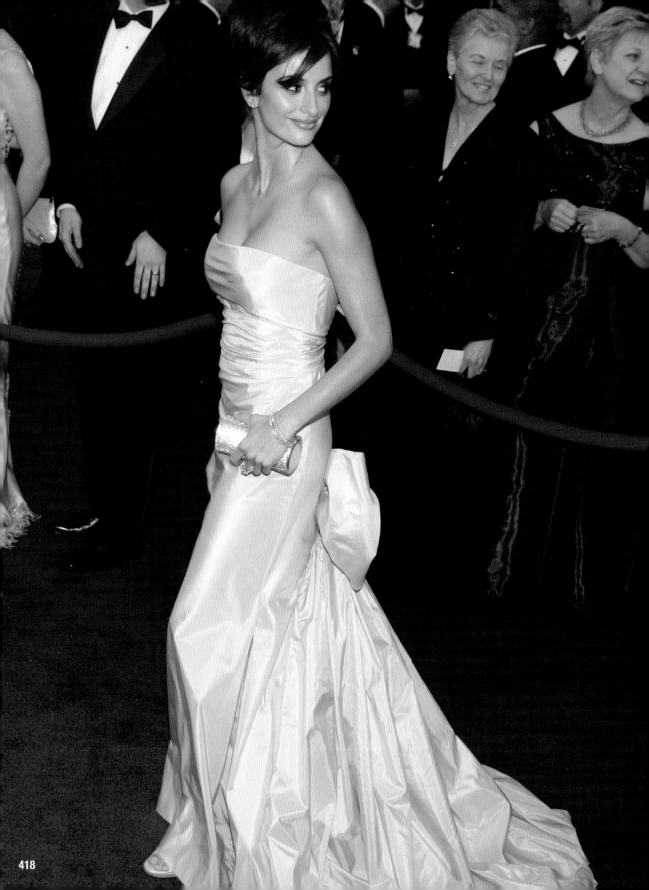

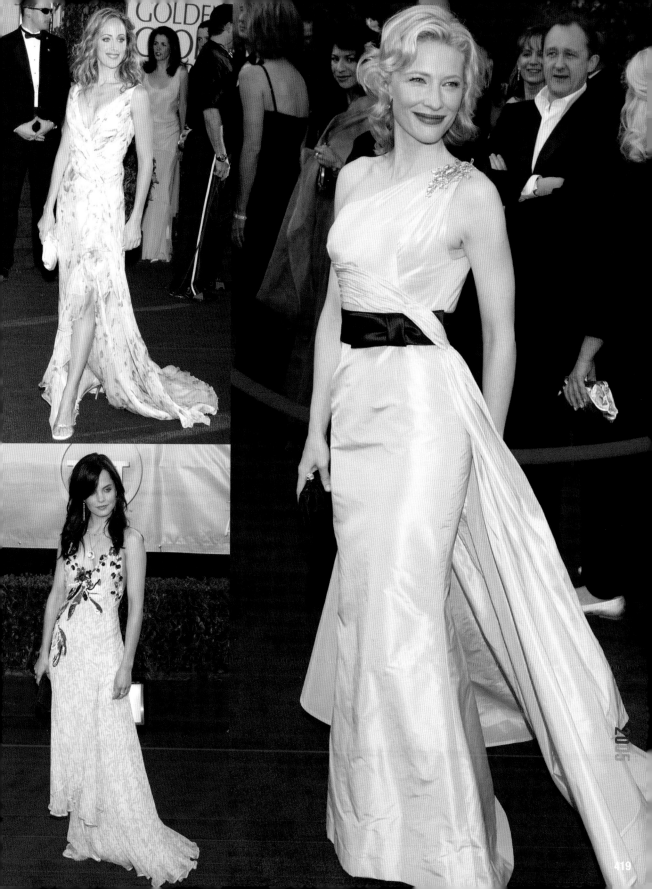

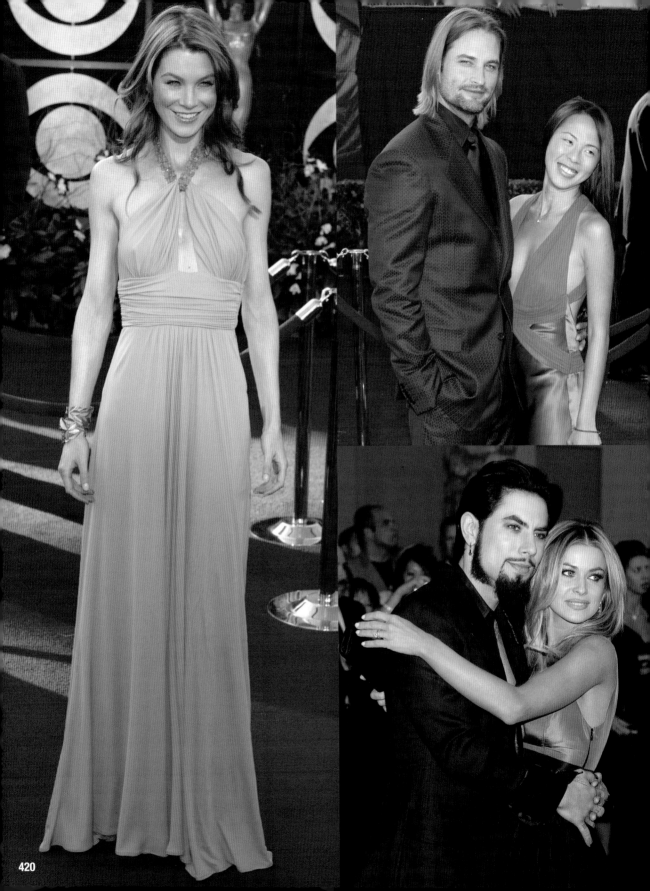

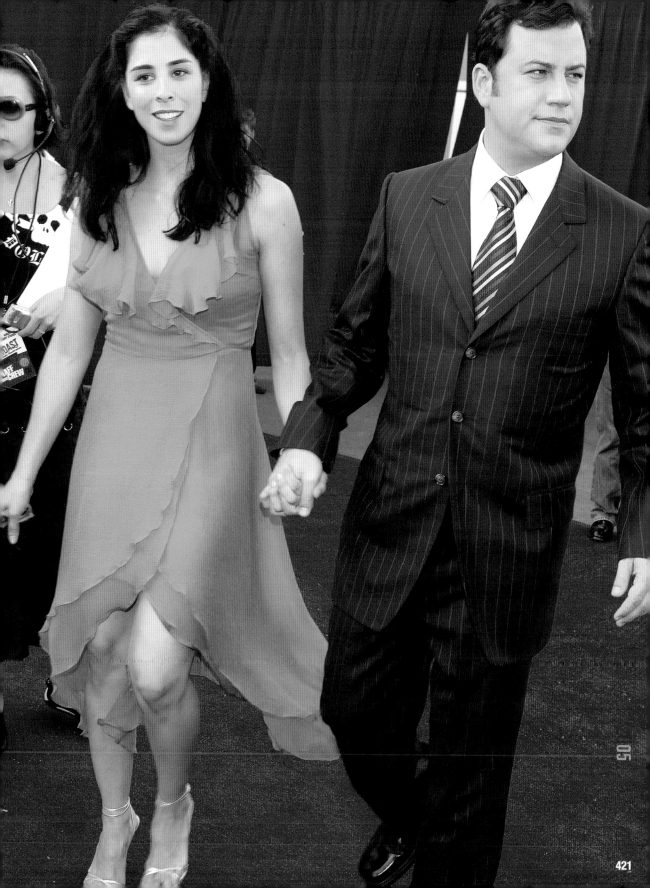

05

421

1987 1988 1989 1990 1991 1992 1993 1994 1995 1996 1997 1998 1999 2000 2001 2002 2003 2004 2005 **2006** 2007

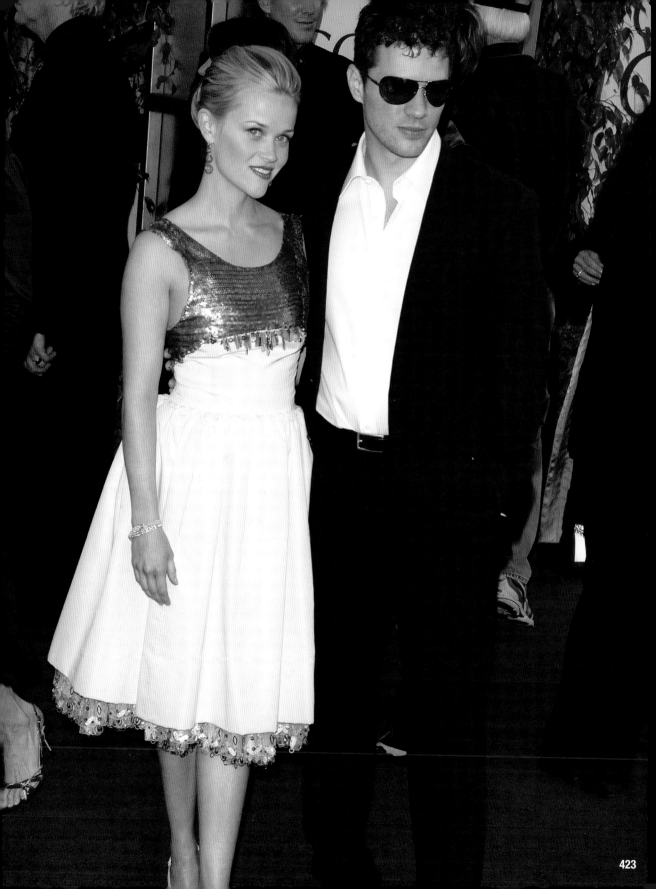

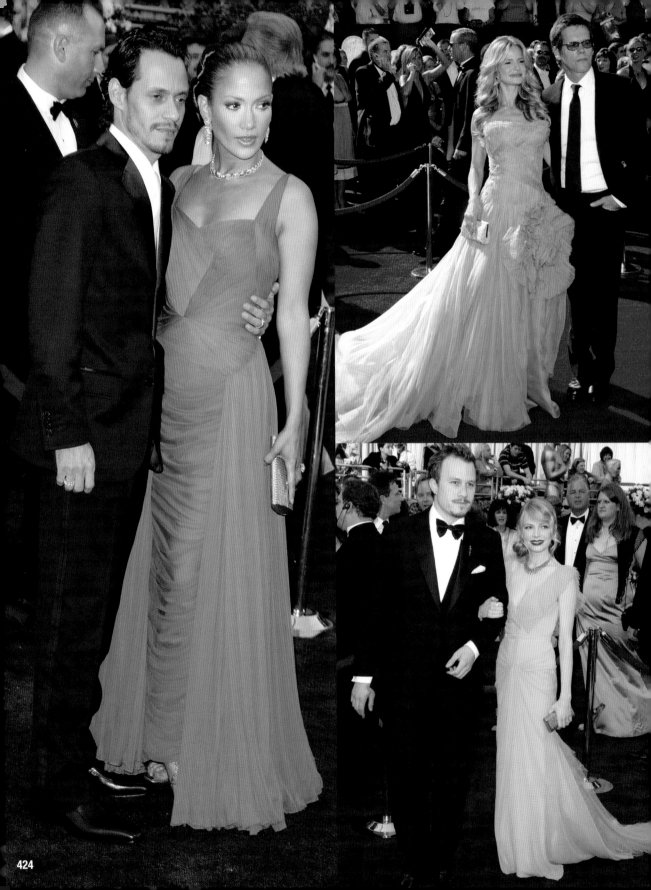

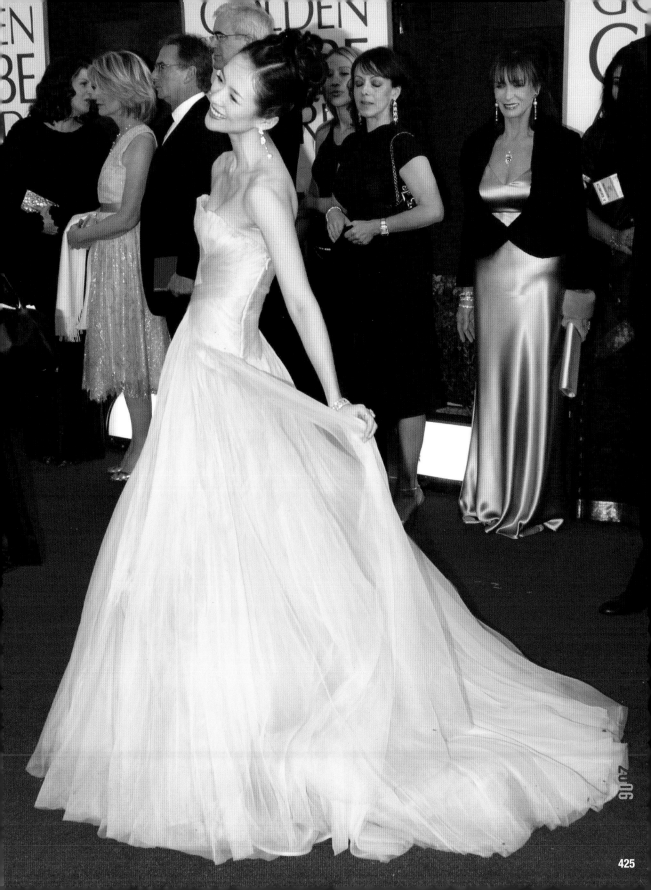

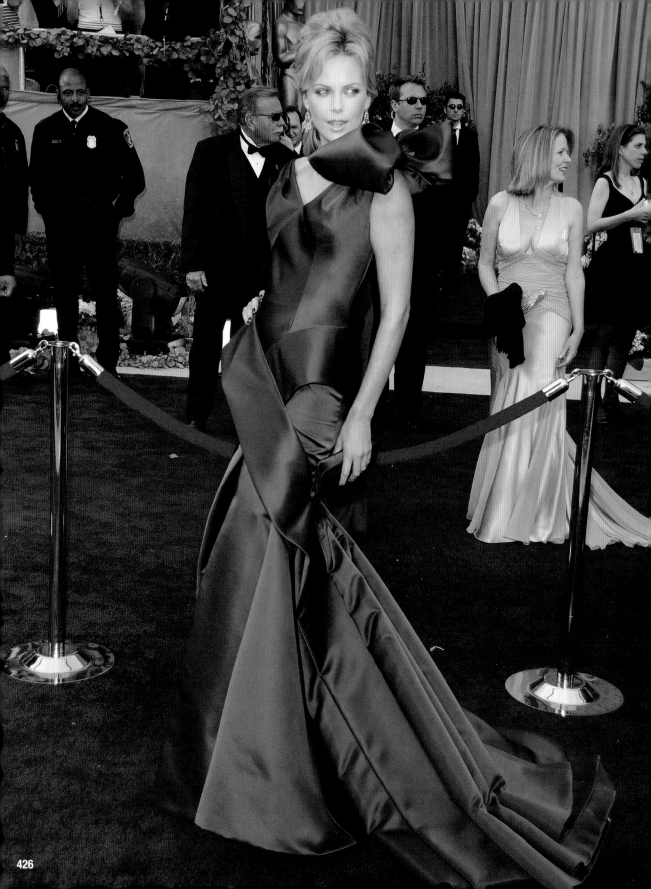

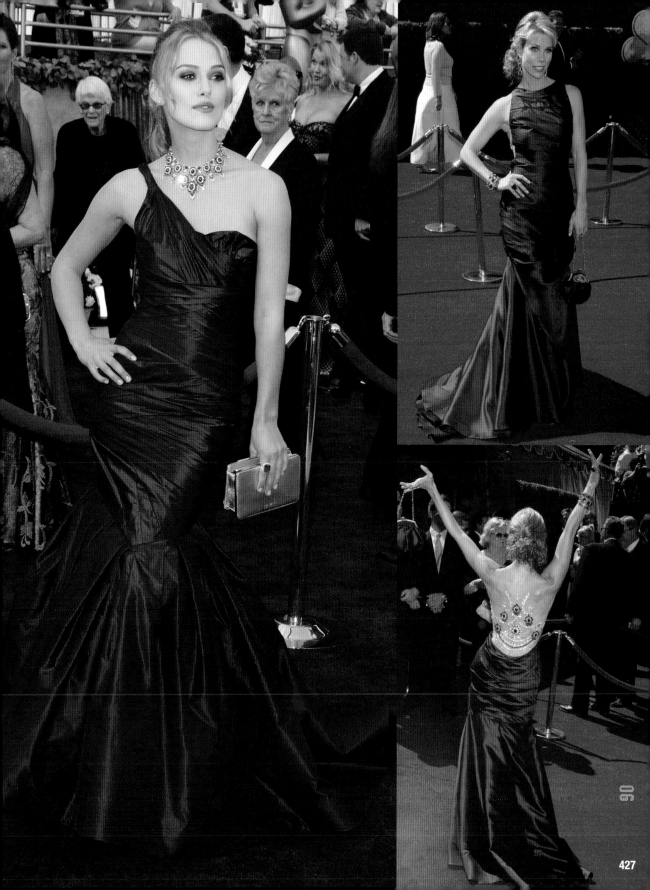

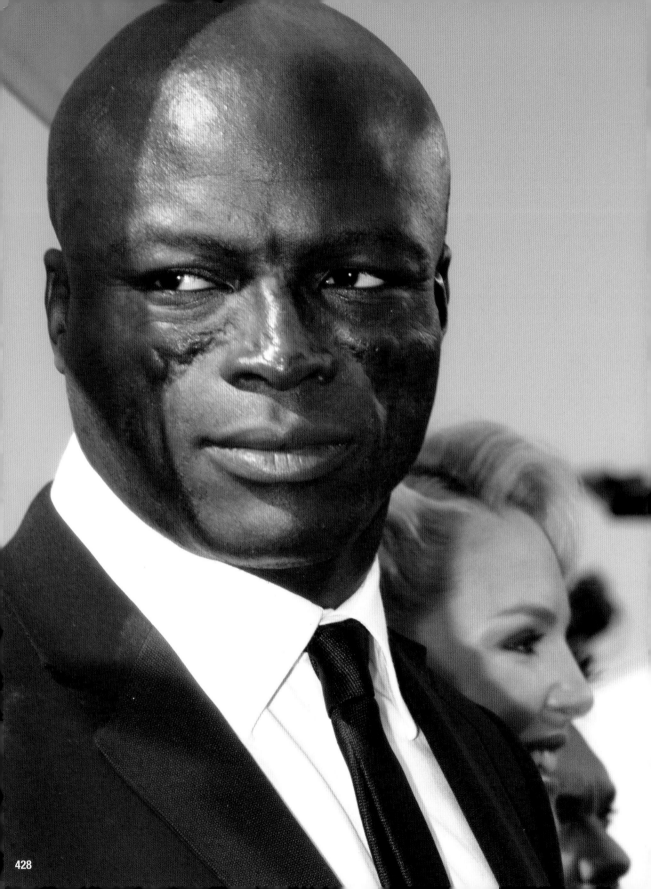

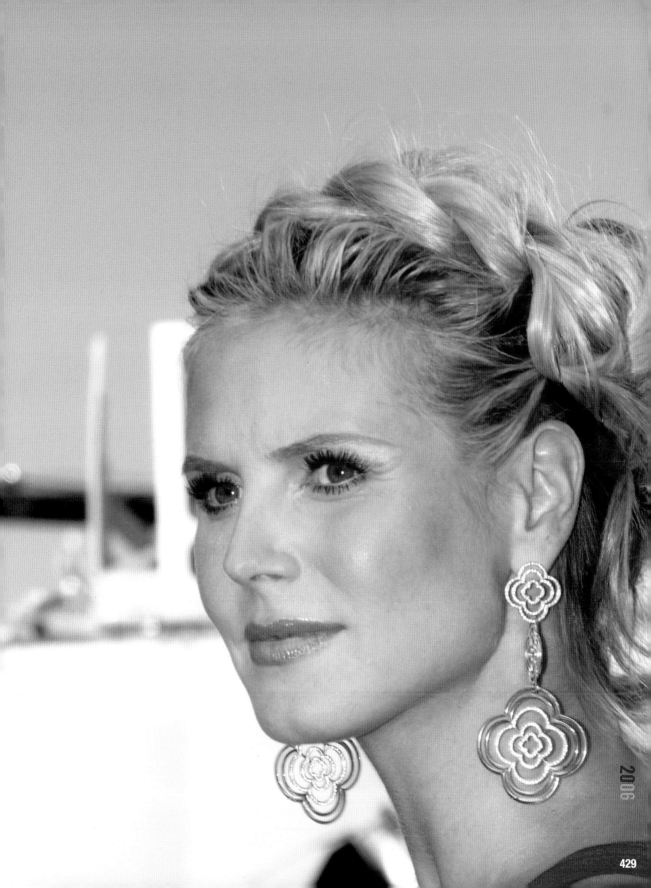

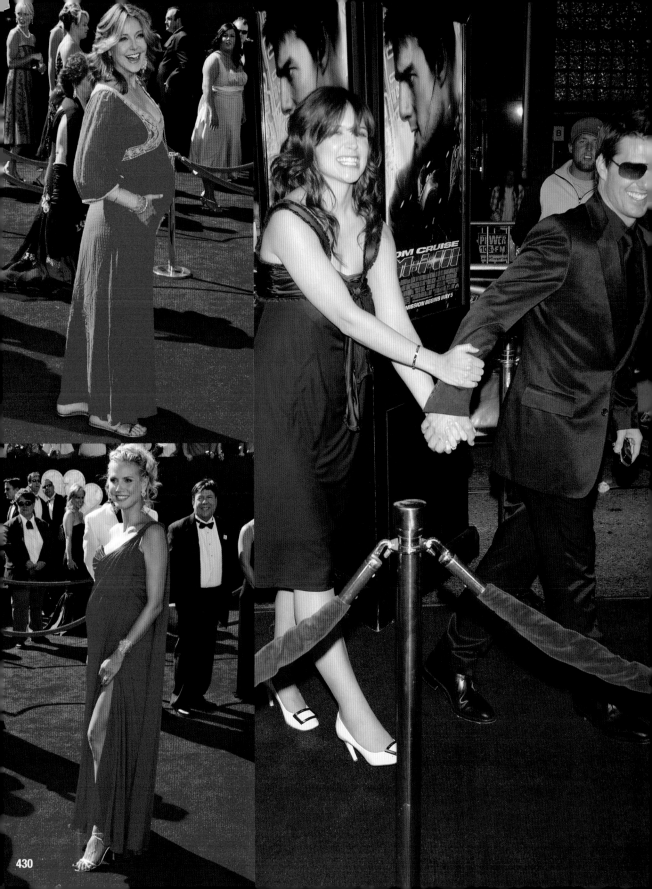

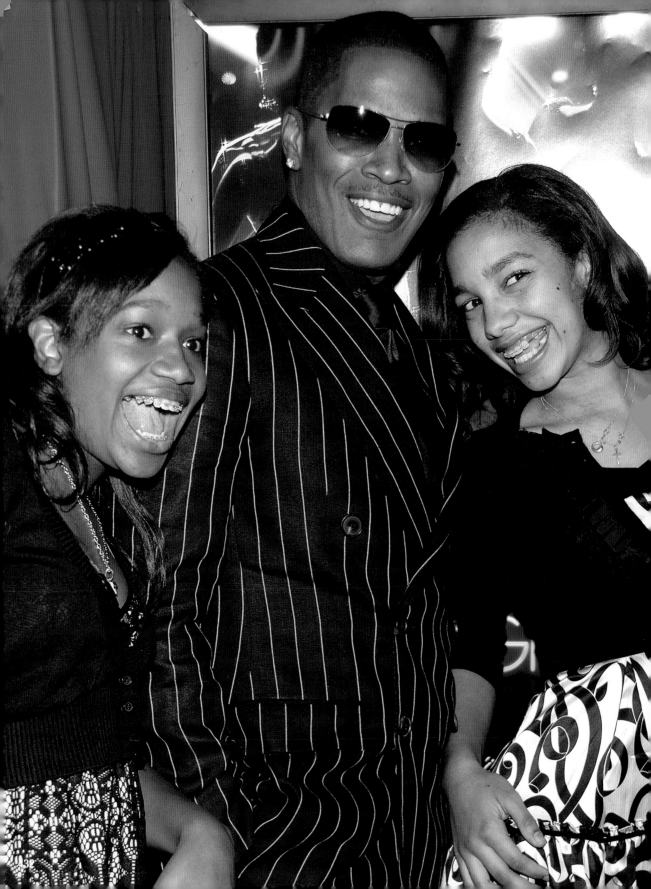

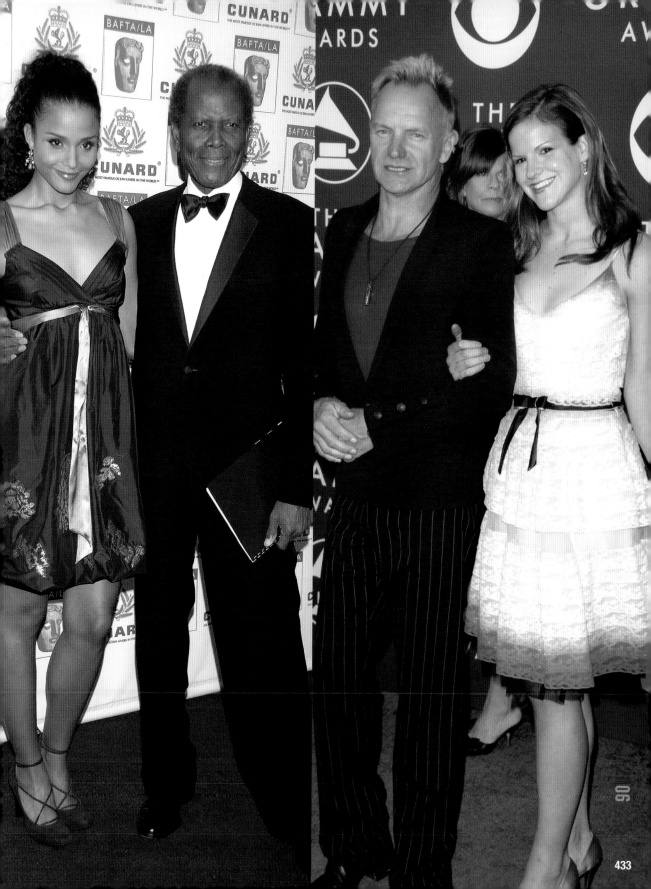

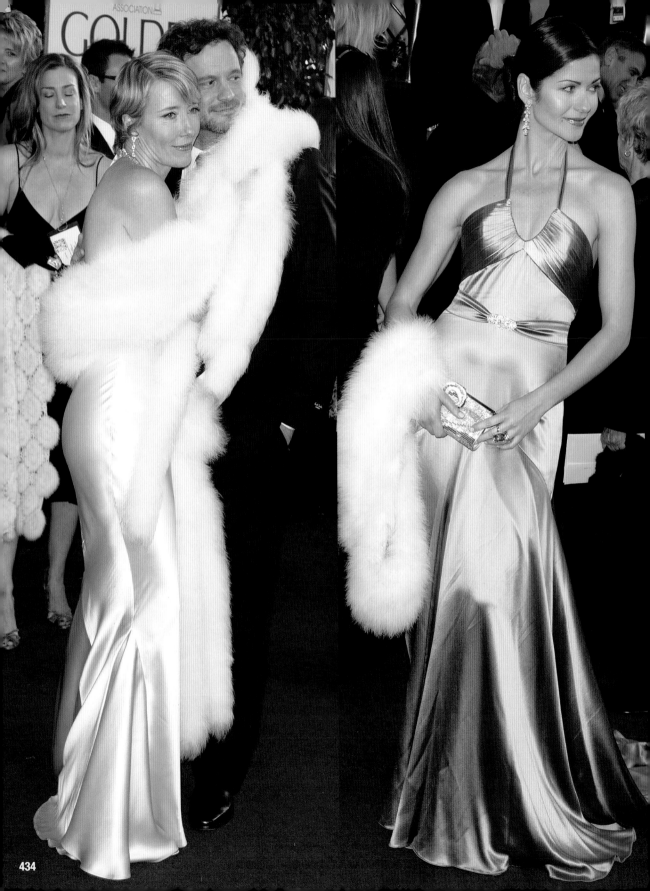

2006

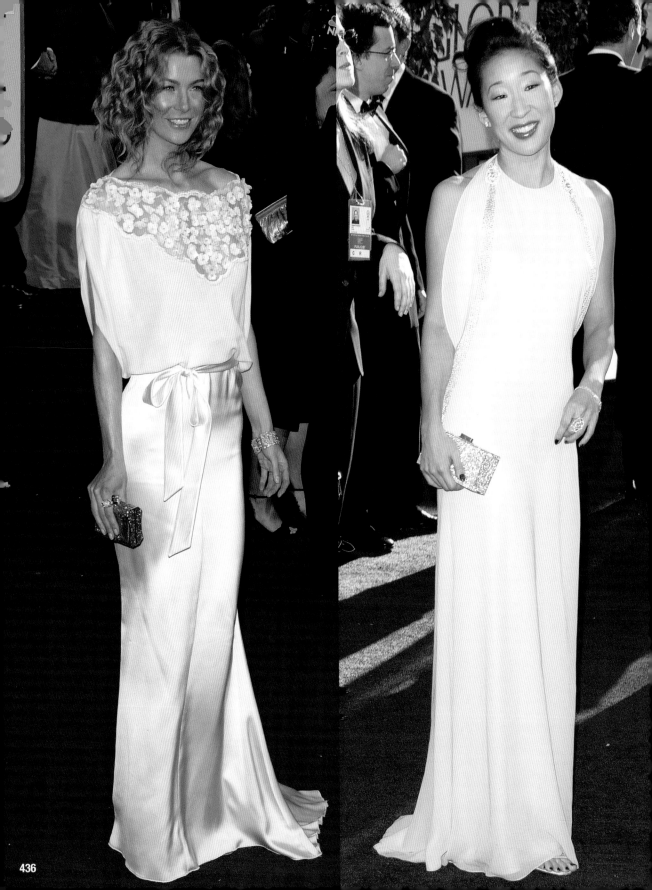

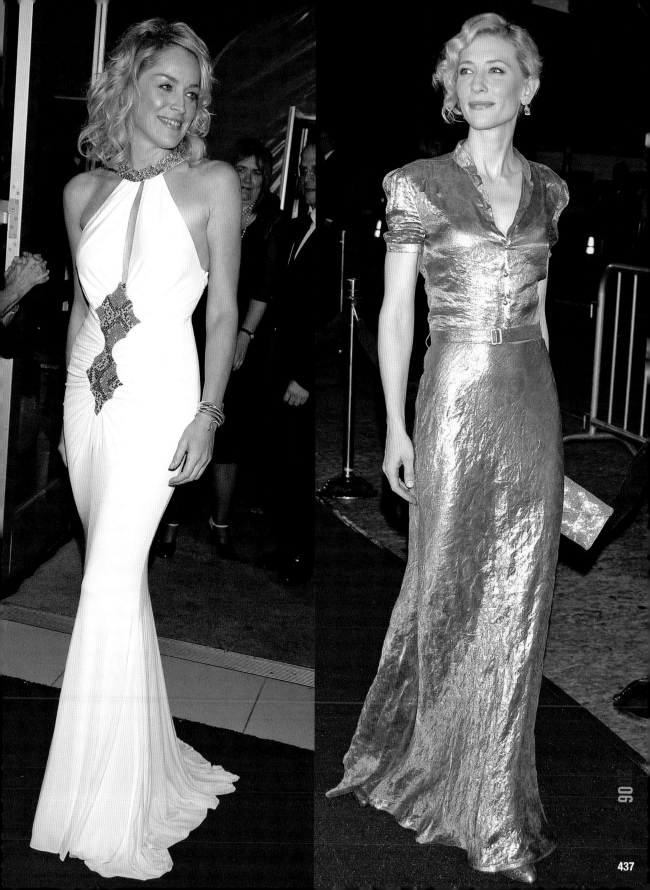

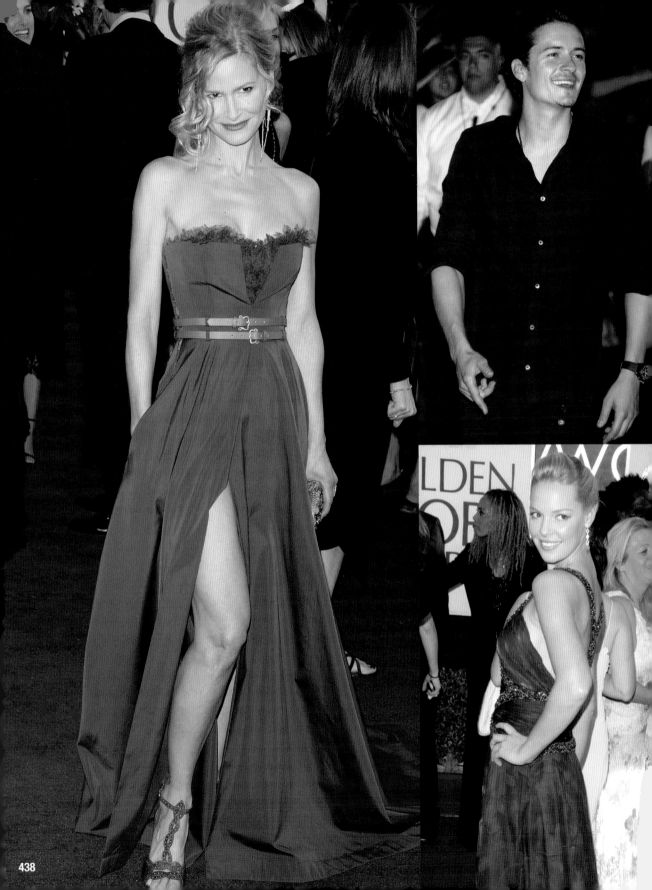

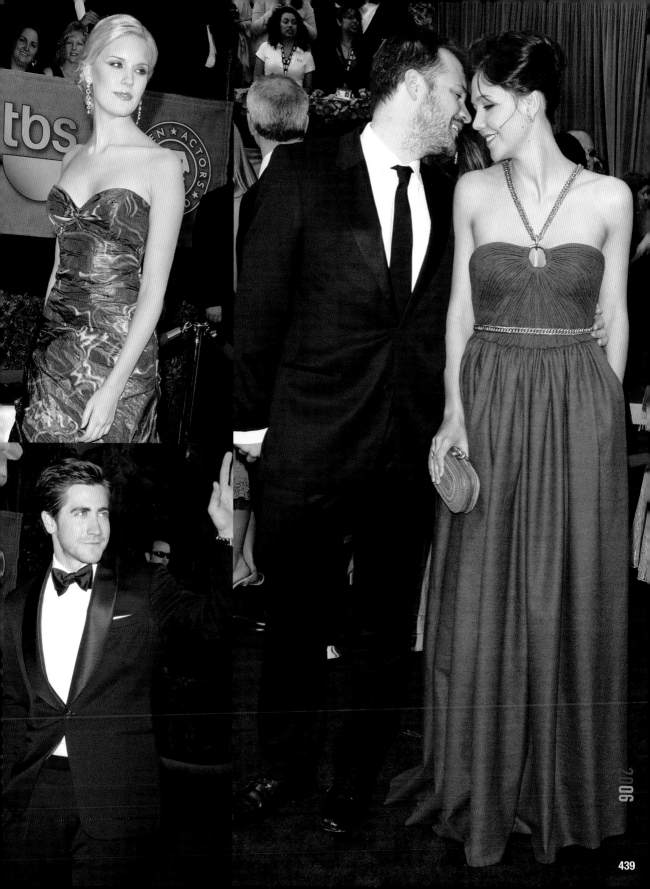

tbs

2006

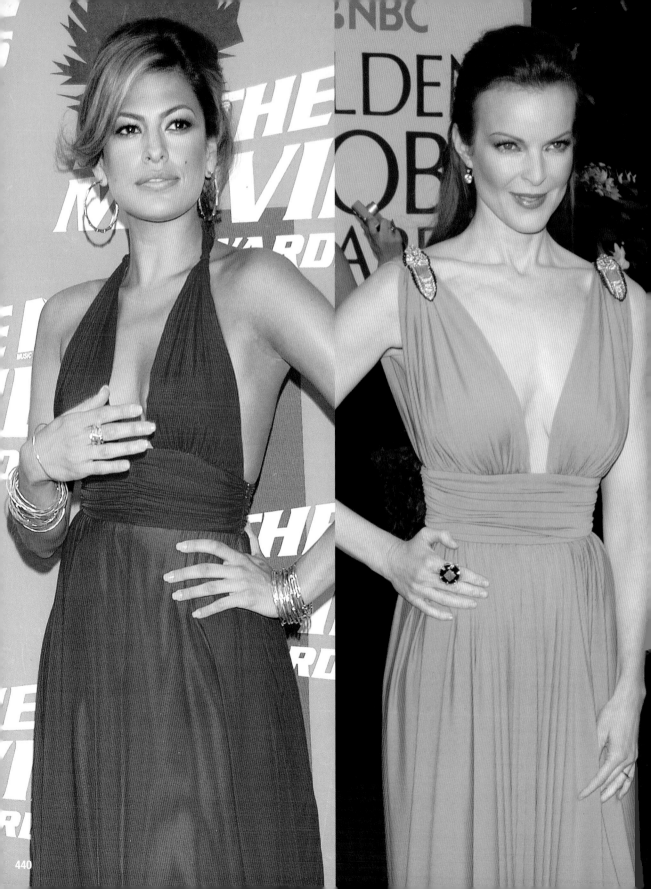

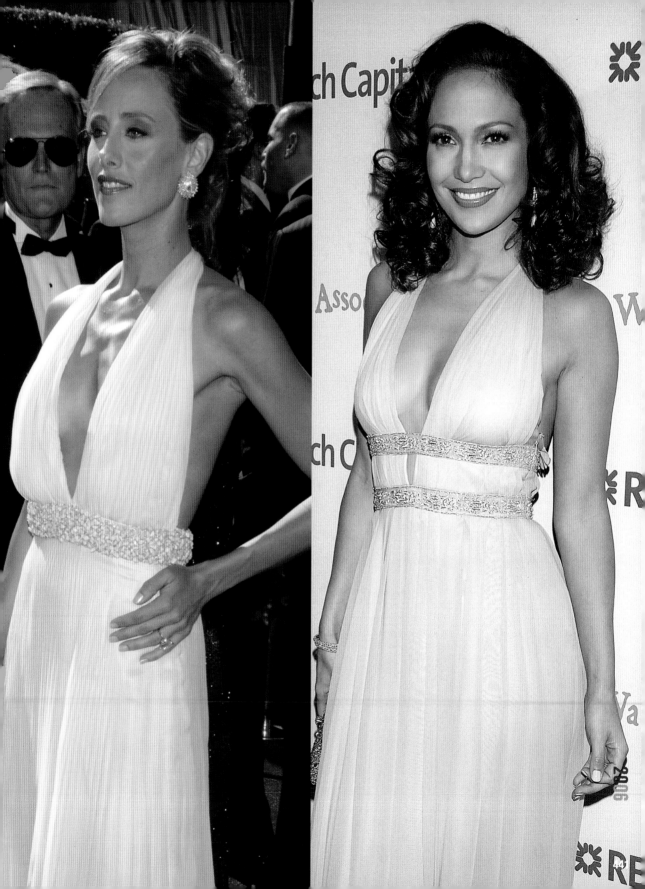

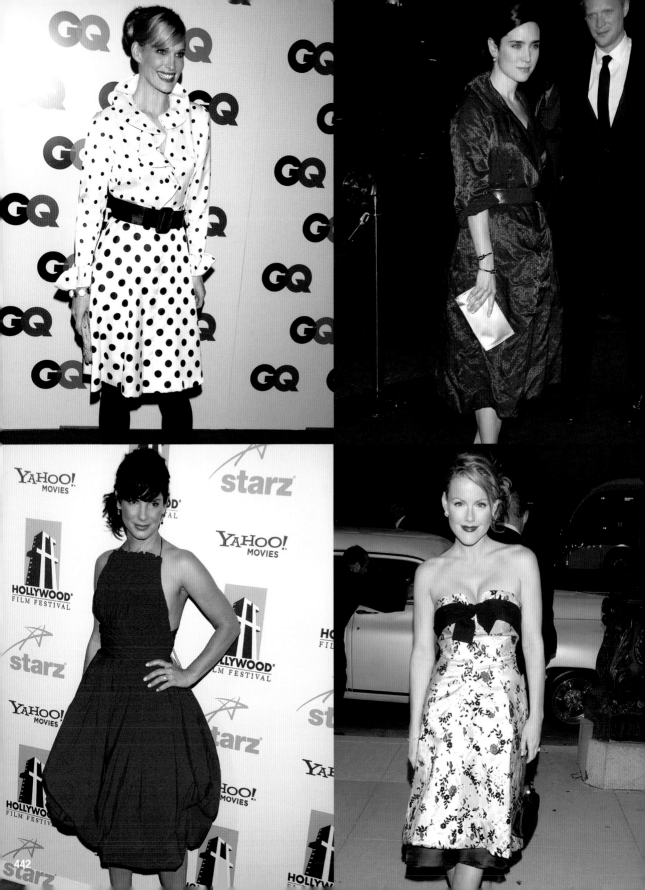

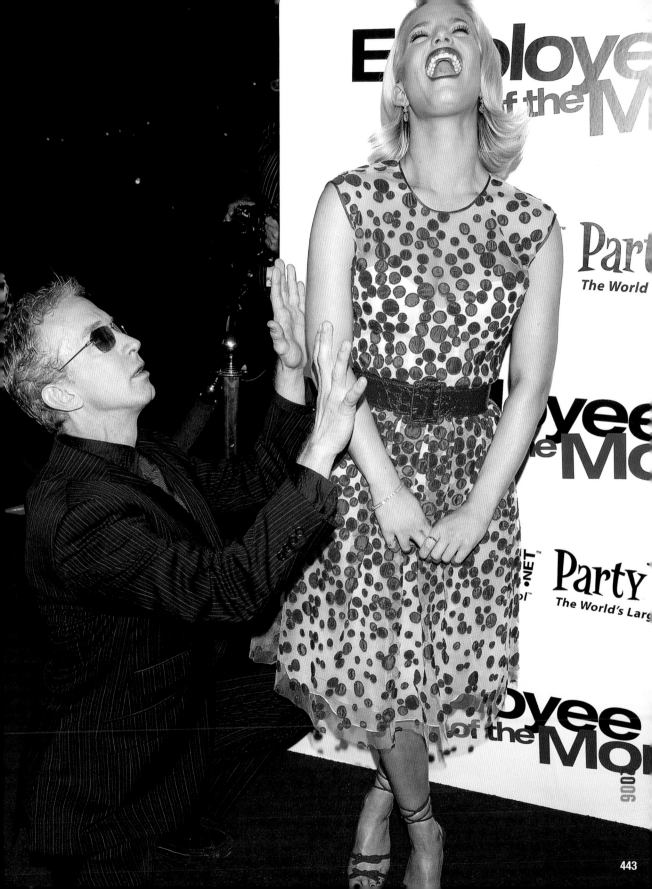

443

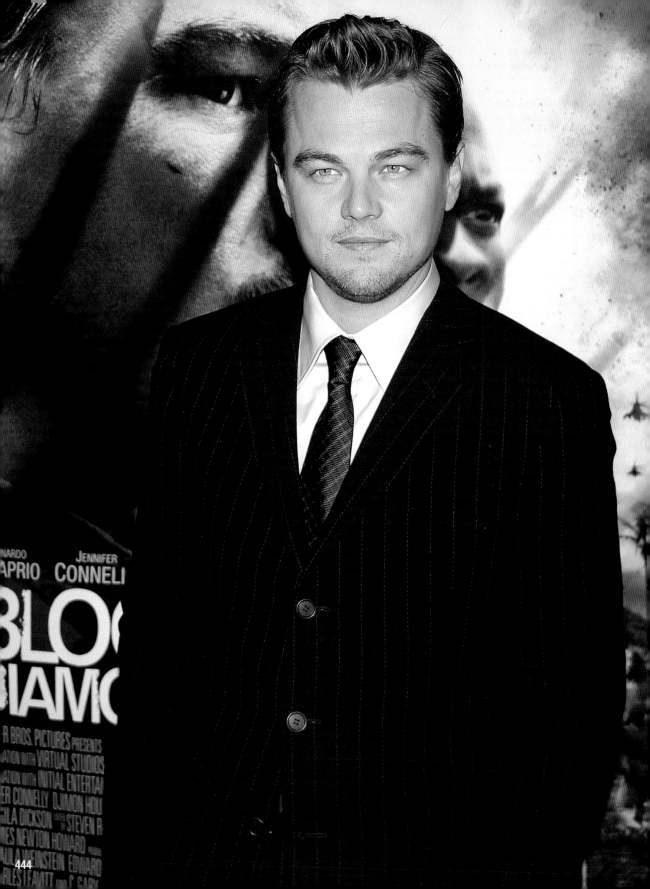

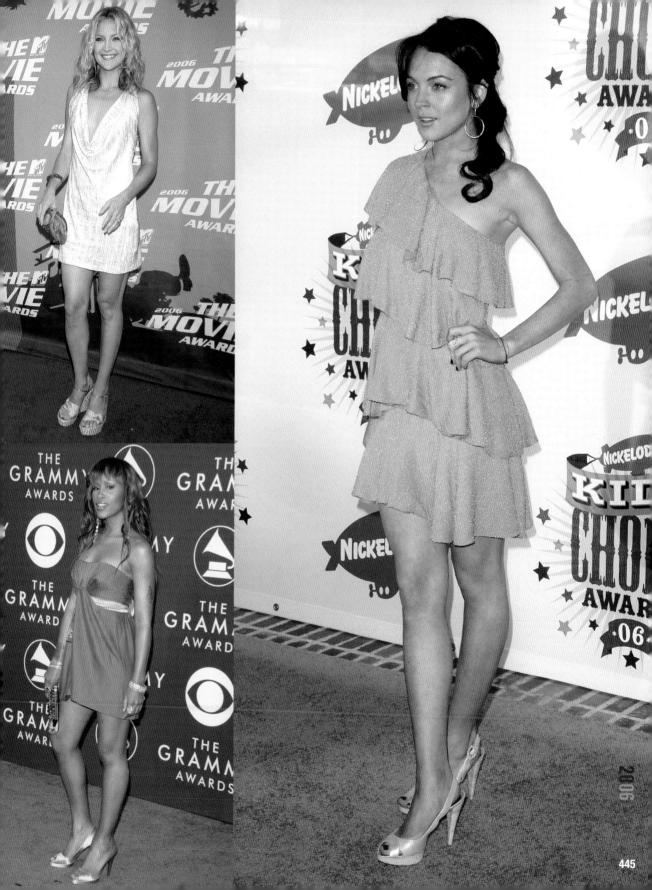

445

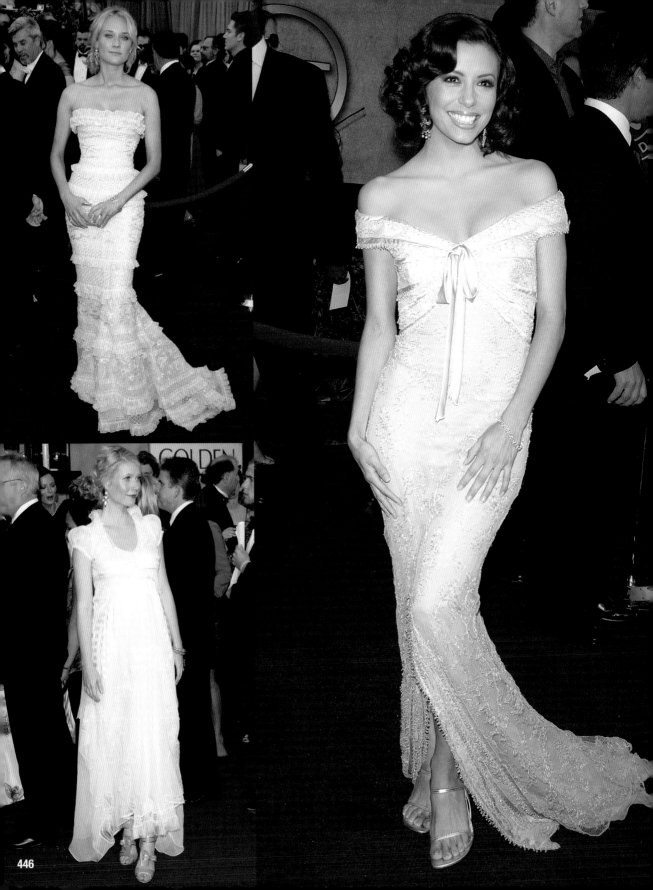

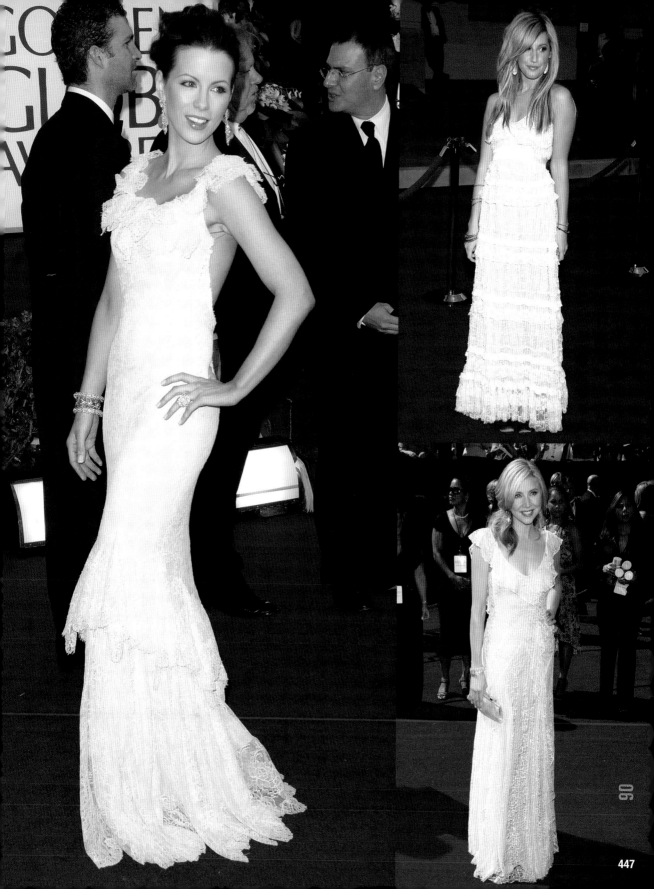

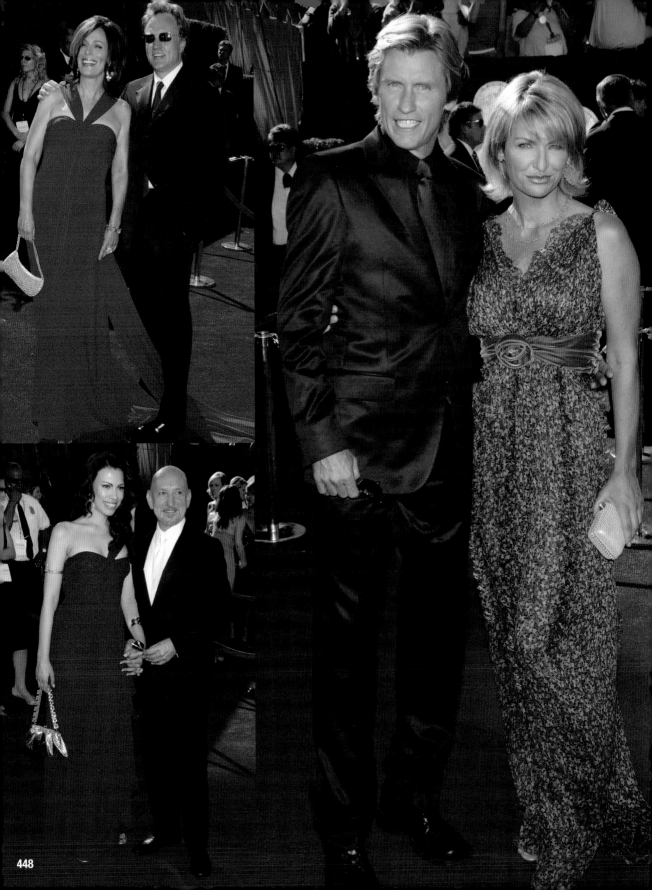

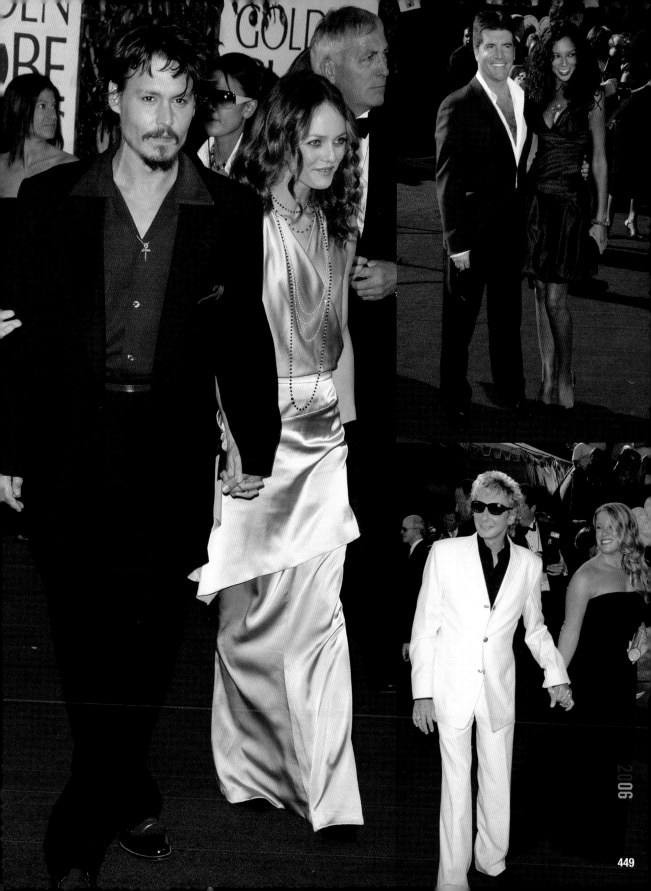

2006

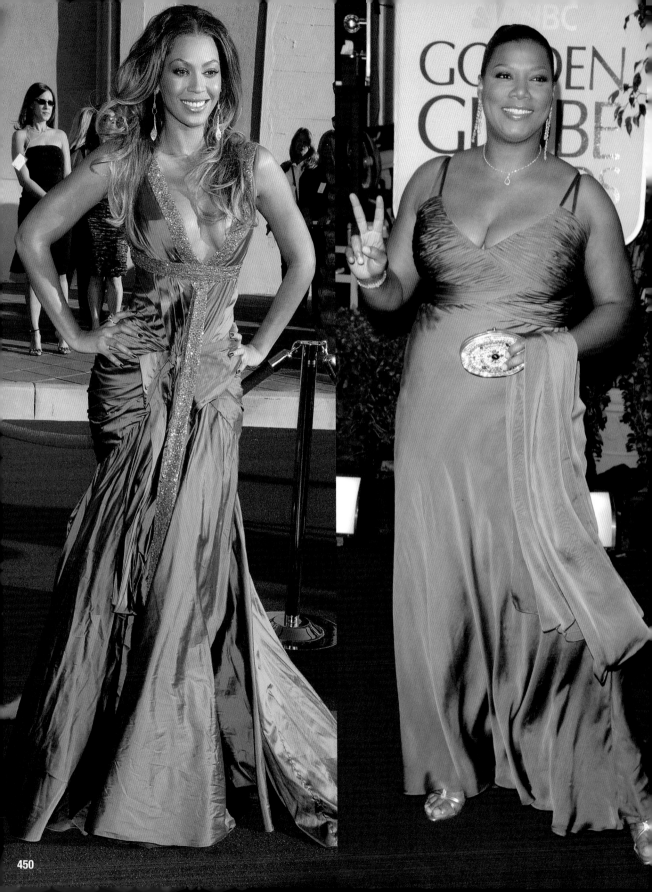

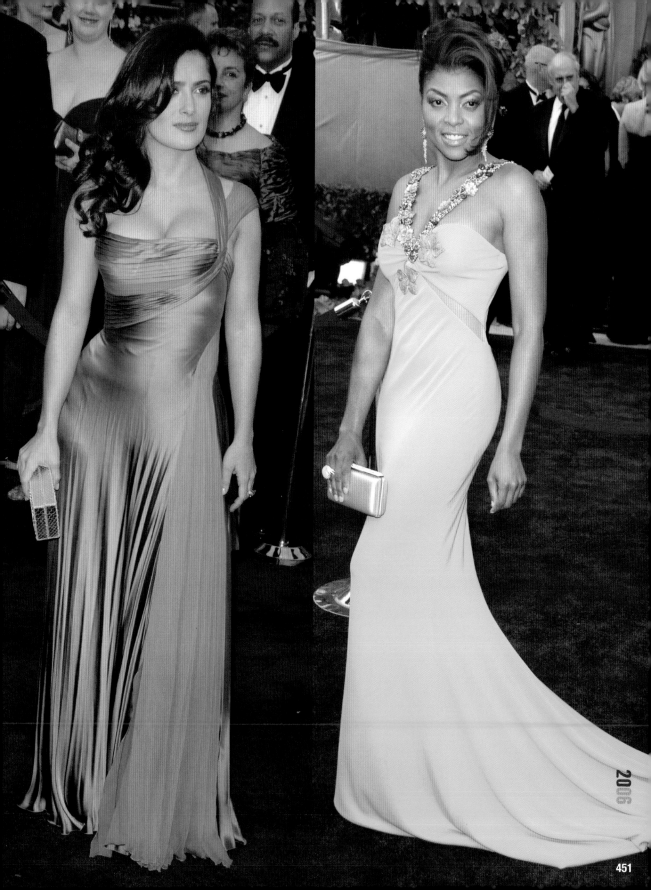

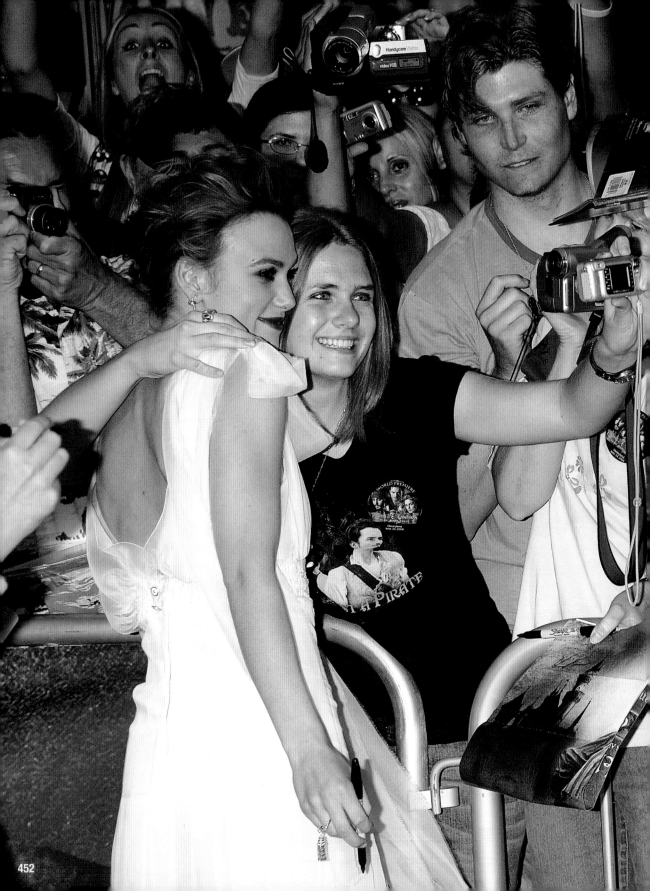

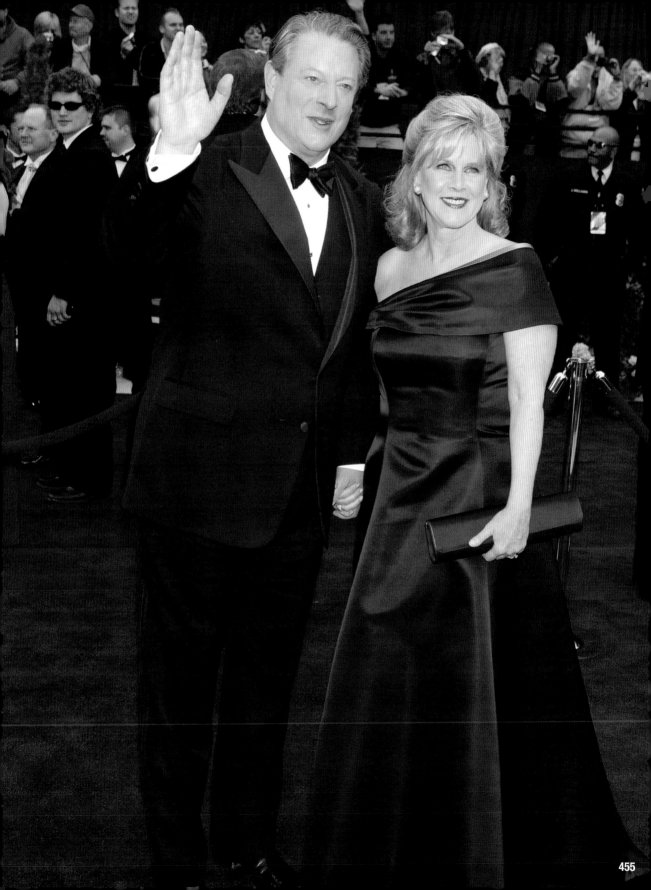

455

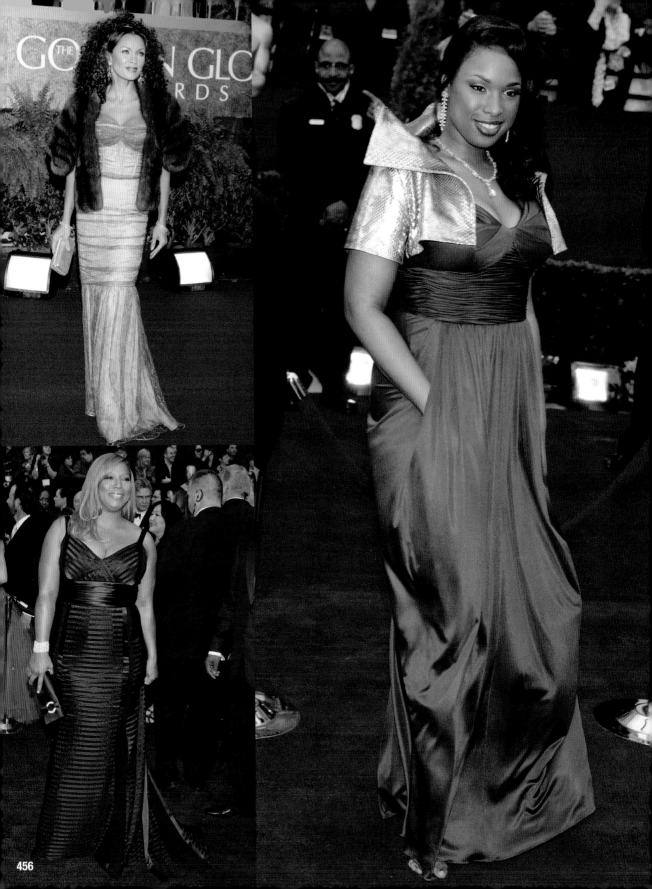

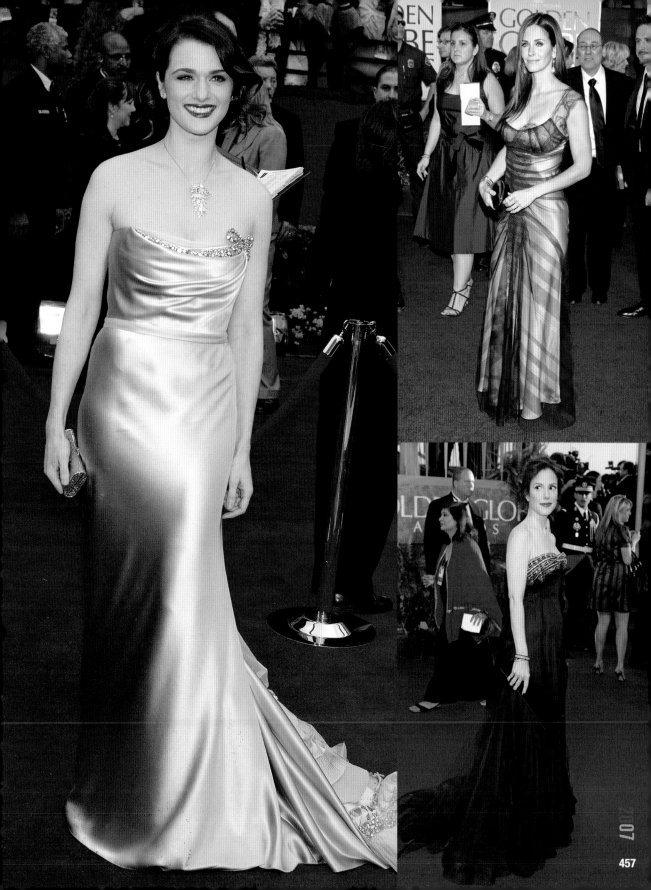

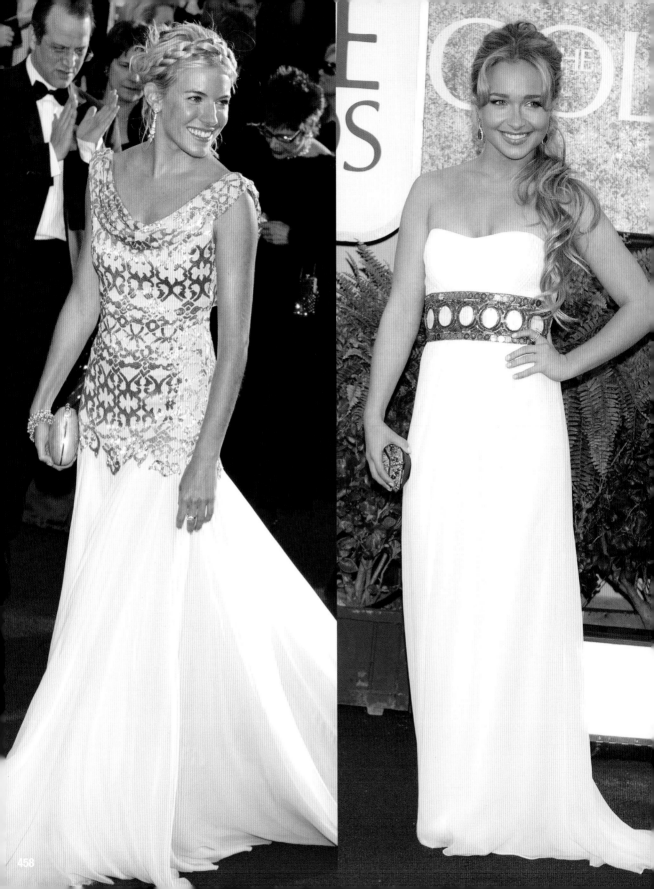

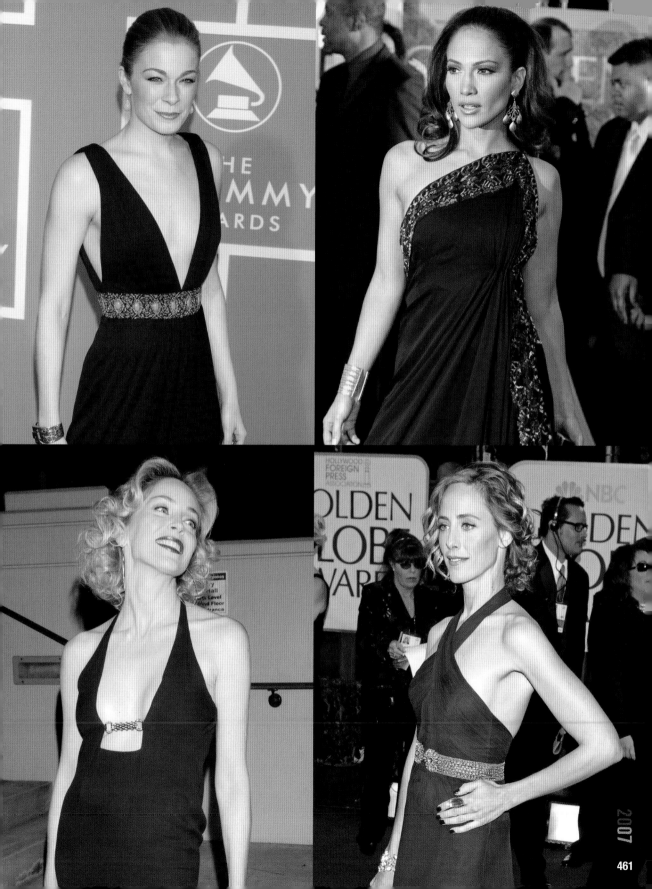

2007

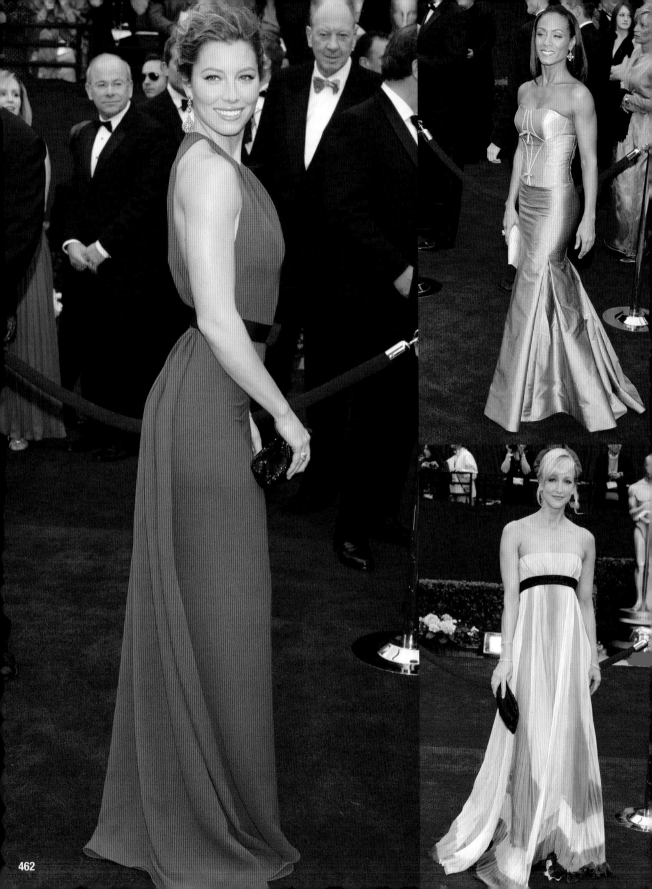

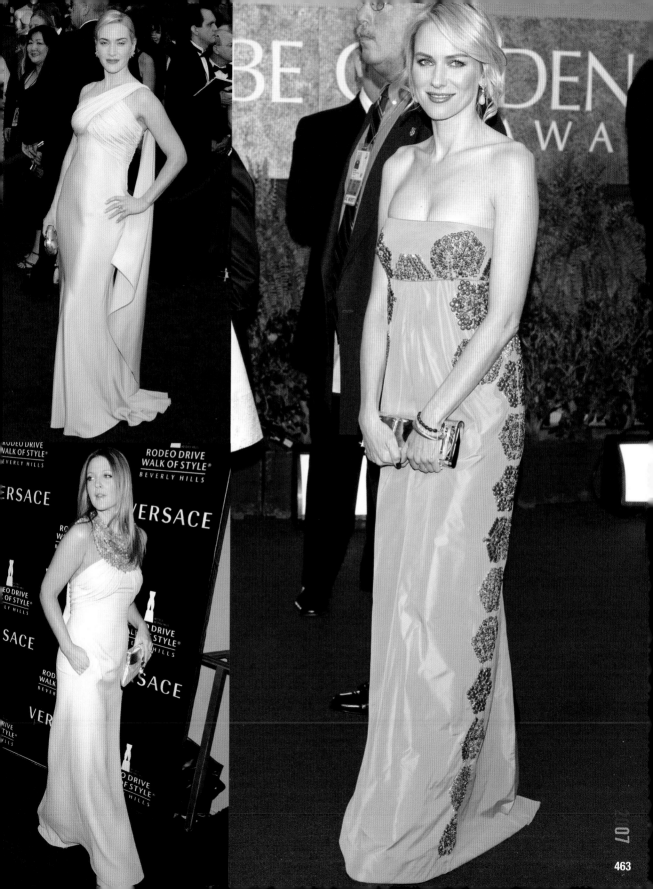

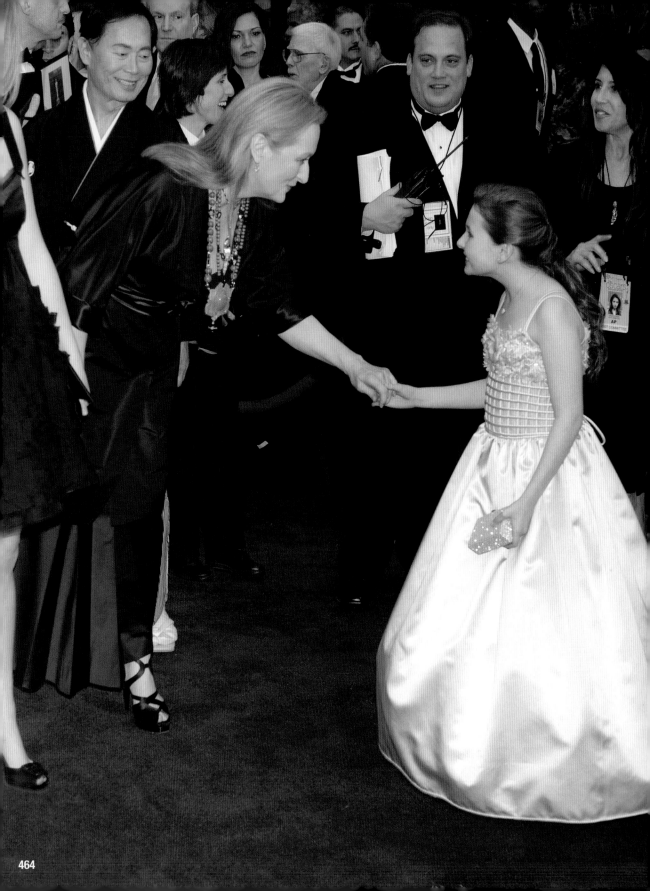

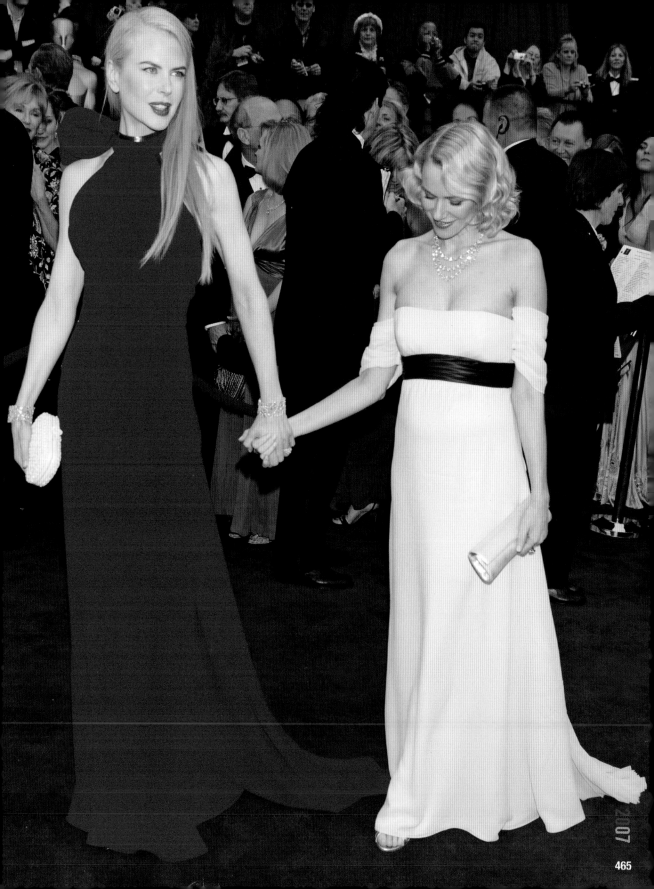

2007

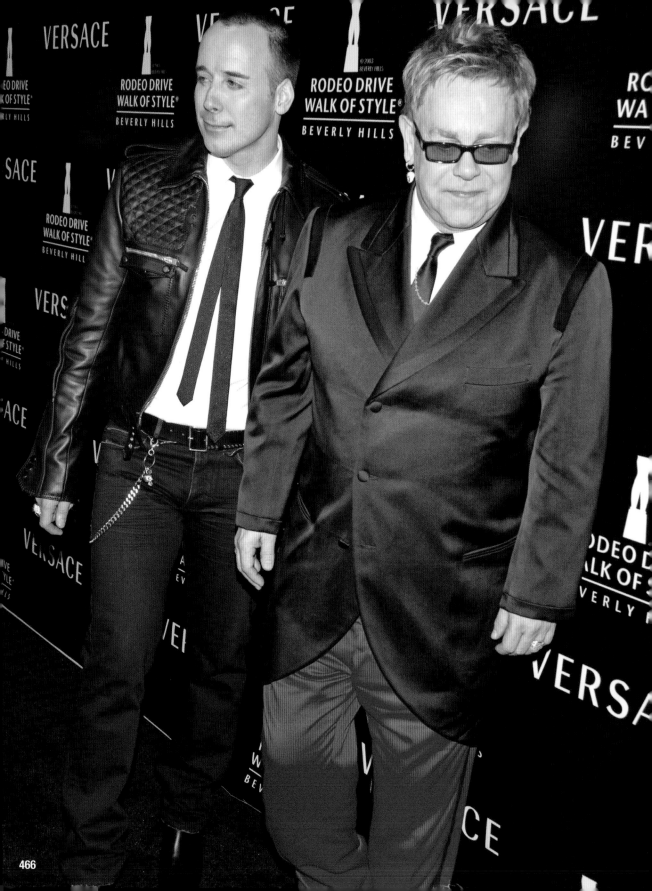

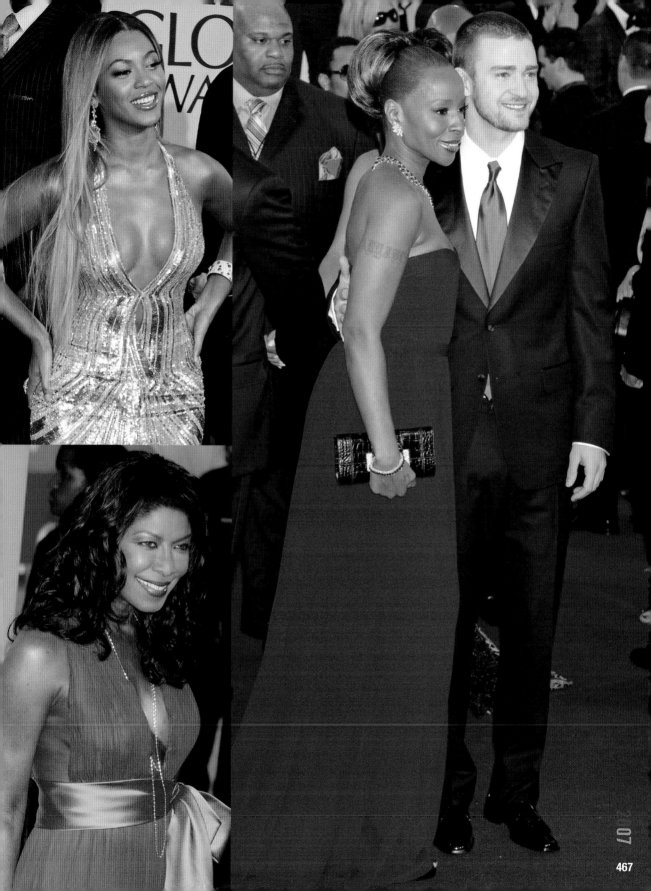

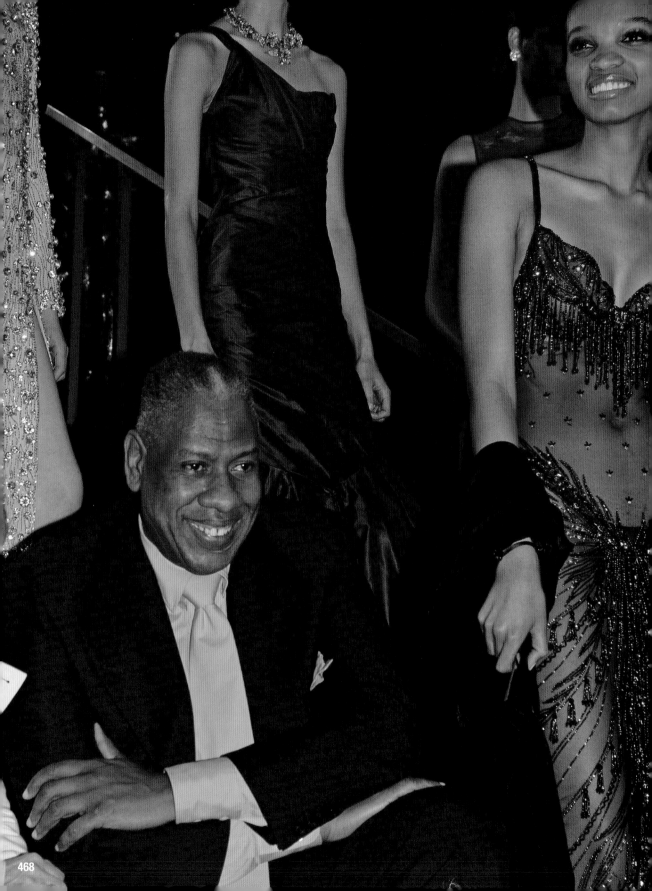

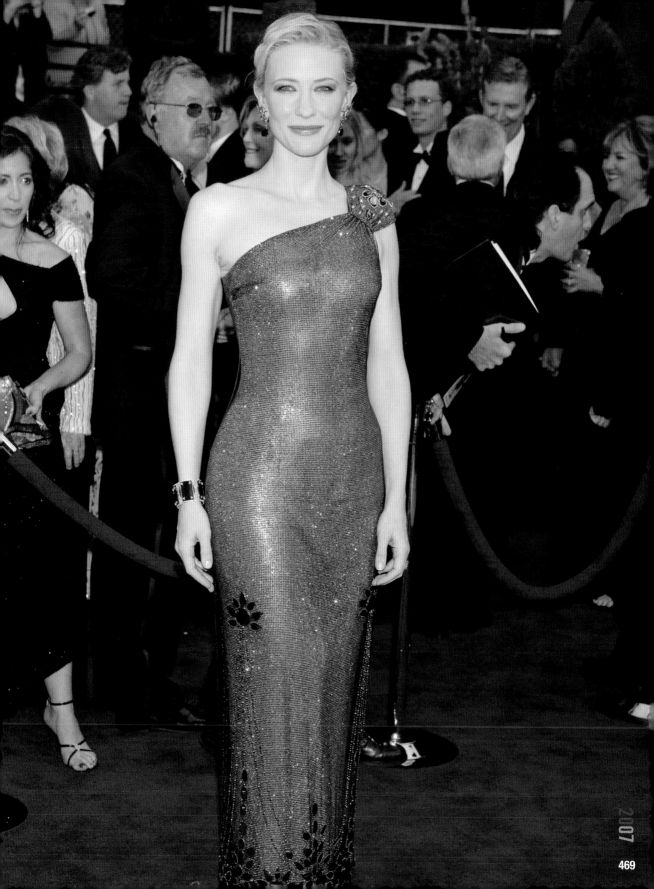

2007

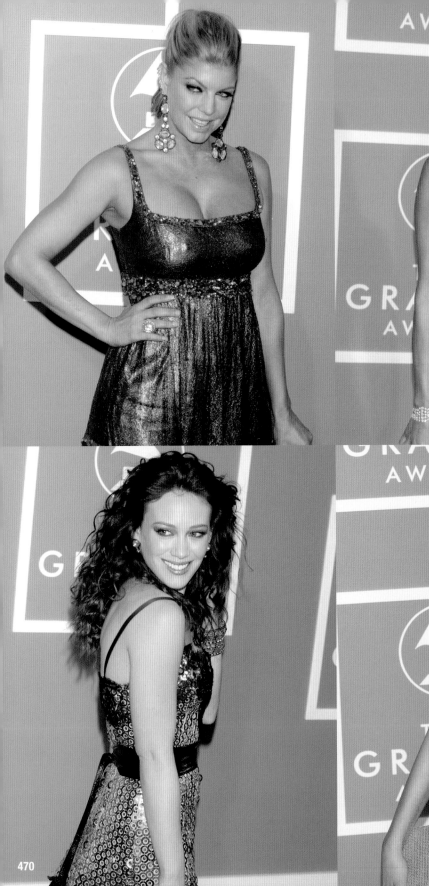
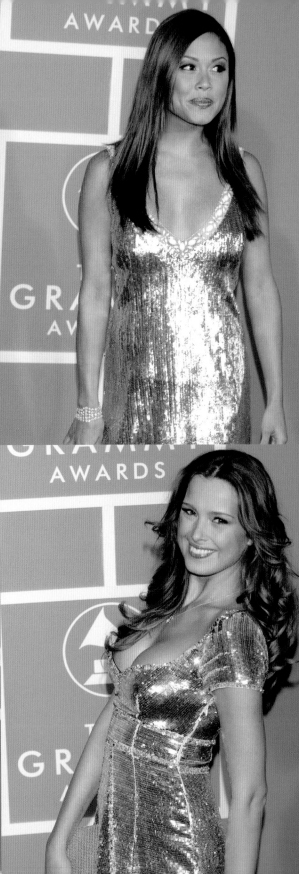

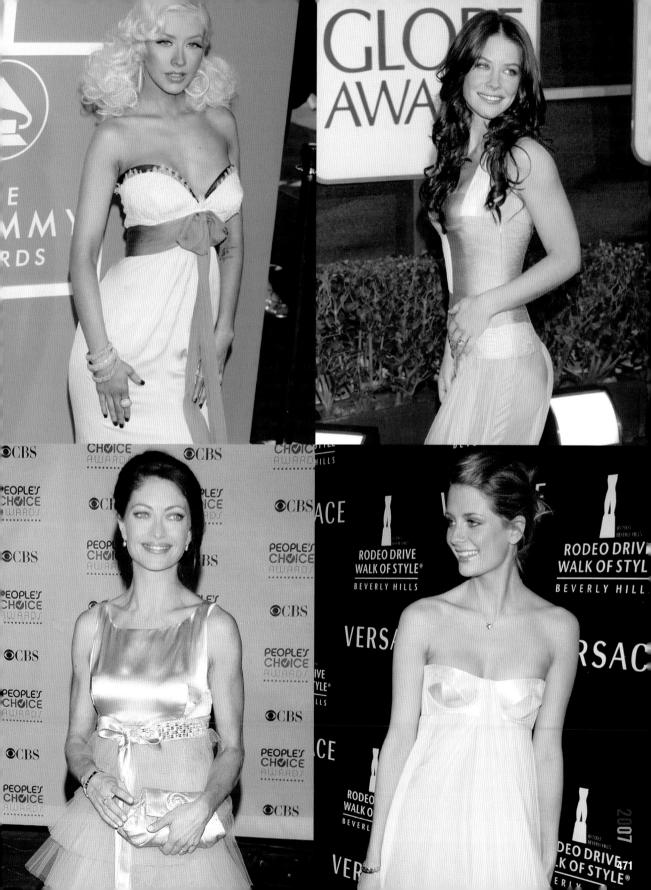

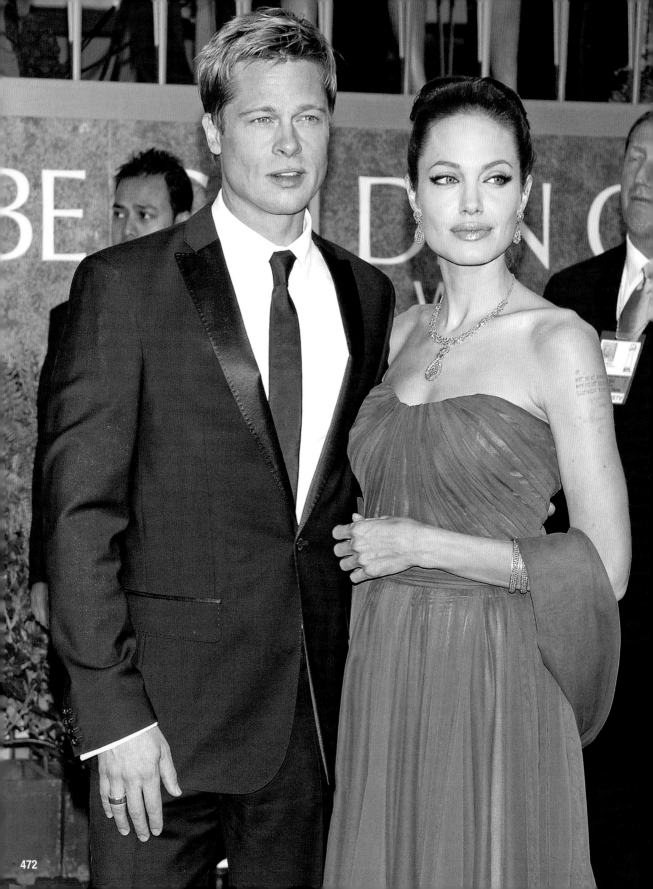

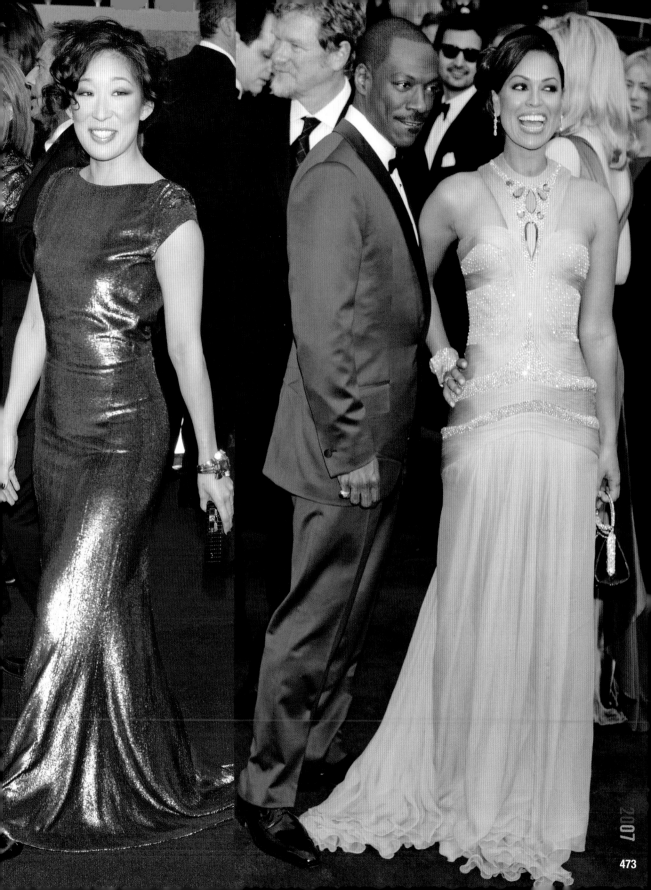

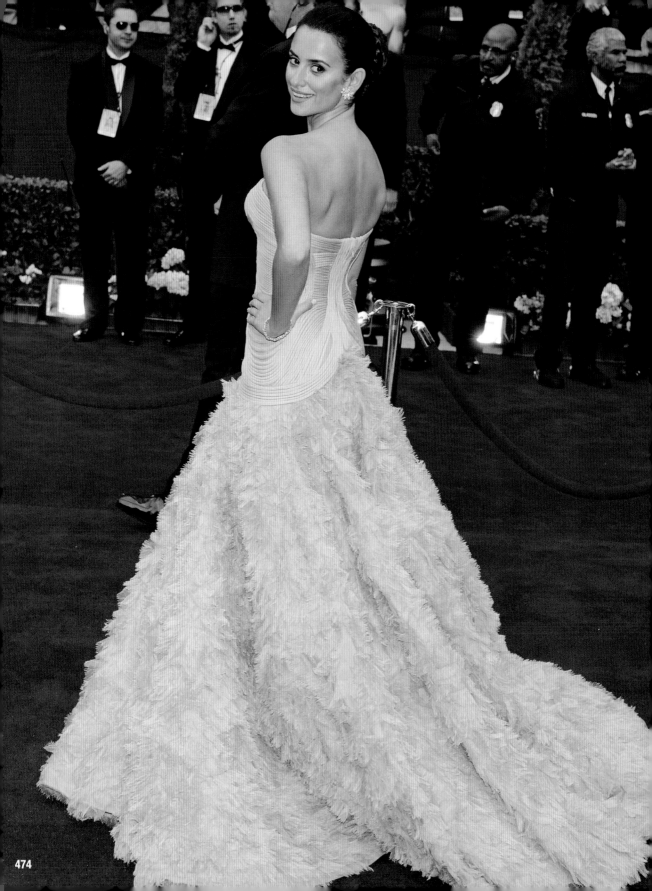

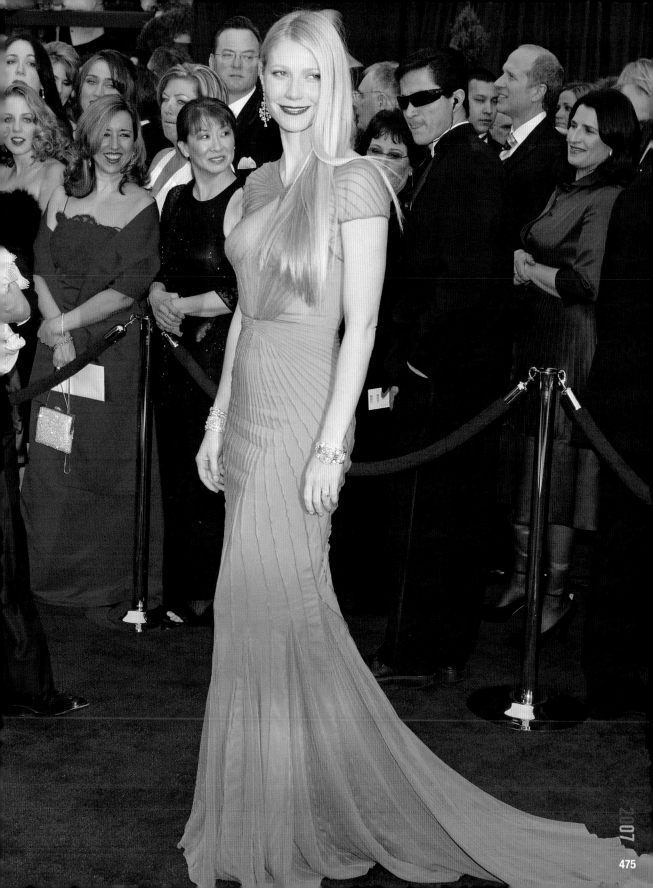

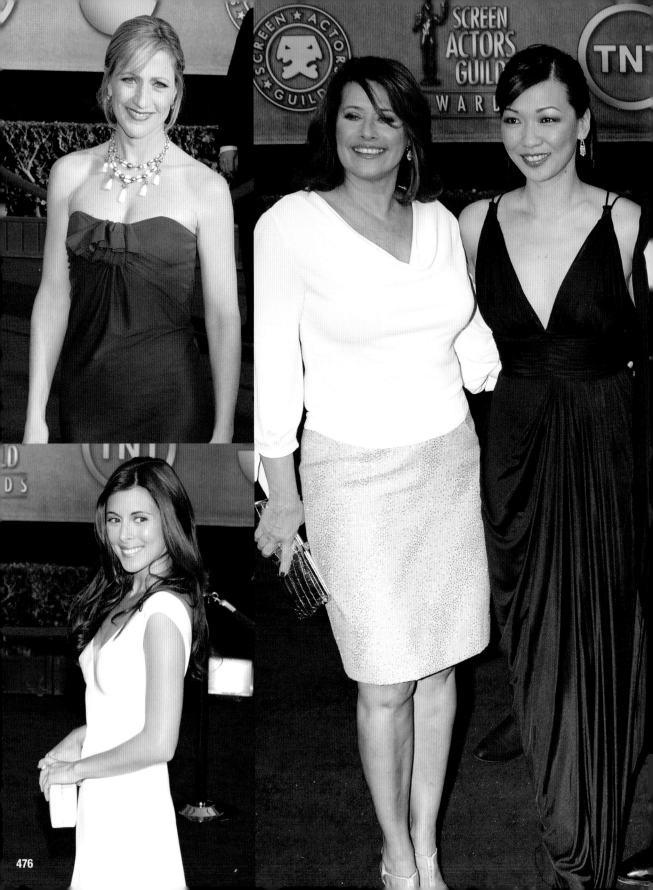

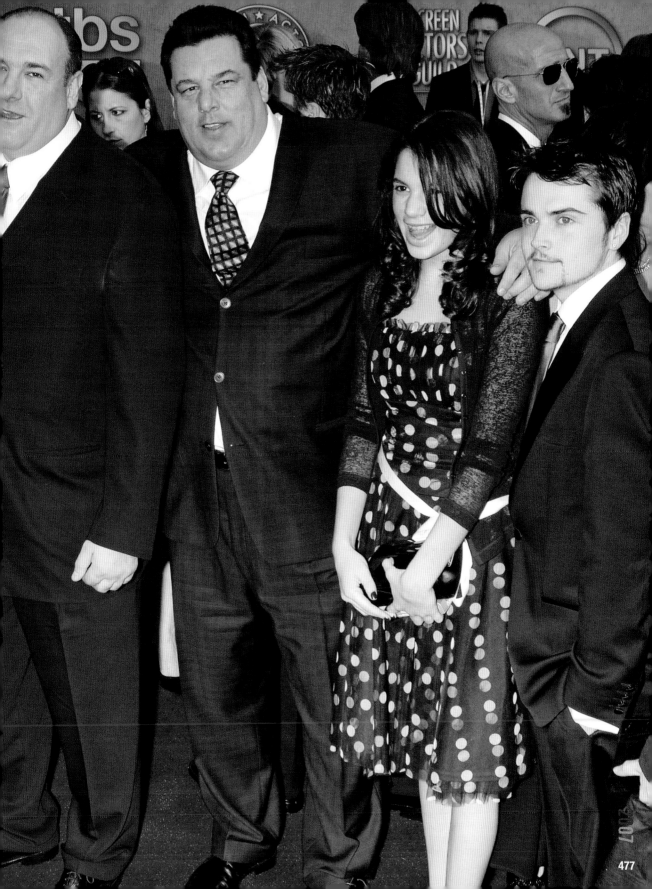

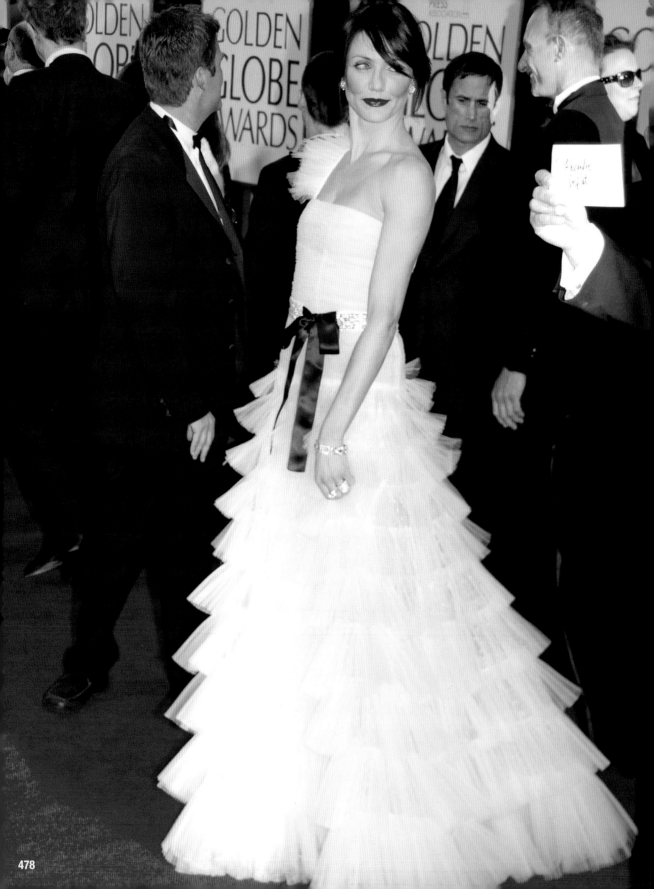

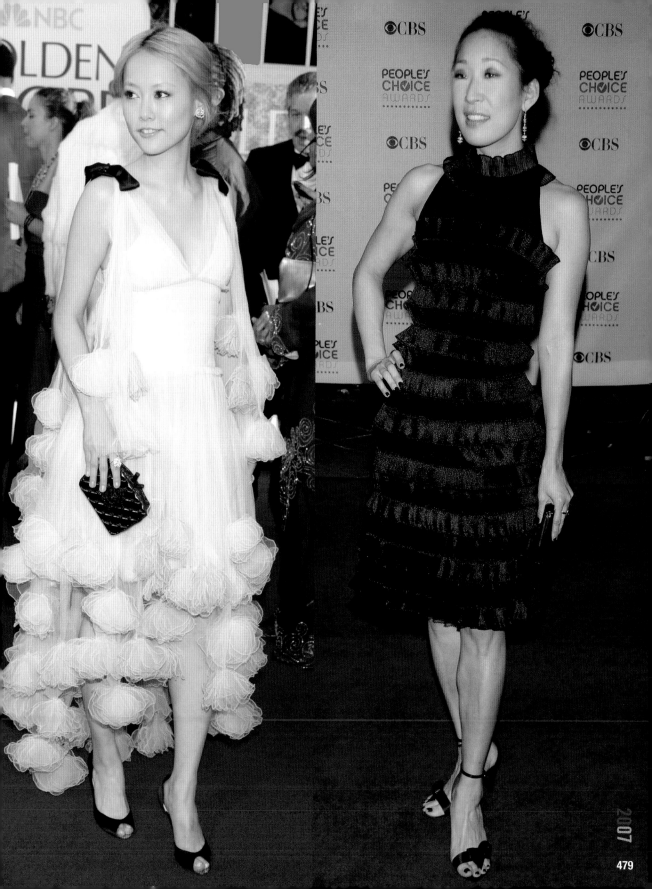

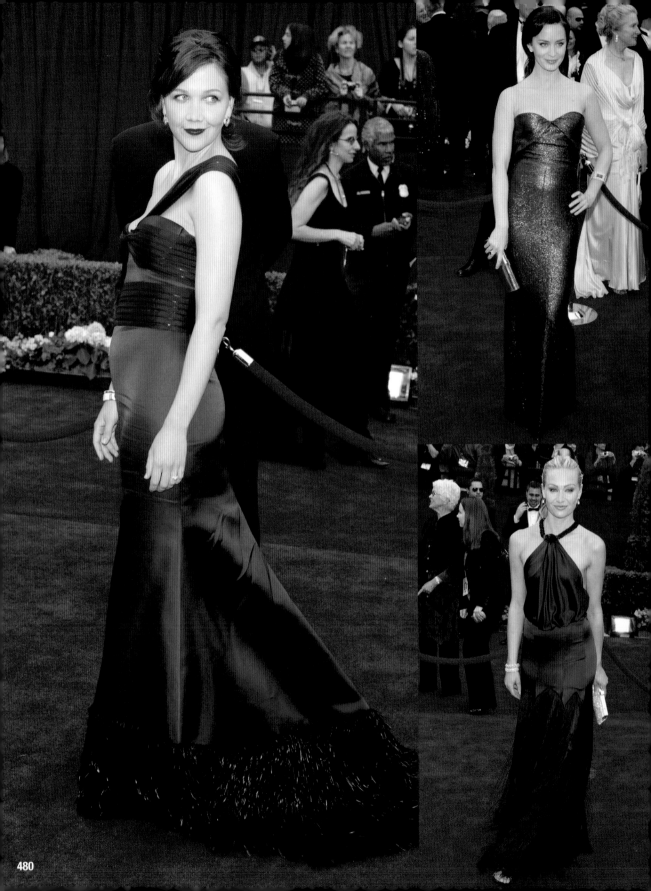

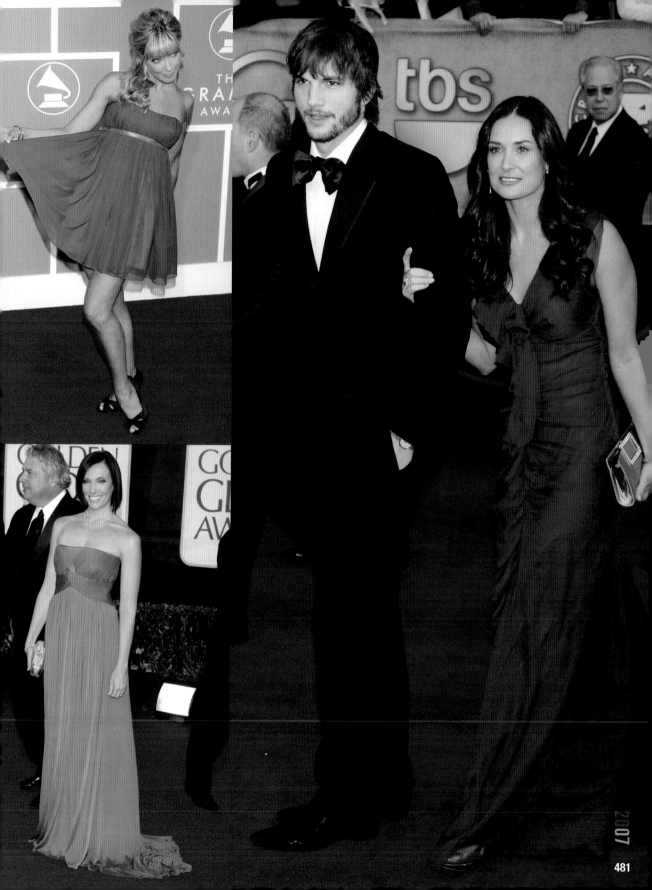

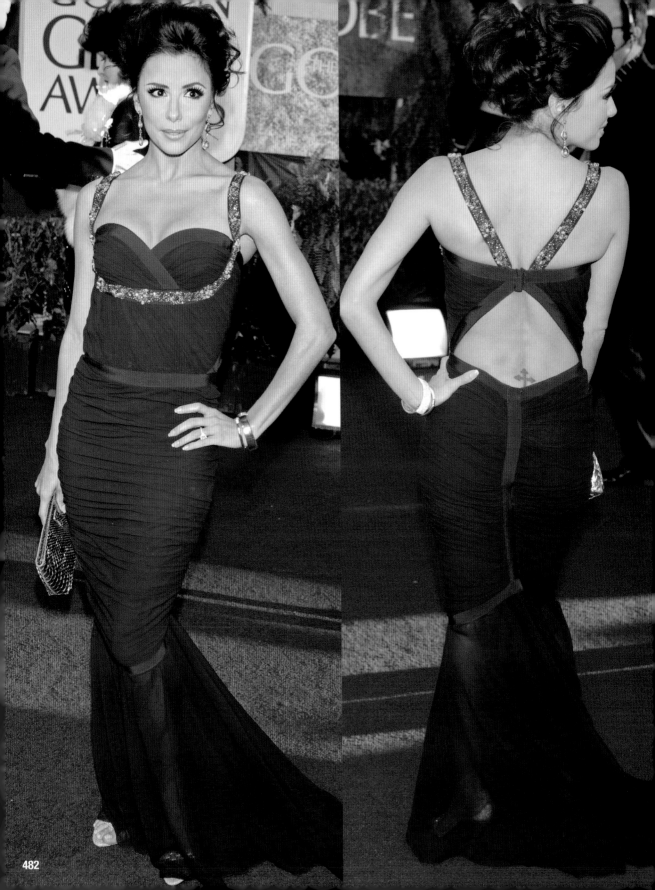

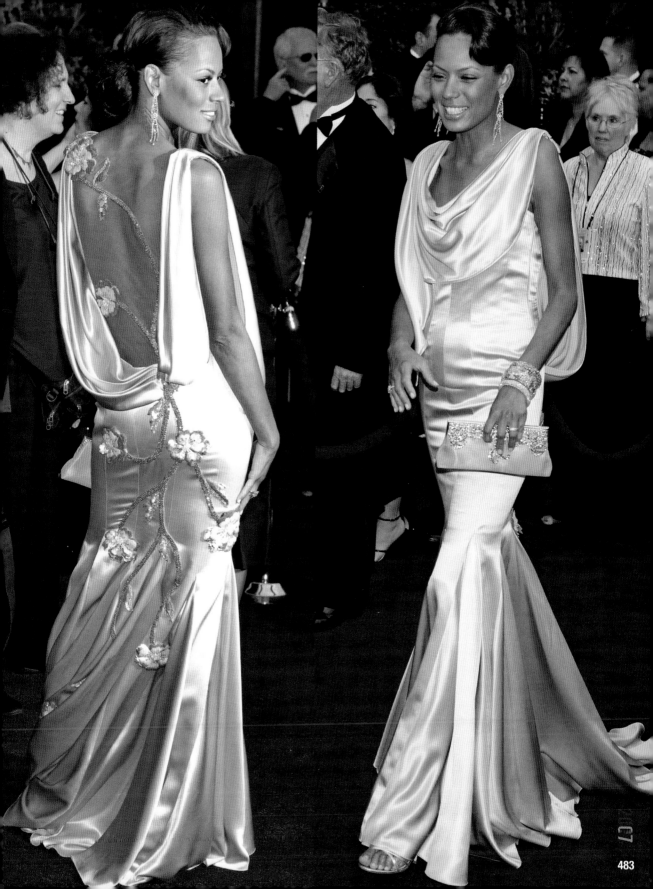

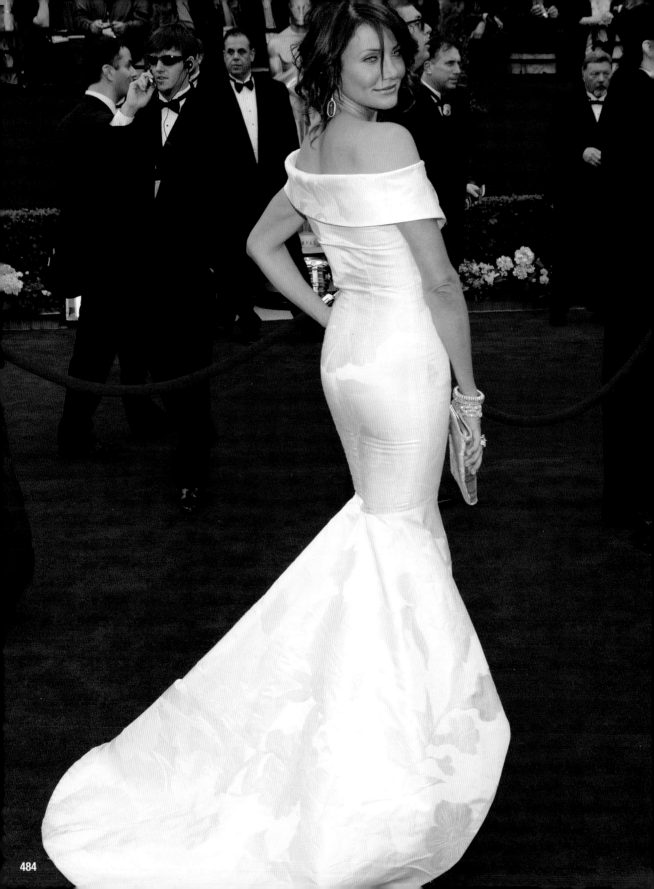

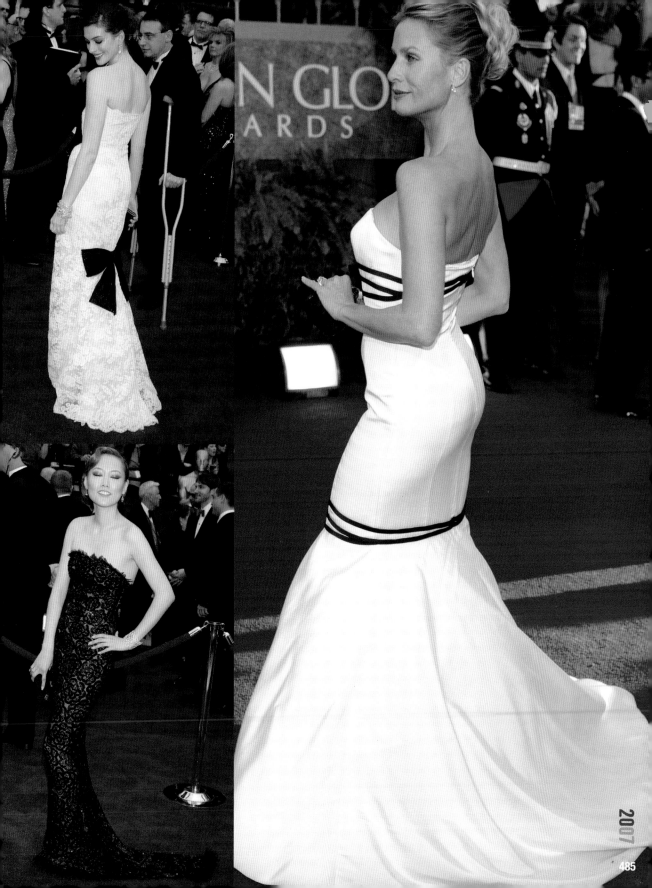

2008

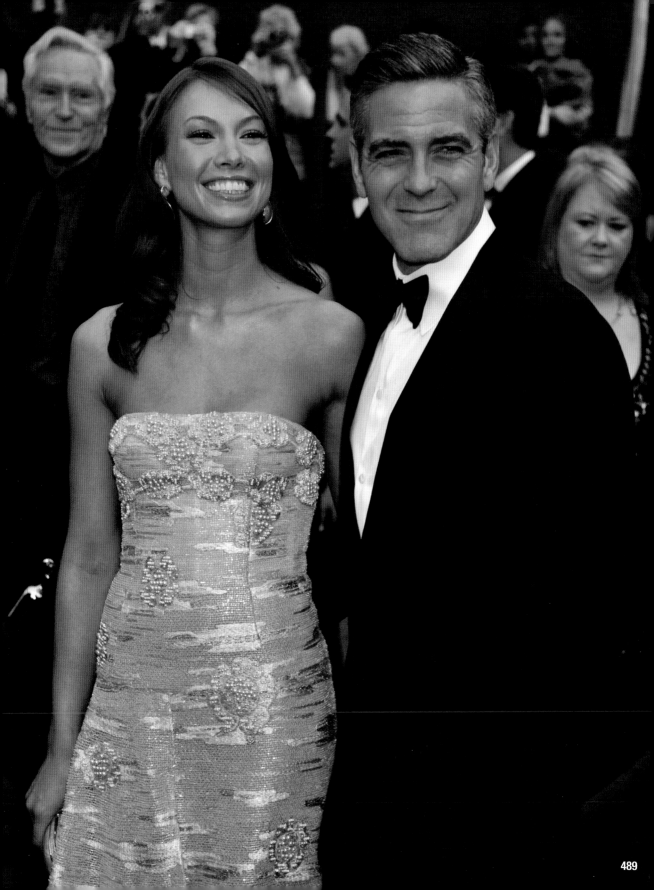

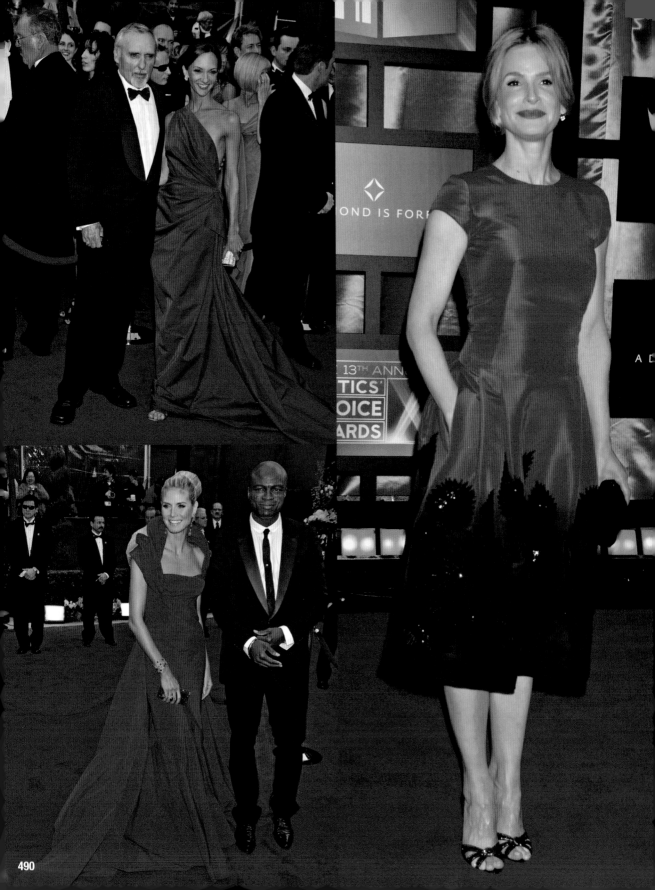

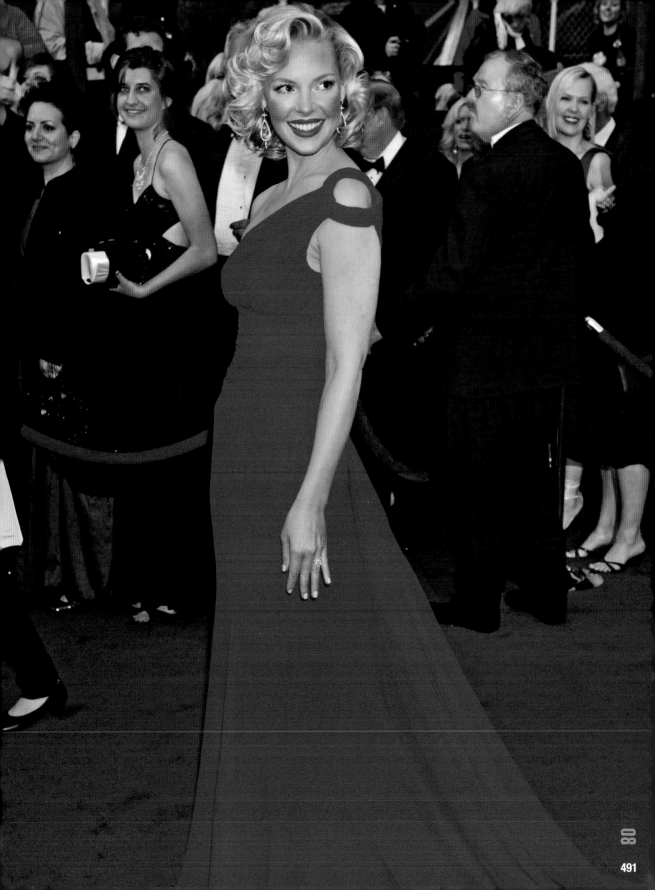

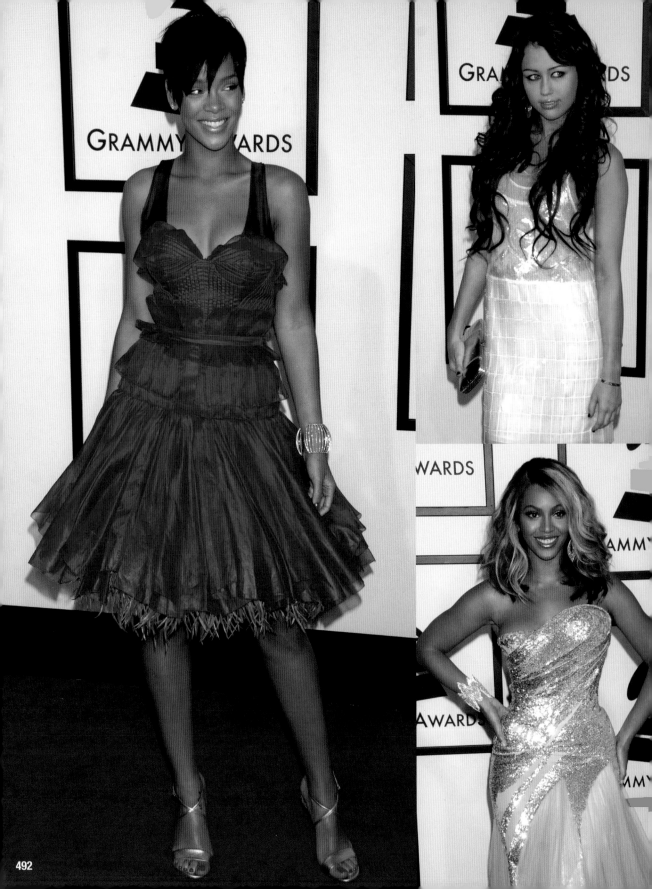

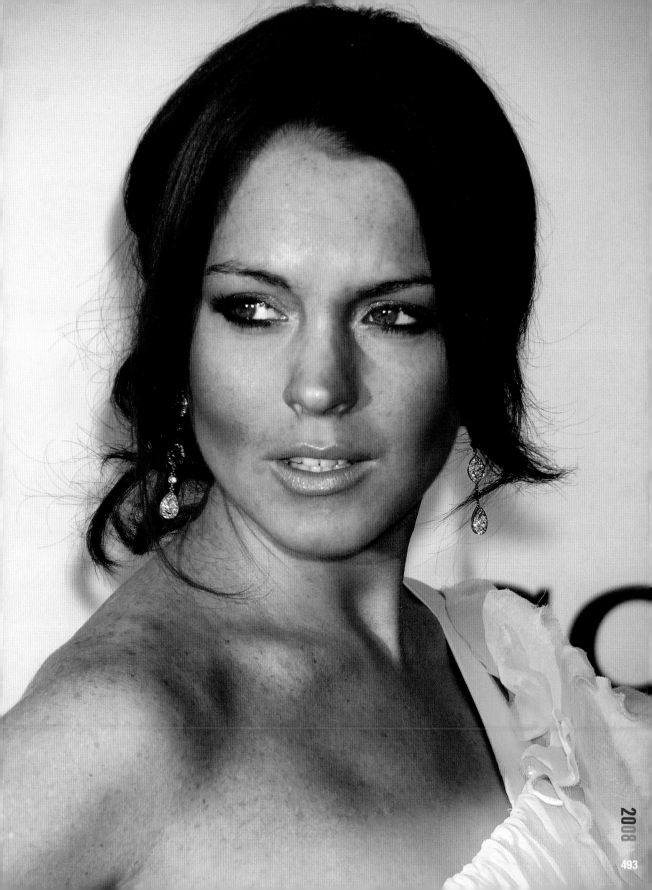

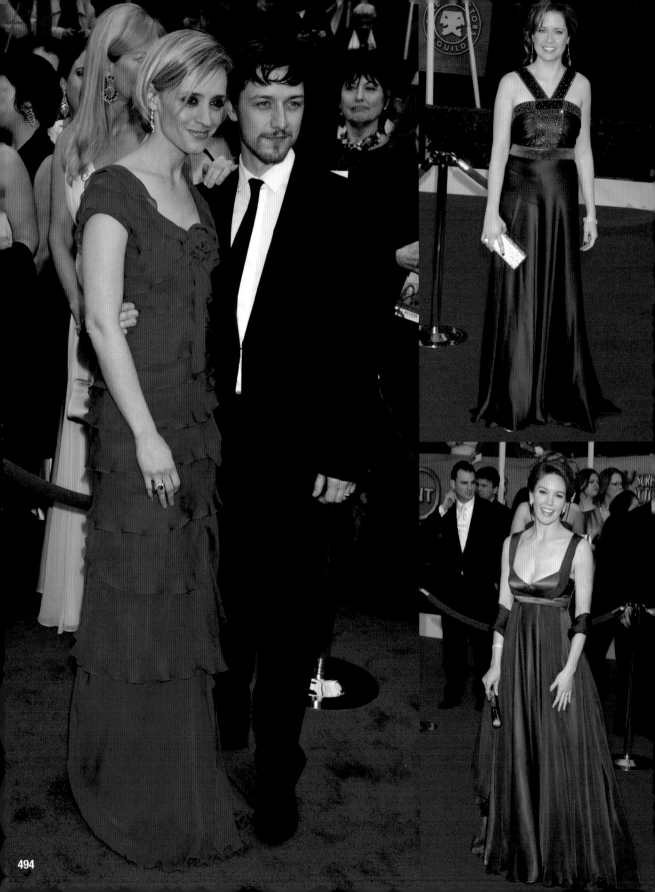

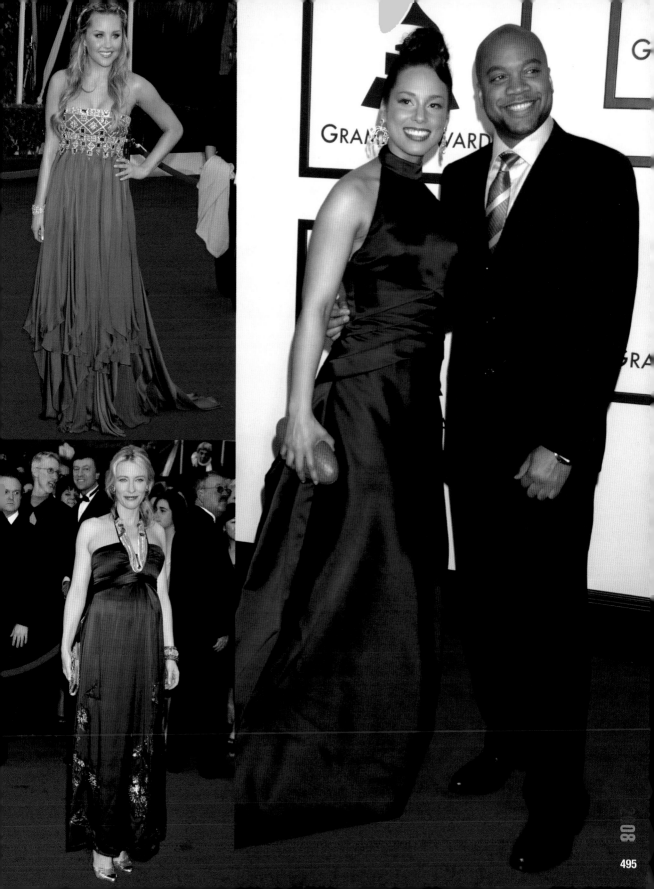

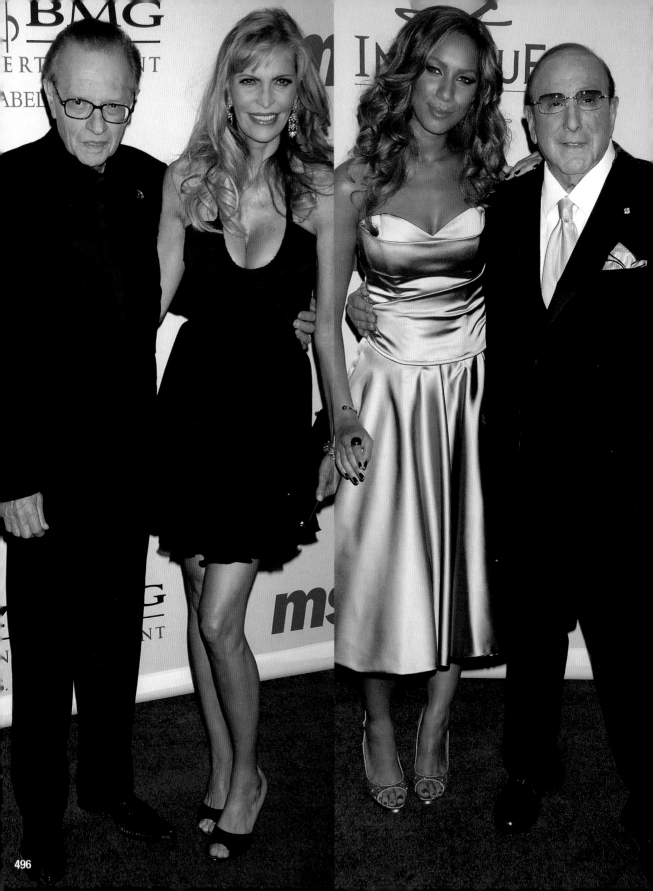

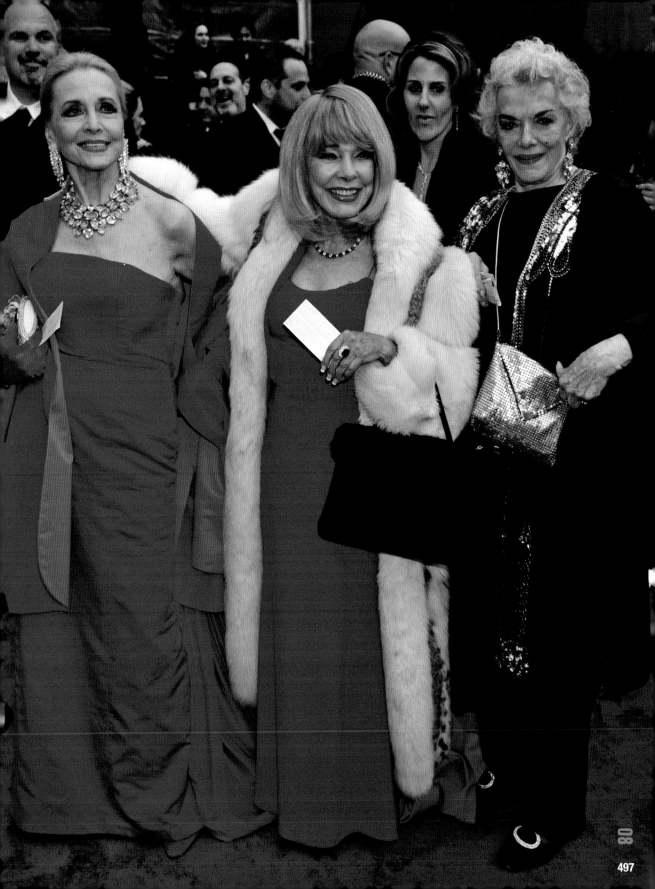

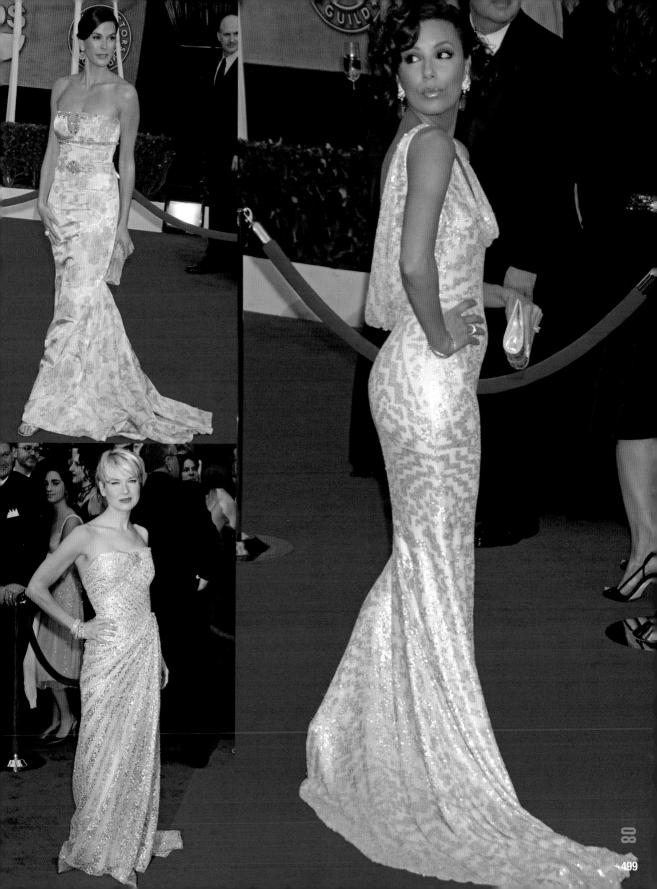

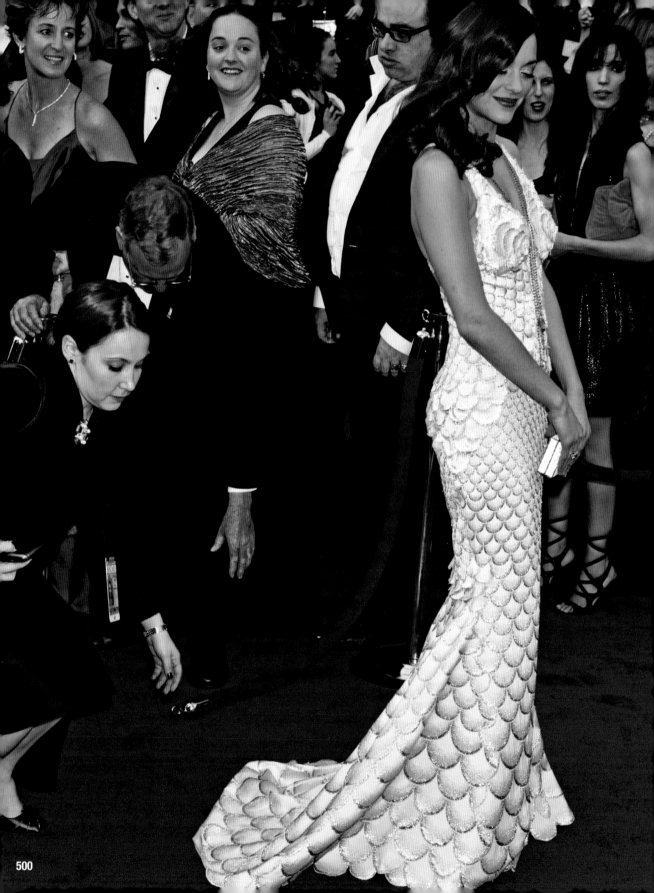

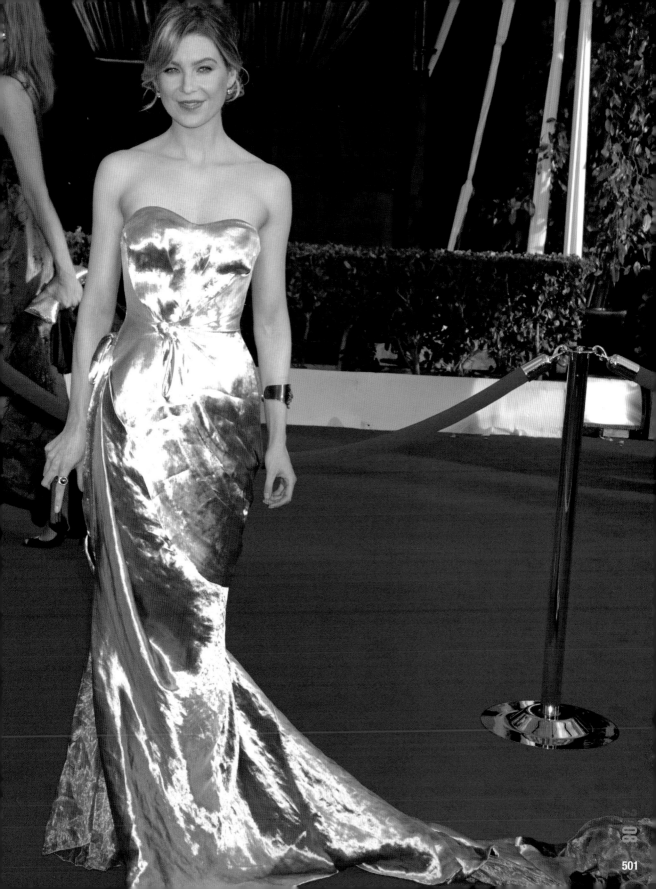

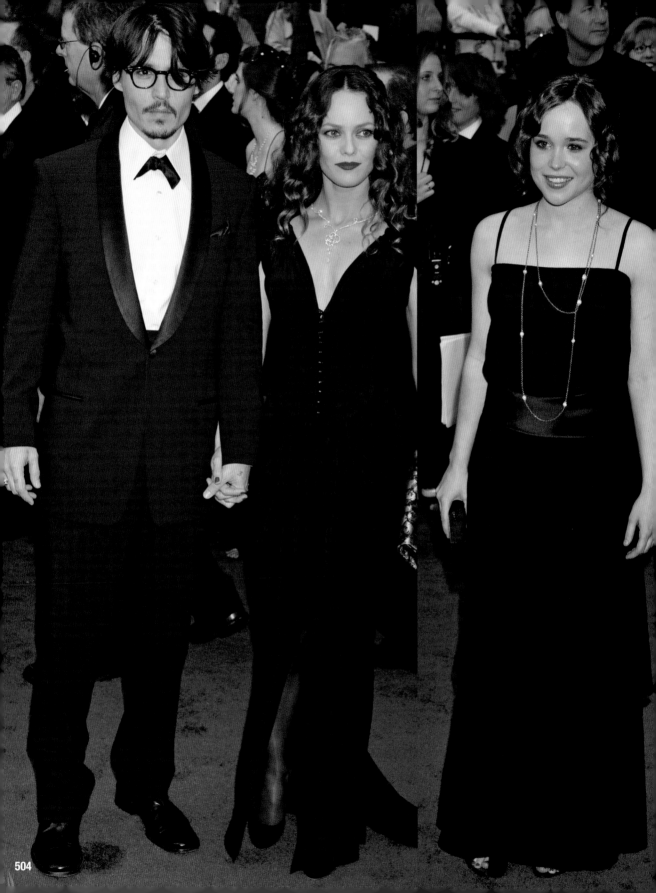

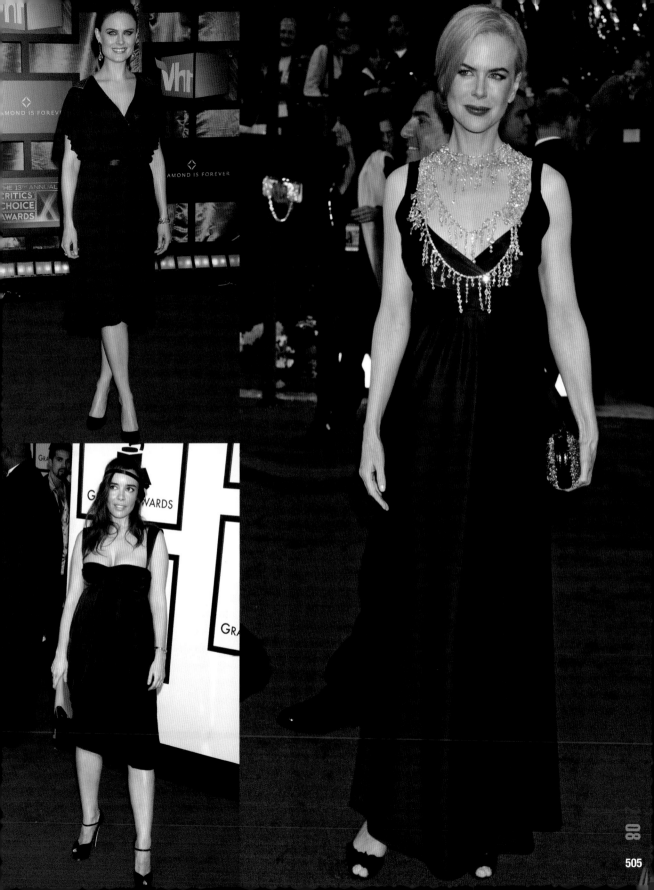

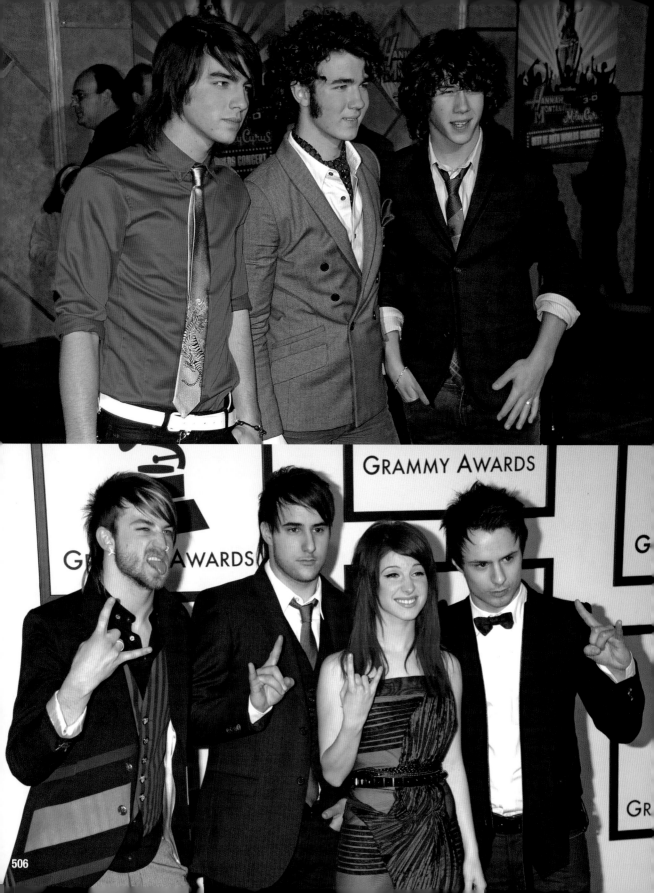

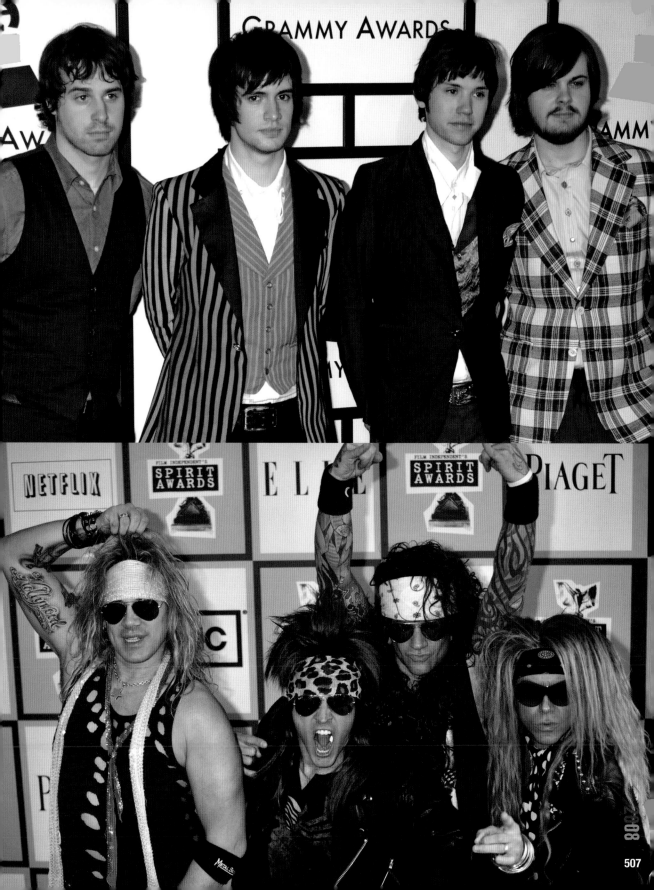

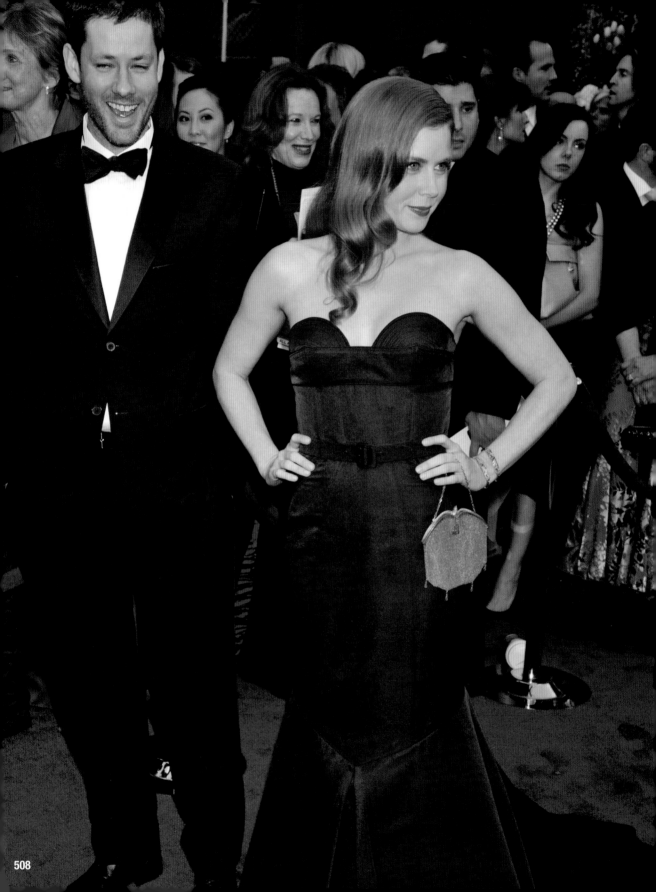

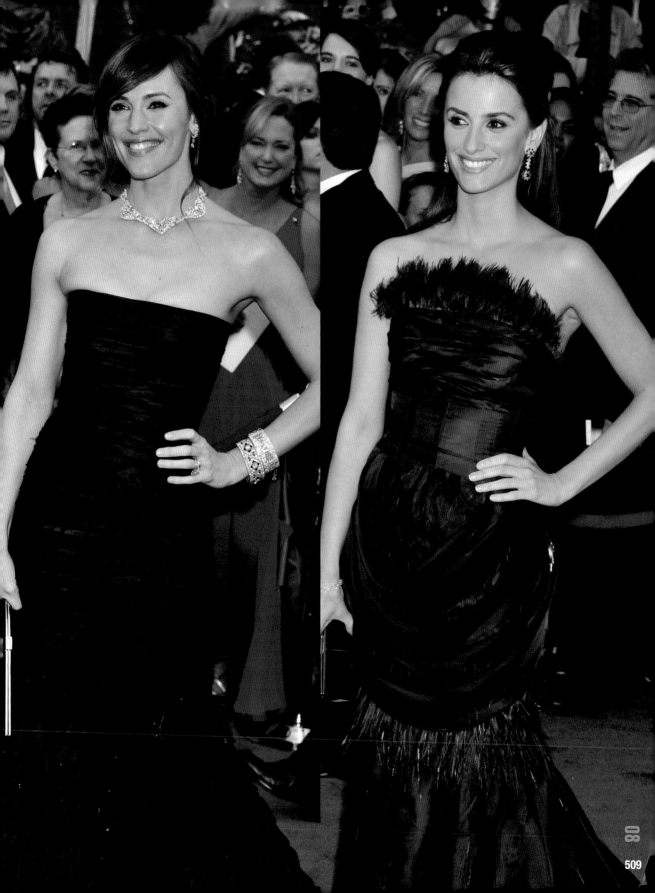

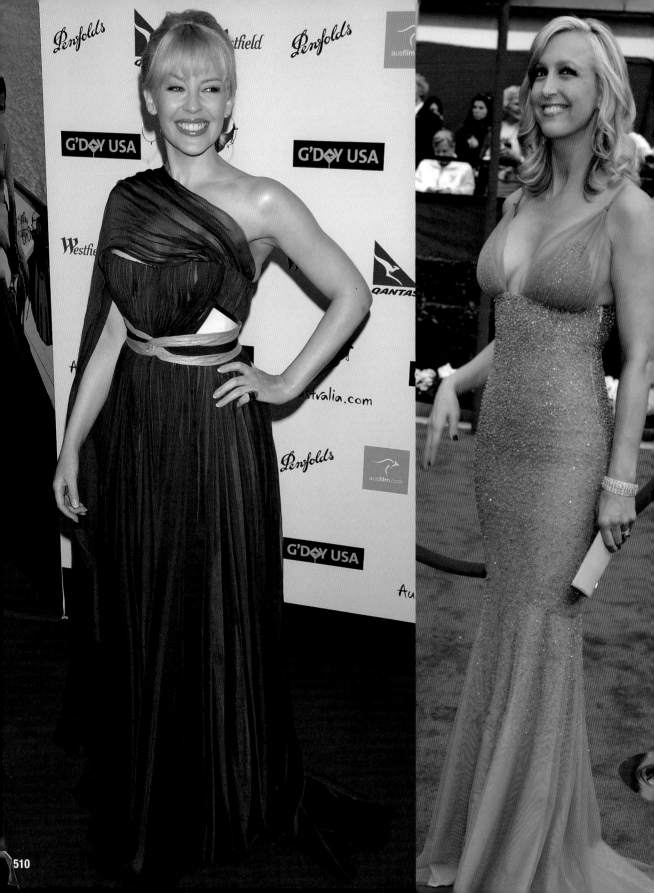

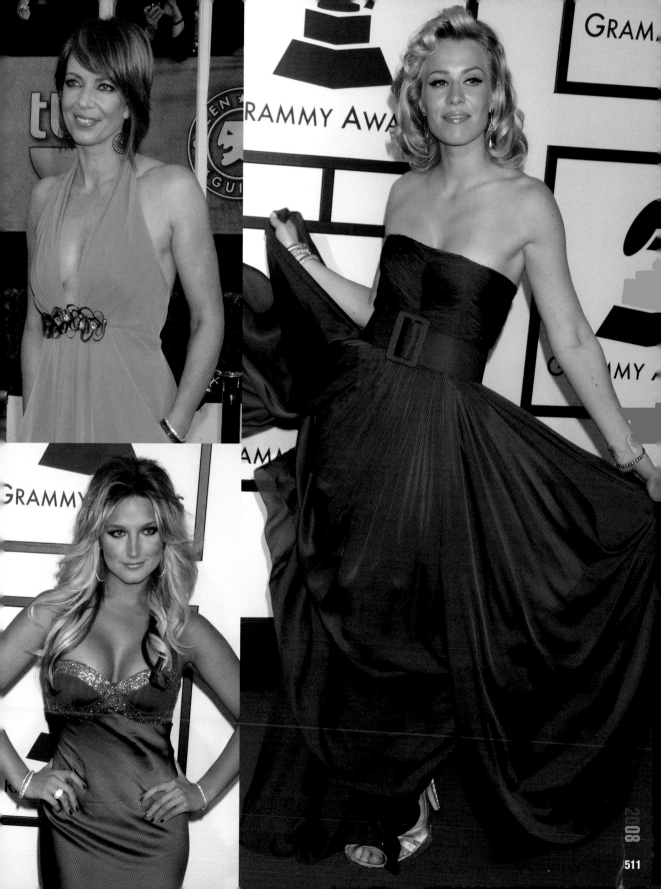

2008

511

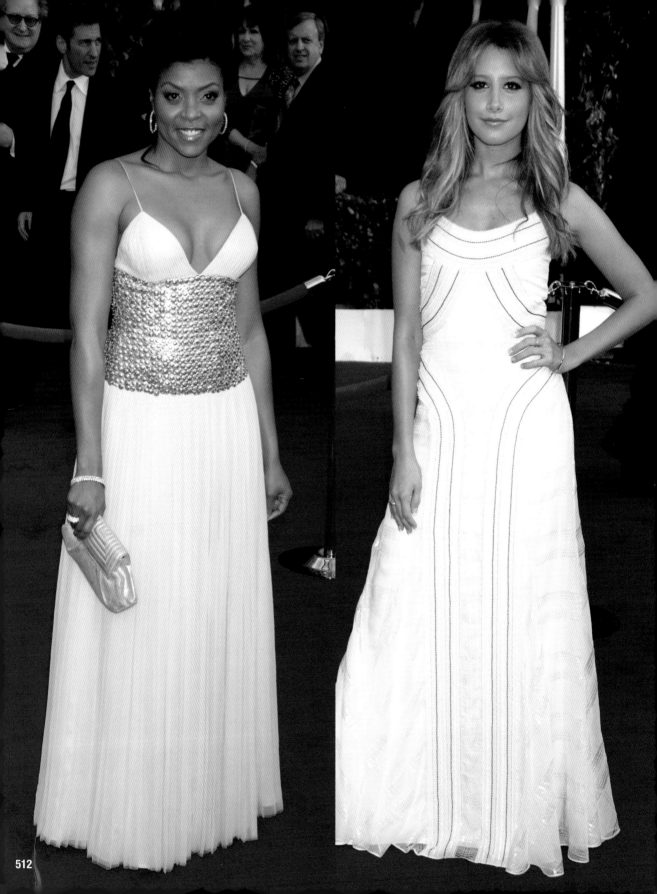

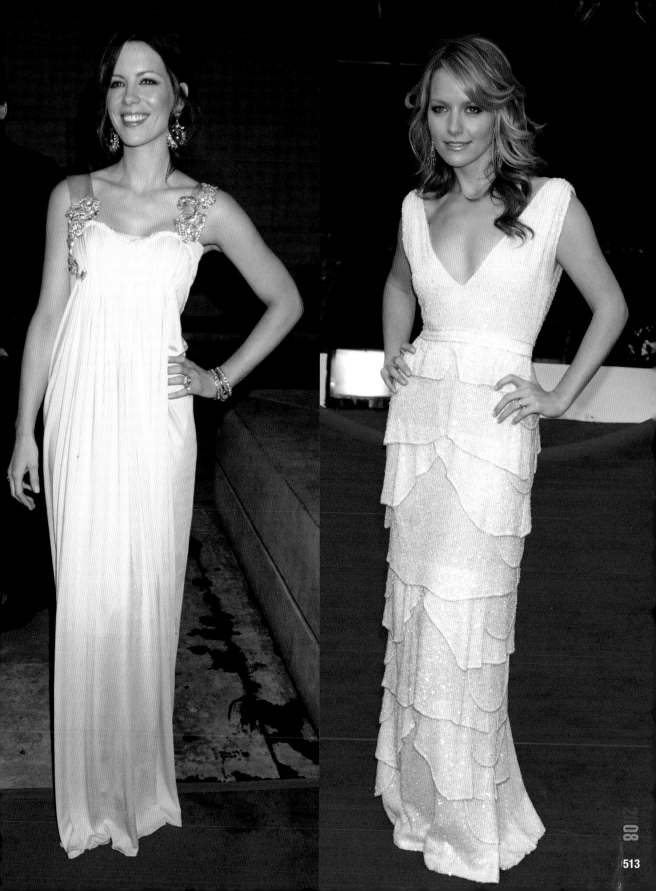

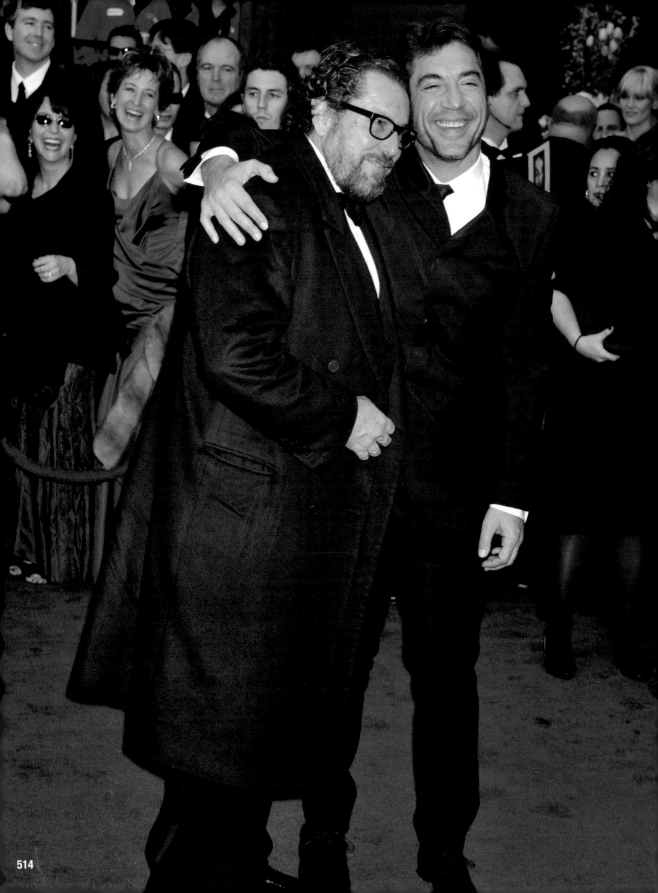

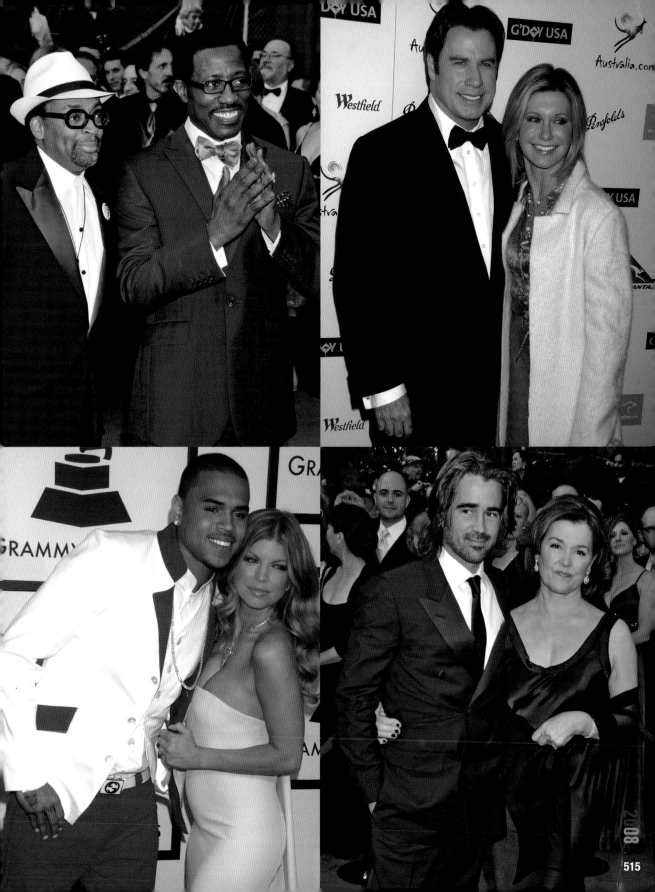

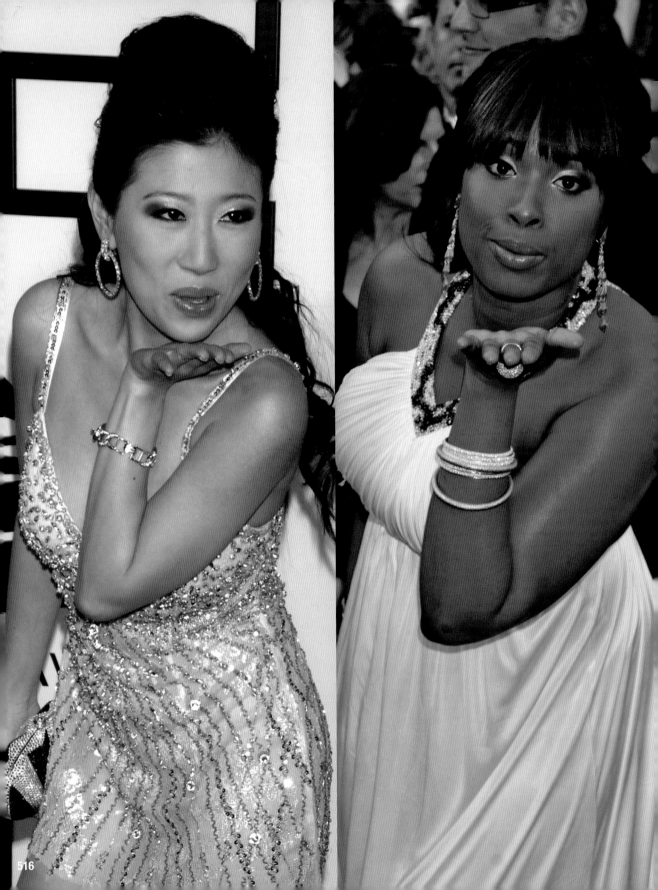

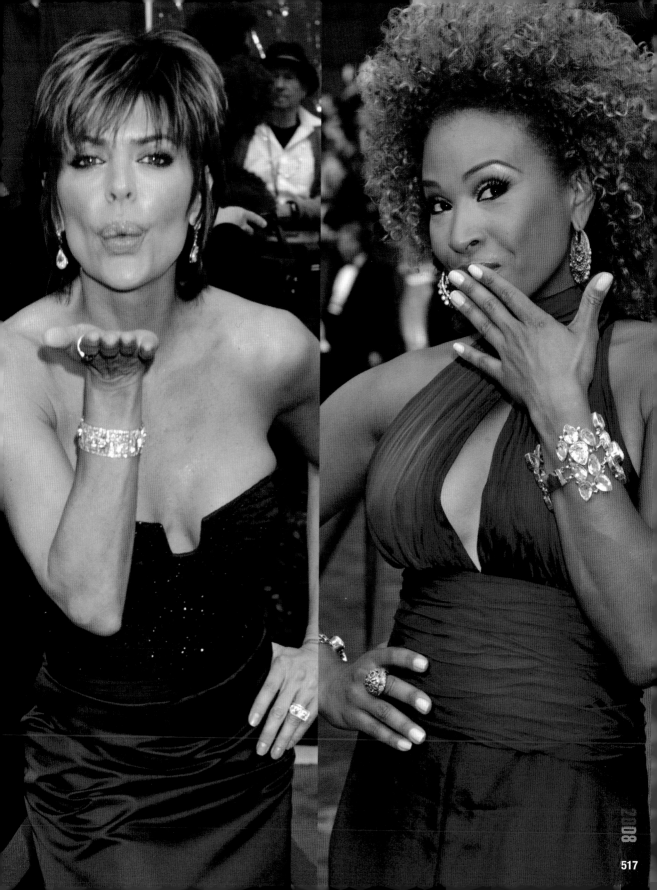

WHO'S WHO ON THE RED CARPET

Photo captions (clockwise from top left):

OPENER

1 **Leslie Mann,** *Fun with Dick and Jane* premiere, 2005
2 **Jennifer Lopez** (in Jean Desses), Academy Awards, 2006
4 **Brad Pitt** and **Jennifer Aniston,** Emmy Awards, 2004
6 **Juliette Lewis,** *Gone in 60 Seconds* premiere, 2000
8 **Jon Voight** with son **James Haven,** daughter **Angelina Jolie,** and mother **Barbara Kamp,** Academy Awards, 1986
10 **Drew Barrymore,** Hollywood Walk of Fame, 2004
12 **Beyoncé Knowles** (in Elie Saab), American Music Awards, 2006
14 **Julia Roberts** and **George Clooney,** American Cinematheque Award, 2006
16 **Billy Crystal,** *City Slickers* premiere, 1991
18 **Gwyneth Paltrow** (in Zac Posen), Academy Awards, 2007
20 **Sidney Poitier, Joanna Shimkus,** and daughters **Anika** and **Sidney Tamiia,** Academy Awards, 1986
22 **Kyra Sedgwick** (in Armani), Academy Awards, 2006
24 **Julie Chen,** Grammy Awards, 2007
26 Red Carpet Arrival Area, Kodak Theater, Academy Awards, 2006

1987

29 **Marlee Matlin** (in Theoni V. Aldredge) and **William Hurt,** Academy Awards
30 **Burt Reynolds** and **Loni Anderson,** Golden Eagle Awards; **Dustin Hoffman** and **Lisa Gottsegen,** Academy Awards; **Robert Redford** and **Sonja Braga,** Golden Eagle Awards; **Richard Dreyfuss** and **Jeramie Rain,** Academy Awards
31 **Oliver Stone** and **Elizabeth Stone,** Academy Awards
32 **Elizabeth Taylor,** Launch party for "Passion Perfume for Women" by Elizabeth Taylor
33 **Sophia Loren,** American Cinema Awards
34 **Sylvester Stallone,** American Cinema Awards; **Mikhail Baryshnikov,** *Dancers* premiere
35 **Christopher Reeve,** Academy Awards; **Jeff Bridges,** Academy Awards
36 **Jane Seymour,** Christian Lacroix fashion show; **Linda Gray,** Evening on Rodeo Drive; **Isabella Rossellini,** Academy Awards

37 **Mary Elizabeth Mastrantonio,** Academy Awards; **William Shatner** and **Marcy Lafferty,** Academy Awards; **Jean Kasem,** Muscular Dystrophy fund-raiser
38 **Hilary Rowland, James Woods,** and **Dianne Wiest,** Academy Awards; **Angie Dickinson, Richard Cohen,** and **Jackie Collins,** Variety Club All-Star Benefit Dinner honoring Joan Collins
39 **Lucille Ball, Bob Hope,** and **Brooke Shields,** Television Hall of Fame Awards
40 **Brogan Lane, Dudley Moore, Kirk Cameron,** and **Brooke Holland,** *Like Father, Like Son* premiere
42 **Dean Martin, Sammy Davis Jr.,** and **Frank Sinatra,** Chasen's Restaurant, Los Angeles
44 **Donna Dixon** and **Dan Aykroyd,** *Empire of the Sun* premiere; **Victoria Tennant** and **Steve Martin,** *Cross My Heart* premiere
45 **Richard Pryor,** *Three Men and a Baby* premiere

1988

47 **Valeria Golino** and **Paul Reubens,** Academy Awards
48 **Robyn Moore** and **Mel Gibson,** Academy Awards
49 **Marlee Matlin** and **Richard Dean Anderson,** Academy Awards; **Jillie Mack** and **Tom Selleck,** Academy Awards
50 **Joan Collins,** Release party for Joan Collins's first novel, *Prime Time*
51 **Richard Cohen** and **Linda Evans,** Annual Motion Picture Ball honoring Robin Williams
52 **Candice Bergen,** Academy Awards; **Liza Minnelli** (in Gianfranco Ferre), Academy Awards; **Vanna White,** Birthday party for George Burns
53 **Audrey Hepburn,** California Lifetime Achievement Award for the Arts honoring Hubert De Givenchy
54 **Cyndi Lauper,** MTV Awards
55 **Edy Williams,** Academy Awards; **Cher** (in Bob Mackie), Academy Awards; **Daryl Hannah,** Academy Awards
56 **Nicolas Cage** and date, Academy Awards
57 **Michael Douglas** and **Diandra Douglas,** Academy Awards; **Mike Tyson** and **Robin Givens,** Emmy Awards
58 **LL Cool J** and **Simone Johnson,** American Music Awards party

1989

61 **Michael Jackson,** Century Plaza Hotel
62 **Tracey Ullman,** Golden Globe Awards; **Morgan Fairchild,** Golden Eagle Awards
63 **Maria Conchita Alonso,** Golden Eagle Awards; **Paula Abdul,** Emmy Awards
64 **Melanie Griffith** and **Don Johnson,** Golden Globe Awards
65 **Amy Irving** and **Steven Spielberg,** Golden Globe Awards; **Tracy Pollan** and **Michael J. Fox,** *Back to the Future II* premiere; **Vanna White** and **George Santopietro,** Launch party for "273 Perfume by Fred Hayman"; **Christine Lahti** and **Thomas Schlamme,** Golden Globe Awards
66 **Sigourney Weaver,** *Ghostbusters II* premiere; **Rebecca De Mornay,** *Earth Girls Are Easy* premiere; **Jane Seymour,** Simon Wiesenthal tribute
67 **Jane Fonda,** Academy Awards
68 **Joan Collins,** AIDS Project Los Angeles benefit; **Sally Kirkland,** Launch party for "273 Perfume by Fred Hayman"
69 **Barbi Benton,** Launch party for "273 Perfume by Fred Hayman"; **Dolly Parton,** *Steel Magnolias* premiere
70 **Joan Rivers** and **Debi Gibson,** American Music Awards; **Andrew Dice Clay,** MTV Movie Awards; **Lisa Blount,** *Great Balls of Fire* premiere; **Rutger Hauer,** *Bloodhounds of Broadway* premiere
71 **Jean Kasem,** Golden Eagle Awards
72 **Kristy McNichol** and **Brian Bloom,** *Bloodhounds of Broadway* premiere; **Kelly Preston** and **Charlie Sheen,** Hollywood Walk of Fame honoring Martin Sheen; **Cynthia Gibb** and **Sean Kanan,** *Listen to Me* premiere; **Brooke Holland** and **Kirk Cameron,** *Listen to Me* premiere
73 **Ally Sheedy** and **Heather Locklear,** Housing Now benefit
74 **Eddie Murphy,** Sammy Davis Jr. 60th anniversary celebration
75 **Louie Anderson,** *Do the Right Thing* premiere

1990

77 **Daryl Hannah** (in Robin McCarter), Academy Awards
78 **Suzanne Somers,** Golden Globe Awards; **Cybill Shepherd,** Golden Globe Awards
79 **Mr. T,** *Total Recall* premiere

80 **Michael Jackson**, CBS honoring Michael Jackson

81 **Brooke Shields**, American Cinema Awards

82 **Julie Tesh**, Party honoring Oliver Stone; **Kim Basinger**, Celebration of Tradition gala; **Laura Dern**, *Total Recall* premiere

83 **Kim Cattrall**, *The Bonfire of the Vanities* premiere; **Diane Sawyer** and **Barbara Walters**, Television Hall of Fame; **Whitney Houston**, American Cinema Awards

84 **DJ Jazzy Jeff** and **Will Smith**, Grammy Awards; **Billy Dee Williams** and **Muhammad Ali**, Event honoring Diana Ross; **Don Johnson** and **Tom Selleck**, Film Independent's Spirit Awards

85 **Oliver Stone** and **Tom Cruise**, Golden Globe Awards

86 **Val Kilmer**, Party honoring Oliver Stone; **Daniel Day-Lewis** (in Katharine Hamnett), Academy Awards

87 **Sharon Stone**, *Total Recall* premiere; **Justine Bateman**, MTV Movie Awards

88 **Kiefer Sutherland** and **Julia Roberts** (in Giorgio Armani), Academy Awards

89 **Balthazar Getty** and **Drew Barrymore**, *Young Guns II* premiere; **Johnny Depp** and **Winona Ryder**, *Edward Scissorhands* premiere; **Kyle MacLachlan** and **Lara Flynn Boyle**, Emmy Awards

90 **Gary Busey** and son **Jake Busey**, Golden Globe Awards; **Debbie Reynolds** and daughter **Carrie Fisher**, Thalians 35th Annual Ball

91 **Ted Turner**, **Jane Fonda** (in Gianni Versace Couture), and son **Troy Garity**, Academy Awards

1991

93 **Al Pacino** (in Armani) and date, Academy Awards

94 **Ed Begley Jr.** and **Annette Bening** (in Bugsy by Albert Wolsky), Academy Awards; Guest, Academy Awards

95 **Debra Winger** (in Valentino), Academy Awards; **Alec Baldwin** and **Kim Basinger** (in Mary Ellen Fields and Bill Hargate), Academy Awards

96 **Richard Gere** and **Cindy Crawford**, The Moving Picture Ball honoring Martin Scorsese

98 **Sylvester Stallone** and **Jennifer Flavin**, *Backdraft* premiere

99 **Kelly Preston** and **John Travolta**, New York Film Critics party; **Kevin Costner**, The 1st Annual Movie Awards; **Marivi Lorido Garcia** and **Andy Garcia**, Academy Awards, **Michael Douglas**, *L.A. Story* premiere

100 **Nicole Kidman** and **Tom Cruise**, Academy Awards

101 **Jill Goodacre** and **Harry Connick Jr.**, Academy Awards; **Paul Qualley** and **Andie MacDowell**, Golden Globe Awards

102 **Dorothea Hurley** and **Jon Bon Jovi**, Academy Awards; **Paula Abdul**, American Cinema Awards; **Donna Mills**, Opening of the Escada Boutique; **Wendy Treece Bridges** and **Beau Bridges**, *Naked Gun 2½* premiere

103 **Tom Petty**, Oscar Eighth Annual Pop Awards dinner; **Delta Burke** and **Gerald McRaney**, Emmy Awards; **Rob Lowe**, The 1st Annual Movie Awards

104 **Macaulay Culkin**, Golden Globe Awards

105 **Whoopi Goldberg**, **Billy Crystal**, and **Kathy Bates**, *City Slickers* premiere

106 **Lenny Kravitz**, MTV Movie Awards; **Billy Idol**, MTV Movie Awards; **Prince** and **Apollonia Kotero**, ASCAP Awards

107 **Lisa Collins** and **Billy Zane**, *Truth or Dare* premiere

108 **Rosanna Arquette**, Academy Awards; **Alex Keshishian** and **Madonna**, American Foundation for AIDS Research benefit; **Sandra Bernhard** and **André Leon Talley**, American Foundation for AIDS Research benefit

109 **Priscilla Presley**, *Naked Gun 2½* premiere

1992

111 **Demi Moore** (in vintage Lily et Cie), Academy Awards

112 **Liza Minnelli** (in Fred Hayman), Academy Awards; **Jane Fonda**, Emmy Awards

113 **Rebecca De Mornay** (in Nolan Miller), Academy Awards; **Elizabeth Taylor**, Carousel of Hope Ball

114 **Warren Beatty**, Golden Globe Awards

116 **Bobby Brown** and **Whitney Houston**, *The Bodyguard* premiere; **Kurt Russell** and **Goldie Hawn**, Carousel of Hope Ball; **Gabriel Byrne** and **Ellen Barkin**, Golden Globe Awards

117 **Loni Anderson** and **Burt Reynolds**, Emmy Awards

118 **Barbra Streisand** (in Patricia Lester), Academy Awards nominee luncheon; **Barbra Streisand**, Academy Awards

119 **Geena Davis**, Academy Awards nominee luncheon; **Geena Davis**, Golden Globe Awards

120 **Jason Priestley** and **Christine Elise**, *Dracula* premiere; **Chris Sualfa** and **Mimi Rogers**, Film Independent's Spirit Awards;

Juliette Lewis and **Brad Pitt**, Film Independent's Spirit Awards

121 **Fisher Stevens** and **Michelle Pfeiffer**, *Batman Returns* premiere

122 **Batman** and **Catwoman**, *Batman Returns* premiere

123 **Alec Baldwin** and **Kim Basinger**, *Malcolm X* premiere

124 **Arnold Schwarzenegger**, Planet Hollywood South opening

126 **Julie Robinson** and **Harry Belafonte**, *Stir Crazy* premiere; **Linda McCartney**, "Sixties: A Portrait of the Era" opening; **Antonio Banderas** and **Ana Leza**, Academy Awards; **Paul McCartney**, "Sixties: A Portrait of the Era" opening

127 **Robin Williams**, *Toys* premiere

1993

129 **Whoopi Goldberg**, Academy Awards

130 **Paul Qualley** and **Andie MacDowell** (in Ralph Lauren), Academy Awards; **Lori Petty**, Organization for the Fight Against AIDS

131 **Michael Bolton** and **Nicollette Sheridan**, American Music Awards; **Sarah Jessica Parker**, MTV Movie Awards; **Vincent Young** and **Tori Spelling**, Golden Globe Awards

132 **Lyle Lovett** and **Julia Roberts**, *The Pelican Brief* premiere

134 **Nicole Kidman**, *The Firm* premiere

135 **Diane Keaton**, *Manhattan Murder Mystery* screening

136 **Julianne Phillips**, **Swoosie Kurtz**, and **Sela Ward**, Golden Globe Awards; **Whitney Houston** and **Bobby Brown**, Billboard Music Awards; **Celine Dion**, American Music Awards

137 **Will Smith** and **Sheree Smith**, Golden Globe Awards; **Jean-Claude Van Damme** and **Darcy LaPier**, Golden Globe Awards

138 **Shirley Jones** and **Carol Channing**, Golden Globe Awards; **Louis Gossett Jr.**, Emmy Awards; **Natalie Cole**, American Music Awards

139 **Jackie Stallone** and **Frances Hilton**, Women in Show Business homage to Barbara Sinatra

140 **Chris Kelly** and **Chris Smith** of Kris Kross, 25th Annual NAACP Image Awards

141 **Corey Haim** and **Brian Austin Green**, Golden Globe Awards

1994

143 **Jay Leno**, *Love Ride II* premiere

144 **Isabella Rossellini**, Fire & Ice Ball;

George Hamilton and Liza Minnelli, Liza Minnelli receives the Thalians 1994 Ms. Wonderful Award; Richard Dreyfuss and Rosie O'Donnell, Academy Awards

145 Martin von Haselberg and Bette Midler, 22nd Annual Lifetime Achievement Award honoring Jack Nicholson; Claudia Schiffer, Fire & Ice Ball; Rod Stewart and Rachel Hunter, Carousel of Hope Ball

146 Sonja Braga, Diversity Awards

147 Nicole Kidman, People's Choice Awards; Keri Russell, Carousel of Hope Ball; Alex Kingston, Academy Awards; Kirsten Dunst, *Interview with the Vampire* premiere

148 Rupert Everett, *Ready to Wear* premiere; Demi Moore, *Disclosure* premiere; Hugh Grant, Hollywood Women's Press Club, 54th Annual Golden Apple Awards

149 Yasmine Bleeth, *Interview with the Vampire* premiere; Fran Drescher, *Little Women* premiere

150 Tom Cruise and Nicole Kidman, *Interview with the Vampire* premiere

151 Arye Gross and Ellen DeGeneres, *Interview with the Vampire* premiere

1995

153 Stedman Graham and Oprah Winfrey (in Gianfranco Ferre), Academy Awards

154 Sharon Stone (in Vera Wang), Academy Awards; Angela Bassett, Fire & Ice Ball

155 Tori Spelling, *Batman Forever* premiere; Jane Fonda (in Versace), Academy Awards

156 Jack Nicholson and daughter Lorraine Nicholson, *Beauty and the Beast* benefit performance

157 Jamie Walters and Drew Barrymore, *Batman Forever* premiere

158 George Clooney and Noah Wyle, People's Choice Awards; Val Kilmer, *Batman Forever* premiere; Johnny Depp, *Nick of Time* premiere

159 Sean Penn, *The Crossing Guard* premiere

160 Jodie Foster (in Armani), Academy Awards; Melanie Griffith, Fire & Ice Ball

161 Andie MacDowell (in Eaves & Brown), Academy Awards; Aitana Sánchez-Gijón, *A Walk in the Clouds* premiere

162 Grant Show and Laura Leighton, Golden Globe Awards; Tom Cruise and Nicole Kidman (in Dolce & Gabbana), *Batman Forever* premiere; Kelly Preston and John Travolta, Screen Actors Guild Awards

163 David Pirner and Winona Ryder (in Colleen Atwood), Academy Awards

164 Sally Kellerman (in Versace), Academy

Awards; Nanà Cecchi and date, *First Night* premiere

165 Tim Chappell and Lizzy Gardiner (in Lizzy Gardiner), Academy Awards

166 Cathleen Lyons and Michael Richards, Screen Actors Guild Awards

167 George Foreman, Cable ACE Awards

1996

169 Matthew Fox, Scott Wolf, Lacey Chabert, Paula Devicq, and Neve Campbell, cast of *Party of Five*, Golden Globe Awards

170 Mariah Carey, American Music Awards; Tyra Banks, Academy Awards; Mary J. Blige, Grammy Awards

171 Susan Sarandon (in Dolce & Gabbana), Academy Awards

172 Hugh Grant and Elizabeth Hurley, *Extreme Measures* premiere; Madonna, *Evita* premiere; Jenny McCarthy, Carousel of Hope Ball

173 Kate Winslet (in Vivienne Westwood), Academy Awards; Marcus Schenkenberg and Patricia Velasquez, Academy Awards; Salma Hayek, Cable ACE Awards

174 Shirley Jones and Phyllis Diller, American Movie Classics Reception

175 Debbie Reynolds and Florence Henderson, American Movie Classics Reception

176 Heather Locklear (in Richard Tyler), Golden Globe Awards; Vanessa Williams (in Versace), Academy Awards; Paula Abdul, American Music Awards

177 Tim Burton and Lisa Marie, *Mars Attacks* premiere

178 Jenny McCarthy, *Striptease* premiere; Kelly Preston, *Broken Arrow* premiere; Angie Harmon, Friends of AIDS Project; Gena Lee Nolin, *Diabolique* premiere

179 Jennifer Tilly, *Mission: Impossible* premiere; Sharon Stone, A Tribute to Style on Rodeo Drive; Angie Everhart, *Courage Under Fire* premiere; Leslie Mann, *The Cable Guy* premiere

180 Quentin Tarantino and Mira Sorvino (in Armani), Academy Awards; Patricia Arquette and Nicolas Cage, Screen Actors Guild Awards; Brooke Shields and Judd Nelson, Carousel of Hope Ball

181 Gwyneth Paltrow (in Calvin Klein) and Brad Pitt, Academy Awards; Jerry Seinfeld and Shoshanna Lonstein, Screen Actors Guild Awards; Claudia Schiffer (in Valentino) and David Copperfield, Academy Awards

182 Salma Hayek, *The Crucible* premiere

183 Andie MacDowell, *Multiplicity* premiere; Jon Tenney and Teri Hatcher, Fire & Ice Ball; Emmanuelle Beart, *Mission: Impossible* premiere

184 Samuel L. Jackson, *A Time to Kill* special screening

1997

187 Anne Heche (in Pamela Dennis) and Ellen DeGeneres (in Pamela Dennis), Emmy Awards

188 Sharon Stone, Golden Globe Awards; Chewbacca, *Star Wars Special Edition* premiere; Prince, VH1 Awards

189 Cybill Shepherd, Golden Globe Awards; Kevin Spacey, *Midnight in the Garden of Good and Evil* premiere; Matt Damon, Minnie Driver, and Ben Affleck, *Good Will Hunting* premiere; Jenny McCarthy, Academy Awards

190 Sean Young, Academy Awards; Courteney Cox, Golden Globe Awards; Demi Moore, Golden Globe Awards

191 Helen Hunt (in Laurel), Emmy Awards; Courtney Love (in Versace), Academy Awards; Gillian Anderson, Golden Globe Awards

192 Natasha Richardson and Liam Neeson, Golden Globe Awards; Nicole Kidman, Academy Awards; Kristen Johnston (in Vera Wang), Emmy Awards

193 Barbara Hershey, Academy Awards; Bruce Willis and Demi Moore, Emmy Awards; Anne Jeffreys, Academy Awards

194 Elizabeth Taylor and Michael Jackson, Elizabeth Taylor's birthday; Marilyn Manson and Rose McGowan, *Alien Resurrection* premiere

195 Dennis Rodman (in Lords) and Stacey Yarbrough, Academy Awards; Tommy Lee and Pamela Anderson, American Music Awards

196 Diane Keaton and Steve Martin, Academy Awards; Michelle Pfeiffer and David E. Kelley, Emmy Awards; Kevin Bacon and Kyra Sedgwick, Golden Globe Awards

197 Alicia Silverstone (in Paco Rabanne) and date, *Batman and Robin* premiere

198 Tea Leoni and David Duchovny, *Playing God* premiere

200 Elise Neal, *Scream 2* premiere; Alicia Silverstone, Humane from Hollywood Charity Evening; Charlize Theron, *Tomorrow Never Dies* premiere

201 Jada Pinkett Smith, *Scream 2* premiere; Melanie Griffith (in Versace) and Antonio

Banderas, Golden Globe Awards; **Jamie Lee Curtis** and daughter **Annie**, *Fierce Creatures* premiere

202 **Portia de Rossi**, *Scream 2* premiere; Guest, *Tomorrow Never Dies* premiere; **Rebecca Gayheart**, *Money Talks* premiere

203 **Julia Roberts**, *Conspiracy Theory* premiere

1998

205 **Madonna** (in Olivier Theyskens and Jean Paul Gaultier) and brother **Christopher Ciccone**, Academy Awards

206 **Mark McGrath**, Blockbuster Entertainment Awards

207 **Gillian Anderson** (in Herve Leger), Golden Globe Awards; **Rebecca Romijn**, MTV Awards; **Jennifer Lopez** (in Paco Rabanne), MTV Awards

208 **Shania Twain**, Billboard Music Awards; **Jeri Ryan** (in Richard Tyler), Emmy Awards

209 **Salma Hayek**, MTV Music Awards; **Angelina Jolie**, Golden Globe Awards

210 **Tyra Banks** (in Halston), Academy Awards; **Geena Davis** (in Halston), Academy Awards

211 **Matt Dillon** and **Cameron Diaz** (in Stella McCartney for Chloé), Academy Awards

212 **Rupert Everett** and **Julia Roberts** (in Todd Oldham), Golden Globe Awards; **Helena Christensen**, Academy Awards; **Kate Winslet** (in Alexander McQueen for Givenchy), Academy Awards

213 **Ellen Barkin** (in Dior by John Galliano), Golden Globe Awards; **Sharon Stone** and **Phil Bronstein**, *The Mighty* premiere; **Sandra Bullock** (in Dior by John Galliano), Golden Globe Awards

214 **Jane Seymour**, People's Choice Awards; **Salma Hayek**, *54* premiere

215 **Andrea Thompson**, Screen Actors Guild Awards

216 **Jessica Biel**, *Halloween H20* premiere; **Brandy**, *I Still Know What You Did Last Summer* premiere

217 **Katie Holmes** (in Badgley Mischka), Emmy Awards; **Kate Hudson** (in Gucci), MTV Awards

218 **Drew Barrymore**, *Home Fries* premiere

219 **Luke Wilson** and **Drew Barrymore** (in Les Habitudes), *Ever After* premiere

220 **Helen Hunt** (in Tom Ford for Gucci), Academy Awards; **Linda Hamilton** (in Pamela Dennis), Academy Awards; **Heather Graham** (in Dolce & Gabbana), *Lost in Space* premiere

221 **Kim Basinger** (in Escada), Academy

Awards; **Helena Bonham Carter**, Academy Awards; **Halle Berry** (in Vera Wang), Academy Awards

222 **Bridget Fonda**, Academy Awards; **Celine Dion** (in Michael Kors), Academy Awards; **Minnie Driver** (in Randolph Duke for Halston), Academy Awards; **Catherine Zeta-Jones**, *The Mask of Zorro* premiere

223 **Melanie Griffith** and **Antonio Banderas**, Academy Awards

1999

225 **Celine Dion** (in John Galliano for Christian Dior), Academy Awards

226 **Liv Tyler** (in Pamela Dennis), Academy Awards; **Uma Thurman** (in Chanel), Academy Awards; **Lucy Liu**, Screen Actors Guild Awards

227 **Salma Hayek**, MTV Movie Awards; **James King**, MTV Movie Awards; **Keri Russell** (in Armani), Emmy Awards

228 **Tom Hamilton**, **Joey Kramer**, **Steven Tyler**, and **Joe Perry** of Aerosmith, Billboard Music Awards

229 **Courtney Love**, MTV Movie Awards

230 **Cameron Diaz**, Golden Globe Awards; **Roma Downey**, TV Guide Awards

231 **Garcelle Beauvais-Nilon**, Screen Actors Guild Awards; **Gillian Anderson**, Emmy Awards; **Catherine Zeta-Jones** (in Ungaro), MTV Movie Awards

232 Guest, *Wild Wild West* premiere; **Jennifer Lopez**, MTV Movie Awards; **Shiva Rose** and **Dylan McDermott**, MTV Movie Awards; **Will Smith**, *Wild Wild West* premiere

233 Members of **Dru Hill**, MTV Movie Awards

234 **Maria Conchita Alonso** (in Bradley Bayou), *The World Is Not Enough* premiere; **Julienne Davis**, *Eyes Wide Shut* premiere

235 **Fran Drescher**, *The World Is Not Enough* premiere; **Lara Flynn Boyle** (in David Cardona), Emmy Awards

236 **Milla Jovovich**, *Eyes Wide Shut* premiere; **Sandra Bullock** (in Badgley Mischka), People's Choice Awards; **Lucy Liu** (in Joseph A. Porro), Emmy Awards

237 **Andie MacDowell** (in Badgley Mischka), Academy Awards; **Helena Bonham Carter**, *Fight Club* premiere; **Julianna Margulies**, Emmy Awards

238 **Catherine Zeta-Jones** (in Versace), Academy Awards

239 **Sean Connery**, *Entrapment* screening

240 **Calista Flockhart**, Screen Actors Guild Awards; **Halle Berry** (in Versace), Emmy Awards; **Jennifer Lopez** (in Badgley Mischka), Academy Awards

241 **Julianna Margulies** (in Oscar de la Renta), Golden Globe Awards

242 Brother **Jake Paltrow** with **Gwyneth Paltrow** (in Calvin Klein), Golden Globe Awards; **Gwyneth Paltrow** (in Gucci), Screen Actors Guild Awards

243 **Angelina Jolie**, Screen Actors Guild Awards; **Angelina Jolie** (in Randolph Duke) and brother **James Haven**, Golden Globe Awards

244 **Tracy Pollan** (in Ralph Lauren), son **Sam**, and **Michael J. Fox** (in Richard Tyler), Emmy Awards; **David Duchovny** and **Tea Leoni** (in Richard Tyler), Golden Globe Awards; **Jada Pinkett Smith** and son **Jaden**, *Wild Wild West* premiere; **Thomas Gibson** and **Christine Gibson**, Golden Globe Awards

245 **Ashton Kutcher**, TV Guide Awards

2000

247 **Matthew Broderick** and **Sarah Jessica Parker** (in Oscar de la Renta), Emmy Awards

248 **Brad Pitt** and **Jennifer Aniston** (in Prada), Emmy Awards; **Halle Berry** (in Valentino), Golden Globe Awards; **Sarah McLachlan** (in Randolph Duke), Academy Awards

249 **Mena Suvari** (in Escada), Academy Awards; **Ethan Hawke** and **Uma Thurman** (in Alberta Ferretti), Academy Awards; **Gwyneth Paltrow** (in Calvin Klein), Academy Awards

250 **Rose McGowan**, *The Cell* premiere; **Chloe Sevigny** (in Yves Saint Laurent), Academy Awards; **Tara Subkoff**, *The Cell* premiere; **Salma Hayek**, Blockbuster Entertainment Awards

251 **Cate Blanchett** (in Jean Paul Gaultier), Academy Awards

252 **Sharon**, **Kelly**, **Ozzy**, **Aimee**, and **Jack Osbourne**, Grammy Awards

254 **Angelina Jolie** and **Billy Bob Thornton**, *Gone in 60 Seconds* premiere

255 **Angelina Jolie** (in Versace), Academy Awards

256 **Kid Rock** and **James King**, Grammy Awards; **Kevin Bacon** and **Kyra Sedgwick**, Blockbuster Entertainment Awards; **Erykah Badu**, Screen Actors Guild Awards

257 **Kirsten Dunst**, Blockbuster Entertainment Awards; **Juliette Lewis**, *Mission: Impossible* premiere

258 **Emily Robison**, **Natalie Maines**, and **Martie Maguire** of the Dixie Chicks, Grammy Awards; members of the **Cheetah Girls**, Billboard Music Awards;

Tionne Watkins, Rozonda Thomas, and **Lisa Lopes** of TLC, Grammy Awards

259 **Tyra Banks** (in Vera Wang), Academy Awards

260 **Britney Spears**, Billboard Music Awards; **Debi Mazar**, *Requiem for a Dream* premiere

261 **Kathy Griffin**, Billboard Music Awards; **Gwen Stefani**, VH1 Music Awards

262 **Portia de Rossi**, Screen Actors Guild Awards; **Geena Davis** (in Pamela Dennis), Emmy Awards; **Tori Spelling**, Carousel of Hope Ball

263 **Pink**, Billboard Music Awards; **Jennifer Lopez**, Grammy Awards; **China Chow**, *Charlie's Angels* premiere

264 **Kirsten Dunst**, Screen Actors Guild Awards; **Lucy Liu**, Emmy Awards; **Lara Flynn Boyle**, Screen Actors Guild Awards

265 **Joan** and **Melissa Rivers**, Academy Awards

266 **Marcus Schenkenberg** and **Pamela Anderson**, Viper Room; **Julia Roberts** and **Benjamin Bratt**, *Red Planet* premiere; **John Oszajca** and **Lisa Marie Presley**, *Lucky Numbers* premiere

267 **Colin Farrell** and **Amelia Warner**, *Quills* premiere; **Jennifer Connelly** and **Josh Charles**, *Requiem for a Dream* premiere; **Christian Slater** and **Ryan Haddon**, *Charlie's Angels* premiere

268 **Elizabeth Hurley**, *Bedazzled* premiere; **Kirsten Dunst**, *Mission: Impossible II* premiere

269 **Sarah Jessica Parker**, Screen Actors Guild Awards; **Britney Spears**, American Music Awards

270 **Chloe Sevigny**, Screen Actors Guild Awards; **Charlize Theron**, Screen Actors Guild Awards; **Julie Warner**, People's Choice Awards

271 **Rose McGowan**, *Ready to Rumble* premiere; **Angie Harmon**, Emmy Awards; **Hilary Swank**, Screen Actors Guild Awards

2001

273 **Bjork** (in Marjan Pejoski), Academy Awards

274 **Hilary Swank** (in Atelier Versace) and **Chad Lowe**, Academy Awards; **Julia Stiles** (in Vera Wang), Academy Awards; **Fiona Apple**, Grammy Awards

275 **Cynthia Nixon, Kim Cattrall, Kristin Davis**, and **Sarah Jessica Parker** of *Sex and the City*, Screen Actors Guild Awards

276 **Halle Berry**, *Swordfish* premiere; **Carmen Electra**, American Music Awards

277 **Juliette Lewis**, *Captain Corelli's Mandolin*

premiere; **Tori Spelling**, *Scary Movie 2* premiere

278 **Nivea**, Teen Choice Awards; **Tyra Banks**, Blockbuster Entertainment Awards

279 **Shakira**, Radio Music Awards; **Christina Aguilera**, Blockbuster Entertainment Awards

280 **Tom Green** and **Drew Barrymore**, *Freddy Got Fingered* premiere; **Dulé Hill** and mother, Emmy Awards; **Debra Messing** and **Daniel Zelman**, Fulfillment Fund honoring Jeffrey Katzenberg; **Gwen Stefani** and **Eve**, Teen Choice Awards

281 **Kid Rock** and date, American Music Awards

282 **Johnny Knoxville**, *From Hell* premiere; **Ashton Kutcher** and **Ashley Scott**, *From Hell* premiere; **Jake Gyllenhaal**, *Harry Potter and the Sorcerer's Stone* premiere

283 **Aaron Paul** and **Samaire Armstrong**, *K-PAX* premiere; **Orlando Bloom**, *Lord of the Rings: The Fellowship of the Ring* premiere; **Barry Watson**, *Ocean's Eleven* premiere

284 **Demi Moore** and **Bruce Willis** with daughters **Rumer, Tallulah**, and **Scout**, *Bandits* premiere

285 **Trudie Styler** (in Jean Paul Gaultier) and **Sting** (in Calvin Klein) with son **Jake Sumner** and daughter **Eliot Paulina**, Academy Awards

286 **Julia Roberts** (in Valentino Couture) and **Benjamin Bratt** (in Armani), Academy Awards

287 **Kate Hudson** (in Vera Wang) and **Chris Robinson**, Golden Globe Awards; **Freddie Prinze Jr.** and **Sarah Michelle Gellar**, Golden Globe Awards

288 **Debi Mazar**, Screen Actors Guild Awards; **Gwen Stefani**, VH1 Music Awards

289 **Bai Ling**, *The Others* premiere; **Debra Messing** (in Ralph Lauren), Golden Globe Awards

290 **Janel Moloney**, Golden Globe Awards; **John Spencer** and **Patricia Mariano**, Golden Globe Awards

291 **Bradley Whitford** and **Jane Kaczmarek**, Golden Globe Awards

292 **Kevin Spacey** and fans, *K-PAX* premiere

294 **Russell Simmons** and **Kimora Lee Simmons**, Macy's and American Express Passport '01 HIV/AIDS fund-raiser; **Pamela Anderson**, Teen Choice Awards; **Carmen Electra**, Macy's and American Express Passport '01 HIV/AIDS fund-raiser

295 **Britney Spears** and **Justin Timberlake**, American Music Awards

296 **Michael Douglas** and **Catherine Zeta-Jones** (in Christian LaCroix), Golden

Globe Awards; **Teri Polo**, People's Choice Awards; **Joan Allen**, Golden Globe Awards

297 **Portia de Rossi** (in BCBG Max Azria), Golden Globe Awards; **Sarah Jessica Parker** (in Ungaro), Golden Globe Awards

298 **Priscilla Presley**, *Harry Potter and the Sorcerer's Stone* premiere

299 **Nicolas Cage** and **Lisa Marie Presley**, *Captain Corelli's Mandolin* premiere

300 **Kate Winslet**, Screen Actors Guild Awards; **Tea Leoni**, *The Family Man* premiere; **Sheryl Crow**, Blockbuster Entertainment Awards

301 **Lucy Liu, Anne Heche**, and **Jane Krakowski** of *Ally McBeal*, Golden Globe Awards

2002

303 **Renée Zellweger** (in Carolina Herrera), Academy Awards

304 **Alicia Keys**, American Music Awards; **Laura Harring** (in $1 million Stuart Weitzman shoes), Academy Awards; **Garcelle Beauvais-Nilon**, People's Choice Awards

305 **Halle Berry** (in Elie Saab), Academy Awards; **Christine Lahti**, Emmy Awards; Shoes worn by **Lisa Edelstein**, GLAAD Media Awards

306 **Andie MacDowell** (in Escada), Golden Globe Awards; **Marg Helgenberger**, Emmy Awards

307 **Natasha Henstridge**, Creative Arts Awards; **Cameron Diaz** (in Emanuel Ungaro), Academy Awards

308 **Paula Abdul**, Emmy Awards; **Jennifer Connelly**, Screen Actors Guild Awards; **Debra Messing**, Emmy Awards

309 **Sheryl Crow**, Grammy Awards

310 **Julianne Moore**, *The Hours* premiere; **Amanda Peet**, *Changing Lanes* premiere; **Jessica Capshaw**, *Catch Me If You Can* special screening

311 **Marisa Tomei**, People's Choice Awards; **Jessica Alba**, Golden Globes ; **Kim Cattrall**, Screen Actors Guild Awards

312 **Beyoncé Knowles**, *Austin Powers: Goldmember* premiere

313 **Heather Locklear** (in Celine), Golden Globe Awards; **Kate Hudson** (in Versace), Golden Globe Awards

314 **Lorenzo Lamas** and daughter **Alexandra Lynne**, *Treasure Planet* premiere; **Will Smith** and son **Jaden**, *Spider-Man* premiere; **Sara Kapfer, Cuba Gooding Jr.**, and sons **Spencer** and **Mason**, *Spider-Man* premiere; **Magic Johnson** and son **Earvin**, *Spider-Man* premiere

315 **Coolio** and sons **Milan** and **Darius**, *The Santa Clause 2* premiere; **Harry Hamlin**, daughter **Delilah**, and a friend, *Treasure Planet* premiere; **Robert Patrick** and son **Samuel**, *Treasure Planet* premiere; **Mario Van Peebles** and son **Mandela**, *Spider-Man* premiere

316 **Britney Spears**, *Crossroads* premiere; **Brittany Murphy**, VH1 "Big in 2002" Awards

317 **Vanessa Parise**, *Catch Me If You Can* premiere; **Cameron Diaz**, *Gangs of New York* premiere

318 **Justin Timberlake** and "nurses", Billboard Music Awards

319 **Anna Nicole Smith**, Party honoring Guess? founders

320 **Jennifer Lopez** (in Versace), Academy Awards; **Kirsten Dunst** (in John Galliano for Christian Dior), Academy Awards; **Audrey Tautou** (in Alberta Ferretti), Academy Awards

321 **Nicole Kidman** (in Chanel), Academy Awards; **Calista Flockhart** (in Oscar de la Renta), Golden Globe Awards

322 **Dakota** and **Elle Fanning**, *The Santa Clause 2* premiere; **Ashlee** and **Jessica Simpson**, *The Hot Chick* special screening; **Samantha** and **Marley Shelton**, *White Oleander* premiere

323 **Ashley** and **Mary-Kate Olsen**, *Austin Powers: Goldmember* premiere

324 **Maria Menounos**, *White Oleander* premiere; **Charlize Theron**, *The Truth About Charlie* premiere

325 **Jessica Alba**, VH1 "Big in 2002" Awards; **Marguerite Moreau**, *Crossroads* premiere

326 **Jada Pinkett Smith** (in Lanvin-Castillo), Academy Awards; **India Arie**, Grammy Awards

327 **Micheline Etkin**, Golden Globe Awards; **Oprah Winfrey**, Emmy Awards; **Elisha Cuthbert**, Emmy Awards

328 **Summer Altice**, *The Scorpion King* premiere; **Kirsten Dunst**, *Spider-Man* premiere

329 **Lauren Ambrose**, Emmy Awards; **Patricia Clarkson**, Emmy Awards

330 **Jack Nicholson** and **Lara Flynn Boyle**, *About Schmidt* premiere

331 **Pamela Anderson** and **Kid Rock**, American Music Awards; **Tara Reid**, Billboard Music Awards; **Nivea**, Billboard Music Awards

2003

333 **Sheryl Crow**, American Music Awards

334 **Tommy Lee** and **Pamela Anderson**, *Scary Movie 3* premiere

335 **Johnny Depp**, *Pirates of the Caribbean: The Curse of the Black Pearl* premiere; **Kim Bordenave**, **Colin Farrell**, and **Claudine Farrell**, Academy Awards; **Billy Bob Thornton**, Hollywood Walk of Fame

336 **Ashanti**, American Music Awards; **Halle Berry** (in Armani), Screen Actors Guild Awards

337 **Roselyn Sanchez**, American Music Awards; **Salma Hayek** (in Narciso Rodriguez), Golden Globe Awards

338 **Jessica Simpson**, American Music Awards; **Renée Zellweger** (in Carolina Herrera), Academy Awards; **Angelina Jolie**, *Lara Croft Tomb Raider: The Cradle of Life* premiere

339 **Nicole Kidman** (in Gucci), Screen Actors Guild Awards

340 **Penélope Cruz** and **Tom Cruise**, *The Last Samurai* premiere; **Mary-Louise Parker** and **Billy Crudup**, Screen Actors Guild Awards; **Bono** and **Ali Hewson**, Academy Awards

341 **Heather Graham**, Academy Awards; **Carey Lowell** and **Richard Gere**, Golden Globe Awards

342 **Cheryl Hines**, Emmy Awards; **Shania Twain**, American Music Awards

343 **Sharon Stone** (in Versace), Golden Globe Awards; **Christina Aguilera**, American Music Awards

344 **Ted Allen**, **Thom Filicia**, **Jai Rodriguez**, **Carson Kressley**, and **Kyan Douglas** of *Queer Eye*, Emmy Awards

346 **Courteney Cox** and **David Arquette**, Golden Globe Awards; **Matt LeBlanc** and **Melissa McKnight**, Emmy Awards

347 **Matthew Perry** and **Rachel Dunn**, Emmy Awards; **David Schwimmer** and **Carla Alapont**, Emmy Awards

348 **Keira Knightley**, *Pirates of the Caribbean: The Curse of The Black Pearl* premiere; **Sarah Michelle Gellar**, Teen Choice Awards; **Amanda Peet**, *Seabiscuit* premiere

349 **Jessica Simpson** and **Nick Lachey**, Teen Choice Awards

350 **Janel Moloney**, Emmy Awards; **Kate Hudson**, *Le Divorce* premiere

351 **Bai Ling**, *Cold Creek Manor* premiere; **Mya**, American Music Awards

352 **Kristin Davis** (in Celine), Screen Actors Guild Awards; **Lara Flynn Boyle** (in David Cardona), Golden Globe Awards; **Sarah Wynter**, Emmy Awards

353 **Hilary Swank** (in Christian Dior), Academy Awards; **Patricia Heaton**, Screen Actors Guild Awards; **Sarah Jessica Parker**, Emmy Awards

354 **Uma Thurman**, *Kill Bill: Volume I* premiere; **Nicole Kidman**, Critics Choice Awards

355 **Elisha Cuthbert**, Golden Globe Awards; **Cameron Diaz** (in Chanel Couture), Golden Globe Awards

356 **Matthew McConaughey** and **Kate Hudson** (in Valentino), Golden Globe Awards; **Cate Blanchett** (in Valentino), Golden Globe Awards

357 **Jules Asner**, Golden Globe Awards; **Uma Thurman**, Screen Actors Guild Awards; **Parker Posey**, Golden Globe Awards

358 **Eric Benét** and **Halle Berry** (in Elie Saab), Academy Awards; **Micheline Roquebrune** and **Sean Connery**, Academy Awards; **Diane Lane** (in Oscar de la Renta) and **Josh Brolin**, Academy Awards

359 **Joely Richardson**, Emmy Awards; **Rachel Griffiths** and **Andrew Taylor**, Golden Globe Awards

360 **Jessica Lange**, Emmy Awards; **Debra Messing** (in Elie Saab), Emmy Awards; **Helen Mirren**, Emmy Awards

361 **Salma Hayek**, Screen Actors Guild Awards

2004

363 **Jennifer Garner** (in vintage Valentino), Academy Awards

364 **Mary-Kate** and **Ashley Olsen**, Kids' Choice Awards

365 **Jennifer Lopez**, Noche de Ninos benefit for Childrens Hospital Los Angeles; **Mandy Moore**, American Music Awards

366 **Charlize Theron** (in Tom Ford for Gucci), Academy Awards; **Naomi Watts** (in Atelier Versace), Academy Awards; **Mariska Hargitay**, Screen Actors Guild Awards

367 **Catherine Zeta-Jones**, Screen Actors Guild Awards; **Patricia Clarkson** (in Michael Vollbracht for Bill Blass), Academy Awards

368 **Diane Keaton** (in Ralph Lauren Collection), Academy Awards

369 **Larry** and **Laurie David**, "Earth to L.A.! The Greatest Show on Earth" benefit for Natural Resources Defense Council; **Goldie Hawn** and **Kurt Russell**, *Raising Helen* premiere; **Muhammad Ali**, *Collateral* premiere; **Antonio Banderas** and **Melanie Griffith**, MusiCares 2004 Person of the Year Tribute to Sting

370 **Renée Zellweger**, Academy Awards, Academy Awards; **Joely Richardson**, Emmy Awards

371 **Diane Lane** (in Loris Azzaro), Academy Awards; **Angelina Jolie** (in Marc Bouwer), Academy Awards

372 **Nicole Kidman** (in Chanel Haute Couture), Academy Awards; **Evan Rachel Wood**, Screen Actors Guild Awards; **Sandra Bullock** (in Oscar de la Renta), Academy Awards

373 **Jennifer Garner**, Emmy Awards; **Uma Thurman** (in Christian LaCroix), Academy Awards

374 **Tom Cruise**, Film Independent's Spirit Awards

375 Tom Cruise fans

376 **Anna Nicole Smith**, American Music Awards; **Courtney Love**, Grammy Awards

378 **Laura Harring** and **Jack Black**, Academy Awards

380 **Andie MacDowell**, Screen Actors Guild Awards; **Molly Sims**, Screen Actors Guild Awards

381 **Gwen Stefani** and dancers, American Music Awards

382 **Ben Stiller** and **Owen Wilson**, *Starsky and Hutch* premiere

383 **Chad Michael Murray**, *A Cinderella Story* premiere; **Jude Law**, *Closer* premiere; **Jared Leto**, *Alexander* premiere

384 **Kate Hudson**, *Raising Helen* premiere; **Kirsten Dunst**, *Spider-Man 2* premiere; **Claire Danes**, 19th American Cinematheque Award honoring Steve Martin

385 **Kate Bosworth**, *Win a Date with Tad Hamilton* premiere

386 **Rebecca Romijn**, *Godsend* premiere; **Elisabeth Rohm**, Screen Actors Guild Awards; **Holly Hunter**, Academy Awards

387 **Eva Longoria**, American Music Awards; **Matt LeBlanc** and **Melissa McKnight**, Emmy Awards; **Sharon Stone**, ESPY Awards

388 **Sting** and **Mary J. Blige**, Grammy Awards; **Brittany Murphy**, Carousel of Hope Ball

389 **Jamie Lynn Sigler**, Emmy Awards; **Beyoncé Knowles**, Grammy Awards

390 **Robert Randolph**, Grammy Awards; **Jack Black**, "Earth to L.A.! The Greatest Show on Earth" benefit for Natural Resources Defense Council; **Andy Dick**, MTV Movie Awards

391 **Stan Lee**, *Spider-Man 2* premiere

2005

393 **Tom Cruise** and **Katie Holmes**, *War of the Worlds* premiere

394 **Annette Bening** (in Armani Prive) and **Warren Beatty**, Academy Awards;

Calista Flockhart and **Harrison Ford**, AFI Life Achievement Award honoring George Lucas; **Lisa** and **Dustin Hoffman**, Academy Awards; **Diane Sawyer** and **Mike Nichols**, Golden Globe Awards

395 **Clint** (in Armani) and **Dina Eastwood**, Academy Awards

396 **Julie Delpy** (in Azzaro by Vanessa Seward), Academy Awards; **Gwyneth Paltrow** (in Jean Paul Gaultier), Academy Awards; **Halle Berry** (in Atelier Versace), Academy Awards

397 **Cate Blanchett** (in Stella McCartney), Golden Globe Awards; **Charlize Theron** (in Dior Couture by John Galliano), Academy Awards; **Claire Danes**, Golden Globe Awards

398 **Katie Lohmann** and **Chewbacca**, *Star Wars*: Episode III *Revenge of the Sith* premiere; **Manuela Testolini** and **Prince**, Academy Awards; **Usher** and **Tameka Foster**, Academy Awards

399 **Pamela Anderson** and **Dennis Rodman**, PETA Gala; **Tony Parker** and **Eva Longoria**, ABC Summer Press Tour; **Maggie Grace** and **Jorge Garcia**, Golden Globe Awards

400 **Tyson Beckford**, *Into the Blue* premiere; **Heath Ledger** and **Michelle Williams**, *The Brothers Grimm* premiere; **Seann William Scott**, *The Dukes of Hazzard* premiere

401 **Melanie Griffith** (in Atelier Versace) and **Antonio Banderas** (in Armani), Academy Awards; **Stephen Dorff**, *Cinderella Man* premiere; **Russell Crowe**, *Cinderella Man* premiere

402 **Ken Watanabe**, *Memoirs of a Geisha* premiere; **Alan Cumming**, Human Rights Campaign Gala; **Ailsa Marshall** and **Gary Oldman**, *Batman Begins* premiere

403 **Al Pacino**, *Two for the Money* premiere

404 **Charlize Theron**, Emmy Awards; **Kate Hudson**, *The Skeleton Key* premiere; **Rene Russo**, *Two for the Money* premiere

405 **Angelina Jolie**, *Mr. & Mrs. Smith* premiere; **Hilary Swank**, Screen Actors Guild Awards; **Beyoncé Knowles** (in Atelier Versace), Academy Awards

406 **Adrian Grenier**, **Jerry Ferrara**, **Debi Mazar**, **Kevin Connolly**, and **Kevin Dillon** of *Entourage*, Golden Globe Awards

408 **Sarah Jessica Parker**, Screen Actors Guild Awards; **Reese Witherspoon** and **Ryan Phillippe**, *Walk the Line* premiere; **Johnny Depp** and **Vanessa Paradis**, Screen Actors Guild Awards

409 **Josh Groban** and **January Jones**, Golden Globe Awards; **Natalie Portman**, Golden

Globe Awards; **Tim McGraw** and **Faith Hill**, American Music Awards

410 **James King**, *Two for the Money* premiere; **Rose McGowan**, Family Television Awards

411 **Scarlett Johansson** (in Roland Mouret), Academy Awards; **Renée Zellweger** (in Carolina Herrera), Academy Awards

412 **Catherine Zeta-Jones**, *The Legend of Zorro* premiere; **Youki Kudoh**, *Memoirs of a Geisha* premiere

413 **Gwen Stefani**, Billboard Music Awards

414 **Shaun Robinson**, Annual American Music Awards; **Olivia Wilde**, Race to Erase MS

415 **Heidi Klum**, Emmy Awards; **Marcia Cross**, Screen Actors Guild Awards

416 **Rosario Dawson**, Screen Actors Guild awards; **Scarlett Johansson**, *Match Point* premiere; **Eva Longoria**, Emmy Awards

417 **Portia de Rossi**, Emmy Awards; **Debra Messing**, Screen Actors Guild Awards; **Jenny Wade**, *Monster-in-Law* premiere

418 **Penélope Cruz** (in Oscar de la Renta), Academy Awards

419 **Kim Raver**, Golden Globe Awards; **Cate Blanchett** (in Valentino Couture), Academy Awards; **Mena Suvari**, Screen Actors Guild Awards

420 **Ellen Pompeo**, Emmy Awards; **Josh Holloway** and **Yessica Kumula**, Emmy Awards; **Dave Navarro** and **Carmen Electra**, Annual American Music Awards

421 **Sarah Silverman** and **Jimmy Kimmel**, Roast of Pamela Anderson

2006

423 **Reese Witherspoon** (in vintage Chanel Haute Couture) and **Ryan Phillippe**, Golden Globe Awards

424 **Marc Anthony** and **Jennifer Lopez** (in Jean Desses), Academy Awards; **Kyra Sedgwick** and **Kevin Bacon**, Emmy Awards; **Heath Ledger** (in Dunhill) and **Michelle Williams** (in Vera Wang), Academy Awards

425 **Zhang Ziyi** (in Giorgio Armani Prive), Golden Globe Awards

426 **Charlize Theron** (in John Galliano for Christian Dior), Academy Awards

427 **Keira Knightley** (in Vera Wang), Academy Awards; **Cheryl Hines**, Emmy Awards

428 **Seal** and **Heidi Klum**, Emmy Awards

430 **Christa Miller**, Emmy Awards; **Katie Holmes** and **Tom Cruise**, *Mission: Impossible III* premiere; **Heidi Klum**, Emmy Awards

431 **Gavin Rossdale** and **Gwen Stefani** (in LAMB), Grammy Awards; **Rachel Weisz**

(in Donna Karan), Golden Globe Awards; **Debi Mazar**, Golden Globe Awards

432 **Jamie Foxx** and daughters **Erin** and **Carrine**, *Dreamgirls* premiere

433 **Sidney Poitier** and daughter **Sydney Tamiia**, BAFTA/LA Cunard Britannia Awards; **Sting** and daughter **Mickey**, Grammy Awards

434 **Emma Thompson** and **Colin Firth**, Golden Globe Awards; **Jill Hennessy**, Golden Globe Awards

435 **Melanie Griffith** and daughters **Dakota Johnson** and **Stella Banderas**, Golden Globe Awards

436 **Ellen Pompeo**, Golden Globe Awards; **Sandra Oh** (in Collette Dinnigan), Golden Globe Awards

437 **Sharon Stone**, BAFTA/LA Cunard Britannia Awards; **Cate Blanchett**, *Babel* premiere

438 **Kyra Sedgwick** (in Bottega Veneta), Golden Globe Awards; **Orlando Bloom**, *Pirates of the Caribbean: Dead Man's Chest* premiere; **Katherine Heigl** (in Escada), Golden Globe Awards

439 **Maggie Grace**, Screen Actors Guild Awards; **Maggie Gyllenhaal** (in Bottega Veneta) and **Peter Sarsgaard**, Academy Awards; **Jake Gyllenhaal**, Screen Actors Guild Awards

440 **Eva Mendes**, MTV Movie Awards; **Marcia Cross** (in Marc Bouwer), Golden Globe Awards

441 **Kim Raver**, Emmy Awards; **Jennifer Lopez**, Tony Bennett's 80th Birthday Celebration

442 **Molly Sims**, *GQ Magazine* Man of the Year dinner; **Jennifer Connelly**, *Firewall* premiere; **Kerry Washington**, *Dead Girl* premiere; **Sandra Bullock**, Hollywood Film Festival

443 **Andy Dick** and **Jessica Simpson**, *Employee of the Month* premiere

444 **Leonardo DiCaprio**, *Blood Diamond* premiere

445 **Kate Hudson**, MTV Movie Awards; **Lindsay Lohan**, Kids' Choice Awards; **Eve**, Grammy Awards

446 **Diane Kruger**, Academy Awards; **Eva Longoria**, Screen Actors Guild Awards; **Gwyneth Paltrow** (in Balenciaga), Golden Globe Awards

447 **Kate Beckinsale** (in Dior by John Galliano), Golden Globe Awards; **Ashley Tisdale**, American Music Awards; **Sarah Chalke**, Emmy Awards

448 **Jane Kaczmarek** and **Bradley Whitford**, Emmy Awards; **Denis Leary** and **Ann Lembeck**, Emmy Awards; **Alexandra**

Christmann and **Ben Kingsley**, Emmy Awards

449 **Johnny Depp** and **Vanessa Paradis**, Golden Globe Awards; **Simon Cowell** and **Terri Seymour**, Emmy Awards; **Barry Manilow** and guest, Emmy Awards

450 **Beyoncé Knowles**, American Music Awards; **Queen Latifah** (in Carmen Marc Valvo), Golden Globe Awards

451 **Salma Hayek** (in Atelier Versace), Academy Awards; **Taraji Henson**, Academy Awards

452 **Keira Knightley**, Academy Awards

2007

455 **Al** and **Tipper Gore**, Academy Awards

456 **Vanessa Williams** (in Carmen Marc Valvo), Golden Globe Awards; **Jennifer Hudson** (in Oscar de la Renta), Academy Awards; **Queen Latifah** (in Carmen Marc Valvo), Academy Awards

457 **Rachel Weisz** (in Vera Wang), Academy Awards; **Courteney Cox** (in Alberta Ferretti), Golden Globe Awards; **Mary-Louise Parker**, Golden Globe Awards

458 **Sienna Miller** (in Marchesa), Golden Globe Awards; **Hayden Panettiere** (in Monique Lhullier), Golden Globe Awards

459 **Jennifer Garner** (in Gucci), Golden Globe Awards; **Kyra Sedgwick** (in J. Mendel), Golden Globe Awards

460 **Drew Barrymore**, *Music and Lyrics* premiere

461 **LeAnn Rimes**, Grammy Awards; **Jennifer Lopez** (in Marchesa), Golden Globe Awards; **Kim Raver**, Golden Globe Awards; **Sharon Stone**, Rodeo Drive Walk of Style

462 **Jessica Biel** (in Oscar de la Renta), Academy Awards; **Jada Pinkett Smith** (in Carolina Herrera), Academy Awards; **Lara Spencer**, Academy Awards

463 **Kate Winslet** (in Valentino), Academy Awards; **Naomi Watts** (in Gucci), Golden Globe Awards; **Drew Barrymore**, Rodeo Drive Walk of Style

464 **Meryl Streep** (in Prada) and **Abigail Breslin** (in Simin), Academy Awards

465 **Nicole Kidman** (in Balenciaga) and **Naomi Watts** (in Escada), Academy Awards

466 **David Furnish** and **Elton John**, Rodeo Drive Walk of Style

467 **Beyoncé Knowles** (in Elie Saab), Golden Globe Awards; **Mary J. Blige** (in Reem Acra) and **Justin Timberlake**, Golden Globe Awards; **Natalie Cole**, Grammy Awards

468 **André Leon Talley** with models, Oscar fashion preview

469 **Cate Blanchett** (in Armani Prive), Academy Awards

470 **Fergie**, Grammy Awards; **Vanessa Minnillo**, Grammy Awards; **Petra Nemcova**, Grammy Awards; **Hilary Duff**, Grammy Awards

471 **Christina Aguilera** (in Emanuel Ungaro), Grammy Awards; **Evangeline Lilly**, Golden Globe Awards; **Mischa Barton**, Rodeo Drive Walk of Style; **Rebecca Gayheart**, People's Choice Awards

472 **Brad Pitt** (in J. Lindeberg) and **Angelina Jolie** (in St. John), Golden Globe Awards

473 **Sandra Oh**, Golden Globe Awards; **Eddie Murphy** and **Tracey Edmonds**, Academy Awards

474 **Penélope Cruz** (in Atelier Versace), Academy Awards

475 **Gwyneth Paltrow** (in Zac Posen), Academy Awards

476 **Edie Falco**, Screen Actors Guild Awards; **Lorraine Bracco, James Gandolfini, Steve Schirripa, Robert Iler**, and guests, Screen Actors Guild Awards; **Jamie Lynn Sigler**, Screen Actors Guild Awards

478 **Cameron Diaz** (in Emanuel Ungaro), Golden Globe Awards

479 **Rinko Kikuchi** (in Chanel Couture), Golden Globe Awards; **Sandra Oh**, People's Choice Awards

480 **Maggie Gyllenhaal** (in Proenza Schouler), Academy Awards; **Emily Blount** (in Calvin Klein), Academy Awards; **Portia de Rossi** (in Zac Posen), Academy Awards

481 **Cheryl Hickey**, Grammy Awards; **Ashton Kutcher** and **Demi Moore**, Screen Actors Guild Awards; **Toni Collette**, Golden Globe Awards

482 **Eva Longoria** (in Emanuel Ungaro), Golden Globe Awards

483 **Keisha Whitaker**, Academy Awards

484 **Cameron Diaz** (in Valentino), Academy Awards

485 **Anne Hathaway** (in Valentino), Academy Awards; **Nicollette Sheridan**, Golden Globe Awards; **Rinko Kikuchi**, Academy Awards

486 Red Carpet Arrival Area, Kodak Theater, Academy Awards

2008

489 **George Clooney** (in Giorgio Armani) and **Sarah Larson** (in Valentino Couture), Academy Awards

490 **Dennis Hopper** and **Victoria Duffy**, Academy Awards; **Kyra Sedgwick** (in Oscar de la Renta), Critics Choice Awards; **Heidi Klum** (in John Galliano Couture) and

Seal (in Dior), Academy Awards

491 **Katherine Heigl** (in Escada), Academy Awards

492 **Rihanna** (in Zac Posen), Grammy Awards; **Miley Cyrus** (in Celine), Grammy Awards; **Beyoncé Knowles** (in Elie Saab), Grammy Awards

493 **Lindsay Lohan**, Clive Davis' Pre-Grammy party

494 **Anne-Marie Duff** (in Moschino) and **James McAvoy** (in Clemens en August), Academy Awards; **Jenna Fischer** (in Collette Dinnigan), Screen Actors Guild Awards; **Diane Lane** (in Versace), Screen Actors Guild Awards

495 **Amanda Bynes** (in Marchesa), Screen Actors Guild Awards; **Alicia Keys** (in Armani Privé) and date, Grammy Awards; **Cate Blanchett** (in Dries Van Noten), Academy Awards

496 **Larry King** and **Shawn Southwick**, Clive Davis' Pre-Grammy party; **Leona Lewis** and **Clive Davis**, Clive Davis' Pre-Grammy party

498 **Christina Applegate** (in Elie Saab), Screen Actors Guild Awards; **Brittany Snow** (in Zuhair Murad), Screen Actors Guild Awards; **Debra Messing** (in Oscar de la Renta), Screen Actors Guild Awards

499 **Teri Hatcher** (in Badgley Mischka), Screen Actors Guild Awards; **Eva Longoria Parker** (in Naeem Khan), Screen Actors Guild Awards; **Renée Zellweger** (in Carolina Herrera), Academy Awards

500 **Marion Cotillard** (in Jean Paul Gaultier Couture), Academy Awards

501 **Ellen Pompeo** (in Nina Ricci by Olivier Theyskens), Screen Actors Guild Awards

502 **Brad Pitt** and **Angelina Jolie** (in Dolce & Gabbana), Critics Choice Awards

504 **Johnny Depp** (in Giorgio Armani) and **Vanessa Paradis** (in Chanel Haute Couture), Academy Awards; **Ellen Page** (in vintage Jean-Louis Scherrer), Academy Awards

505 **Emily Deschanel**, Critics Choice Awards; **Nicole Kidman** (in Balenciaga gown and L'Wren Scott necklace), Academy Awards; **Elodie Bouchez**, Grammy Awards

506 **Jonas Brothers**, *Hanna Montana* premiere; **Paramore**, Grammy Awards

507 **Panic! At the Disco**, Grammy Awards; **Metal Skool**, Film Independent's Spirit Awards

508 **Amy Adams** (in Proenza Schouler gown and Fred Leighton purse), Academy Awards

509 **Jennifer Garner** (in Oscar de la Renta),

Academy Awards; **Penélope Cruz** (in Chanel Haute Couture), Academy Awards

510 **Kylie Minogue** (in J'Aton), G'Day USA ball; **Lara Spencer**, Academy Awards

511 **Allison Janney** (in Pamella Roland), Screen Actors Guild Awards; **Natasha Bedingfield** (in Reem Acra), Grammy Awards; **Brooke Hogan**, Grammy Awards

512 **Taraji P. Henson** (in Bradley Bayou), Screen Actors Guild Awards; **Ashley Tisdale** (in Badgley Mischka Couture), Screen Actors Guild Awards

513 **Kate Beckinsale** (in Alberta Ferretti), *Snow Angels* premiere; **Becki Newton** (in Elsie Katz Couture), Screen Actors Guild Awards

514 **Julian Schnabel** and **Javier Bardem** (in Prada), Academy Awards

515 **Spike Lee** and **Wesley Snipes**, Academy Awards; **John Travolta** and **Olivia Newton-John** (in Ralph Lauren), G'Day USA ball; **Colin Farrell** (in Dunhill) and mother **Rita**, Academy Awards; **Chris Brown** and **Fergie** (in Calvin Klein), Grammy Awards

516 **Adrienne Lau**, Grammy Awards; **Jennifer Hudson** (in Roberto Cavalli), Academy Awards

517 **Lisa Rinna**, Academy Awards; **Tanika Ray**, Academy Awards

530 **Carrot Top**, Blockbuster Movie Awards, 1997

CELEBRITY & DESIGNER INDEX